BLACKS
AND
WHITE TV

BLACKS
AND
WHITE TV

African Americans in Television since 1948

Second Edition

J. Fred MacDonald

Nelson-Hall Publishers/Chicago

Project Editor: Rachel Schick

Library of Congress Cataloging-in-Publication Data

MacDonald, J. Fred.
 Blacks and white TV: African Americans in television since 1948 /
J. Fred MacDonald. — 2nd ed.
 p. cm.
 Includes bibliographical references and index.
 ISBN 0-8304-1326-X
 1. Afro-Americans in television broadcasting—History. I. Title.
PN1992.8.A34M3 1992
791.45′08996073—dc20 91-39089
 CIP

Copyright © 1992 by J. Fred MacDonald

Manufactured in the United States of America

10 9 8 7 6 5 4 3 2 1

For Clay Hodges,
whose standards of fairness and
distaste for prejudice were crucial

Contents

Contents

Part Three: The Age of the New Minstrelsy, 1970–1983

Part Four: Blacks in the New Video Order, 1983–Present

Preface

It has been almost a decade since I completed the first edition of this inquiry into the historic treatment of African Americans by the white-dominated television industry. It has been a tumultuous ten years for broadcasters, as challenging a time as any since radio emerged in the 1920s and television in the 1940s. This is because broadcasting has begun to disintegrate. Structural changes that started in the 1980s continue to sap the vitality and the purpose from over-the-air television. By providing more channels and more choices, cable and other electronic technologies have weakened the appeal of TV as monopolized by three big networks. The large homogeneous audiences basic to broadcasting have been fragmented, scattered among the dozens of outlets now available to the average viewer.

This second edition comes with more optimism than that offered by its predecessor. A new video order is materializing. Greater choice and more channels necessarily mean enhanced opportunity for minority involvement, and a greater possibility of realizing the promise of bias-free programming inherent in the birth of the industry. But let us not be naive: the regressive forces of race prejudice still flourish in the United States. Racism still makes money and it still generates votes. The opportunity and possibility created by the new television reality are theoretical: they must be confronted aggressively by African Americans of talent and influence, and by insightful whites who recognize the moral and material reasons for breaking with the old discrimina-

tory ways. If this propitious time is not grabbed and exploited by the proponents of racial harmony, there will be no hope of ever overcoming the racist legacy that continues to shackle this democratic republic.

Helping me considerably in preparing this second edition are people with whom I have come in contact over the past decade. Thanks go to two members of the United States House of Representatives, Congresswoman Cardiss Collins and the late Congressman Mickey Leland, who have placed in the official record the story of the prejudicial treatment of all racial minorities by white television. Thanks also to Robert Hooks, Brock Peters, Bernard Shaw, and Ray Nunn, distinguished men within the newscasting and entertainment industry, who shared their ideas with me. Etta Moten Barnett, an indefatigable woman of accomplishment and charm, also helped to clarify ideas.

My gratitude goes to Professors Robert Thompson of Syracuse University, Samuel Betances of Northeastern Illinois University, and Darrell Hamamoto of the University of California, Los Angeles. Thanks, too, to Richard Prelinger, of Prelinger Associates, and to Les Waffen of the National Archives. And to the list of private collectors cited in the first edition, I need to add appreciatively the names of others whose assistance has been crucial: Omer Whayne, Wayne Sarnowski, H. B. "Pancho" Elder, Steve Rebro, Ray Courts, Jerry Nelson, Ron Spenser, Andy Jaysnovitch, Carl Hoglund, Mike Pipher, Sam Samuelian, Bob Crozier, Bob Lippet, Barbara Watkins, and Murray Schantzen.

Finally, my gratitude to Steve Ferrara, the president of Nelson-Hall Publishers, who has supported my scholarship and placed great importance on bringing to public exposure the history of the treatment of African Americans by U.S. television.

Preface to the First Edition

Love it or hate it, television is an integral part of American civilization. It is at once a seductive and entertaining theater in the home, a readily available source of news and information, an arena for sporting events, a forum of debate, an audio-visual billboard for advertising, and a reflector and creator of the popular mood. Those who adore it are often addicted to its mesmerizing offerings. Those who despise it are compelled, nevertheless, to recognize its powerful influence in the national existence. Whatever a critic's perspective, TV is on in America, and America is on TV.

To African Americans, television has had a relationship that is especially important. The medium emerged in the liberal climate of the years immediately following World War II, a time when the first modern strides toward freedom were being taken by blacks. Video matured in the midst of the civil rights movement. In fact, that movement was the first political groundswell to recognize the importance of TV and enlist the medium in a social crusade.

As well as being linked to television by history, blacks also watch TV. Statistics reveal that proportionately more blacks than whites view TV. This is especially the case with African-American children living in poverty.

This is a study of the relationship between television and blacks in the decades since the medium became popular. It is a history of great talents, achievements, and anticipations. It is also a history of disappointments, prejudices, and failures within the

xi

Preface to the First Edition

video industry and American society. Ultimately, however, it is the story of a promise never fully kept—a promise whose fullest dimensions perhaps were never totally realizable.

While much has been written about blacks in motion pictures, this is the first book-length consideration of blacks in the most popular medium, television. As such a study must be, this is drawn from many sources, including private film and tape collections, extensive viewing of TV, publications such as *Variety* and *TV Guide*, interviews, and discussions. Where possible, citations from actual programs have been noted. Where such citations have been extracted from unpublished sources, the dating of the programs—whenever possible—has been incorporated into the text.

One cannot write a book such as this without the assistance of many people. I owe a great debt to those who shared with me their time, materials, and energies. My thanks goes to those private collectors who know better than many trained scholars the historic value of kinescopes, old films, vintage fan magazines, and TV memorabilia. For their kindnesses in this regard, I thank those in the Chicago area: Dick Andersen, Joe Sarno, Chuck Schaden, Dave Denwood, Wayne Banchik, Larry Charet, Irv Abelson, Tony Bedner, Ken Kapson, Veto Stasiunaitis, and Thomas Boren. Thanks also to Nat Bilsky, Alan Blum, Dan Pearson, and Morry Roth in Chicago. Elsewhere, I greatly appreciate the help of Bernard Bachrach, Eli Segal, Lyn Losmandy Karch, J. David Goldin, Dave Tottenham, Patricia Ahmann, Harold Doebel, Ivy Orta, and Joanne King. But especially, I want to thank Larry Urbanski of Chicago for his invaluable assistance in gathering materials which were integral to this study.

I owe many people a great debt for sharing their ideas and sensitivities. James Briggs Murray of the Schomburg Center for Research in Black Culture in New York City was very important, as were Sterling Stuckey of Northwestern University, Edward A. Robinson and Gussie Ware of Northeastern Illinois University, Charles Branham of the University of Illinois at Chicago Circle, Lewis A. Erenberg of Loyola University of Chicago, Harry Shaw of the University of Florida, and Tom Arthur of James Madison University. Also of help were Tony Brown of Tony Brown Productions, Dwight M. Ellis of the National Association of Broadcasters, George Schaefer of Compass Productions, Richard Crenna, and Richard Durham.

Preface to the First Edition

Few people have labored as arduously for interracial understanding and communication as has Anne Blair. Working in Chicago with the late Earle Chisolm and the Pro & Con Screening Board, she brought me into contact with many thoughtful men and women whose ideas were stimulating. Among those humanist thinkers were Grace Holt, Clovis Semmes, Bud Salk, Gwendolyn May, Myrna Henricks, Ira Rogers, James Herd, the late Alphonso Sherman, Paul Winfield, and William Marshall.

There are others whom I wish to thank. Katharine Heinz of the Broadcast Pioneers Library in Washington, D.C. made her archives available, as did Travis Whitlow of the A. C. Nielsen Company in Northbrook, Illinois. I am in debt, also, to Michael Marsden and Jack Nachbar of Bowling Green State University for their pioneering encouragement of cultural research in television history, and for permission to reprint from the *Journal of Popular Film and Television* (vol. 7, no. 3) my article "Black Perimeters—Paul Robeson, Nat King Cole, and the Role of Blacks in American TV."

Financial assistance for this study came partially from the Committee on Organized Research of Northeastern Illinois University. Thanks also to Frank Pettis and the Illinois Humanities Council for their indirect support of this research.

Generous thanks also to two special people. My wife, Leslie W. MacDonald, offered her perceptive advice and understanding during the months of research and writing needed to complete this study. I thank her sincerely. And I thank an old friend, Clay Hodges, who many years ago was most influential to me as a model of racial tolerance and understanding. This book is dedicated to him and his integrity.

Introduction

In its earliest years, television held the prospect of a bright and appealing future for Americans. Decades before it became a popular reality in the late 1940s, many saw the emerging medium as a wellspring from which would flow great social, cultural, and intellectual benefits. Combining the other popular arts—radio, film, theater, literature—into a single, ultimate medium, TV seemed to be propelling the United States toward a new era in its democratic civilization.

Comedian Eddie Cantor in 1936 envisioned television as an irresistible theater for mass diversion. It was to be an exciting forum bringing audiences "such entertainment as the world has never dreamed of."[1] Dr. Ernst Frederick Werner Alexanderson, one of the most renowned scientists working on the development of radio and television, foresaw that video would have a significant political role to play. "Television will be a great asset to politicians," he predicted in 1930, for the "day is likely to come when candidates for President of the United States will campaign by television."[2]

The new medium was hailed as the answer to a variety of social problems. Some suggested the use of TV in the fight against crime. Here it could be used in such activities as the search for missing persons, the identification of suspects, and the transmission of information on wanted criminals. Experts wrote of TV as the educator of the future, a mechanism through which college courses would come to students in their own

homes. Patrons of the arts felt it would bring uplifting opera, ballet, theater, and lectures to the appreciative masses. Businessmen saw television as facilitating intercity and international business meetings. And military strategists discussed the ways in which TV would assist them in peacetime, and in the event of another war.

One of the most hopeful prognostications came from famed sociologist Orrin E. Dunlap, Jr. Writing in 1932, he predicted that the "great kaleidoscope," as he termed it, was about to usher in an unprecedented era of international peace and understanding.

> Television is a science and an art endowed with incalculable possibilities and countless opportunities. It will enable a large part of the earth's inhabitants to see and to hear one another without leaving their homes. . . . Eventually it will bring nations face to face, and make the globe more than a whispering gallery. Radio vision is a new weapon against hatred and fear, suspicion and hostility.[3]

If television gave promise of overcoming hatred, fear, suspicion, and hostility, to no group was this hope more personal than to American blacks. For generations African Americans had been victims of bigotry. Institutionalized in dehumanizing slavery, and continued in the Jim Crow laws, oppressive patterns of exclusion formally barred blacks from the search for self-betterment that is the cornerstone of the American Dream. And where slavery and Jim Crow laws were absent, segregation and discriminatory practices continued to deter blacks from entering the mainstream of national life.

Fundamental to the success of these legal and extra-legal tactics was the antisocial image of blacks that was popularly communicated. In the popular arts and in traditional folklore, whites were conditioned to view blacks in hostile, patronizing terms. Here the impression was firmly established that blacks were lazy, conniving, emotional, and uneducated inferiors. To many, the most advanced African American did not match favorably with the least advanced white person. Such a view not only fostered racism, it also seemed to justify continued discrimination.

On their part, blacks drew from popular culture a similarly distorted image of themselves. There were few examples of intel-

ligent black men or women in literature, movies, or broadcasting. African-American professionals were seldom offered as social role models. Yet, there were limitless instances where blacks were portrayed as maids, cooks, butlers, shoeshine boys, un- skilled laborers, and doltish fools.

Television, however, had the potential to reverse centuries of unjust ridicule and misinformation. In terms of utilization of black professional talent, and in the portrayal of African- American characters, TV as a new medium had the capability of ensuring a fair and equitable future. This possibility was well ap- preciated by a black critic who suggested in the early 1950s that "as a new industry, TV has a great opportunity to smash many un-American practices and set new standards. Will TV meet the challenge or will it miss the boat?"[4]

Now, more than four decades after TV first established itself as an integral part of American popular culture, it is profitable to look at television and its relationship to African Americans. What emerges from such a study is the picture of an association that has been, at best, ambivalent. On the one hand, it is the story of a genuine effort by some to treat blacks as a talented and equal part of the citizenry, to employ them fairly, and to depict them honestly. On the other hand, it is the tale of persistent stereo- typing, reluctance to develop or star black talent, and exclusion of minorities from the production side of the industry.

Compared to the prejudice traditionally found in other pop- ular media, TV has made singular progress in bettering minority social conditions. Moreover, within the industry there exists a historical trend toward constructive change in the treatment of blacks. Nevertheless, to the present day, TV has not matched performance with potential. Many of those connected with the medium have yet to understand the responsibility television has to project undistorted, honest information as an antidote to the cultural legacy of bigotry. While the medium has accepted the invitation "to set new standards," it has never fully realized the implications of the challenge before it.

To understand the history of television and its association with American blacks, it is possible to divide the record into four distinct time periods. During its formative first decade, the TV industry veered from honesty to duplicity in its depiction of Afri- can Americans. In the second period, which was particularly

touched by the civil rights movement of the 1960s, television slowly, but undeniably, evolved toward a fairer treatment of blacks, yet even here, TV was not without significant failings. In the third stage, between the 1970s and early 1980s, a new balance was struck in American television—a synthesis in which blacks were more prevalent in programming, while they remained vulnerable to racial distortion. Never had so many African Americans appeared on television, yet never was their image more stereotyped.

Throughout these first three distinct time periods, black representation was shaped by the attitudes and priorities of the predominately white males who ran the television industry. But, whatever their personal feelings on racial matters, these were executives who understood TV as a profit-seeking enterprise. It may have been a national medium espousing egalitarian purposes, but first and foremost it was a capitalist business committed to making money. And in their finite wisdom, these executives felt that profits could be maximized by employing African Americans in stereotypical roles that would be acceptable to predominately white audiences. As well as being a biased methodology, this way of programming national TV was an unfair distortion created by the monopoly that was network broadcasting in the United States.

From the outset, national TV was structured as a monopoly controlled by ABC, CBS, and NBC. Through much of its first forty years, U.S. television at best consisted of three national networks and a few independent stations in each market area. The most popular operations were VHF (Very High Frequency) outlets ranging from channels 2 to 13. Due to technical requirements, however, there could never be more than seven VHF stations in a single market—and only Los Angeles and New York City had that many.

Network control of U.S. video was so solid that when UHF (Ultra High Frequency) stations, channels 14 through 84, began to appear in the mid-1950s, they failed to weaken network dominance. Indeed, UHF stations—local in their orientation and lacking the capital with which to produce original programs—were soon filled with reruns of series popularized and partly owned by ABC, CBS, and NBC.

With such channel scarcity, the greatest profits were earned

by those operations that attracted the largest audiences. This was the era of *broad*casting, a time when TV executives and sponsors sought broadly-based audiences, conglomerations of diverse viewers fused together to watch TV shows communicating attitudes held in common. Programs were aimed at mainstream, majority tastes: what experienced programmers felt most people would watch. Minority preferences—be they racially, politically, culturally, or intellectually outside this mainstream—were seldom served by commercial television.

It is important, however, that this exclusionary arrangement was not set in stone. As actor Bernie Casey noted in 1983, "It is not an act of God that television is so white. It is a conscious decision made by white men who think the world is all white and refuse to understand that it is not. Things can change."[5] Indeed, since the early 1980s there has been change, encouraging change triggered by the slow but steady erosion of monopolistic broadcasting. In its place there has been emerging a *narrow*casting system offering dozens of national program services and scores of channels that are delivered by cable, direct broadcast signal, and other electronic advances. This has resulted in an unsettled new video reality characterized by intense competition for audiences and, consequently, the need to serve narrower constituencies.

Inherent in this metamorphosis toward narrowcasting is the *possibility* of a television New Deal for African Americans. This possibility arises not because of any great libertarian conversion; it exists because industry leaders and advertisers now recognize blacks as a formidable consumer force with size, money, and definite likes and dislikes. While they received relatively scant attention when the three broadcasters were competing for at least one-third of the national audience, black viewers are now a desirable demographic bloc—representing more than 12 percent of the U.S. population—that is often courted by networks and stations competing aggressively for select audiences.

Ironically, it appears that the only way to have realized the bias-free, original promise of TV was to destroy the channel scarcity fundamental to discriminatory broadcasting. In this light, the rearrangement of U.S. television and the subsequent decline of the three national networks, events that have occurred in the fourth time period, offer the greatest hope for positive African-American representation since the early years of national video.

PART ONE

THE PROMISE DENIED, 1948–1957

The first years of American television were uncertain ones. There were questions about the acceptability of the medium by the American people. Many remembered the disastrous "introduction" of TV in 1939, a move which cost the Radio Corporation of America money and prestige when its sales and programming campaign failed to attract a mass audience.

Some in the industry questioned whether advertisers would pay the large fees demanded by local stations and networks. Radio advertising had served business well for two decades, and radio rates were lower than those of TV, even at this early stage. There were also programming problems. Television officials sought a balance between live drama, live comedy-variety shows, filmed series, vintage movies, and local productions such as news, children's shows, and homemaker programs with their limited appeal and comparatively crude production standards.

In this formative period, one of the most pressing questions concerned the utilization of blacks. The historic circumstances of postwar America suggested equitable treatment of African-American entertainers, and unbiased images. But this was a nation with deeply rooted racist institutions and traditions. To what degree should the new industry transmit egalitarian ideals at the expense of viewer ratings and advertiser revenue? Was there a place in television for black talent? What types of programs best suited African-American celebrities? To what degree should the tastes of minority viewers be considered? To what ex-

tent would prejudice, especially the institutionalized segregation found in the South, shape the content of network television? Should TV adopt the racist stereotyping that flourished in radio and motion pictures, or could the medium establish new boundaries of black expression and racial dignity? In the earliest years of television, these were profound questions that no one in the industry was prepared to answer fully.

1

The Promise

On the surface, early television seemed to be almost color blind. Insatiable in its quest for talent in the late 1940s and early 1950s, the new industry frequently featured black celebrities. On local and network programs, blacks appeared in a wide variety of roles. Black dancers, singers, musicians, and comedians were an important part of the nascent medium.

Many felt that TV promised a new and prejudice-free era in popular entertainment. *Ebony* magazine epitomized this sentiment, when it reported in 1950 that television offered better roles for blacks than any other medium. The magazine contended that the appearance of numerous African Americans on TV was a "sure sign that television is free of racial barriers."[1]

In the older electronic media—motion pictures and radio—black talent had long been confined to demeaning characterizations, such as comedic roles with their roots deep in the minstrel shows of the nineteenth century. Pliant Uncle Toms, rascalish and indolent "coons," motherly maids, and shrewish mammies abounded in movies and broadcasting. To obtain steady employment, talented black actors like Mantan Moreland, Lincoln Perry (Stepin Fetchit), Lillian Randolph, and Eddie (Rochester) Anderson adopted distorted racial characteristics. They cultivated stereotyped Negro accents. They learned to walk with a shuffle, to pop and roll their eyeballs, and to emit high-pitched giggles. These were standard traits of the distinctive personalities which,

for white audiences, made black characters so funny, lovable, and controllable.

There were several reasons to believe, however, that TV held a bright promise for African Americans. Some of the most influential people in TV openly proclaimed that blacks would be given a new deal now that the medium was becoming popularly accepted. Ed Sullivan argued in 1950 that television was playing a crucial part in assisting "the Negro in his fight to win what the Constitution of this country guarantees as his birthright." According to Sullivan, the respected host of the CBS variety show *Toast of the Town,* video was now taking the chronic struggle for minority civil rights directly "into the living rooms of America's homes where public opinion is formed, and the Negro is winning."[2]

Five years later, Steve Allen reiterated the promise, suggesting that talent was the cutting edge of success in TV, and that "talent is color blind." Allen, then the host of the *Tonight* show on NBC, added that "television needs the Negro performer and benefits by his contributions to the medium." Allen tempered his remarks, however, by noting that "I consider it unfortunate that this idea is still not generally accepted by the television industry."[3]

The National Broadcasting Company also testified to the new era television was bringing to African Americans. In 1951 it launched a public relations drive to improve its image with blacks. NBC also published guidelines for the equitable portrayal of minorities on TV. According to this revised declaration of standards and practices, henceforth all programs treating "aspects of race, creed, color and national origin" would do so "with dignity and objectivity." Inspired by the NBC move, the National Association of Radio and Television Broadcasters ratified a television code in 1951 in which members pledged: "Racial or nationality types shall not be shown on television in such manner as to ridicule the race or nationality."

Black entertainers had been an important part of television during its experimental years in the 1930s. Long before TV became popularly available, such performers as the Ink Spots, Eddie Green, Bill Robinson, and Clarence Muse had appeared on camera. There was reason to believe that such use of black talent would continue once video emerged commercially.

The politics of postwar America also encouraged many to envision a bright, bias-free future in television. The new medium emerged in the midst of a liberal, reform-minded period in history. In waging a costly war against fascism, Americans had confronted the horrendous results of institutionalized prejudice and theories of racial superiority. During and after the war a sensitized government and public began to combat domestic racism in the United States.

In the latter half of the 1940s President Harry S. Truman took important first steps toward addressing the modern racial problem. Truman in 1945 established a special Committee on Civil Rights, an organization of prominent citizens whose report two years later—published in book form under the title *To Secure These Rights*—outlined the ways in which state and federal legislation could effect "the elimination of segregation, based on race, color, creed, or national origin, from American life."

In 1948 Truman became the first modern American president to present a legislative plan for ending racism. Among the proposals Truman recommended were federal laws to protect against lynching, to prohibit discrimination in interstate transportation, to ensure voting rights, to create organizations protective of civil rights, and to establish a Fair Employment Practices Commission to guard against unfair discrimination in employment. Truman also urged the creation of committees in Congress and the Department of Justice whose functions would be to assure justice for all American blacks.

Truman made other bold, liberal gestures. By executive order he ended segregation in the United States armed forces. In another executive order he established fair-employment practices throughout the various branches of government, making merit and fitness the only qualifications for employment or advancement. And in November 1948, when the president was re-elected in spite of defection from the Democratic party by southern politicians who rejected his civil rights record, further progress seemed inevitable.

Pressures for ending racial discrimination came also from private citizens. Church groups, such as the American Friends Race Relations Committee and the Department of Race Relations of the Federal Council of Churches of Christ in America, were either newly established or rededicated to the struggle

against racism. Membership reached new heights in older organizations like the Urban League and the National Association for the Advancement of Colored People. And new groups, such as the American Council on Race Relations, were also organized to help the struggle toward "the achievement of full democracy in race relations."

Complementing these achievements was a new militancy and self-awareness among blacks. In many instances this mindset was articulated by African-American celebrities. Black artists such as Paul Robeson, Canada Lee, Katherine Dunham, and Lena Horne openly criticized the prejudice encountered in their professional and private activities. Other, less well-known, black leaders made important inroads into such segregated professions as law, academe, government, the arts, science, business, and industry. In this atmosphere of progressive change, one scholar wrote in 1949 that the "door of opportunity has never been closed tight. It is constantly opening wider. The outlook for the Negro in America is one of slow but steady advance toward democracy."[4]

The struggle against prejudice also emerged in American popular culture in the late 1940s. After decades of negative stereotyping of minorities, Hollywood motion pictures became persuasive vehicles for disseminating ideas of racial equality and the end of discrimination. Feature films like *Crossfire, Gentleman's Agreement,* and *The Boy with Green Hair* dealt frankly with the effects of prejudice. Specifically focusing on antiblack bias, *Pinky, No Way Out, The Well, Lost Boundaries,* and *Intruder in the Dust* presented poignant insights into American intolerance and its consequences.

Radio, too, mirrored the new thinking of postwar America. Black entertainers such as Eddie Green, the Billy Williams Quartet, Ernestine Wade, and Lillian and Amanda Randolph became important regulars on network series. Several African-American stars had their own programs. Among them were Nat King Cole and Hattie McDaniel. In local broadcasting as well, important new strides toward freedom were being taken. In New York City, station WMCA launched *New World a-Coming,* an omnibus series inspired by Roi Ottley's book of the same title. The weekly series premiered in 1944 and was heard on that station until the late 1950s.

The most impressive black radio series in the history of the medium was *Destination Freedom,* heard on Chicago station WMAQ from 1948 to 1950. Written by Richard Durham, a former editor of the black newspaper *Chicago Defender,* this series in more than ninety dramatic scripts probed the heroes and movements in black history. From Sojourner Truth and Crispus Attucks, to Langston Hughes, Fats Waller, and Joe Louis, Durham showed black achievers contributing in the struggle for racial equality. Durham also awakened his listeners to the black cultural legacy, as he treated such topics as the John Henry and Stackolee tales, and the story of black spirituals. No black creative person until Alex Haley in the 1970s matched Durham's entertaining and informational contribution to the broadcast arts.[5]

Things seemed to be improving for African Americans. By the early 1950s black entertainers were reporting that even in the South—the home of most American blacks and, traditionally, the most segregated section of the nation—racial barriers were being lowered. Lionel Hampton, Duke Ellington, Count Basie, and Billy Eckstine all testified to substantial improvement in southern attitudes. Although he said this change was proceeding at a "crawling" pace, Eckstine appeared optimistic in 1952 when he announced that "It's not the old South any more."[6]

Basic to all political, social, and cultural change for African Americans was the fact that postwar black society constituted a rapidly expanding consumer force. In the 1940s the average income of black families in the United States tripled, compared to a 100 percent increase for the general population. In the same decade, black enrollment in high schools reached record levels, and college attendance increased by 100 percent. In 1951 a survey termed the black consumer market of New York City a "billion dollar plus" entity. By 1953 the black population of the United States exceeded the population of Canada, and the national racial market had become an annual $15 billion enterprise. To *Variety* editor Robert J. Landry, African Americans at this time were "the most important, financially potent, and sales-and-advertising serenaded 'minority' in the land."[7]

Despite the trend toward social improvement coincidental with the emergence of television, permanent change was slow to materialize. The corporations that controlled radio broadcasting continued to control network and local television. And since un-

der the auspices of NBC, CBS, ABC, and the many independent stations, radio frequently cast blacks in minstrel roles, the persistence of this practice in TV was not surprising. In many ways, television simply became visualized radio: the enactment for viewers of story lines and stereotypes that had proven successful for decades in radio.

Television also emulated radio in the way it was financed. The selling of air time to advertisers meant that the commercial pressures encountered in radio applied to television as well. TV programs were interrupted by commercials or audio-visual billboards, and program content had to be acceptable to an array of sponsors and their advertising agencies. Hence, TV, like radio, was subject to program decisions wherein commercial realities outweighed social ideas.

Importantly, this was the era of broadcasting, a time when three national networks held a virtual monopoly over television and offered similar programs for audiences of common tastes and prejudices. There was little room here for those with narrower sensibilities. Almost everything on TV was mainstream. And video was sold to the same mass audience that had accepted and even expected demeaning black images in the other popular arts. Postwar liberalism notwithstanding, race prejudice was still widespread and profitable in mass America. It would have been naive to expect the experiences of World War II to erase longstanding racial prejudices within a few years.

This lag was most apparent in the southern part of the United States. Despite the argument that the specter of the "white southern market" was actually a myth, to the entertainment industry it was reality.[8] TV executives and advertisers feared alienating the white consumer in the South. They avoided programs that might be too flattering or egalitarian toward blacks. And there was evidence to support their trepidation. When the networks in 1957 moved to censor racially objectionable words like "massa," "darkey," and "old black Joe" from the songs of Stephen Foster, southern politicians reacted with hostility. Governor Marvin Griffin of Georgia became a spokesman for the protestors. It was his contention that blacks should strive to be more like George Washington Carver and Booker T. Washington. As for the expurgation of the Foster lyrics, he chided the networks, "Have you ever heard of a bigger pack of

foolishness?"[9] Even more threatening was the reaction in 1952 of Governor Herman Talmadge of Georgia (later a United States senator), who blasted network TV for racially integrated programming which, he felt, propagated a "complete abolition of segregation customs" in the South. In an editorial in his influential newspaper, *The Statesman,* Talmadge specifically objected to black entertainers dancing with "scantily clad white females," to black and white children shown dancing together, and to African Americans and whites shown talking together "on a purely equal social status." And Talmadge fired what to television executives was the ultimate weapon. In order "to clean up television now before the situation grows more offensive," the governor threatened a massive boycott by whites of products sponsoring such programming.[10]

Television programming executives themselves were not immune to prejudice. Preconceived notions of appropriate roles for blacks in TV were shared by industry leaders in all regions of the United States. For example, when the executive vice president of WDSU-TV (New Orleans) spoke to TV officials in New York City as part of a series of television program clinics in 1952, he apparently received no criticism when he related his professional response to the sudden death of one of his stereotyped black TV personalities.

> I mentioned this colored cook we have. The first one we used died one morning at five o'clock, just after we'd sold the show to a big salt company. I got into the office and there was the regional sales manager of the salt company with all of his characters in the next room, and thousands of dollars in pictures and everything of this girl who had unfortunately died that morning. So he said, "What are you going to do about this?" I said, "I don't know; I didn't kill her." That day we auditioned four other negro cooks. Any one of them could have had the job, and we got one beauty. We renamed her—we call her Mandy Lee. Mandy, conservatively, weights 375 pounds. We can hardly get her all in the camera at one time, but she's terrific. . . .[11]

To counter the inertia caused by racial prejudice in broadcasting, black actors and others organized several important special-interest pressure groups. As well as organizations such as

the NAACP, black talent banded together in professional associations like the Television Authority Committee on Employment Opportunities for Negroes, the Committee for the Negro in the Arts, the Committee of Twelve, the Harlem Committee on Unemployment in Television, and the Coordinating Council for Negro Performers. With mixed results these groups interceded with network and local administrations for increased employment of African-American personnel and for more realistic depiction of blacks.

For example, as early as 1951 the Television Authority Committee conferred with officials of NBC, CBS, ABC, and the DuMont network. The goal of these meetings was "to secure representation of Negroes on television programs," and to make certain such representation matched "their role in everyday life."[12] In an idealistic statement, the committee challenged writers, directors and producers to employ black specialty acts, integrate black singers and dancers into chorus groups, use black actors in the many dramatic roles reflecting their participation in everyday life, and create new programs appropriately utilizing black talent.

In a similar way, the Coordinating Council for Negro Performers acted throughout the 1950s as a persistent critic of prejudice and black underemployment in TV. In late 1954, in its first report on television, the CCNP censured the industry, advertising agencies, and sponsors for virtually eliminating blacks from video. One of the most glaring examples of discrimination cited in the report concerned the acclaimed NBC production of *Amahl and the Night Visitors*, the first opera commissioned for television. Written by Gian-Carlo Menotti and premiered in 1951, the opera, a Christmas story in which the Three Wise Men visit a crippled boy while on their way to Bethlehem, had become a regular seasonal offering on the network. The CCNP objected that no blacks appeared in the story, despite the fact that according to Biblical accounts, one of the Wise Men was an Ethiopian.

2

Blacks in TV: Nonstereotypes versus Stereotypes

In this ambivalent atmosphere, early television often spotlighted black talent. On local and network levels. African-American entertainers appeared frequently as regulars or guest stars on variety series, as hosts or central characters on black-oriented programs, and as performers on one-shot dramatic and musical productions.

African-American personalities appeared on several of the most popular comedy-variety programs of the late 1940s and early 1950s. Ethel Waters, Louis Armstrong, Cab Calloway, Martha Davis and Spouse, and Nat King Cole were guests many times on *Your Show of Shows,* the *Garry Moore Show,* the *Colgate Comedy Hour,* the *All Star Revue,* and the *Jackie Gleason Show.* Sports personalities such as Jackie Robinson, Willie Mays, and the Harlem Globetrotters made special appearances. Several black dance orchestras appeared on the DuMont network's *Cavalcade of Bands* series in 1950 and 1951. Among them were the bands of Lionel Hampton and Duke Ellington.

No matter how intermittently black singers, dancers, and musicians were used in early television, the employment of these talents was a definite breakthrough for black entertainers. Never had network radio—even in the late 1940s and early 1950s—utilized as many African-American stars so consistently. Early TV needed talented and well-known personalities who would be effective in variety-show formats. Black celebrities were a natural resource from which the new industry could draw.

Whenever performers like singer Pearl Bailey, her dancing

11

brother Bill Bailey, or pianist Hazel Scott appeared on television, they did so with dignity, not as minstrel-show stereotypes. When Lena Horne made one of her many appearances, more critical eyebrows were raised because of her provocative clothing than because of her racial background. Consider, for example, the review of her TV performances that was published in the Chicago edition of *TV Forecast* on June 7, 1952—an issue with Horne's radiant photograph on its cover. This was no tribute to a demeaning racial stereotype.

> Television viewers were getting an all-too-frequent glimpse of the best torch singer in the country, Miss Lena Horne. . . . Lena is a study in seduction by goose pimples. Embracing a suitable song, she strips it of any ordinary treatment and drapes it with a sleek, tiger-like ferociousness. Then she sells it, first of all with a pair of flaring, frenzy-struck eyes that swim with unmistakable insinuation. With the feeling established, she taunts and coddles the lyrics with her large sensuous mouth, close-pinched nostrils and expressive hands. It's all mood. A dimly-lit stage. A strikingly beautiful woman. And a dusky, low-down treatment of a plaintive tune.

Typical, too, of the new fairness emerging in and with early video was the performance by singer Arthur Lee Simpkins on Jackie Gleason's *Cavalcade of Stars* on October 26, 1951. Simpkins was a new talent from the West Coast whose operatic technique lent itself well to the romantic "Song of Songs" and whose tenor voice and mastery of Irish dialect permitted him to give a creditable rendition of "Back to Donnegal," a song usually reserved for white male singers of Irish descent.

Such utilization of blacks was a conscious effort on the part of a new medium in an atmosphere of postwar liberality. The essence of this development was stated candidly during a skit on the *Texaco Star Theater* on May 29, 1951. In a musical revue entitled "The United Nations of Show Business," host Milton Berle and his guest, Danny Thomas, enunciated the ethic of the new medium, reiterating the bias-free promise of early television.

Thomas: You know, I've been watching, Milton, the *Texaco Star Theater* from the very beginning, and I have seen great

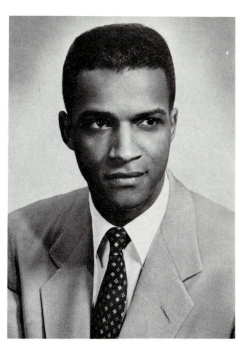

James Edwards was an outspoken critic of the manner in which black performers were utilized in television in the 1950s. (*Courtesy of the Schomburg Center for Research in Black Culture*)

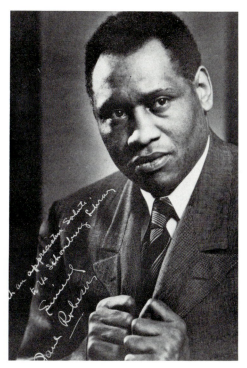

Paul Robeson was effectively banned from American TV when his appearance in March 1950 on Eleanor Roosevelt's talk show was canceled by NBC. The network's action followed unprecedented pressure from veterans' organizations and other groups intolerant of Robeson for political and racial reasons. (*Courtesy of the Schomburg Center for Research in Black Culture*)

Pop singer Billy Daniels was the first African-American performer to host his own sponsored musical program on national television. For thirteen weeks in the fall of 1952, the *Billy Daniels Show* appeared on ABC. (*Courtesy of the Schomburg Center for Research in Black Culture*)

On radio and in film Mantan Moreland mastered the role of the buffoon. With the telecasting of *Charlie Chan* movies on TV, Moreland's "coon" character, Birmingham Brown, is still a reminder of the minstrel show roots of such prejudicial comedy. (*Courtesy of the Schomburg Center for Research in Black Culture*)

In the *Little Rascals* comedy shorts, Farina (Allen Hoskins) helped to revive the "pickanniny" stereotype. These films were released theatrically as *Our Gang* comedies in the 1920s and 1930s, but thanks to television, new generations of American youngsters were able to experience the movie images which helped shape adult prejudices. (*Courtesy of the Schomburg Center for Research in Black Culture*)

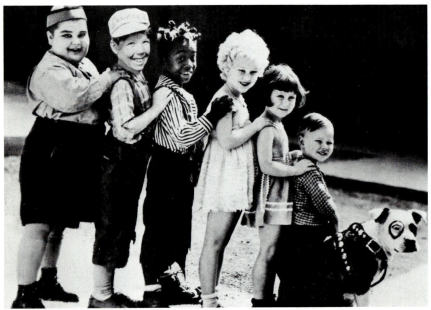

Obsequies

OF

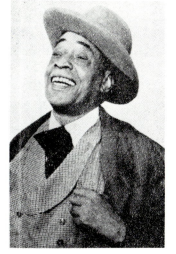

HARRY R. (TIM) MOORE
"Kingfish"
1887 - 1958

He was a maker of laughter,
A master of his art,
Who blessed the earth with joy and mirth,
Even with tears in his heart.

Somewhere in the happy hereafter,
Far from this world of strife;
He stars on a stage that will never age,
Rewarded with lasting life. —*Andy Razaf*

Saturday, December 20, 1958
1:00 P. M.

MOUNT SINAI BAPTIST CHURCH
2610 SOUTH LA SALLE

Dr. H. B. Charles
Officiating

Tim Moore appeared as the stereotyped shiftless schemer, George "Kingfish" Stevens, on the controversial *Amos 'n' Andy* series. Despite his video image as an exploiter of his friends, in real life Moore was a beloved entertainer who first emerged in black vaudeville in the 1920s. This front page of the program for Moore's funeral services attests to his popularity. (*Courtesy of the Chicago Historical Society*)

Lillian Randolph appeared on radio and television as a black maid working for a middle-class white family. Here, with Willard Waterman and Stephanie Griffin, she was cast as Birdie Lee Coggins on the syndicated situation comedy the *Great Gildersleeve*. (*Courtesy of the Schomburg Center for Research in Black Culture*)

As the cook in a white southern home, Claudia McNeil starred as the friend and confidant of two children in "A Member of the Wedding," which appeared on CBS in 1958. With McNeil are Dennis Kohler (left) and Collin Wilcox. (*Courtesy of the Schomburg Center for Research in Black Culture*)

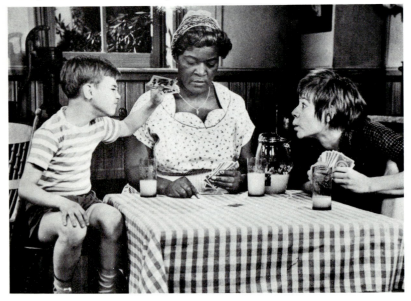

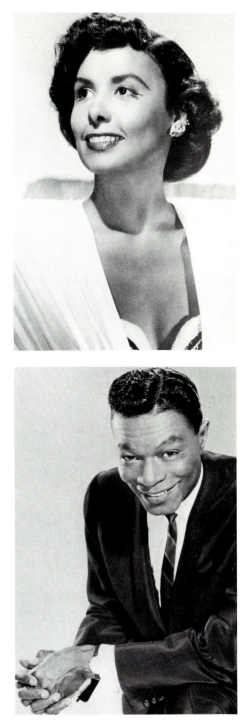

One of the most popular guest performers in early TV was Lena Horne. Throughout the early 1950s she performed frequently on the many musical-variety programs on network television. (Courtesy of the *Cleveland Press*)

The premier black entertainer of his day was singer Nat King Cole. His musical show failed in December 1957 despite great support from NBC. Not until seven years later did network TV schedule another African American as the star of a weekly program. (*Courtesy of Kraft, Inc.*)

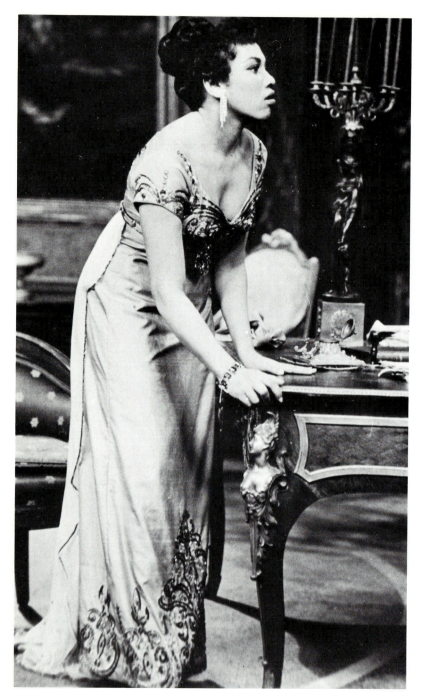

During the 1950s and early 1960s, Leontyne Price appeared in several operatic productions on NBC. Southern affiliates frequently preempted the operas when Price performed. (*Courtesy of the Schomburg Center for Research in Black Culture*)

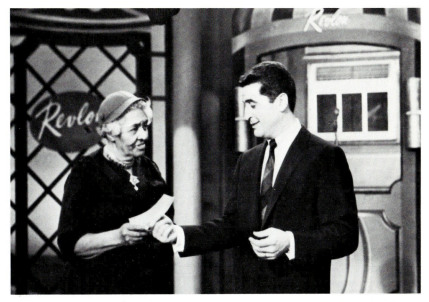

Blacks were an important part of the quiz show phenomenon in the 1950s. Here Hal March on the *$64,000 Question* awards a check to Frances DeBerry, a seventy-four-year-old expert on Shakespeare. (*Courtesy of the Chicago Historical Society*)

One of the most popular acts in American show business, the Mills Brothers performed on television as early as the mid-1940s. Throughout the following decades they appeared often as guests. (*Courtesy of Kraft, Inc.*)

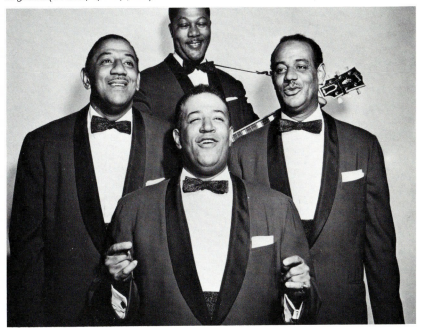

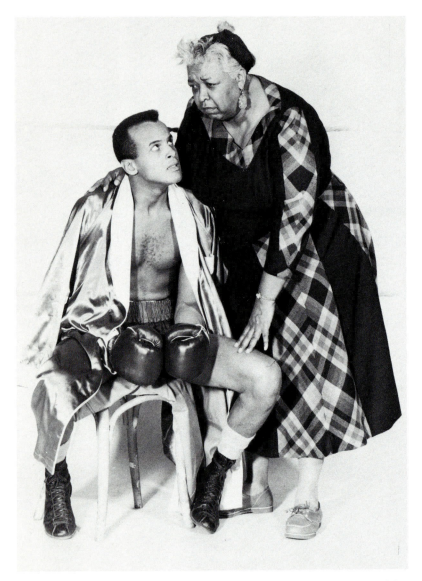

Two of the more recognizable roles for blacks in American popular culture, Harry Belafonte as a boxer and Ethel Waters as his long-suffering mother, as they appeared on the *General Electric Theater* in 1955. (*Courtesy of the Chicago Historical Society*)

young stars born right here on this stage. But, the thing that impressed me most about your shows is that it's not just a showcase for talent, it's a showcase for democracy.

Berle: Well, what do you mean, Danny?

Thomas: Let me put it this way, Milton. In the past three years the great performers who have appeared here on the *Texaco Star Theater* have represented a cross section of the world. I mean Italians, Spaniards, Australians, the white man, the Negro, the oriental, the Protestant, the Catholic, the Jew— they've all shared the spotlight on this stage.

Berle: Well, Danny, if I may inject, that's the way show business operates. Danny, there's no room for prejudice in our profession. We entertainers rate a brother actor by his colorful performance, and not by the color of his skin.

Thomas: While we're on the subject and show business is about to take a bow, let's also inject that we in show business cannot tolerate intolerance.

Berle: Well, throughout the years, Danny, the world of the theater has presented a united front against bigotry. . . . The entertainers of America are firm in the belief that a happy nation is a strong nation.

Thomas: And to that end, we have tried to the best of our ability to keep America laughing, singing, and dancing.

Berle: You can't frown on anyone while you're laughing.

Thomas: Yes, and you can't shout at anyone while you're singing.

Berle: And you can't kick anyone while you're dancing.

Thomas: We entertainers of America are deeply grateful for the opportunity our country has given us—a country that knows no barrier of race or of creed.

Berle: A country whose sons and daughters are free to choose their own profession and to follow it as far as their talents can take them.

Two influential employers of black talent in early TV were Ed Sullivan and Steve Allen. From the inception in 1948 of his *Toast of the Town* (later called the *Ed Sullivan Show*), Sullivan liberally seasoned his Sunday evening variety program with African-American celebrities. Despite periodic letters of criticism from prejudiced viewers and anxious advertisers, Sullivan

persisted in welcoming entertainers as diverse as singers Sarah Vaughan, Ella Fitzgerald, and Harry Belafonte; comedian Dewey "Pigmeat" Markham; rhythm and blues performers Billy Ward and the Dominoes; operatic soprano Marian Anderson; dancers Peg Leg Bates, Bunny Briggs, and the Will Mastin Trio with Sammy Davis, Jr.; and Dr. Ralph Bunche, United Nations Commissioner and recipient in 1950 of the Nobel Peace Prize for his role in settling the Arab-Israeli war. Even former heavyweight boxing champion Joe Louis appeared on *Toast of the Town* in an unsuccessful venture as a song-and-dance entertainer.

Sullivan felt that by bringing black personalities directly into the homes of Americans, TV would undermine racism. He believed that white adults and children, seeing and appreciating black talent, would be forced to reassess racist stereotyping and their own prejudices. Sullivan was particularly sensitive to the impact such images would have upon children, for it was they, he suggested, "who will finally lay Jim Crow to rest."[1]

Equal to Sullivan in his employment of black talent in early television was Steve Allen. As host for more than two years (1954–1957) of the popular *Tonight* program, Allen was especially attracted to African-American musicians. An accomplished jazz composer and performer, Allen hosted such celebrities as Duke Ellington, the Ink Spots, Carmen McRae. Lionel Hampton, and Sammy Davis, Jr. One program was telecast from the famous New York jazz club, Birdland. Another show was dedicated to exploration of black music in general.

But Allen was sympathetic to more than African-American music. He occasionally focused a full program on problems of pressing social interest to blacks. One show, for example, dealt with the issue of civil rights. Another telecast treated brotherhood. Steve Allen was a socially-conscious intellectual as well as an entertainer who occasionally used his program to promote discussion on a range of contemporary issues. By integrating racial questions into the *Tonight* show, Allen gave his program a seriousness that was generally absent from shows seeking purely to entertain.

It must be remembered, however, that not all viewers were comfortable with nonstereotyped black performances on the new medium. Flattering appearances by minority entertainers often provoked hateful reactions. And all concerned in such

bookings—the white host as well as the sponsor, station, network, and African-American talent—risked vile insult, even physical abuse, from racist whites. Nowhere was this pattern more obvious than in the case of the Will Mastin Trio and its performance with Eddie Cantor on the *Colgate Comedy Hour.*

Following rave reviews for the act at the prestigious Ciro's nightclub in Hollywood, Cantor brought the Trio—consisting of twenty-four-year old Sammy Davis, Jr. supported by his father and uncle—to his NBC comedy-variety showcase on February 17, 1952. That Cantor was impressed was obvious in the way he introduced these entertainers to the TV audience. "The other night I saw the Will Mastin Trio and one of the greatest hunks of talent I've ever seen in my life, Sammy Davis, Jr. In my twenty years of going around this cafe [Ciro's], this is the greatest act I have ever seen."

The Trio then offered an energetic twelve-minute distillation of the Ciro's floor show. Davis tap danced, joked, sang, and delivered impersonations of celebrities such as Edward G. Robinson, James Cagney, and Billy Eckstine. So worked up was Davis that Cantor at one point walked on camera with a handkerchief to dry the young entertainer's perspiring face. And near the end of the act Cantor returned to the stage and brought the performers to the microphone. With his arm resting on Davis's shoulder and flanked by the rest of the Trio, Cantor asked the enthusiastic audience about Davis, "Am I right? Is this the greatest hunk of talent you've seen in years?" Then he made a surprise announcement. "Sammy, I've got news for you. I'll probably get killed for this, but you're coming back here on my next show four weeks from tonight."

It was a tour de force performance that helped to establish Sammy Davis, Jr. as a national celebrity. But it had its sinister aspect. As Davis recalled in his autobiography, *Yes I Can,* much of the mail he received in response to the appearance was terrifying. "Dear lousy nigger, keep your filthy paws off Eddie Cantor" read one letter, "he may be a jew but at least he is white and dont [*sic*] come from africa where you should go back to I hope I hope I hope. I wont use that lousy stinking toothpaste no more for fear maybe the like of you has touched it. What is dirt like you doing on our good American earth anyway?"

Similarly, "an avalanche" of hate mail was received by Can-

tor, the station, and the sponsor. One letter to Cantor wondered, "Where do you get off wiping that little coon's face with the same handkerchief you'd put on a good, clean, white, American face?" According to Davis, Colgate warned Eddie Cantor that he would be taken off the air "if anything like this happens again." Cantor responded by signing the Trio for three more appearances that TV season. Davis later pondered the irony of the situation. "How could you figure it? Here there were people going out of their way to kick me in the face with nothing to gain by doing it, then along comes a man like Eddie Cantor with everything to lose, but he deals himself into my fight and says, 'They'll have to kick me, too.' "[2]

While variety shows were important to early television, sports programming also was crucial to the emerging medium. The prospect of viewing baseball, boxing, and football was an important lure to new customers. Importantly, television also gained popularity as two lesser sports—professional wrestling and roller derby—attracted large audiences in those first years.

Black participation in TV sports fit into an interesting pattern. African Americans were practically absent from wrestling and roller derby. In baseball, racial integration had only been accomplished with Jackie Robinson's play for the Brooklyn Dodgers in 1947. Thus, black baseball players were still relatively few in the early 1950s. Since professional basketball and football usually drew their personnel from graduating college classes, the paucity of black players reflected the small number of African Americans graduating from colleges and universities with well-developed athletic programs.

The sport that most fully highlighted black athletes was boxing. Traditionally, boxing had been a vehicle for upward social mobility and financial success for working-class Americans. Immigrant groups such as the Irish, Italians, Jews, and East Europeans had enjoyed ascendancy in boxing in the first half of the twentieth century. By mid-century, however, the sport was being flooded with young black and Latino athletes.

Boxing was a staple on prime-time network and local television throughout this period. And in all weight classifications—from featherweights like Sandy Saddler to heavyweights such as Ezzard Charles—televised boxing continually featured African-American performers. Champions like Sugar Ray Robinson,

Randy Turpin, Jimmy Carter, Archie Moore, Johnny Bratton, and Kid Gavilan were familiar participants on weeknight bouts.

In the first years of TV popularity boxing matches gained high ratings. The heavyweight championship bout between Joe Louis and Jersey Joe Walcott was one of the highest-rated telecasts in 1948. During the 1950–1951 TV season, the *Cavalcade of Sports,* a Friday night boxing program sponsored by the Gillette Safety Razor Company, was the sixth most popular show, with an average rating higher than that of *Arthur Godfrey and His Talent Scouts, Toast of the Town,* and *Kraft Television Theater.*

Blacks appeared on a wide range of early nonstereotyped programming. In 1948 *Television Chapel,* the first regularly scheduled religious program, occasionally featured a black congregation during its Sunday worship. The same year, the DuMont network televised Solomon Lightfoot Michaux, a well-known clergyman from Washington, D.C., and the Southernaires, a gospel choir, appeared on ABC.

In the early 1950s, the Mariners, an integrated male quartet, were regulars on the popular CBS show, *Arthur Godfrey and Friends.* Phil Taylor and Bill Grant were song-and-dance performers on Paul Whiteman's *TV Teen Club* in 1951. Early rhythm and blues music appeared on national television when the Larks performed on the *Perry Como Show* on February 14, 1951. Blacks were among the nonprofessionals cast on *The Black Robe,* an NBC series that in 1949 reenacted the drama of night court. A black couple was among those married on KLAC-TV's (Los Angeles) *Wedding Bells* in 1950. In 1949 and 1950, Amanda Randolph hosted *Amanda,* a home-oriented show telecast five mornings a week for over a year on the DuMont network. And in 1954, explorer Matthew Henson discussed his Arctic adventures on NBC's *Today* show.

African Americans regularly appeared on audience participation and quiz programs in the 1950s. Black women often competed for prizes on *Queen for a Day,* a popular daytime program shown on local TV in Los Angeles and later on the ABC network. Amateur programs also spotlighted black talent. Three of the most significant winners on early network amateur shows were Diahann Carroll on *Chance of a Lifetime,* Johnny Nash on *Arthur Godfrey and His Talent Scouts,* and Gladys Knight on Ted Mack's *Original Amateur Hour.*

During the quiz-show craze of the mid-1950s, blacks occasionally were contestants. Among the more renowned competitors, Ethel Waters won $10,000 on *Break the $250,000 Bank*, dancer Geoffrey Holder won $16,000 on *The $64,000 Question*, ex-boxer Beau Jack earned $1,900 on *Strike It Rich*, and Joe Louis and his wife gained $41,000 on *High Finance*.

Winning large amounts of money made celebrities out of black contestants. Steve and Dorothy Rowland became nationally famous when they earned $75,000 on *Do You Trust Your Wife?* Such fame came also to Frances DeBerry, a seventy-four-year-old widow whose expertise on Shakespeare won her $16,000 on *The $64,000 Question*; and to Gloria Lockerman, a teenager who won $16,000 on the same series and also $32,000 on its sister show, *The $64,000 Challenge*. On another quiz show, *Name That Tune*, teen-aged Leslie Uggams won the top prize of $25,000 while gaining national recognition as a promising young vocal talent.

By the end of the quiz fad, *Ebony* compiled the totals. According to the magazine, more than twenty-five black contestants had been substantial winners on network quiz programs. Their earnings totalled more than $500,000. In the process, these winners appeared before 120 million viewers.[3]

While television utilized blacks in a wide variety of program formats, the medium could be harsh on obvious reminders of a less tolerant past. White men wearing burnt cork, the classic make-up of the minstrel show, failed in early television. Although a star like Eddie Cantor occasionally might appear in blackface for one or two songs on the *Colgate Comedy Hour*, network TV found it unprofitable to build an entire show around the minstrel format. *American Minstrels of 1949* was a stillborn ABC project. It intended to revive the popularity of Pick Malone and Pat Padgett—blackface comedians for over a decade on network radio—and feature their mocking comedy routines. The program, however, was poorly received and left the air quickly.

A few months earlier, CBS had been unsuccessful with its own minstrel show, *Captain Billy's Mississippi Music Hall*. Perhaps these costly disasters persuaded NBC to abandon plans for a minstrel show which, it was rumored in 1949, was to star the greatest blackface entertainer of the century, Al Jolson.

Even local productions that adhered too closely to the minstrel format were short-lived. *Olympus Minstrels* on WLTW (Cin-

cinnati) in 1948 was such a program. So, too, was *Sleepy Joe*, a daily children's feature on KTSL (Los Angeles) which in 1948–1949 starred white dialectician Jimmy Scribner as a blackface Uncle Remus type who rocked lazily on the front porch of his slave cabin while relating tales of Br'er Rabbit, Br'er Fox, and Br'er Bear to "de chilluns." Scribner, who had mastered two dozen minstrel-show voices, had been on radio for twenty years as the sole star of a "black" serial, *The Johnson Family*. Now on local TV, he used his stereotyped voices as those of the Br'er folks when he told his stories. The condescension inherent in such stereotyping was unconsciously delineated by a Los Angeles television magazine when it described the format of *Sleepy Joe*.

> The show always begins with some action, ending the same way. "Sleepy" in character is an old-time story teller, who owns his own little plot with a log cabin cozily situated in the green lands of the deep south. "Little Missy" and "Sonny Jim" are the children who visit daily from the "big white house" on the hill. With them he plays numerous child games until he tires and retreats to that wicker rocking chair on his front porch. The children squat eagerly before him and wait excitedly for a story.[4]

The ambivalent nature of early TV, as seen in the range of roles in which it portrayed blacks, was further demonstrated by the fact that several black entertainers hosted their own non-sponsored, quarter-hour network series. In the summer of 1950 jazz pianist Hazel Scott hosted a fifteen-minute show three times a week on the DuMont network. Between 1948 and 1950 singer-pianist Bob Howard was a regular part of the early evening programming on CBS. He was also a regular in 1950–51 on the musical quiz show, *Sing It Again*. When Howard left CBS, he continued to appear locally on WOR-TV in New York City.

Of major significance for blacks in television was the *Billy Daniels Show*. This was a quarter-hour musical series aired Sunday evenings on ABC throughout the fall of 1952. Although it lasted only thirteen weeks, the program was a milestone. First, it was a network project carried in the largest cities in the nation: Boston, New York City, Detroit, Birmingham, Philadelphia,

19

Chicago, Salt Lake City, Denver, Los Angeles, and San Francisco. It was also the first black show to be broadcast nationally by a single sponsor, the Vitamin Corporation of America for its Rybutol B-complex vitamins. The enthusiasm of Daniels and his entourage—including the Benny Paine Trio and the white announcer Jimmy Blaine—was evident in the premiere telecast. After belting out familiar show tunes like "It Was Just One of Those Things" and "Sunny Side of the Street," Daniels (called by Blaine "the peppiest man in show business") helped to deliver a commercial for Rybutol and signed off optimistically, "Want to thank you for listening and say that we'll be back again with some new songs, and we do hope you join us."

Importantly, the series was perceived as a watershed for other black entertainers with aspirations for success in television. It was this latter point, no doubt, which prompted a writer for the *Chicago Defender* to announce the cancellation of the show with a sarcastic comment about having overstocked his medicine cabinet with Rybutol, in the hope that buying the product would help keep the program viable. Although discontinued after one-third of a season, the *Billy Daniels Show* established the precedent for a national, sponsored network series centering around a black entertainer.

Yet, several years before Billy Daniels' unsuccessful network series, the most ambitious network project highlighting black talent occurred on CBS. *Sugar Hill Times* was conceived as an all-black, hour-long variety program. It made its debut in September 1949. Unfortunately, it was scheduled for Tuesday evenings opposite Milton Berle's incredibly popular *Texaco Star Theater* on NBC. Competing with the top show in television, and inhibited further by a discouragingly low budget, *Sugar Hill Times* had little chance of surviving.

The program was hosted by a New York musical and radio personality, Willie Bryant. Music came from Don Redman and his orchestra. During its short run, its guests and regulars included actor Avon Long, jazz trumpeter Hot Lips Page, and singers Thelma Carpenter, Maxine Sullivan, the Charioteers, the Chocolateers, the Orioles and newcomer Harry Belafonte. These were all competent acts, but none was considered top-rank at the time.

To assure their ascendency, moreover, Berle and NBC coun-

tered *Sugar Hill Times* with black guest stars of broader appeal. Bill "Bojangles" Robinson danced in what proved to be his last TV appearance before his death several weeks later. Jackie Robinson of the Brooklyn Dodgers appeared while his team was tied with the St. Louis Cardinals for first place in the last week of competition for the National League baseball championship. Berle also hosted the most celebrated black band leader of the era, Duke Ellington.

To rescue *Sugar Hill Times* after only two poorly viewed telecasts, CBS altered its structure and scheduling. Now a half-hour show on alternate Thursdays, it was placed opposite the ABC quiz show, *Stop the Music!* On radio earlier that year, *Stop the Music!* had devastated its network competitors. After seventeen successful years on NBC, Fred Allen abandoned his radio career, disgusted with the giveaway show that had wooed away most of his listeners. On CBS, Edgar Bergen took Charlie McCarthy and Mortimer Snerd into a year of retirement, unable to match the ratings of the quiz program. As might be expected, *Sugar Hill Times* fared no better. It was aired only twice at its new time before being canceled.

In reviewing the history of this attempt at all black programming, *Variety* criticized the low budget and merciless scheduling of the show. The trade journal also raised an important thought which producers would have to consider in the future: Were there enough nationally prominent entertainers to make an all-black variety program competitive? Given the history of the film and broadcasting industries in retarding black talent, and given their tradition of producing all-black entertainment primarily for black audiences, was the pool of recognized African-American celebrities large enough to offer a competitive weekly variety program to a racially mixed national audience?[5] If big-name guests were strategic to the popularity of *Toast of the Town, Texaco Star Theater*, and the like, was it not unrealistic of CBS to launch a black variety program in 1949 with talented, but relatively unknown, personalities? Perhaps *Sugar Hill Times* failed as much from the legacy of stultifying, segregated American entertainment as it did from feeble budgets and suicidal scheduling. Significantly, the all-black format never reemerged in network variety programming.

Much more prevalent were black programs produced on

nonnetwork television. These were usually musical-variety features spotlighting local personalities and an occasional celebrity guest. A typical offering was *Club Ebony* on WAVE-TV (Louisville) in January 1949. This was the first black revue on southern television. It starred the local Odell Baker Quintet, a sultry singer named Edmonia, and a Louisville rhythm ensemble, the Gutter Pipers. On its premier broadcast, Lionel Hampton and several members of his orchestra were guest performers.

Similar shows appeared on local TV throughout the nation. In Chicago, *Happy Pappy* with the Four Vagabonds on WENR-TV in 1949, and *Jesse Owens' Dixie Showtime* on WGN-TV in 1951 were indicative of such programming. So, too, was the *Al Benson Show*, a local teenage dance program in Chicago, on which popular singers like Joe Williams guest-starred in 1951. *Sepia* was a musical revue in mid-1949 on WFMB-TV in Indianapolis. The *Hadda Brooks Show* on KLAC-TV and KGO-TV (Oakland) featured West Coast talent. Bob McEwen's *Capitol Caravan* followed a nightclub format for more than four years in Washington, D.C., and the *Mary Holt Show* was a popular feature on KYW-TV in Cleveland in the mid-1950s.

In New York City, there were several significant local black shows. The *Hazel Scott Show* on WABD presented the nation's foremost female jazz pianist five nights per week in 1950. *Spotlight on Harlem* on WJZ-TV, and *Stairway to the Stars* on WATV (Newark), were black amateur shows in the early 1950s. And *Club Caravan* on WATV in 1954 featured the aspiring young singer, Roy Hamilton.

Few black shows were produced or directed by blacks. Where such programs did exist, they were local in their orientation and predictable in content. These shows seldom failed to highlight music. Whether it was a religious series like the *Mahalia Jackson Show* on WBBM-TV (Chicago) in 1955 or the *Gospel Show* on WATV in 1957, a jazz showcase such as *Rhythm Review* on KCOP-TV (Los Angeles), or a cooking feature like the *Kenny and Flo Show*—with Herb Kenny of the Ink Spots—on WMAL (Washington, D.C.), music was invariably the central ingredient. Significantly, these presentations represented a miniscule portion of American TV programming. *Ebony* touched on this fact when it reported that as late as 1957 there were less than a dozen programs in the United States being produced by blacks.[6]

African Americans were present at the birth of television. They were regularly before TV cameras in local and network programming. Granted, they were usually seen in the context of musical entertainment. Granted, too, that blacks almost always appeared as guests rather than regulars or hosts—and when they did host their own series, blacks did not enjoy success. But these were the early days of video. Few expected overnight changes in entertainment patterns. And the fact that there were so many African-American personalities to be found in the young medium kept viable the promise of bias-free programming. There were, however, ominous signs in early TV. The most threatening was the great popularity of black entertainers when they appeared in controversial stereotyped roles.

If the history of blacks in early television suggests that shows stressing authentic images failed to establish lasting success, the same cannot be said of those series and programs presenting African Americans in caricatures drawn from a tradition of prejudice. The mass audience, and consequently sponsors and stations, looked more approvingly on the mammies, coons, and Uncle Toms of the past than they did on blacks seeking approval through non-stereotyped talents.

The mammy figure—usually portrayed as a black maid in a white household—was a familiar stereotype. She emitted a certain human warmth that was sometimes difficult to discern beneath her aggressive self-confidence and implacable personality. In early television the black maid was a highly popular character. Between 1953 and 1964, Lillian Randolph played Louise, a maid for the Williams family on *Make Room for Daddy* (later called the *Danny Thomas Show*). She also appeared in the mid-1950s as Birdie Lee Coggins, the maid on the syndicated *Great Gildersleeve* series—a role which she had enacted on the radio version of that series for more than a decade before it came to video.

While Louise and Birdie were supporting characters, *Beulah* spotlighted the trials and tribulations of the black maid for the white Henderson household. As portrayed by Ethel Waters, followed by Hattie McDaniel for a short while, and then Louise Beavers, *Beulah* appeared for three seasons between 1950 and 1953. Beulah was surrounded by familiar types. Her dim-witted friend was Oriole, the black maid of the white family next door. When played by Butterfly McQueen, Oriole was a flighty

woman of minimal intelligence. When Ruby Dandridge assumed the role, she added a heavy dose of her recognizable high-pitched giggles to Oriole's personality. Beulah also had a boyfriend, Bill Jackson. As played by Percy Harris, Dooley Wilson, and Ernest Whitman, he may have been the owner of a fix-it shop, but Jackson was oafish, perpetually hungry, and definitely unromantic.

As for the central character herself, Beulah was a portly, conscientious, and lovable stereotype of the black domestic. She might berate her black friends, but around her boss, "Mr. Harry," and his wife, "Miss Alice," Beulah was always respectful. The problems around which each episode of *Beulah* revolved were common to the genre—invariably an honest misunderstanding which caused the protagonist to do one thing when quite another was called for. But Beulah suffered and endured. And she usually did so without open complaint—except at the beginning of the show when she was wont to exclaim something like, "If marriages are made in heaven, my guardian angel is sho been loafin' on the job. Ha, ha, ha, ha, ha, ha. . . ."

Black men were also successful in stereotyped characterizations. Eddie Anderson had little difficulty moving his Rochester character from radio to TV on the *Jack Benny Program*. As Benny's valet, confidant, and "conscience," Rochester had been a strategic part of the broadcasting success of the program since 1937. He contributed substantially to its television popularity once Benny moved his show to video in the 1950s. Although Jack Benny and his writers had toned down considerably the minstrel-show quality originally possessed by Rochester on the radio, Anderson's character was still a stereotype. Usually the only black in the telecast, Rochester was a chauffer and general handyman for his white boss. Anderson's naturally harsh voice gave him a vocal quality akin to the throaty "coon" dialect developed by minstrel endmen. Although he was not as stark a caricature of black manhood as Sleepy Joe and Bill Jackson, Rochester did little to advance the cause of the realistic portrayal of African Americans in popular culture.

If Eddie Anderson failed to enhance the image of blacks in television, Willie Best was absolutely detrimental to that image. Ironically, Best was also the most prolifically employed black actor in early TV. Best entered movies in the 1930s where, as a

younger version of Stepin Fetchit, he was nicknamed "Sleep 'n' Eat." He could pop his eyeballs when nervous, speak classic pidgin English, and shake his lanky body at the thought of entering a graveyard. On television, Best appeared in several series developed by Roland Reed Productions. On *Trouble with Father* (1950–1955), he played Stu Erwin's brainless handyman, Willie. On *My Little Margie* (1952–1955), he was Charlie, an elevator operator. He also appeared as a less characterized shipboard handyman on Preston Foster's tugboat series, *Waterfront* (1954–1956). Throughout the first years of television, Willie Best's bumbling minstrel character, although well acted, presented a demeaning image of African Americans that was directly contrary to the spirit and accomplishment of postwar blacks. The fact that Best's characters never possessed surnames, and were always called by diminutive first names, strongly tied these characters to an earlier age when slaves were called by first names only. Tellingly, in series that stressed interaction between loving family members, Willie never had a family—like a rootless black cipher he moved in and out of white domestic life, always following Caucasian direction, but never encumbered by relationships with his own wife, children, friends, or other relatives.

There were many types of programming insensitive to the search for honest and realistic portrayals of blacks. Well into the 1950s, local stations continued to show vintage motion pictures containing prejudiced characterizations. Typical of such old films was *The Two Black Crows in Africa,* a stereotyped comedy short from the 1930s featuring blackface vaudevillians Charles Mack and George Moran. More popular were the Charlie Chan feature films, a series of theatrical motion pictures featuring various white actors portraying Earl Derr Biggers' famous oriental detective—and often featuring Stepin Fetchit or Mantan Moreland in stereotyped "coon" comedy roles. The *Our Gang* comedy shorts, syndicated on television as the *Little Rascals,* introduced a new generation of children to those famous pickaninnies of the 1920s and 1930s, Farina, Buckwheat, and Stymie. And the Eastside Kids movie series from the early 1940s continued to spotlight Sunshine Sammy Morrison in the role of Scruno, the lone black member of the comedic youth gang who uttered memorable phrases such as "Who dat say 'Who dat?' when I say 'Who dat?' "

Racist characterizations were found occasionally in the B Westerns that were plentiful in early video. This was especially true of Westerns set in the South following the Civil War. Such films generally took a position hostile to displays of black freedom, and to white interlopers seeking to assist the former slaves. Such a motion picture was *Texas Terror*, which in 1935 starred John Wayne as a defender of local racial inequality against a group of Yankees and so-called renegades trying to protect the newly won freedom of ex-slaves. When Wayne won, it meant a victory for racist traditions and the continued subservience of blacks.

Particularly demeaning to black Americans were the many exotic jungle documentaries prevalent in early television. In these motion pictures, usually filmed among primitive African tribesmen in the 1930s, the image of "uncivilized" blacks dancing themselves into frenzies or acting out "savage" social rituals suggested that African Americans had family roots deep in barbarism.

The African documentaries of filmmakers like Martin and Osa Johnson, focusing on women with ornamented lips and elongated earlobes or men with tribal scars on their faces and bodies, were pernicious to black Americans. These films pictured the ancestral home of African Americans as a strange place filled with crocodiles, warthogs, lions, and baboons. In one scene, Martin Johnson went so far as to credit the wild beasts with more intelligence than the human natives: "I had always contended that the baboon was the most intelligent of the monkey family," he remarked, "and a lot smarter than some of the savages I had met."

Moreover, while no television station or network at that time would have considered airing the frontal nudity of a white woman, these films of preindustrial Africa seldom failed to show pictures of bare-breasted black women of all ages. The racist implications of such a double standard were obvious.

If films of African tribal life were deleterious to the search for equitable treatment for blacks in the United States, those fictional jungle-adventure series produced for TV exacerbated the situation. Although they avoided the anthropological starkness of the documentaries, these programs served to juxtapose the inferiority of black natives with the technological advancement of

white civilization. *Ramar of the Jungle* (1952–1954) starred Jon Hall as a research scientist named "Ramar—White Witch Doctor," whose manly heroism contrasted with the child-like blacks who dutifully called him "Bwana." *Jungle Jim* in 1955 presented a middle-aged Johnny Weissmuller, long past his prime as a movie Tarzan, in the role of a guide more at home in the Kenyan jungle than the natives he encountered. The most exaggerated of these exotic adventure series was *Sheena, Queen of the Jungle.* Drawn from a comic book character, Sheena was a statuesque blonde who, during the 1955–56 TV season, swung on jungle vines and raced across the Dark Continent wearing only skimpy leopard-skin clothing. Again, however, the native Africans were portrayed as weaker and less intelligent than this "great white mother."

It has been difficult for Americans to abandon their taste for jungle programming. African imagery has remained a popular part of local and network television. As late as 1961, station KDKA-TV in Pittsburgh offered viewers "Bwana Don" as host of *Safari,* a Saturday morning showcase which revived old jungle films like *Tarzan and the Mermaids* and Frank Buck's *Bring 'em Back Alive.* Between 1966 and 1969, NBC broadcast a new Tarzan series starring Ron Ely. And into the 1990s vintage jungle programs are still available to local outlets, while Tarzan feature films continue to appear on broadcast and cable stations.

Such programming could have aroused black indignation. The assumptions that there were no black heroes in Africa and that native Africans always were less successful than white men or women, and the fact that documentary films fed racist imaginations more than they educated mass audiences were issues that could have produced legitimate criticism of television programming. But hostility to TV's treatment of African Americans was directed almost entirely at one stereotyped series, *The Amos 'n' Andy Show.* The controversy that this program created reveals the disdain felt by many Americans toward TV and the direction it was taking in its first decade as a mass medium.

Amos 'n' Andy had been a favorite comedy with Americans since its emergence on radio in the late 1920s. In radio the principal roles had been played by two white dialect actors, Freeman Gosden and Charles Correll. In bringing the program to television, however, Gosden and Correll rejected the idea of doing it in

blackface. Instead they undertook a national search for black actors who could embody their popular comedic creations.

The casting of *Amos 'n' Andy* became a nationally publicized event. President Harry S. Truman suggested that Texas State University, a black college with a reputable drama department, might have actors to suit Gosden and Correll. General Dwight D. Eisenhower recommended a black soldier whom he had known during the war. Black vaudevillian Flournoy Miller was hired to assist in the quest. The intensity with which the casting was undertaken was evidenced in May 1950, when Gosden and Correll bought a full page in *Variety* to advertise the event.[7]

The roles they sought to cast were classic minstrel figures. Amos Jones (eventually played by Alvin Childress) was a low-key, compliant Uncle Tom. He and his wife, Ruby, were an unhumorous twosome who tried to bring reason and level-headedness to bear upon their rascalish Harlem friends. Andy, whose full name was Andrew Hogg Brown (played by Spenser Williams, Jr.), was an easy-going dimwit, who always had an eye for a pretty girl and never ceased to be duped by his supposed friends. In George "Kingfish" Stevens (portrayed by Tim Moore), the show presented the stereotyped scheming "coon" character, whose chicanery left his pals distrustful and the audience laughing. Added to the three mainstays were Kingfish's shrewish wife, Sapphire Stevens (Ernestine Wade) and domineering mother-in-law, Mama (Amanda Randolph); a feeble-minded janitor, Lightnin' (Horace "Nicodemus" Stewart); and a thoroughly disreputable lawyer, Algonquin J. Calhoun (Johnny Lee).

Even as the series premiered in June 1951, the NAACP was in federal court seeking an injunction to prevent CBS from televising it. In the minds of groups and individuals sensitive to the struggle for black civil rights, *Amos 'n' Andy* was an affront to social achievement. The Michigan Federation of Teachers condemned the TV series, calling it "a gross and vulgar caricature of the fifteen million Negro citizens of our country."[8] This sentiment was echoed by the Students for Democratic Action, the United Hatters, Cap and Millinery Workers Union, and by the secretary-treasurer of the Transport Workers Union.

The show business editor of the black newspaper *California Eagle* blasted *Amos 'n' Andy*. Referring to "the slow and steady

poison of twenty years of *Amos 'n' Andy* on the radio," he attacked the distorted message received by "middle class and sheltered whites." This message, that "the 'happy and smiling' Negro is the 'good' Negro—the stolid, unemotional Negro is the 'bad' kind," was unfair and unwanted. "To my way of thinking," he concluded, "the *Amos 'n' Andy* show is not controversial. It just doesn't belong on TV or anywhere else."[9]

Even more caustic was the reaction in 1951 of actor James Edwards. An outspoken proponent of dignified roles for African-American actors, Edwards assailed the irresponsibility of the series. He contended that

> for the sake of 142 jobs which Negroes hold down with the *Amos 'n' Andy* show, 15 million more Negroes are being pushed back 25 years by perpetuating this stereotype on television. The money involved (and there's a great deal) can't hope to undo the harm the continuation of *Amos 'n' Andy* will effect. We don't have to take it, not today.[10]

At its convention in Atlanta in June–July 1951, the NAACP passed a resolution critical of the new TV series and other programs stressing negative stereotypes. According to that resolution, "The new television show, *Amos 'n' Andy,* depicts Negroes in a stereotyped and derogatory manner, and the practice of manufacturers, distributors, retailers, persons, or firms sponsoring or promoting this show, the *Beulah* show, or others of this type is condemned."[11] In its legal suit against CBS, however, the NAACP became more specific in enumerating the dimensions of *Amos 'n' Andy* it felt objectionable.

- It tends to strengthen the conclusion among uninformed and prejudiced people that Negroes are inferior, lazy, dumb and dishonest.
- Every character in this one and only show with an all-Negro cast is either a clown or a crook.
- Negro doctors are shown as quacks and thieves.
- Negro lawyers are shown as slippery cowards, ignorant of their profession and without ethics.
- Negro women are shown as cackling, screaming shrews, in big-mouth close-ups using street slang, just short of vulgarity.

- All Negroes are shown as dodging work of any kind.
- Millions of white Americans see this *Amos 'n' Andy* picture and think the entire race is the same.[12]

Although the series was produced for only two seasons, 1951–1953, *Amos 'n' Andy* continued in syndication. Not until 1966, after years of litigation, did CBS agree to withdraw the program from circulation. Moreover, the impact of the series lasted beyond its original run. In 1956 one critic still attacked it vociferously as a weekly reminder of "discarded and dated" minstrelsy, an oppressive form of entertainment "invented by white plantation owners to make them feel benevolent toward their picturesquely slaphappy, indolent, craps-shooting, lovable, no-account field hands who wouldn't be able to make a living but for the white man."[13] And in 1964, as it entered its thirteenth run in local Chicago television, *Amos 'n' Andy* triggered city-wide criticism for "promoting the old foot-shuffling, ignorant and lazy stereotypes."[14]

Amos 'n' Andy was not without its defenders. Many argued that the program was simply comedic caricature, no more offensive to blacks than *The Goldbergs* was to Jews or *Life with Luigi* was to Italians. They contended that the writing was humorous, the acting was solid, and the popularity of the show was commercially impressive. The fact that *Amos 'n' Andy* ended the 1951–1952 TV season as the thirteenth most popular program in the nation seemed to confirm such contentions. The influential black newspaper, the *Pittsburgh Courier*, supported the series. According to that journal, "it provides for the first time lucrative and continuous employment for many talented troupers who have waited a long time for this kind of an open-door opportunity into the great and rapidly expanding television industry."[15] Echoing this sentiment, the actors in the series attacked black activists in the NAACP for being "ill-informed people of our own race who have irresponsibly threatened a boycott of our sponsor and have unfairly characterized the show, its producers and ourselves."[16]

One of the more constructive defenses of *Amos 'n' Andy* came from Dr. S. Randolph Edmons, a professor of Humanities at Florida A & M University. Edmons called for productive criticism. "If there are to be campaigns to close shows," he remarked

in 1951, "there should be campaigns to open shows. If there are to be negative protests against plays which untruthfully reflect the life and character of the race, there should be creative programs to find the right dramas to fill the creative vacuums. This is only fair."[17]

Decades after the premier of *Amos 'n' Andy* on television, controversy still swirled around the program. In their cursory study of the show, Bart Andrews and Ahrgus Julliard concluded in 1986 that it was fraudulent in its representation of African Americans. "Amos and Andy were only black on the outside," they noted. "Their birth, nurturing, and development—all of the inner 'machinations'—were white." According to the two writers, "*Amos 'n' Andy* never really was a 'black' show. There were no black scriptwriters, no black producers, no black directors." Indeed, they asserted, "Blacks rarely had any symbiotic connection with what eventually became lucrative renditions of their own music and life-styles. It was therefore inevitable that black representations were devoid of authenticity."[18]

In contrast, Melvin Patrick Ely was somewhat apologetic in his detailed study of the *Amos 'n' Andy* phenomenon. Writing in 1991, Ely described the series in terms of "race-consciousness," but not racism—of comedic "toying with color" instead of racial distortion or discrimination. He was impressed by the innocence of Gosden and Correll in presenting their black characters, and he pointed out that not all African Americans opposed the series, and not all whites applauded it. Ely also found literary merit in *Amos 'n' Andy*, relating it to the honored traditions of American humor, from oral folk tales of the nineteenth century, to the writings of Mark Twain, to the movie antics of Stan Laurel and Oliver Hardy. Still, he was moved to conclude that "However benign Gosden and Correll's intentions may have been . . . *Amos 'n' Andy*'s fans could easily see the series not only as a traditional burlesque of universal human greed, but also as a portrait of African-American character and communal values. That picture was no compliment to the race."[19]

On television, too, the debate over *Amos 'n' Andy* has remained heated. Through his syndicated documentary in 1984, *Amos 'n' Andy: Anatomy of a Controversy*, producer Michael Avery offered a spirited vindication of the series. Hosted by comedian George Kirby, the hour-long production lined up an im-

pressive group of defenders that included Ernestine Wade, Rev. Jesse Jackson, and Charles Correll's son, Richard. But the failure of the documentary to offer a similar array of hostile critics rendered it less an anatomy of a controversial program and more a protracted justification for rerunning the old episodes.

Three years later, beginning January 26, 1987, hostess Doris McMillon took up the debate for a full week of her nightly talk show, *On the Line with* . . . on the cable Black Entertainment Network. Viewers encountered conflicting views from people as diverse as Horace Stewart, who lauded the show and role he played in it, to the Reverend Emmett Burns of the NAACP, who argued that the series remained socially divisive and a denigration of all African Americans. Interestingly, when viewers were invited to telephone an 800- number to vote on whether or not *Amos 'n' Andy* should appear again on television, more than 80 percent voted in the affirmative.

There is little doubt that *Amos 'n' Andy* contrasted with the more realistic image of blacks offered by television. Written, produced, and directed by white men, the series was a stereotyped projection of black life. Certainly characters were exaggerated for purposes of comedy, but their essence was drawn directly from offensive minstrel shows, an entertainment form that was anachronistic in the 1950s. Defenders were correct in noting that the series meant success for many black actors. Some felt that as the first long-running network program utilizing dozens of blacks, it might be the beginning of prosperity for blacks in TV. But critics were also right in maintaining that *Amos 'n' Andy*, despite its popularity, was no breakthrough for African Americans.

Nonetheless, *Amos 'n' Andy* occasionally demonstrated humanizing qualities. The Stevens' apartment was the first look at a black residence in television history. It was typical of situation comedy sets—modestly furnished, clean, apparently homey, but situated in Harlem. Except for the recurring characters, supporting black roles were usually socially substantial. A black businessman, lawyer, music instructor, judge, and the like were not played for laughs. Their seriousness offset the caricature of the cast regulars.

Although Sapphire and Mama were less than picturesque images of black feminity, the program frequently featured beau-

tiful black women in lesser roles. They were generally the objects of Andy's harmless flirtations, or they were cast as secretaries.

Nor were there any overt signs of racial segregation. When the Kingfish and his family stopped at a roadside diner in Connecticut, they encountered no problem in being served. When white men and women entered the story line, they never acted smugly or discriminated against a black character, no matter how outlandish viewers found him. In one episode, a radio station had no qualms about substituting the Stevenses for a quarrelling white couple whose "Happy Home" program was about to be aired in New York City. In this instance, *Amos 'n' Andy* was without prejudice, a slice of urban life in which discrimination and segregation were never suggested.

When the plot focused on Amos and his family, audiences encountered a sensible, working-class black couple with an attractive, well-behaved child. Here was a responsible father and a level-headed mother. Here, too, were family love and genuine affection for all the characters with whom Amos and Ruby came into contact.

Nowhere was such sentimentality—a human emotion that was never a part of the minstrel-show tradition—more visible than in the annual Christmas show. Reenacting a story that had been heard for years in the radio version of *Amos 'n' Andy*, this program concerned a tolerant and loving Andy working as Santa Claus for one day in a department store. Andy's unselfish goal was to earn money to buy his goddaughter, Amos' daughter Arbedella, a beautiful black doll. Andy's coddling of youngsters telling Santa Claus their wishes, the exchanging of gifts between Andy and Amos and Ruby, the tenderness seen in the relationship between Andy and Arbedella, and the seasonal warmth suggested by Amos' cozy home and decorated Christmas tree were capped by an emotional final scene. Here, with a choir singing off-camera, Amos interpreted the "Lord's Prayer" for his daughter who lay tucked securely in bed.

But the humanity occasionally suggested by *Amos 'n' Andy* was constantly defeated by the racist imagery projected by the series. Here was minstrelsy in its latest fashion. The legacy of Tambo and Bones and their burnt cork comedy routines was inherent in the series' characters. Neither Andy, Kingfish, nor Sapphire could utter a sentence without using incorrect grammar,

malapropisms, or mispronunciations to illustrate their basic ig-
norance. Thus, ultimatum became "ultomato," secretary was
pronounced "sekatory," legitimate became "layjiterat," and
Kingfish's moaning "holy mackerel," was always exclaimed as
"holy mack'l."

Amos 'n' Andy perpetuated the myth of the black matriarch.
This was manifest in the image of shrewish women continually
browbeating their men. There was no male chauvinism or sexual
equality here. The series projected dominating black women and
socially weak black men. Granted, Kingfish was a shiftless loafer;
Sapphire's constant shrill criticism was nonetheless debilitating.
And when Sapphire was backed in her attack by Mama, the ver-
bal assault was devastating, as illustrated in a dinner-table con-
versation between Kingfish, Mama, and Sapphire:

Kingfish: Have some more peas, mother-in-law dear?
Mama: When I want some, I'll help myself.
Kingfish: Oh, well, I just . . .
Mama: Why, I got along all these years without you telling me
what to eat.
Kingfish: Well, if you don't want 'em, don't take 'em. That's all
right with me.
Mama: Ah, you're begrudging me the food. Well, I eat little
enough without you complaining all the time.
Kingfish: Now, listen, Mama, can't we just . . .
Mama: You mind your own business. I'm talkin' to my daughter.
Sapphire: George, stop pickin' on Mama!

The Kingfish always lost such confrontations. Frequently,
he was shown being ejected from his own home by his victorious
wife. Such scenes were all the more poignant in that he invari-
ably stood on the apartment steps with a framed lithograph of a
laughing white cavalier offsetting his own downcast facial ex-
pression. The prerecorded laugh track was always turned up at
this point. In the climate that made Amos 'n' Andy popular for so
long, it was considered hilarious to see a bumbling middle-aged
black schemer being kicked out of his home by a haranguing
black woman.

If African Americans looked for role models in Amos 'n'
Andy, there were none to be found. Most central characters had

no jobs. The Kingfish and Andy were always unemployed, and women in the series were unsalaried housewives. Amos, who appeared only fleetingly in the programs, drove a taxicab. Lightnin' was a janitor. The only professional in the regular cast was Calhoun. But he was a nefarious lawyer whose lack of professional ethics was outweighed only by his misuse of the English language. Because there were few other TV series offering positive role models for black viewers, the disservice done by this popular program is apparent.

White viewers saw in *Amos 'n' Andy* a deceptive picture of ghetto life. There were few legitimate social aspirations in the series. Amos and Lightnin' were content with their careers. Although there was unemployment, there was no welfare dependence and no hunger. Further, unemployment was seen as a product of personal laziness, not the result of discrimination, segregation, or inferior education. Although there was social achievement on the part of Calhoun, the lawyer was seen as an incompetent buffoon with corrupted values.

This was a patronizing picture of black society. It depreciated black maturity, rendering most of the adult characters as harmless children filled with pranks and pretensions, but ultimately unthreatening. There were no civil rights tensions in this show. *Amos 'n' Andy* was a false interpretation of black reality, unfairly lulling whites into complacency and unjustly reducing African Americans to a position of inferiority.

3

Blacks in News Programming

If controversial series such as *Amos 'n' Andy* and *Beulah* relied heavily on distorted stereotypes, and if nonstereotyped black entertainers were usually dancers, singers, and musicians, the most realistic image of blacks emerged in news and news documentary programming. It was not that there were news programs meant specifically for black audiences, or that network or local outlets conscientiously sought to cover minority affairs. Instead, the increasing concern of television with African Americans reflected the growing importance of blacks at home and abroad.

Internationally, the European empires were crumbling. The powerful European nations—Great Britain, France, Belgium, Portugal, Spain, and the Netherlands—had been crippled by the loss of life and treasure during two world wars. Increasingly, native leaders—often schooled in European and American universities—demanded independence for their homelands. Spurred by the successful struggle for self-determination and statehood in India, Asian and African colonies since the late 1940s moved inexorably toward independence. By the television era it was obvious that third world nations would play an increasingly powerful role in global affairs.

In the postwar United States, blacks exerted unprecedented influence in domestic politics. The integration of the armed services made black servicemen more influential in military affairs. Black economic, educational, and demographic advances affected national priorities. Longtime black leaders and new spokespersons

enunciated the need for better racial conditions. Coalescing these forces was the decision by the Supreme Court in 1954 that segregation in the public school system was unconstitutional. The ruling in the case of *Brown v. Board of Education* set into law the fact that "separate but equal" was inherently unequal. It effectively began the civil rights movement and propelled black politics into unprecedented activism and reform.

That decolonization in the third world and the renewal of the civil rights movement in the United States became realities at the same time was not coincidental. The social myths and the political-economic-military realities supporting white global supremacy had been shattered by the two world wars. By the late 1940s, with Europe militarily and morally exhausted and the United States locked in a Cold War, it was inevitable that those suppressed by Western imperialists would demand fundamental changes.

Nobody better comprehended the linkage between African independence and the African-American struggle than the Reverend Martin Luther King, Jr. On March 6, 1957, the day that the British colony of the Gold Coast became the independent nation of Ghana, he shared his thoughts in an interview with Etta Moten Barnett in Accra, capital city of the new country. Barnett, a star of stage and screen in the 1930s and 1940s, was in Ghana with her husband Claude A. Barnett, the founder of the Associated Negro Press news service, as part of the official U.S. delegation headed by Vice President Richard M. Nixon. She was also taping feature reports for her own Chicago radio program.

Her conversation with King captured the civil rights leader at a moment of high optimism. Fresh from his victorious struggle against Jim Crow laws affecting bus transportation in Montgomery, Alabama, King had come to Ghana in no official capacity— he sought only to experience this celebration of black independence in West Africa. "Well, the minute I knew I was coming to Ghana, I had a very deep emotional feeling, I'm sure," he told Barnett, "thinking of the fact that a new nation was being born symbolized something of the fact that a new order is coming into being, and an old order is passing away, so that I was deeply concerned about it. And I wanted to be involved in it, and be a part of it, and notice the birth of this new nation with my own eyes." That King understood the historical fullness of the times was obvious in this exchange with his interviewer.

Barnett: Reverend King, do you have any feelings about the far-reaching influence of this particular occasion in the history of mankind, in the history of peoples of color all over the world? How far do you think this will reach? How much do you think it will influence the affairs of men that we're interested in?

King: I think this event, the birth of this new nation, will give impetus to oppressed peoples all over the world. I think it will have worldwide implications and repercussions—not only for Asia and Africa, but also for America. As you well know, we have a problem in the Southland in America, and I think this freedom—the freedom in the birth of a new nation—will influence the situation there. This will become a sort of symbol for oppressed people all over the world. Just as in 1776 when America received its independence, the harbor of New York became sort of a beacon of hope for thousands of oppressed people of Europe; and just as, when after the French Revolution, Paris became a beacon of hope for hundreds and thousands of common people; now Ghana will become a symbol of hope for hundreds and thousands of oppressed peoples all over the world—Africa and in Asia, and also oppressed people in other sections of the world as they struggle for freedom as I confront it.

Barnett: Yes, that is so very, very true. And when you stop to contemplate this, doesn't it give you more hope for the situation in which you find yourself—well, ourselves—in America?

King: Yes, it does. It certainly does. It renews my conviction in the ultimate triumph of justice. And it seems to me, this is fit testimony to the fact that eventually the forces of justice triumph in the universe, and somehow the universe itself is on the side of freedom and justice. So that this gives new hope to me in the struggle for freedom.[1]

American print and radio journalism covered these developments. But television brought filmed actualities into the homes of mass America. Visual images of the black and brown world in revolt emphasized the importance of the human reevaluation taking place. It was one thing to read or hear of unrest among American blacks; it was another to *see* men and women protesting against segregation and discrimination.

No network TV journalist treated blacks more fairly and frequently than Edward R. Murrow, a highly respected CBS newsman because of his radio coverage of the British role in World War II. Murrow's achievements in television were equally impressive, particularly through his weekly news-analysis program, *See It Now,* and his weekly TV visit to the homes of celebrities, *Person to Person.*

On *See It Now,* Murrow showed Americans a realistic image of blacks. Nowhere was he more poignant in such presentation than in the numerous segments of the program he devoted to the Korean War, the first war in which African-American soldiers fought in integrated units. Murrow and his reportorial crew—including Robert Pierpoint, Lou Cioffi, Bill Downs, and Larry LeSueur—vividly illustrated this new aspect of American democracy.

Particularly striking were the two programs devoted to "Christmas in Korea." In 1952 and in 1953, Murrow and *See It Now* traveled to South Korea to report on the conditions facing United Nations troops. Filmed in the trenches and foxholes of the battle front, these hour-long reports showed many black GI's among the American troops. Most of the black soldiers extended Christmas greetings to loved ones at home, and told Murrow and his crew they longed for a military victory and a return to the United States. To illustrate that the Korean war was an allied venture, Murrow also focused on troops of other nations. Among them were Ethiopian solders celebrating the Christmas holiday.

Except in showing black Americans as equals with white soldiers, there was nothing radical about the "Christmas in Korea" broadcasts. Except in presenting African troops among the United Nations forces supposedly fighting to stop the spread of Communism, there was nothing different about the programs. But for Americans, these were radically different images. Unlike the distorted images of George "Kingfish" Stevens and Willie Best's characterizations, here were real black men expressing real human emotions. Here, too, were dark-skinned Africans, not of the savage primitiveness seen in old travelogues, but dressed in military fatigues and observing a Christian holiday, while thousands of miles from home fighting alongside Americans against a common enemy. The lessons in brotherhood and internationalism were obvious.

Murrow occasionally analyzed race relations in the United States. Eight days after the Supreme Court decision on segregation in public schools, he treated domestic racism in a memorable *See It Now* program. Telecast on May 25, 1954, "A Study of Two Cities" compared racial attitudes in two small southern towns. In typical Murrow fashion, he used filmed interviews with white and black residents of the two towns to document the various positions being taken in the wake of the Supreme Court decision. And although the focus was upon southern reactions, Murrow was careful to suggest that the race problem in America was a national crisis.

> Our greatest need at the moment is level-headedness. Whites of the South should not panic. Negroes should not whet their impatience.... In a day when many nations and races are looking to us for leadership to peace and to freedom, we need to reflect in our own country the traditional American virtues of justice and fair play. All parts of the country, not only the South, should do some real soul-searching in this respect.[2]

Murrow's celebrated attack upon the demagogic investigatory tactics of Senator Joseph McCarthy was heightened when on March 16, 1954, he focused on the plight of a black government worker, Annie Lee Moss. Charged by McCarthy's senatorial committee with being a member of the Communist party, the elderly Mrs. Moss was intimidated by McCarthy's questioning and innuendo. Murrow's argument was not whether Moss was a Communist. Instead, he illustrated that because she was never able to confront her accusers, her right to due process of the law—a right shared by all Americans—was being violated.

Not all *See It Now* programs focusing on blacks concerned political matters. On December 13, 1955, Murrow presented highlights of Louis Armstrong's musical tour of Europe. In a program aired on December 30, 1957, Murrow showed film of soprano Marian Anderson's successful tour of the Far East.

The Murrow series that introduced Americans most intimately to black personalities, however, was *Person to Person*. This half-hour CBS feature took TV cameras into the homes of celebrities. With Murrow sitting in his New York studio asking questions of his guest hosts, viewers in the mid-1950s encoun-

tered sports figures like Althea Gibson, Sugar Ray Robinson, Joe Louis, Jesse Owens, and Don Newcombe; musical talents like Eartha Kitt, Mahalia Jackson, Duke Ellington, Cab Calloway, W. C. Handy, and Ethel Waters; and statesmen such as Ralph Bunche and Walter White. The equanimity with which Murrow treated black Americans was suggested in the premier of *Person to Person* in October 1953, when CBS cameras visited the home of Brooklyn Dodgers catcher Roy Campanella.

Edward R. Murrow and CBS also recognized the increasing importance of African politics. In the midst of the decolonization movement, *See It Now* produced frank analyses of the unrest among black Africans. In December 1954, Murrow presented a two-part "Report on South Africa" that exposed the racial explosion inherent in that peculiarly discriminatory policy, apartheid. Less than two years later, in the spring of 1956, *See It Now* produced another two-part study, "Report from Africa." Traveling throughout the continent, CBS cameramen revealed the turmoils of decolonization. Viewers encountered rigid laws of racial separation in Rhodesia and the Union of South Africa and violent social unrest in French Algeria, British Kenya, and the Belgian Congo. But they also saw stability in newly independent Ghana and in long-independent Ethiopia and Liberia.

Such African realities were revealed again in December 1956, when *See It Now* telecast highlights of a 50,000-mile trip by comedian Danny Kaye on behalf of the United Nations International Children's Emergency Fund. Part of the program showed Kaye as a UNICEF representative and entertainer visiting Nigerian children in a leper colony, and Moroccan children suffering from trachoma. Such programming certainly belied the stereotyped image of Africa and Africans contained in *Ramar of the Jungle* and the films of Martin and Osa Johnson.

Yet for all of its early exploration of the black condition at home and abroad, American television was never more meaningful than it was on November 23, 1953, when ABC, CBS, and NBC televised an hour special from the dinner honoring the Anti-Defamation League of B'nai B'rith on its fortieth anniversary. It was one of those innocent, yet seminal events in U.S. history, recognizable later for its integral relationship to momentous developments about to materialize. Viewers saw this liberal Jewish organization, dedicated to civil rights and civil liberties,

presenting its America's Democratic Legacy medallion to President Dwight D. Eisenhower. Two U.S. senators in the audience—Democrat Hubert H. Humphrey of Minnesota and Republican Irving M. Ives of New York—were lauded for their concern with civil rights matters. But most significantly, viewers also were introduced to five members of the United States Supreme Court who were attending the dinner: Felix Frankfurter, Robert Jackson, William O. Douglas, Tom Clarke, and the newly-appointed Chief Justice, Earl Warren.

What made this gathering of profound importance was that it occurred at exactly the same time the Warren Court was assessing legal briefs in the *Brown vs. Board of Education* case—and two weeks before Thurgood Marshall and other lawyers from the NAACP presented the Court with oral arguments in favor of equal educational opportunity. At this point the Court was strongly divided on the issue of school desegregation. Its unanimous decision would not be rendered for another six months. Yet, what unfolded on television here in late November was essentially a national seminar on civil rights, and the President and the Supreme Court of the United States sat as the principal students.

As well as humor and songs from Lucille Ball and Desi Arnaz, Perry Como, Ethel Merman, and the African-American operatic baritone, William Warfield, there was considerable reference to the moral and legal necessity for establishing racial justice. There was an archival film of President Franklin D. Roosevelt signing Executive Order 8802 that banned racial discrimination in hiring for defense industries and government—and Eleanor Roosevelt addressing the United Nations. And Lilli Palmer read from the Declaration of Human Rights, a document fundamental to the United Nations, declaring, "It is essential that human rights should be protected by the rule of law."

More specifically, narrator Martin Gabel praised the historic role of the U.S. Supreme Court in championing social justice—as he phrased it, in handing down "decision after decision which have been milestones in our ceaseless struggle for human rights." Gabel added, "We still have a long way to go. But we know that the journey will be undertaken with due respect for the law, as interpreted by the highest court in our land." After

introducing the Supreme Court justices in the audience, Gabel returned to his liberal theme, noting suggestively, "What future questions of civil liberties and civil rights these men must decide, no one knows. But every American must feel reassured that on these issues so vital to him, he is guaranteed his day in court."

Embellishing on this televised lesson in civil rights, British actor Rex Harrison recalled that the National Theater in Washington, D.C., was once closed for four years when actors refused to play the theater because it banned African Americans from the audience. And in explaining why they had assembled this salute to the Anti-Defamation League, Richard Rodgers and Oscar Hammerstein II underscored the libertarian tenor of the evening. According to Rodgers, "We thought it was a pretty good chance to put the American theater to work directly in the interest of democracy. I think the theater has a better right than almost any other influence in America to speak for democracy." Hammerstein responded, "We have no intolerance on our American stage, and so we can plead for tolerance everywhere else." And Rodgers added, "We're never at a loss in the theater for blistering names to call each other, but they're never based on color or religion."

One of the most emotional segments of the program was a scene from the final act of the Broadway drama, *Harriet*. Here the celebrated actress Helen Hayes delivered a moving soliloquy as Harriet Beecher Stowe, the author of *Uncle Tom's Cabin*. Describing her experience in a recent meeting with President Abraham Lincoln during the Civil War, Stowe explained to her family and friends,

> He has made me see that this war, which seems so final to us now, is but one small pattern in a vast tapestry of struggle. Since the dawn of history there have always been tyrants, great and small, who have seized upon and enslaved their fellow men. But equally, always, there have been noble souls who have bravely and gladly given their lives for the eternal right of man to liberty. The hope of today lies in this: that we as a people are no longer willing to accept these tyrants and the world they make without question. We are beginning to understand that a world that holds happiness for some, but misery for others, cannot endure. Oh, yes, that is our hope.

Others, too, contributed to the appeal for equal justice. Philip M. Klutznick, the president of B'nai B'rith, explained why "the dignity of the individual is precious to us, however humble his origin or station in life. For we believe with the great philosopher Spinoza, that the state has, for its end, so to act that its citizens shall in security develop soul and body and make free use of their reason, for the true end of the state is liberty." Henry Edward Schultz, the head of the Anti-Defamation League, cited the reasons why his organization that evening was presenting President Eisenhower with its America's Democratic Legacy award. "We honor you for your leadership in the great crusade to bring about the elimination of Nazi tyranny over the oppressed people of Europe—for your vigorous campaign to eliminate racial segregation in the armed forces—for your efforts to end undemocratic patterns of discrimination here in Washington, our capital city," Schultz said. "But most of all, we honor you for your continued leadership of the free world . . . in grateful recognition of a life devoted to the furtherance of freedom."

The highlight of this momentous event, however, was Eisenhower's nine-minute acceptance speech. Delivered without a prepared text, it was one of this President's most empassioned public statements. This was no superficial presentation of thanks. Here was a serious recipient, a man touched by the events of the evening, a President who was close to tears. And here, too, was an influential audience to thousands of viewers at home, and to a majority of the Supreme Court presently considering what course to take on the race question.

What Eisenhower said was his fullest public utterance on the matter of civil rights. After reiterating several of the individual liberties guaranteed under American law, he recalled wistfully the Fourth of July orators he had heard as a boy growing up in Abeline, Kansas. As he remembered them, they were usually long-winded speakers whose patriotic discourses could be narrowed down to one important consideration: why Americans should be proud of their citizenship.

The root of this pride, Eisenhower declared, rested not in material wealth, natural resources, or any physical or esthetic sense of accomplishment. Instead, he argued, pride in being an American lies in humanitarian intangibles for "the deep things that are American are of the soul and of the spirit. The Statue of

Liberty is not tired, and not because it is made of bronze. It's because no matter what happens here, the individual is dignified because he is created in the image of his God. Let's not forget it." Somberly, the President concluded, "I am proud to be an American. But if I could leave you with one thought, you not only will repeat it everyday of your lives, but you'll say, 'And I'll do my part to make it always true for my children and my grandchildren.' "

4

Bias in Video Drama

In the early years of television, the relationship between African Americans and the medium was contradictory. Trapped between the traditions of racial stereotyping and the promise of color-blind programming, talented blacks found only limited opportunity in TV. In contrast to the derisive minstrel-show roles popular in cinema and radio, however, black entertainers hosted their own TV shows, or more frequently appeared as guests on musical variety programs. Still, beyond musical entertainment, the most successful and lucrative roles for African Americans continued to be found in stereotyped situation comedies like *Amos 'n' Andy* and *Beulah.*

This ambivalence was compounded because respectable dramatic parts for black actors were practically nonexistent. During the 1950s, as dramatic production flowered in the new medium, television theater was lily white. This was a situation well understood by Jack Gould, the TV critic of the *New York Times.* Writing in late 1953, Gould suggested that "opportunities for Negroes in television have been considerable in the realm of vaudeville and musical shows." Yet, he continued, except for "the usual stereotyped roles," there have been "very few leading parts for some of the most gifted artists in our midst."[1]

One local series which attempted to break this pattern of exclusion was *Harlem Detective,* a short-lived police drama on New York City station WOR-TV. The show was a weekly live play focusing on a pair of detectives—one black and one white—

investigating crime in Harlem. The program premiered on October 14, 1953, and last appeared on January 13, 1954. During its brief run several actors, including William Hairston and William Marshall, played the central characters.

While the interracial theme was unique and engaging, *Harlem Detective* suffered fatally from a low budget. With limited capital with which to employ set designers, directors, supporting actors, and writers, the program was neither a critical nor popular success. A contemporary reviewer criticized it for "the avalanche of production crudities that almost decimated the noble aims of the show."[2] It was, however, the first TV dramatic series to feature a nonstereotyped African American as its co-star. As such, *Harlem Detective* was a decade ahead of its time. Not until Bill Cosby appeared in *I Spy* in 1965 was a similar program produced.

Despite the inundation of live and filmed dramas that marked the first decade of popular television, black actors seldom commanded other than minor supporting roles. And they were fortunate to obtain these parts. Frederick O'Neal, the noted actor and founder in the 1940s of the American Negro Theater, speculated that black actors in 1952 accounted for only four-tenths of one percent of all performances on TV. He argued that of the 6,620 actors used during an average week on TV, only thirty-one were black. Of all the mass media, according to O'Neal, "TV is the worst" in its treatment of African-American talent.[3]

On the other hand, actor Frank Wilson seemed genuinely pleased when he told *Jet* magazine in 1953 that television was affording blacks "a new freedom." Wilson boasted that he had already appeared in supporting roles in more than twenty television dramas, the latest being a Polynesian king in the *Studio One* production of "A Breath of Air." He argued, moreover, that he was only one of about fifty black performers who regularly received such assignments.[4]

Wilson's enthusiasm notwithstanding, black actors in early TV plays were scarce. Several reasons account for this. First, the legacy of discrimination established in film, radio, and print continued to exist in television. Despite liberal and reformative sentiments which influenced popular culture in the postwar period, the prejudices of the past entered television. Clearly, the prom-

ise of bias-free participation was being denied by the nascent medium.

Early video also honored the long-established color line in its dramatic presentations. A traditional component of motion pictures, the color line resulted in black actors being employed only when a script specifically called for black characters. When an "extra" or incidental character could be of any racial background, invariably he or she was white. *Ebony* magazine in 1955 decried this practice when it related the story of Abbie Shuford. An aspiring young actress, Shuford had worked for three unsuccessful years in New York City, hoping to break the color line in television.[5] Four years earlier Ed Sullivan had wondered in the same magazine if TV could "crack America's color line." The case of Abbie Shuford suggested that the answer was negative.

Although they produced deleterious results, discrimination and adherence to the color line were at least obvious practices which could be openly challenged. Much more difficult to combat was the preproduction censorship that occurred behind the scenes. It was difficult, for example, to deal with the establishment by some producers of discriminatory racial quotas. The use of quotas meant that never more than a few black performers could appear on the TV screen at one time. It also meant that stories treating racial controversy were rarely produced. Even the use of black extras was affected by racial quotas. In situations where more than a few black actors might be expected to appear—in urban street scenes, on public transportation, on public school campuses, or in hospital waiting rooms—they were severely restricted.

According to historian Thomas Cripps, this practice was complicated when liberal activist groups brought pressure for change upon TV producers. Cripps showed how protests from organizations like the NAACP actually led producers to curb further their utilization of black talent. For every African American cast as a menial character, the NAACP demanded that another black actor be included in a professional role. Such a demand led some to ignore black parts altogether. And this discrimination was justified on the grounds that it avoided unwanted disputes over racial quotas and sensitive minority themes.[6]

Pressure for censorship in television dramatics came from sponsors, networks, advertising agencies, and even production

personnel. Above all, these elements feared offending the preju-
dices and the economic strength of their white audiences. Fear-
ing it was too controversial for the South, the CBS sales depart-
ment failed to obtain a sponsor for the documentary of Marian
Anderson's operatic tour of the Far East. Not until Edward R.
Murrow and co-producer Fred W. Friendly personally found a
sponsor would CBS air this *See It Now* feature in prime time.
When Du Pont financed an adaptation in mid-1958 of the popu-
lar Broadway play, *A Member of the Wedding,* it was suggested
that the tenderness and embracing between the mammy charac-
ter and her white employers' children should be eliminated or
toned down. Sensitive to civil rights tensions, the sponsors of the
CBS series, *Climax,* compelled writer Ernest Kinoy to change
two boys trapped in a cave from a black and a white to a white
and a Mexican-American.

One of the most striking examples of preproduction censor-
ship occurred when Reginald Rose's drama, "Thunder on Syca-
more Street," was telecast on *Studio One* on March 15, 1954.
Here, sponsor (Westinghouse), advertising agency (McCann-
Erickson), and network (CBS) united in shaping the play. The
original story was inspired by an attempt in 1953 by blacks to
move into a local housing development in Cicero, Illinois. Ac-
cording to Rose, he wrote the drama because the "inhuman me-
dieval attitudes of these free, white Americans had so disturbed
me that I had decided to do a play about them in an attempt to
explore the causes behind their mass sickness." For television,
however, Rose was forced to make his central character an ex-
convict instead of a black. Rose explained that it was "unpalata-
ble" to behind-the-scenes elements that a black man should be
"the beleaguered hero of a television drama." Particularly, they
felt, viewers in southern states would be "appalled" by such a de-
piction.[7]

It was an axiom in the advertising industry that southern
whites would not tolerate positive images of blacks on television.
Advertisers and their agencies feared a white economic backlash
should they finance African-American talent in other than
minstrel-based comedy roles. As an advertising executive ex-
plained to black actor Frank Silvera, a company such as Pillsbury
could not afford to become associated too closely with African
Americans or their cause. If it became a popular perception that

a Pillsbury product was a "nigger flour," the company would be severely hurt in sales.[8]

Boycotts by southern consumers in the 1950s had adversely affected large corporations on more than one occasion. When black workers were permitted to work alongside whites on production lines at the Ford Motor Company, white southerners boycotted Ford automobiles until the practice was changed. When a black girl won a Chicago beauty contest, southern whites boycotted the sponsor of the contest, Philip Morris. The fear of such organized consumer resistance was what writer Rod Serling termed "a wrathful wind to come up from the South."[9]

The clamor for censorship moved from the lowest to the highest levels in American society. Dealers holding franchises to sell nationally advertised products—especially the more expensive commodities such as automobiles—interpreted white consumer prejudice and in turn pressured corporate offices to avoid positive black characterization. Sponsors and their advertising agencies translated this anxiety into directives to writers, directors, and producers of television plays. Few personalities except Ed Sullivan and Steve Allen had the conviction and leverage necessary to withstand these pressures.

As the noted dramatist Paddy Chayefsky explained to a TV audience in 1958, no matter how compelling the story, if it had racial implications it was almost impossible to produce. Speaking of the unwinding story of integration in Little Rock, Arkansas, Chayefsky argued that it could never become television drama. To be acceptable for TV, he remarked, a writer would have to make the central character not a black child seeking integrated education, but "a Hungarian immigrant coming in from another country, and the reason they didn't like him was because he looked dirty." Simply stated, in Chayefsky's view "you can't write the Little Rock thing because they can't sell the sets down South . . . or you can't sell the aluminum paper down South."[10]

A flagrant example of southern pressure on a TV dramatic production occurred with a play written by Rod Serling for the *United States Steel Hour* telecast on April 25, 1956. Although the play, "Noon on Doomsday," was not a racial drama, its theme was inspired by the Emmett Till case—a murder case in Mississippi in which an all-white jury acquitted two white men of kill-

ing Till, a black teenager who had made the mistake of whistling at a white girl. For Serling the poignancy in the acquittal was that although the two men were set free, the townspeople ostracized them as if they had been convicted.

Serling intended to stress this poignancy, the notion of a closed society rejecting state laws, but dispensing justice according to local values. To avoid racial controversy and to make his theme universal, Serling located his drama in an unspecified, unsouthern locale. His victim was an elderly Jewish pawnbroker. The killer was made a neurotic malcontent who killed out of "his own unhappy, purposeless, miserable existence."[11]

When it was publicized that Serling's play was related to the Till murder case, however, reaction was quickly forthcoming. In the several months before it was actually produced, White Citizens Councils and similar organizations sent more than fifteen thousand letters and telegrams protesting its showing. Despite denials in the press, "Noon on Doomsday" was anticipated as a racial play.

Bending to the pressure, U.S. Steel demanded and obtained wholesale changes in the drama. The story was now set in New England. The victim was made a foreigner of unspecified ethnicity. The killer was no longer a psychopath, but an average American boy who had just gone wrong for a moment. Anything hinting at the South—the word "lynch," fried chicken, any social institution or event—was forbidden. Even Coca-Cola bottles were removed from the set, because the national headquarters of that soft drink company was in Atlanta.

This is not to suggest that the South was the only region of the nation antipathetic to strong, honest portrayals of African-American life. If such were the case, network TV would have avoided such imagery, but local television in the rest of the country would have aired consistently positive programs. The latter phenomenon never materialized. With its higher percentage of black residents, with its segregated caste system, and with its economic power securely in the hands of the white population, the South was only an intensified microcosm of national racial attitudes. Its Jim Crow laws were more blatant, its segregation was more developed, and its economic disparity was more apparent than in other regions of the United States.

With the civil rights movement growing in the mid-1950s, many commercial elements in TV programming feared association with the black cause. With the weight of federal law and force threatening to overturn the inequitable social system established in the Reconstruction era, many considered it economic suicide for a national manufacturer to sponsor a video drama showing the black minority in a flattering or martyred light.

When black performers or racial themes did gain dramatic exposure, characterization was anticipatable. Ethel Waters appeared on TV as early as August 1947. On the *Borden Theater* production of "Ethel's Cabin," she portrayed a middle-aged black woman saddled with a lazy husband and a dilapidated cabin—yet with still enough soul to sing the blues. One reviewer understood the implications of the telecast. While he praised the vocal talents of Waters, he noted that "presenting the lazy Negro, supported by his wife, is objectionable as fostering color discrimination."[12]

Waters' dramatic roles were typecast. As well as playing the lead for almost two years in the *Beulah* series, she appeared from time to time during the 1950s on such vehicles as *General Electric Theater, Playwrights '56, Climax,* and *Favorite Playhouse.* In all instances, she was portrayed as a faithful mammy servant, beloved darkie, or suffering mother.

The struggling boxer was a familiar role for black actors. During this first decade of TV production, Canada Lee, Frederick O'Neal, and Harry Belafonte appeared in teleplays as boxers. Another acceptable role for black actors was that of a Latin-American. Frank Silvera, for example, played a Latin-American musician on the *Studio One* production of "Guitar" on August 26, 1957. Although born in Puerto Rico and raised in the Spanish language, Juano Hernandez spoke flawless English. Nonetheless, his most substantial TV parts were as a Latin-American professor and doctor on two *Studio One* productions.

Even when stereotyped, seldom were African-American performers given parts like Frank Silvera's role as a wrongly convicted, pitiful prisoner and Georgia Burke's role as his enduring wife, in "The Julian Houseman Story" on *The Big Story* on November 25, 1949. It was an unfamiliar television scene for a black actor when, after the court reversed its conviction of Silvera's character, he spoke into the camera:

You see, I learned somepin. That—ef you believe somepin, don't put you head down. Don't say, "Nah, that can't be." Put you face up and fight what you believe. Ef you do that, people care, cause they see you cares.[13]

There were, of course, other significant exceptions to the pattern of exclusion found in television drama. An episode of *Death Valley Days* in June 1953, "Land of the Free," concerned two black prospectors in the old West. Although it was only a single episode in a lengthy syndicated series that totalled 532 episodes, it represented one of the few instances in which blacks were shown to have been a part of the frontier legacy.

Other appearances by blacks were notable. Eartha Kitt performed on the *Ed Sullivan Show* at least six times in 1955. She ended the year with a highly praised dramatic performance in "Salome" on the prestigious *Omnibus* program on December 18. Similarly, Harry Belafonte, dubbed as "America's foremost balladeer," made five guest appearances in 1955 on the *Colgate Comedy Hour*. He sang on the *Ed Sullivan Show*. He starred in a CBS musical special, *Three for Tonight*, on June 22, 1955. Belafonte ended the year in a dramatic role, co-starring with Ethel Waters in "Winner by Decision" on the *General Electric Theater* on November 6.

James Edwards, best known for his portrayal of the black soldier in Stanley Kramer's controversial film, *Home of the Brave*, appeared in two dramatic productions in 1955. In "D.P." on the *General Electric Theater* in January, he portrayed an American soldier stationed in Germany whose bitterness was mellowed when he became the surrogate father of an orphaned black boy. In "Toward Tomorrow," on the *Du Pont Cavalcade Theater* in October, he played the young Ralph Bunch struggling with the idea of whether or not to attend college.

There were other dramatic triumphs. Sidney Poitier played a central character on "The Parole Officer," a presentation on the distinguished *Philco Television Playhouse*. Clarence Muse in 1955–1956 enacted the role of Sam, the piano-playing friend of Rick on Warner Brothers' short-lived series, *Casablanca*. And Duke Ellington lent his narrative voice and musical talent to "A Drum Is a Woman," a jazz fantasy which he composed for the *United States Steel Hour* telecast of May 8, 1957.

Combining the best of drama and music, Leontyne Price made her debut on national television in the title role of Puccini's *Tosca*. Produced on the *NBC Opera Theater* on January 23, 1955, it was an artistic triumph for the young soprano from Laurel, Mississippi. *Variety* praised her performance effusively, announcing that "a new operatic star was born." Unfortunately for opera lovers in the South, several southern affiliates refused to carry the program because Price was black.

Much of the South was also unable to see Leontyne Price in her next several appearances on the *NBC Opera Theater*. She precipitated local preemptions on January 15, 1956, when she sang the role of Pamina in Mozart's *The Magic Flute*. Several southern stations canceled the program on December 8, 1957, when she appeared in the role of Mme. Lidoine in Poulenc's *Dialogues of the Carmelites*. As late as August 10, 1960, racial prejudice caused the cancellation in the South of a Leontyne Price operatic performance. This time eleven of NBC's forty stations below the Mason-Dixon line refused to broadcast Mozart's *Don Giovanni* because Price sang the role of Donna Anna.[14]

As poignant and artistic as were many of these performances, the most profound role given a black actor in early TV was Sidney Poitier's part as Tommy Tyler in the *Philco Television Playhouse* production of "A Man Is Ten Feet Tall." Written by Robert Alan Aurthur, the play was televised on October 2, 1955, as the last effort sponsored by Philco in seven years with this dramatic showcase. Knowing that that was to be the last program for the sponsor, both Philco and Aurthur decided to be forthright in this final product.

Poitier played a railroad worker who befriended a white deserter from the Army. A sensitive and humane character, Tommy Tyler invited his white friend to share Christmas dinner with him and his wife. The play ended, however, with Tyler dying—stabbed in the back when he intervened in a fight between his friend and another white man.

The drama possessed an interracial theme, a sense of Christian suffering, and a remarkable probing of human emotionality. It was definitely not the type of show with which black talent was usually associated. Years later, Aurthur recalled the reaction to his drama. "Following the show I received more than 1,100 letters, cards, telegrams," he stated. Further, according to Aurthur:

We won seven awards. . . . Two Southern newspapers printed editorials calling me a Communist, and several others condemned the network for airing the show. Six Philco distributors threatened to cancel franchises, and we received a rolled-up petition from Jackson, Miss., with more than six thousand signatures of people who swore they'd never watch the *Playhouse* again. Too late.[15]

More familiar to viewers in the early years of television was the image of blacks cast in stereotyped parts. These ranged from Ossie Davis in the celebrated *Emperor Jones* on *Kraft Television Theater* on February 23, 1955, to a dramatization of *Uncle Tom's Cabin* on *Omnibus* on April 10, 1955. The most flagrantly stereotyped presentation, however, was *The Green Pastures*, and it appeared three times on network television during the 1950s.

The Green Pastures was an acclaimed all-black play which premiered on Broadway in 1930. Written by a white man, Marc Connelly, it played in New York City and 112 other locales before it was produced in 1936 as a motion picture. The drama was a boon for black actors, since its eighty roles were played by African Americans. But it was an outlandishly stereotyped fantasy about the Old Testament, one which envisioned black Heaven as "one big fish fry, where Mammy Angels feed custard and fish to little cherubs."[16]

The Pulitzer-Prize-winning play made its debut on television on April 7, 1951, when excerpts were enacted on ABC's *Showtime, U.S.A.* The cast for this production included Avon Long and Ossie Davis. William Marshall played the leading role, that of de Lawd. More elaborate was the ninety-minute version of *The Green Pastures* which was presented on October 23, 1957 on the celebrated *Hallmark Hall of Fame*. Here it was given a full treatment, complete with engaging sets, believable special effects, and strong direction by George Schaefer. The main roles were played by William Warfield, Eddie Anderson, and Frederick O'Neal. And it was successful. It received awards from *Look* magazine and Sylvania television. The ninety-minute version was also repeated for Hallmark on March 23, 1959, by essentially the same cast.

Nevertheless, *The Green Pastures* owed as much to minstrel shows as it did to Biblical inspiration. Its character development

and impressive realization could not but be diminished by its overpoweringly prejudicial script. Many of the cliches created in nineteenth-century ministrelsy were prominent. The term "boy" was used frequently to refer to adult men, there were crap games, drinking and carousing, pidgin English, knife fights, emasculating women, and a generalized atmosphere of "fightin', gamblin', and loafin'." Emerging from this facile picture of black religious fundamentalism was an imposing image of God, de Lawd, whose overbearing preeminence rendered all other characters simple children. For the racially prejudiced, this was a safe portrait of American blacks. All the characters were essentially Sambos—uncomplicated children whose mischief would be handled by the inexorable acting out of the Old Testament story. Even the black God was unthreatening. His bad grammar and dialect immediately compromised his superiority. This was no character affected by contemporary considerations of civil rights and social freedom. Here was another Uncle Tom, the "good old darky" image drawn directly from the entertainment stage of the previous century. The fact that the program was repeated and found such widespread approval suggests, moreover, that unlike the dramas of Reginald Rose, Robert Alan Aurthur, and Rod Serling, *The Green Pastures* more accurately reflected popular racial perceptions.

By the close of TV's first decade, the original promise of unbiased treatment for African Americans remained unfulfilled. Certainly, there were black faces on the video screen. But they continued to appear in familiar or stereotyped situations: as dancers, vocalists, and comedians on variety shows; as supporting characters in a few dramas; as occasional contestants on audience participation and quiz shows; and as impersonal competitors in some sports. Equally striking were the TV niches into which no blacks fit. In early television there were no black newscasters or correspondents, no black Western stars, no black staff announcers, no black detectives or undercover agents. Likewise, African Americans were minimally represented, if at all, in TV producing, directing, and writing, as well as in network and station management, and in related work with sponsors or advertising agencies.

As television emerged and adapted to the values and tastes of its audience, there developed certain perimeters clearly mark-

ing the borders of black expression in the medium. These were not necessarily dictates from any network official or television producer. They emanated, usually, from the process of adaptation TV experienced as it found its place within the American culture. On the one hand, it was quickly established that racial resentment and frustration—especially as enunciated by militant black spokesmen—were unacceptable on network and local television. On the other hand, TV showed itself chronically inhospitable to sponsored national programming hosted by black entertainers.

Hostility toward African-American militancy and nonsupport for black-hosted network series at first seem unrelated postures. But their implications and relationship were clearly demonstrated in two events during TV's first decade—the banning of Paul Robeson from network and local television, and the cancellation by NBC of the *Nat King Cole Show*.

5

The Perimeters of Black Expression: The Cases of Paul Robeson and Nat King Cole

The Case of Paul Robeson

Paul Robeson was a singular American. He was a brilliant student, graduating with honors from Rutgers University, and then earning a law degree at Columbia University. An outstanding athlete, he was named an All-American football player in 1917 and 1918. He was also a premier operatic bass, and a sensitive interpreter of folk music. He is well remembered as an impressive stage and screen actor. Yet, Robeson jeopardized his professional success by insisting that his first social priority was to speak for black Americans—that no matter what praise he received from the world of culture, he was still a part of an abused minority whose plight was dismal and whose champions were few.

Robeson used his international fame as a platform from which to denounce the hypocrisy of a society founded on personal liberty, yet tolerant of segregation, inequitable Jim Crow laws, and lynchings. In stressing his point, Robeson publicly announced his approval of the Soviet Union as the highest arrangement of social equality in the world.

Although Robeson was not a member of the Communist party, his passion for the betterment of African Americans frequently led him parallel to Communist ideology. Throughout the 1930s, he was a familiar spokesman for the Soviet formula: a blend of socialism, pacifism, and egalitarian rhetoric.

While he was tolerated in the Depression years, during

World War II—a time when the United States was a military ally of the Soviet Union—Robeson became a political asset. He often appeared on radio as a spokesman for the Allied cause. On several occasions his voice was beamed around the world via shortwave. In his speeches and concerts, and by his physical presence, Robeson suggested that the lot of the black American was improving. In the fervor of the war against a racist Fascist enemy, his crusade against American bigotry seemed also to be reaching fruition.

The postwar world, however, was different for Robeson. Personally, he found in the newly established Progressive party a legitimate political organization through which to channel his reformist energies. As did millions of citizens, he rallied behind the Progressive candidate in the presidential elections of 1948, former Vice-President Henry Wallace. Robeson seemed genuinely inspired when, in a campaign speech in Washington, D.C., he told an audience, "We have taken the offensive against fascism! We will take the power from their hands and through our representatives we will direct the future destiny of our nation."[1]

The least of Robeson's postwar defeats was the dismal showing made by Wallace in the November elections. In a society now locked in a cold war with the Russian rival, Robeson's progressive politics were labeled "communistic" and "treasonable." He consistently suffered because of his outspoken political views. Speeches were abruptly canceled, concerts were called off, biographies of Robeson were banned from public libraries, and rioting often occured during his appearances.

His pro-Russian views put Robeson in an untenable position. When Congress held hearings on legislation outlawing the Communist party, Robeson was asked to testify on the issue. When he proclaimed that it was "unthinkable" that American blacks would "go to war on behalf of those who have oppressed us for generations" and against the USSR, "a country which in one generation has raised our people to full human dignity of mankind," he was denounced by social leaders, black and white.

Robeson's alienation from American society reached its peak in 1950 when, in the midst of an anti-Communist hysteria aggravated by the outbreak of hostilities in Korea, the State Department revoked his passport. Until the Supreme Court ruled this action unconstitutional, Robeson was unable to perform at

home or to travel abroad. This "imprisonment" lasted for eight years.

It was in this atmosphere that he was invited in 1950 to appear in New York City on *Today with Mrs. Roosevelt*, a Sunday afternoon discussion program on NBC hosted by Eleanor Roosevelt. Robeson was asked to represent the Progressive party in a discussion of "The Position of the Negro in American Political Life." The public affairs show was scheduled for March 19. Joining him and Roosevelt were to be Rep. Adam Clayton Powell, a liberal Democrat, and Perry Howard, a black Republican committeeman from Mississippi. The program never took place.

Instead of discussing black politics, Robeson became the first person officially banned from American television. Less than twenty-four hours after his appearance was announced, it was canceled. The decision was made by NBC, although neither Mrs. Roosevelt nor Elliott Roosevelt and Martin Jones, coproducers of the program, seemed to resent the network directive. The NBC decision was bluntly pronounced by a vice-president.

> We are all agreed that Mr. Robeson's appearance would lead only to misunderstanding and confusion, and no good purpose would be served in having him speak on the issue of the Negro in politics. The announcement that Mr. Robeson would be a participant was premature and I cannot understand why it was made.[2]

The banning of Robeson from *Today with Mrs. Roosevelt* was a reaction to an unprecedented barrage of public criticism which followed the March 12 announcement of his appearance. Most strident in its criticism of Robeson was the Hearst newspaper, the *New York Journal-American*. In the midst of the cold war, his newspaper specialized in sensationalism and innuendo. In glaring headlines and flamboyant stories, it "exposed" Communists in the government, Russian aggression around the world, and threats of an H-bomb and a biochemical World War III.

In its March 13 editions, the *Journal-American* placed on the front page the story of Robeson's scheduled appearance. Next to it was a story supportive of Senator Joseph McCarthy, who had just named two State Department aides "pro-Communist." In the Robeson report, the black celebrity was described as "pro-

Communist," "Moscow-admired," and "long a champion of things Russian." The paper quoted a black former Communist who had told congressional investigators that Robeson was secretly a member of the party with ambitions of becoming "the Black Stalin of America."

More effective in precipitating the cancellation of Robeson, however, were the hundreds of war veterans who phoned NBC about their displeasure. On September 12 and 13, the network offices in New York City received more than 300 hostile telephone calls. The protest was loosely organized by several veterans' organizations, and it was fueled by the sensational story printed in the *Journal-American*.

Following NBC's capitulation, veterans' leaders were anxious to trumpet their victory. And the *Journal-American* gave them news space in which to boast.[3] The state commander of the New York American Legion alleged that Robeson's appearance "would have incited hatred and bigotry." He contended that the presence of Robeson "on any NBC program would have been an outrage to every decent American." The New York State commander of the Catholic War Veterans agreed. He declared that his organization "believes that the time has come for broadcasting systems to become conscious of their great responsibility to American citizens."

Other officials were also happy to state their case. Another leader of the Catholic War Veterans was pleased with NBC's decisiveness. "We commend NBC's prompt action in cancelling the appearance of Robeson," he declared. He clearly hoped that this action was precedent-setting. "We want programs," the official asserted, "that will not feature any individual whose affiliations are in conflict with American ideology."

The war veterans, however, were not alone in attacking Robeson. Rabbi Benjamin Schultz of the Joint Committee Against Communism wondered why "anyone would select Robeson, an avowed champion of Russia, to speak for any section of American Negroes!" And H. V. Kaltenborn, the venerable NBC commentator who once had championed the cause of the Scottsboro boys and had spoken for the Loyalist, anti-Franco side in the Spanish Civil War, now blasted Robeson. Contending that Communists "are not intellectually honest," and that "deceit and falsehood are part of their stock in trade," Kaltenborn concluded:

The issue of free speech for Communists would arise far less frequently and would be much easier to handle if we outlawed the Communist Party. It is an association of subversive agents of a foreign government. It is not a political party. There is no reason to grant freedom of speech to any member of a group which proposes to use it to destroy it.[4]

Robeson had few supporters. Except for the Baltimore *Afro-American* which headlined "Air Not Free at NBC,"[5] the black press remained strangely silent. A few union members, mainly the Harlem Trade Union Council, picketed the NBC offices. The American Civil Liberties Union also backed Robeson's position. It formally protested the network action as "censorship by private pressure."[6]

For her part, Eleanor Roosevelt was unrepentant. After first denying that she personally had asked Robeson to participate (the invitation was made to the Progressive party, and the party selected Robeson, its vice-president), Roosevelt told a delegation of angry Young Progressives that she would never share a program with Robeson "because it would give the impression that she endorsed his left-wing political views, with which she sharply differs."[7]

Robeson, however, was not silent. He used the occasion to attack NBC. "It is not surprising to me," he asserted, "that a huge network which practically excludes colored persons from its large army of professional personnel should balk at a discussion of the colored group in American politics which professes to present all points of view."

According to Robeson, NBC "evidently does not want colored Americans reminded too forcibly of the fact which becomes increasingly evident . . . that is, that there is no real hope for my people—American working men of the majority of the population—in the two old parties which are wedded to a program of cold war abroad and privation and suppression of popular dissent at home.[8]

The decision to ban Robeson from American television had political and racial dimensions. Politically, it was simply too controversial for a commercial network to air the views of an admitted leftist at a time when cold war tensions were nationally unsettling. Further, a young network was not going to incur the wrath

of government and the public at a time when its investment in the nascent industry was substantial and TV was still not entrenched as a mass medium. When Robeson was rebuked by people as diverse as Jackie Robinson and members of Congress, questions about free speech were academic to NBC.

Without being enunciated, there was a racial component to the Robeson affair. He was an outspoken political activist. A powerful man with deep convictions, he was not content with personal success gained while other African Americans remained deprived. And Robeson was unrelenting. The day before his NBC appearance was announced, he was quoted as saying that "Russia's program of raising the little people of all races to basic equality in their nation and in the world is the opposite of what our country and England and the Fascists stand for."[9]

Because of his international and national prestige, Robeson was a political force. Because he was a black man, this force was inherently racial. Unlike other black spokesmen, Robeson was neither an academic like W. E. B. DuBois, nor narrowly focused like A. Philip Randolph—neither a reactive voice like those in the National Association for the Advancement of Colored People, nor tied to an unjust national system like those in Congress. From his cultural position, he brought humanistic criticism to bear upon the American conscience. In his rhetoric, moreover, he linked the African-American cause with decolonization in Africa and Asia and with the condition of oppressed people around the world.

Except for rare appearances by men like Ralph Bunche of the United Nations and Walter White of the NAACP, black political leaders were practically absent from early TV. It was unrealistic to expect network television to accommodate a racial threat such as Robeson. Magnified by his international reputation, whatever he had said about the condition of black Americans in 1950 would have had impact throughout the world. In censoring Robeson, network and program personnel were declaring that criticism of American racism was not permissible if that criticism was profound, uncompromising, and internationally provocative. The line of demarcation was clearly drawn: television would not tolerate militant African-American reformers.

That perimeter endured throughout the 1950s. Eight years after the incident with NBC, Robeson encountered the same sit-

uation when he was slated to appear on a local public affairs television program in Chicago. When in late March 1958, it was announced that Robeson would be a guest on *V.I.P.*—hosted on WBKB, the ABC station, by Norman Ross—popular reaction precipitated postponement and then cancellation of the appearance. Instead of a half-hour interview with Robeson, Chicago viewers saw a travelogue about India. Robeson was not only banned from *V.I.P.*, he was never permitted to appear on American television to discuss his ideas.

The Case of Nat King Cole

At first glance Nat King Cole appears to have been the diametric opposite of Paul Robeson. Nonpolitical and noncontroversial, Cole was a jazz pianist and vocalist whose mellow King Cole Trio enjoyed wide acceptance throughout the 1940s. In the following decade, when he disbanded his Trio and pursued a career as a singer of popular ballads, Cole continued to receive approval from black and white listeners.

If any black performer seemed destined for his own network TV series, it was Cole. He had already hosted an NBC radio series, *King Cole Trio Time*, which in 1946 had been sponsored nationally by Wildroot hair tonic. At a time when most African-American singers imitated the group harmonies of gospel ensembles, trios like the Ink Spots, or the rhythm and blues sound whose roots lay in less sophisticated folk music forms, Cole was a well-trained, disciplined vocal artist. Only Billy Daniels and Billy Eckstine rivaled him in vocal polish, and neither had the number of hit recordings produced by Cole.

Between 1944 and 1957, Cole had forty-five recordings which were listed in the competitive charts maintained by *Billboard* magazine. Several of these songs—"For Sentimental Reasons," "Nature Boy," "Mona Lisa," and "Too Young"—reached the number one position, and thirteen were listed in the top ten. In the period 1940–1955, Cole records were on the *Billboard* charts for a total of 274 weeks. This made him the ninth most popular recording personality in that fifteen-year period—ahead of such celebrities as Frank Sinatra, Doris Day, Tommy Dorsey, and Dinah Shore.

Cole did well in early television. He appeared on network TV

as early as June 1, 1948 when he was the principal guest on the CBS human interest series, *We, the People,* when it debuted as the first regularly-scheduled program aired simultaneously on radio and television. Throughout the first half of the 1950s he performed as a visitor on most top-rated variety programs. Whenever he appeared with such personalities as Ed Sullivan, Jackie Gleason, Red Skelton, or Perry Como, Cole's style always elicited strong audience approval. In mid-1954 when he signed with CBS to make ten guest appearances, it was rumored that this was in preparation for his own forthcoming show.

Compared to Robeson and his social militancy, Cole was assimilated, unthreatening, and popularly accepted. While he was not the first black host of his own network series, as the top African American recording artist of his generation Cole had the best chance of success. The premier of the *Nat King Cole Show* on NBC on November 5, 1956 seemed to open a new era for black performers.

The program was a weekly quarter-hour feature which on Mondays led into the evening news with Chet Huntley and David Brinkley at 7:45 P.M. (EST). It was a spirited program with a pleasant mixture of upbeat tunes and slower ballads. Cole was backed by reputable orchestras—Gordon Jenkins when the show emanated from New York City, and Nelson Riddle when in Hollywood. An occasional guest, such as Count Basie, also enhanced the offering.

Cole was aware of the significance of his program. He referred to himself as "the Jackie Robinson of television." In 1956, he defined his undertaking as a struggle against racism.

> I have a fight right now in my own business in TV. I realize what TV is doing. I know they are freezing the Negro out. I know that no Negro has a TV show. I'm breaking that down. I'm fighting on the inside, without publicity.[10]

That conviction stayed with Cole throughout his television career. In September 1957, he told *TV Guide* that his program was "a step in the right direction" toward allaying network fears about black shows being televised to prejudiced viewers.[11]

Unfortunately, the seeds of destruction were within the *Nat King Cole Show* from the beginning. First, the program was

never popular. Opposite it on CBS was *Robin Hood,* one of the top-rated shows on TV, which attracted over half the audience at 7:30 P.M. As Figure 5.1 attests, during the few times the *Nat King Cole Show* was rated by Nielsen, it failed to demonstrate a sizable following.

Coupled with poor ratings, the *Nat King Cole Show* suffered from lack of a consistent national sponsor. Occasionally the quarter-hour show was bankrolled by Arrid deodorant and/or Rise shaving cream. More often than not, the program was sustained by NBC. Cole seemed painfully aware of his tenuous predicament. The words with which he ended the program of February 11, 1957 were less than confident. With his theme song playing in the background, Cole told his viewers:

> Well, I guess folks, that's about it for tonight. We expect to be around this same time next week—same station—same show, we hope. Until then, see you later.

Figure 5.1: A Comparison of the *Nat King Cole Show* and *Robin Hood* Ratings

Date of Rating	Percent of Potential Audience	Percent of Sets in Use	Relative Ranking
Jan. 7, 1957			
NKC Show	12.7	19.7	110
Robin Hood	31.6	51.1	23
Jan. 21, 1957			
NKC Show	11.3	18.1	116
Robin Hood	31.6	50.3	23
Feb. 4, 1957			
NKC Show	13.0	20.9	106
Robin Hood	30.6	48.6	24
Feb. 18, 1957			
NKC Show	11.5	18.0	107
Robin Hood	30.9	50.0	22
Mar. 4, 1957			
NKC Show	10.5	16.3	112
Robin Hood	31.0	48.9	24
Mar. 18, 1957			
NKC Show	9.7	15.4	115
Robin Hood	31.4	51.3	21

Despite poor ratings and a sporadic pattern of sponsorship, NBC expanded the *Nat King Cole Show* to thirty minutes, raised its operating budget, and as a summer experiment placed the program in prime time competition. The revamped show premiered on Tuesday, July 2, at 10 P.M. (EST). Opposite it was a formidable CBS rival, *The $64,000 Question*—the fourth-ranking program during the 1956–57 season.

Cole and his friends seemed determined to save the series by showing its potential to attract viewers. More important, the show became a battlefield in the civil rights movement. To rescue the most dignified black program in TV history, some of the biggest talents in show business volunteered to appear on the *Nat King Cole Show* for the union-approved minimum wage. Men and women whose energies commanded TV salaries in five figures now appeared with Cole for a few hundred dollars. Among them were Ella Fitzgerald, Tony Martin, Julius LaRosa, Peggy Lee, the King Sisters, Sammy Davis, Jr., Pearl Bailey, Robert Mitchum, Frankie Laine, and Mel Torme.

With a new time and an extended format, ratings of the *Nat King Cole Show* improved. When Harry Belafonte was a guest on the program of August 6, the show came within three Trendex rating points of its CBS rival. Cole later noted that his summer program was the top-rated show in New York City, and that it was eighth in the Los Angeles area.[12]

The insurmountable problem for Cole, however, was his failure to attract a national sponsor. Despite improved popularity, with no advertiser willing to buy the series, NBC was compelled to sell the time slot to the Singer Sewing Machine Company for *The Californians*, an adult western which premiered in the fall.

In defense of NBC, the network tried to salvage the program. It had sustained the series throughout the summer, and beginning September 17, it carried the half-hour *Nat King Cole Show* on Tuesday evenings at 7:30 P.M. (EST). Now the show was offered as a cooperatively sponsored feature. By this arrangement a local business, or a national advertiser wanting only single-market exposure, could purchase the show in a given city. Thus, Regal beer sponsored the program in New Orleans; Coca-Cola paid for it in Houston; in San Francisco its underwriter was Italian Swiss Colony wine; Rheingold beer handled it in Hartford and New York City; and in Los Angeles it had two sponsors,

Gallo wine and Colgate toothpaste. Still, the program attracted only thirty sponsors nationwide.

As far as the network was concerned, the cooperative arrangement was not as profitable as having a single national sponsor. During the summer NBC had sustained the series in seventy-six cities. With a low number of co-op advertisers in the fall, the network demanded that the show be rescheduled in January to a less expensive time slot—Saturdays at 7:00 P.M. This move, however, was unacceptable to Cole. Given the day and time (6:00 P.M. in the midwest and 5:00 P.M. in some areas), a time when "most people are eating or shopping," Cole accepted the cancellation of his series. The last telecast of the *Nat King Cole Show* was on December 17, 1957.

The *Nat King Cole Show* was not a failure. For fifty-nine consecutive weeks it appeared on NBC. During that span, the network acted responsibly toward Cole. Unlike Robeson's assessment of the network, Cole praised NBC for maintaining "democratic and wise public relations"[13] in backing his efforts. According to Cole, his cancellation by NBC was a function of TV reality: "They wanted me on the network; they wanted to keep me. But they had to shift me around because I didn't have a network sponsor and shows with single, network sponsors get preferential treatment.[14]

Cole, however, did name a culprit in his television demise. The focus of his animosity was the advertising industry which, he claimed, never really tried to sell his program to a national account. For a man with a reputation for reserve and gentility, Cole was vitriolic when he wrote in *Ebony* that "Madison Avenue, the center of the advertising industry, and their big clients didn't want their products associated with Negroes." Cole asserted that he never found a sponsor because "Madison Avenue said I couldn't be sold, that no national advertiser would take a chance on offending Southerners."

Ironically, experience with television led him to a position remarkably similar to that of Robeson, the leftist activist who approved of the classless Soviet Union and its Marxian social and economic arrangement. "It's not the people in the South who create racial problems," Cole argued, "it's the people who govern the South." According to the singer, most southerners "are fine people. But those who govern isolate the people by advocat-

ing a rigid policy of discrimination; whether the people want it or not, they are not allowed to participate in mixed audiences because of their laws."[15]

As Cole saw it, bigotry was purposely nurtured by an influential minority, "those who govern and those who incite others through organizations such as the White Citizens Council."[16] Significantly, he dismissed most white southern bigots as small-minded people who worried about lesser matters such as "the mixing of the races."[17] But he attacked "the big men" who exploited the situation.

In Cole's quasi-Marxian analysis, "the big men" were those "who control Wall Street, the men who run Madison Avenue." And they, in Cole's view, "are worried about economics." In a statement worthy of Robeson, Cole wrote that "racial prejudice is more finance than romance."

Bitter, disappointed, and frustrated by his experience, Cole refused to blame his cancellation on southern prejudice, for as he noted, "After all, Madison Avenue is in the North." In absolving the South, he alleged that "I think sometimes the South is used as a football to take some of the stain off us in the North.[18]

In a conclusion with which Robeson would have concurred, he called upon all blacks to organize and assert their financial strength to offset "the big men." According to him, "We need to show the strength of the Negro market." He continued:

> Negroes above all, must become financially independent. All things, as intelligent Negroes know, boil down to money. We must, before it is too late, solidify our positions. We must support organizations like the Urban League and the NAACP. . . . They are all working for racial betterment. Negroes, too, must invest more, not only in entertainment enterprises, but in all businesses. We should put our money to work because money is what the people working against us respect.[19]

Emerging through the frustration in Cole's argument was an insightful description of the reluctance of the advertising industry to sell his series. Madison Avenue did not think the show would survive. Even with a new format and improved summer ratings, agency interest in selling the program to an advertiser was not kindled. At the base of this lack of enthusiasm was the

sensitivity of Madison Avenue to the so-called Southern Market. Ironically, five months before the *Nat King Cole Show* premiered, *Variety* reported that pressure from advertisers with southern markets was "setting back by many years the advancement made in television toward providing equal job opportunities regardless of race, creed, or color." With the civil rights movement swelling in the South, national advertisers and their agencies feared offending white consumers who were resisting the movement toward integration. Their answer was to keep blacks off national television as much as possible. "At one major agency," *Variety* noted, "the word has gone out: "No Negro performers allowed.' "[20]

Aften ten years of popularly accepted television, it was legitimate to wonder where by the late 1950s black Americans had gone. In a nation where more than 10 percent of the population was African American, TV was nowhere near 10 percent black. Several citizens openly expressed their bewilderment at this situation. Natalie Fuller Shean, a woman from New York City who described herself as "nobody, just a housewife," wondered in 1956 if there existed in television "a conscious ban against the use of Negro actors. . . . I see very few on TV, and I often see none at all being intelligently used on shows in situations where they logically belong."[21] Several months later Thurgood Marshall, then the special counsel for the NAACP, protested conditions in a letter to *Variety*. He wrote about "the spotty use of Negro actors and actresses on the legitimate stage as well as in television and films save in 'token' jobs or in stereotyped roles."[22] As late as 1959, a reader of *TV Guide* questioned in that journal: "Why can't some of the detective and comedy series work Negroes into their scripts, making them an ordinary part of television life as they are an ordinary part of everyday life?"[23]

The prejudice-free enterprise that *Ebony* magazine foresaw for TV in 1950 was nonexistent by 1957. Fewer and fewer blacks were finding significant employment in the television industry. The collapse of the *Nat King Cole Show* served only to reaffirm what many felt to be true: television was no place for African-American talents to seek success. Nonetheless, in the next stage of the history of blacks in TV substantial changes would be effected. Not because of any great liberal change of heart at the networks, but as an outgrowth of the dynamics of the civil rights

movement, the posture of blacks in television would be substantially realigned and improved. In the late 1950s and throughout the next decade all social life in the United States would be touched by TV and its depiction of the black minority. In many ways, too, a growing fairness in that video image became a barometer of the nation's progress toward realizing its professed democratic ideals.

PART TWO

BLACKS IN TV IN THE AGE OF THE CIVIL RIGHTS MOVEMENT, 1957–1970

The promise of a color-blind future in television was made prematurely. In its earliest years when TV seemed to promise artistic and social equality for blacks, the medium was neither widely available nor overwhelmingly lucrative. As television became nationally distributed and enormously profitable, however, the hopes and expectations of earlier years were virtually forgotten.

After its first two years of full-scale operation, television was still a fledgling industry. In December 1949, for example, there were only ninety-seven TV stations operating in fifty-eight market areas throughout the nation. Although New York City and Los Angeles each had seven outlets, only a few cities had more than one station. Nationally, moreover, there were only 3,415,474 TV sets in operation. Sixteen states had no television outlets transmitting from within their borders.

Television was still in infancy at the end of 1949. Most TV was produced and seen in the midwest-northeast axis. Importantly, in the southern section of the United States—the region in which antiblack prejudice was considered by programmers and advertisers as inimical to minority participation in TV—television was barely a reality. There were only thirteen southern market areas with TV by December 1949. While that represented 22.4 percent of all cities having television, only 4.5 percent of TV sets were in the South. As the industry entered the 1950s, the South was retarded as a consumer of television. And given the freeze on licensing new stations by the Federal Com-

73

munications Commission, not until 1953 was the South able to redress this imbalance. Until that date, there were no operative TV transmitters in Mississippi, Arkansas, or South Carolina.

It is also noteworthy that while southern stations carried network affiliations and network programming, in many instances stations such as WDSU-TV in New Orleans and WMCT in Memphis chose their evening programming from the offerings of all four national networks. This made it easier to preempt "controversial" programs coming from New York City or Hollywood. Local social standards could be respected by selecting carefully from network shows, being careful to present quality entertainment while rejecting programs with threatening messages and disruptive images.

The American South, moreover, was not tied directly into network TV until coaxial cable and relay stations were fully installed in the mid-1950s. Only then could most stations in this region receive shows directly from New York, Chicago, or Los Angeles. Until that time, much southern TV was a blend of network and syndicated films, kinescopes, and local productions.

From its earliest years, moreover, TV was national and under the control of ABC, CBS, and NBC. The DuMont network was a lackluster presence, and most independent stations were economically strapped and relegated to rerunning vintage network series. The production companies making television shows increasingly churned out new programs for network exposure. For the first decade of TV, most viewing was done on VHF channels: those outlets from channel 2 through 13. But because some VHF channels were reserved for other transmission purposes (FM radio, marine and aviation communications, civil defense operations), and because interference from stations broadcasting in nearby localities made some channels unusable, most viewers had access to five stations or less. Only Los Angeles and New York City had the maximum seven possible VHF outlets.

When the Federal Communications Commission in the early 1950s finally opened UHF channels 14 through 84 for operation, growth of this alternative spectrum was slow and ineffective in challenging the network monopoly. Although ABC, CBS, and NBC were legally permitted to own and operate UHF channels, they quickly abandoned the desire to invest in the new frequency.

Rivaling each other for supremacy, the three networks programmed to the largest possible audiences. Advertisers, too,

Figure P2.1: Total Revenue of Television Networks and Stations

1947 $ 1.9 million	1954 $593 million
1948 $ 8.7 million	1955 $744.7 million
1949 $ 34.3 million	1956 $896.9 million
1950 $105.9 million	1957 $943.2 million
1951 $235.7 million	1958 $1.03 billion
1952 $324.2 million	1959 $1.163 billion
1953 $432.7 million	1960 $1.2686 billion

wanted as many viewers as possible. In this broadcasting atmosphere, minority concerns—be they fine arts concerts, foreign language programs, educational forums, or positive black representations—received slight attention. If the ratings system proved that the mass audience preferred *Amos 'n' Andy* to Leontyne Price, or bumbling Willie Best to the accomplished Nat King Cole, then distorted stereotypes would endure at the expense of realistic depiction. That way the majority would be entertained and the profits would flow, programming would be homogenized, and narrower interests would be ignored.

TV's projection of a hopeful future for blacks emerged in these years of regional imbalance. In practical terms the promise was made before industry leaders understood the implications of a national video system having to be sensitive to local and regional predilections. And simultaneously with the geographic growth of television, it became enormously successful as a profit center for advertising.

As TV became increasingly available, it grew financially at an unprecedented rate. Figure P2.1 illustrates the rise of the industry from obscurity to a billion-dollar operation in little more than a decade.[1]

By the end of the 1950s, with television revenues headed toward $2 billion, idealistic promises of an earlier time were lost in the whirl of success. As well as a national medium, TV was now big business. In light of disastrous financial repercussions that might follow the realization of old expectations, past pledges had to be reconsidered. An executive with WHEN in Syracuse summarized in 1953 the new mentality and motor force of the video industry. According to Paul Adanti, "TV must not be sold as a promotion medium but as what it actually is—an advertising and sales medium with the lowest cost-per-thousand and the most effective results."[2]

6

The Southern Factor

It would be incorrect to argue only that when the South with its overt antiblack social patterns was integrated into the national television audience, the hopes of those seeking an equitable future for African Americans in the medium were crushed. If the South were solely responsible, one could have expected racial equity in television before the mid-1950s. Such, however, was not the case.

Nonetheless, network executives, station owners, advertising agencies, and sponsors were sensitive to the programming with which they became associated. As was the case in the heyday of network radio, no one concerned with television broadcasting wanted to offend large segments of the audience by being linked with politically volatile causes. And because of the politics of the time, achieving social justice for minorities—which a few years earlier had been a legitimate liberal political goal—was a controversial, even unpatriotic posture by the mid-1950s.

The modern civil rights movement was nurtured in the postwar 1940s. It did not grow into a powerful national concern, however, until the United States Supreme Court decided in May 1954 that the notion of "separate but equal" was inherently wrong. Following that decision the civil rights movement became increasingly visible and confrontational. Beginning with school segregation, agitators soon were demanding an end to all forms of American racism. And as often as Jim Crow laws were challenged by racial reformers, hostile whites organized to defy those demanding change.

Chapter 6

This was especially true in the South. Here, where patterns of racial discrimination were most chronic and most obvious, were found the early points of confrontation. In Montgomery, Alabama, the issue was the right of blacks to sit anywhere they wanted while riding public transportation. In Little Rock, Arkansas, the issue was court-ordered integration of public high schools; in New Orleans, Louisiana, it was segregated public facilities. In Nashville, Tennessee, it was the right of blacks to be served in restaurants.

In this atmosphere of racial explosiveness, it was threatening for a national network or advertiser to be associated with black performers, or with any program appearing to take sides. Oddly enough, one of the first national series to face this problem dealt not at all with civil rights issues.

The Gray Ghost was a syndicated series seen throughout the nation in the 1957–1958 TV season. Its sensitive feature was that it was the first fictional series in broadcasting history to focus on a military dimension of the Civil War. Centered on the exploits in Virginia of Confederate Colonel John Singleton Mosby and his band of cavalry raiders, it was essentially a Western set in the early 1860s. In a typical episode, a beautiful young woman, recruited by the Union to spy on the Confederates, was actually a double agent reporting directly to Colonel Mosby. When Union soldiers discovered her perfidy, she was tried and sentenced to death. Only a daring rescue by Mosby's mounted raiders saved the woman's life.

As romantic and formulaic as were the thirty-nine episodes of *The Gray Ghost*, it was a highly controversial series. Produced by CBS Films, it was originally intended as an early evening network series beginning in the fall of 1957. The reluctance of national advertisers to associate themselves with anything that might antagonize sectional tension, however, compelled CBS to abandon the series as a network project, and offer it for syndication on a market-by-market basis. Although it was syndicated successfully, CBS Films canceled the series after one season.

There is no doubt that *The Gray Ghost* was a casualty of the segregation issue. Although it never dealt with the slavery problem in the Civil War, the premier of the series in September 1957 coincided with the inflammatory confrontation at Central High School in Little Rock. Even local sponsors were fearful that

78

mounting civil rights tensions might precipitate a misunderstanding of their sponsorship of a series in which the white southern heroes seldom lost. Just as advertisers shunned association with black causes, they also avoided open affiliation with white southern intransigence.

The discontinuance of the series stemmed more from advertiser anxieties than from viewer complaints. Anticipating a new season of racial conflict over school integration, local sponsors throughout the nation advised against renewal of *The Gray Ghost* for the fall of 1958.

Viewers were less apprehensive. *Variety* reported in late 1958 that in the North the program had been accepted "without much excitement, even though the series leaves the implication that Federal troops never won a battle." Southern newspapers were dismayed at the cancellation. Harry Ashmore's *Little Rock Gazette* editorialized that "we are opposed to censorship as such. . . . It seems unlikely that we have come to pass where sectional shooting could be touched off by a TV show, no matter how stimulating to the old glands and juices." The *Raleigh News and Observer* was dismayed that this meant the end of a program which "proves weekly that one Reb is better than a regiment of Yankees. The old ratio of one to seven is gone. The South never lost except in 1865." And the *Birmingham News* warned that "TV should smarten up. With the coming of the one hundredth anniversary of those stirring times, interest is mounting to a new high."[1]

Despite the popularity in the South of *The Gray Ghost,* there were instances in the late 1950s and 1960s in which local broadcasters and viewers were less charitable, particularly toward network programming featuring African Americans. Motivation in these instances was often mixed. While there were examples of simple racial prejudice, many stations feared "northern" network series would inflame community tensions already near the kindling point. While some outlets were reluctant to offend white viewers by projecting black images not in conformity with dominant local standards, others were fearful that the black consumer market—a market which accounted for 40 to 60 percent of buying in the South—would be upset by programming offensive to blacks. And in local productions, especially in news coverage, station executives also were apprehen-

sive that without an objective policy advertisers with national products might withdraw their sponsorship of local shows.

Such pressures by the late 1950s caused most southern stations to adopt a strict hands-off policy toward the ongoing civil rights issue. Typical of this studied neutrality was a declaration in 1958 from WAVY-TV (Portsmouth, Virginia) which announced that the station and its news personnel "will not editorialize, give an opinion, or predict any future development relative to the integration issue." Further, the station underscored that interviews with local school officials and members of local and state government, "will be handled so that no side or definite stand will appear to result from the questions asked by our newsmen."[2]

Not all elements of southern society followed the example set by local stations like WAVY-TV. Politicians, for example, often used the medium as a means to communicate segregationist positions popular with registered voters. Orval E. Faubus of Arkansas, George C. Wallace of Alabama, and J. Lindsay Almond, Jr. of Virginia were southern governors who appeared frequently on national, statewide, and local television to articulate segregationist positions. Other governmental leaders found TV convenient, particularly in election times, for informing viewers of their positions opposing integration. Typical of these officials was Mills E. Godwin, Jr. in his bid to be elected lieutenant governor of Virginia in 1961. Godwin, who eventually became governor of the state, told his constituents via TV:

> I make no apology to the people of Virginia for my efforts in recent years to maintain segregation in the public schools . . . because I am of the opinion that both races receive a better education in separate schools. Having stated this position is not to suggest that I favor now or have ever favored, the abandonment of public education in Virginia in order to keep our schools segregated. . . . It is my earnest opinion that the period of resistance to integration in our public schools served a most useful purpose in giving us time to prepare and adjust to an unwanted situation when mixed schools were to be forced upon us by the overriding power of the federal government.

Even more impassioned was W. Lee "Pappy" O'Daniel, who purchased statewide TV time in July 1956 to explain to fellow

Texans why he should win the Democratic nomination for governor in a forthcoming primary election. Although O'Daniel was not victorious, he articulated the rage many white southerners felt about local school desegregation that was mandated by the federal courts. According to this political leader, who served as governor of Texas from 1939 to 1941, and was twice elected to the U.S. Senate in the 1940s, "those nine old men" of the U.S. Supreme Court were guilty of consulting Communists instead of Texans before ordering integration. O'Daniel claimed that in opposing "that unlawful, that irreligious, that immoral" edict to integrate, he was leading the battle to save the purity of the races. As he explained it,

> If we would follow that edict, it means that in fifty or seventy-five or a hundred years the pure-blood Negro race and the pure-blood white race would be extinct in Texas, and a new mongrelized race, looking altogether different and acting different, would spring up in Texas. And if that thing happened, our children would get out the old family album, you know, with our pictures on it, and they'd get their pictures and paste them in there, and see the difference, and would curse the day they were born. And they would want to go out and get rotten eggs and throw them at our tombstones for having permitted this edict to go into effect. So, we're not going to pay any attention to it. We're going ahead in Texas and continue to live under segregation just as we always have.

The simultaneous emergence of the civil rights movement and television was fortuitous for those advocating reform in race relations. While radio verbalized matters such as the U.S. Supreme Court decision on school segregation in 1954 and the black boycott of city buses in Montgomery in 1955 and 1956, the mixture of pictures and sound via TV was considerably more impressive. The mental suggestion of radio could never match the dramatic impact possible on television. Images of chanting demonstrators being sprayed by fire hoses and attacked by police dogs, freedom riders being abused, sit-in participants being taunted or beaten, and small black children requiring military escorts to enter public schools—these pictures made TV a powerful propaganda tool for those wanting progressive change.

But there were numerous instances of traditionalists at-

tempting to thwart the revolutionary influence of video. Many southern stations refused to accept syndicated and network movies because they felt such films would upset local social standards. Motion pictures such as *Go, Man, Go*, the story of the Harlem Globetrotters, and *The Jackie Robinson Story*, a biography of the first black man to play major league baseball, were accepted only hesitantly by many stations. The all-black musical, *Cabin in the Sky*—an MGM film made in 1943 starring Lena Horne, Ethel Waters, and Eddie Anderson, and directed by Vincente Minnelli—was rejected in many southern markets in 1957. Fearing a hostile reaction from its thirty southern affiliates, ABC refused for the 1962–1963 season to air *The Defiant Ones*, starring Tony Curtis and Sidney Poitier in the thinly veiled morality tale about the need of cooperation between whites and blacks.

Even before they became available to TV, several movies encountered problems in the South. As reported in *Variety*, Dallas police in 1958 banned Brigitte Bardot's film, *And God Created Woman*, from black theaters. The police explained that the French film was "too exciting for colored folk."[3] One year earlier, the Alabama House of Representatives unanimously resolved to ask Alabama theater operators not to exhibit *Island in the Sun*, featuring Harry Belafonte and Joan Fontaine, because, in the words of one legislator, "the making of such films will be most pleasing to the Communists and other un-American organizations, and to all intents and purposes will amount to another tactic in their campaign to brainwash the American public into acceptance of race mongrelization."[4]

Regional resistance to the images and messages communicated by national television ranged from preemption of controversial programs to organizing for regional autonomy. In the early 1960s, Monitor South was a Louisiana-based group which attempted to coordinate station rejection of provocative network shows. This group wrote southern stations questioning the advisability of showing network documentaries probing the civil rights problems. Where it could not effect preemptions, Monitor South attempted to obtain equal time "to rebut any false political propaganda which serves the Communist racial ideology."[5]

Another example of sectional resistance was found in the incipient rebellion developing in the early 1960s among southern broadcasters within the National Association of Broadcasters.

Feeling that too much network programming was unfriendly to the South, for several years southern stations spoke unsuccessfully of bolting from the national trade association and forming their own regional group. Speaking to a summer meeting in 1961 of the South Carolina Broadcasters Association, Walter J. Brown of WSPA-TV (Spartanburg) called for creation of a regional association to combat network news and programs "which are slated against the South." According to Brown, "our way of life is under attack." He felt that such an association would be able to use collective force to "convince the networks and news services that they should not be overly influenced by these minority blocs which are being pampered as they peddle their vendetta against the South."[6]

There is no doubt that television by the early 1960s was challenging southern traditions. More powerfully than literature, more effectively than radio, television communicated a single, nationally acceptable message with regard to the civil rights issue. No amount of rhetoric or obscurantism could dull the meaning on the evening news, or in special documentary programming, of white bigots abusing black demonstrators. No amount of qualification or compromise could thwart ambitious blacks who saw "the good life" on their favorite TV shows and in the many materialistic commercials shown on the medium. And no distorted television dramas and sitcoms could undermine the validity of the authentic black heroes emerging on the nightly TV news—from Martin Luther King, Jr. leading the year-long boycott of city buses in Montgomery, Alabama to Thurgood Marshall arguing the case for school integration before the U.S. Supreme Court.

There were unintelligent acts of desperation which attempted to blunt the impact of TV. One of the more contrived came from a Georgia state legislator, who in 1959 requested a feasibility study on the prospect of completely educating Georgia high school and college students via television. Predicting that the schoolhouse would soon be a thing of the past, he called for TV education as a means of bypassing the issue of school integration. "God has given us the answer to our problem of how to educate our children in the face of the integration threat," he announced. "You may think I've lost my senses by introducing a resolution of this kind," he told his fellow legislators, "but within ten years' time you'll see I'm right."[7]

But S.I. Hayakawa, the noted semanticist and later U.S. senator from California, was correct in his perceptive essay, "Television and the American Negro," published in 1963. According to Hayakawa, it was already too late for the South to reverse the influence of television. Its message was already registered in black and white minds. In an age of mass production and mass communication, TV was the most powerful medium ever known. And to maintain the southern caste system in the age of TV, segregation would have to be extended to television. According to Hayakawa, "members of different castes must not be permitted to communicate freely with each other, and they must also be separated from each other by receiving their communications from different channels." Since this was not possible, and since national television would continue to communicate a single standard understood by all races, Hayakawa correctly concluded that "a powerful unifying force is at work to bring whites and Negroes together in their tastes and their aspirations, in spite of the best efforts of the White Citizens Councils and the Black Muslims."[8]

7

Blacks and Network TV: The Early 1960s

That network television was inhospitable to substantial black involvement was evident in the collapse of the *Nat King Cole Show* in December 1957. Given the acrimony surrounding the cancellation, and the regional and national sensibilities being antagonized by the emergent civil rights movement, it would not be until the middle of the next decade that significant programming featuring black stars would occur.

With several notable exceptions, African Americans continued in TV as infrequent guest stars on variety shows, or as occasional stars in filmed or live dramas, still cast in traditional roles. Certainly Ed Sullivan continued to bring familiar and newly popular black entertainers to his Sunday evening program. In 1959, for example, his black celebrities included Eartha Kitt, Lionel Hampton, Dorothy Dandridge, Johnny Mathis, Della Reese, and the Platters. Although less numerously, blacks the same year also appeared on the *Steve Allen Show*, among them Sarah Vaughan, Roy Hamilton, Earl "Fatha" Hines, and Sammy Davis, Jr.

American TV in the late 1950s and early 1960s was dominated by Westerns. They came in all shapes and formats with dozens of gimmicks to set them apart. There were ex-Confederates (*The Rebel*) and ex-Yankees (*The Loner*) as heroes, there were gamblers (*Maverick*), newspapermen (*Jefferson Drum*), lawyers (*Black Saddle*), and even a bounty hunter (*Wanted: Dead or Alive*). As well as sheriffs, marshals, and detectives, the Westerns also featured as heroes a mercenary (*Have Gun/Will Travel*), a

85

rancher (*The Rifleman*), a gun salesman (*Colt .45*), a former gun-fighter (*Johnny Ringo*), a woman sharpshooter (*Annie Oakley*), and twin brothers (*Two Faces West*). As for ethnicity, there was a predominance of white champions, but also an Hispanic (*The Cisco Kid*), and an Apache with a Harvard law degree (*Law of the Plainsman*).

In this plethora of frontier heroes, however, no central character was African American. In fact, black actors were virtually absent from the Western genre. Although blacks played a crucial part in the history of the actual West, only rarely did they appear in the television West created in Hollywood. Sammy Davis, Jr. was a featured star in several dramas, including *Zane Grey Theater* in 1959, *Lawman* in 1961, and *The Rifleman* and *Frontier Circus* in 1962. Rex Ingram appeared in one episode of *Black Saddle* in 1959, and Frank Silvera was featured in a single episode of *Johnny Ringo* in 1960. Considering that the genre dominated television for several years, and that in the fall of 1959 there were twenty-eight different Western series aired weekly on network TV, black representation in the Western was minuscule.

Detective series were also popular in TV in the early 1960s. Set as they usually were in modern urban surroundings, one might have expected substantial utilization of African-American actors. While blacks did appear more often in detective dramas than in Westerns, this did not signify a breakthrough for minority talent. Instead, blacks appeared only occasionally as local color characters, or in supporting roles in individual episodes of series such as *Peter Gunn* (James Edwards and Diahann Carroll in 1960), *Naked City* (Diahann Carroll in 1962; Juano Hernandez and Cicely Tyson in 1963), *The Law and Mr. Jones* (Bernie Hamilton in 1961 and Rex Ingram in 1963) and *Cain's 100* (Dorothy Dandridge in 1962). The only detective series to employ blacks in recurring roles was the comedic program *Car 54, Where Are You?*, which between 1961 and 1963 occasionally featured Nipsey Russell and Frederick O'Neal as humorous policemen.

To complement this racial exclusion, the color line remained operative in network television. Whenever black actors did star in dramatic productions, invariably they appeared in roles written specifically for a black actor. Typical of this pattern was the drama, "Good Night, Sweet Blues," an episode of *Route 66* telecast October 6, 1961. The central characters of the series, played

by Martin Milner and George Maharis, weekly traveled U.S. Highway 66 and other alternative thoroughfares, stopping somewhere to play a dramatic part in the lives of people they happened to meet. In "Good Night, Sweet Blues," they encountered a dying blues singer played by Ethel Waters. Her last wish, that before dying she could be reunited with her old jazz band, became their command.

Before the program ended, viewers saw an array of black actors and jazz musicians—from Juano Hernandez and Frederick O'Neal to Coleman Hawkins and Roy Eldridge—portraying members of her "Memphis Naturals" jazz group. Waters' character, now among old friends and singing the blues once more, slowly expired as the program ended.

Many African-American performers voiced their discontent with bias in the entertainment industry. Hilda Simms, star of the hit Broadway play of the 1940s, *Anna Lucasta*, denounced the color line and the so-called Negro plays. Testifying in 1962 before the House Committee on Education and Labor, headed by Harlem congressman Adam Clayton Powell, Jr., Simms declared, "Of course, there are Negro plays. Well, damn Negro plays." She continued, "I am not asking for romantic parts, a blending of blood, but just a chance. . . . I say it's immoral when we see casting notices and know bloody well it's no use applying because there are no Negro parts."

At the same congressional hearing, others protested the prejudices which inhibited their careers. Comedian Dick Gregory quipped that "the only TV show that hires Negroes regularly is Saturday night boxing." Ossie Davis noted that while he was probably the most employed black actor on Broadway—having had thirteen parts in sixteen years—it had been still a touch-and-go existence. Sidney Poitier attacked racism in the movie world. According to the Academy Award winner, "I'm probably the only Negro actor who makes a living in the motion picture industry which employs 13,000 performers. . . . It's no joy to me to be a symbol." And Hilda Simms recalled her anger when, because of her light complexion, more than two hundred letters of complaint were received by NBC after she appeared on a network drama as the wife of an obviously black doctor.[1]

P. Jay Sidney, a black actor with considerable experience in minor parts in radio and TV, was critical also of the absence of

African Americans in television. Speaking of the *Players' Guide* for 1960, Sidney attacked it as inadequate for finding black actors since it listed only a handful of black talent. This *Guide*, so crucial for casting directors and producers seeking performers, listed about fifty African-American men, women and children, while it contained several thousand white actors and actresses. Sidney urged producers and networks to be more imaginative in their search for black talent.[2]

Interestingly, when producers did break the color line and employ African-American actors in nontypical black roles, they frequently received criticism from affronted white viewers. Such was the case in 1963 in an episode of *Perry Mason* in which a black was cast as the judge before whom Mason pleaded. Despite protests from throughout the country, the producer of the series explained that her action was reflective of the judiciary in California, and that was the setting for the series.[3]

Fear of similar reactions, however, prompted General Motors, sponsors in 1964 of the Western series *Bonanza*, to threaten withdrawal from the program should an episode starring black actors William Marshall, Ena Hartman, and Ken Renard be aired. After confrontations with NBC and the NAACP, as well as considerable negative publicity, General Motors reversed its position. The episode, "Enter Thomas Bowers," was telecast on April 26 as scheduled.[4]

There were other instances of major advertisers withdrawing sponsorship from single broadcasts when a series focused on blacks. This was especially true for corporations like Gulf Oil and Metropolitan Life Insurance, which were fearful of becoming associated with programs showing film of the racial struggle. According to *Variety*, "dramatic footage of the actual strife gets people riled up, in the core of their stomach, and such an experience might alienate customers and outlets of national advertisers, especially in the South.[5]

There were few advertisers like Bell and Howell who, at this time, were willing unequivocally to sponsor documentary shows treating the civil rights movement. Their underwriting of ABC's prime-time documentary series *Closeup*, from November 1961 to June 1963, was an uncommon gesture of social responsibility.

But sponsor interference was limited neither to the early 1960s nor to nonfiction television. As late as 1968, Chrysler Mo-

tors Corporation and the advertising agency handling its account, Young & Rubicam, complained openly about a show which they had sponsored for Plymouth automobiles. *Petula* was an NBC special featuring the popular British singer, Petula Clark. Her principal guest star was Harry Belafonte. Chrysler may have approved of Clark's singing skills, but when she held Belafonte's arm during their appearance together, it was considered too intimate for a white woman to be seen on camera in such a pose with a black man. Ironically, *Petula* was aired April 2, 1968—two days before Martin Luther King, Jr. was assassinated in Memphis, Tennessee. Chrysler's complaint was forgotten in the aftermath of King's murder.

One of the few programs to spotlight black talent regularly was *American Bandstand*. Hosted by Dick Clark, this was a teen-oriented afternoon and weekend program designed to show young people the latest dances and rock-and-roll performers in action. The use of black artists not only served to popularize their recordings, it also reminded viewers of the link between rock-and-roll music and African-American culture. In a similar vein, other network rock-and-roll shows—including *Shindig, Hullabaloo, Shivaree*, Alan Freed's short-lived *The Big Beat*, and the Saturday evening feature, the *Dick Clark Show*—consistently highlighted black singers and musicians.

But for every *American Bandstand* there were dozens of programs like *Riverboat*. Between September 1959 and January 1961, this series concerned the adventures encountered by the crew of a riverboat paddling up and down the Mississippi, Missouri, and Ohio rivers in the 1840s. Although the vessel often entered the slave states, the program never mentioned the racial question. Further, Darren McGavin, who starred in the show, complained that despite his protests, *Riverboat* failed to show a single black person in forty consecutive weeks.[6]

Even more striking in their avoidance of African-American characters were the popular comedy shows set in the South in the 1960s. Foremost among them was the immensely popular *Andy Griffith Show*. Sheriff Andy Taylor and the denizens of Mayberry, North Carolina operated in a blanched world where humor, respect, and occasional pathos were brilliantly merged. But there were no racial minorities in town, despite the facts that the civil rights movement preoccupied southern politics and a

quarter of the population of North Carolina in 1960 was African American. The same exclusionary rule operated in other country comedies, among them *Petticoat Junction, Green Acres, Hee Haw,* and *Mayberry, R.F.D.*

As well as excluding blacks from television dramas and comedies, the industry was slow to counteract the racism in televised college sports. This was particularly true in the case of college football, a mainstay of fall programming since the early 1950s. Adhering to segregationist state laws and customs, network television did little until the mid-1960s to correct discrimination in intercollegiate sports in the South. The Sugar Bowl, for example, was an annual New Year's Day football game held in New Orleans and regularly televised in the 1950s and 1960s by NBC. Because most competitors in the Sugar Bowl since its founding in 1935 were from all-white southern universities, there was no challenge to the de facto segregation existing in Louisiana sports competition. When the University of Pittsburgh fielded several black players on its 1956 Sugar Bowl team, however, the Louisiana state legislature soon passed legislation formally forbidding sports competition between blacks and whites. The law was so effective that the University of Pittsburgh, again with blacks on its football team, was prevented from appearing in the Sugar Bowl in 1964.

Only after considerable adverse publicity did NBC meet with bowl officials to change this discriminatory situation. The state law was reversed, and in 1965 Syracuse University with eight varsity blacks was permitted to play Louisiana State University in the Sugar Bowl. Similarly, only after the segregated Blue-Gray game from Montgomery and the Senior Bowl from Mobile had been televised for years did critical publicity and the threat of lost TV revenues compel officials of these Alabama contests to permit blacks to participate beginning in 1965. In the case of the Blue-Gray game, moreover, NBC canceled its telecast of the game in 1963 when advertisers, threatened with a national boycott, withdrew their sponsorship. And in 1964 the Blue-Gray contest was shown only regionally on six southern stations.[7]

While network TV slowly rectified persistent discriminatory practices, corporate officials by the early 1960s were outspoken in their advocacy of justice in the industry for blacks. In the spring of 1962, declarations of network principles were delivered

by CBS vice-president, Hubbell Robinson, and NBC vice presi-
dent, Mort Werner, both announcing the continued adherence
of their corporations to policies of "no discrimination because of
race, creed, religion, or national origin."[8] That same year officers
from the three national networks told congressional investiga-
tors that their corporations continued to adhere to long-standing
policies of nonbias—the oldest being an NBC policy that could
be traced to a code of nondiscrimination developed in 1919 by
the network's parent company, the Radio Corporation of Amer-
ica.[9] In September 1963, even the small Metromedia network
added its voice to the antibias chorus. According to John H.
Kluge, Metromedia president, "the time has passed for mere lip
service to a policy on nondiscrimination in business in general
and the broadcast industry in particular."[10]

The need to testify publicly against TV racism affected more
than network officers. In July 1963, the Writers Guild of America
West declared its support for demands being made by the
NAACP and the Congress on Racial Equality (CORE) for the
employment of more blacks in all phases of the entertainment
industry.[11] The same month the New York chapter of the Na-
tional Academy of Television Arts and Sciences issued its credo
which stated that "all Americans must be afforded the opportu-
nity to make their contributions in front of and behind the cam-
eras, as well as in other areas of television, solely upon the basis of
ability."[12]

One of the most broadly based declarations of nonbias came
in June 1963, from a coalition headed by the American Federa-
tion of Television and Radio Artists (AFTRA), the entertainers'
union. Included in this coalition were organizations representing
employers, networks, stations, advertising agencies, packagers,
transcription companies, record manufacturers, agents, man-
agers, and impresarios.

But the gap between liberal industry rhetoric and the reality
of chronic racial discrimination in TV created in many minds
doubts about the sincerity of nonbias policy statements. During
this period, the NAACP was especially active in lobbying TV and
film producers and trade unions for the acceptance of more
blacks. The most heartening statement it could make in mid-
1963, however, was that this was still "a period of appraisal."[13]
The *Chicago Defender* articulated much of the frustration and

cynicism felt by African Americans when it editorialized on June 11, 1963, that "much as we like non-bias declarations, we would prefer some non-bias action." The prominent black newspaper continued:

> While the good intentions of AFTRA are admirable, the TV industry as a whole is still perpetuating a picture of lily-white America on video in keeping with the "boob tube" concept. No doubt, the TV industry, from sponsors to networks, from producers to actors, is trying to mend its ways, as the newest declaration indicates. But no one seems to be trying very hard. The Negro does not ask a quota system to judge TV's performance—one-tenth of TV's time for one-tenth of the population that is Negro. Rather, it seeks a common sense, realistic portrait of America as it is, not the make-believe fluff of TV, where Negroes never seem to get into the picture.[14]

The degree to which African Americans were excluded from the nation's most popular medium of information and entertainment was most graphically presented in October 1962 by the Committee on Integration of the New York Society for Ethical Culture. According to a study completed by this nonsectarian humanist group, during a two-week period on TV in New York City, blacks were scarcely visible. Of 393 half-hour units of viewing, blacks appeared on only 89 units—the bulk of these being irregular appearances as singers, dancers, or musicians, or as the subjects in hard news and documentary programming. Such limited and stereotyped exposure, concluded the society, was "psychologically damaging" to the image of African Americans.[15]

8

Actualities and Blacks in TV: The Early 1960s

If dramatic roles were minimal for black actors in the early 1960s, the one dimension of television in which there was increasing visibility for African Americans was in news coverage—not because of the employment of TV reporters or anchorpersons, but because of contemporary politics. The events of the time compelled TV to cover happenings in black society. Specifically, because of two developments—the policies of the new presidential administration of John F. Kennedy and the politics of the civil rights movement and its leadership—blacks became familiar to American viewers in the early 1960s.

In contrast to the ideas of Dwight D. Eisenhower, who conceived of the presidency as a benign secretariat for the enhancement of American business and hence the American people, the youthful President Kennedy envisioned a vigorous role for the presidency in improving the quality of life for all citizens. In his liberal view, any element of society that inhibited harmonious growth—be it big business, recalcitrant state officials, or chronic exploiters of social misery—was fair target for an assertive federal government to take rectifying action.

The Kennedy administration soon made known to broadcasters its priorities on two crucial factors: the state of American television and the condition of the African-American social movement. When Newton Minow, JFK's appointee as head of the Federal Communications Commission, spoke bluntly in May 1961 to the National Association of Broadcasters, his words

were interpreted by broadcasters as the thoughts of the administration. In that speech Minow gained greatest notoriety for his assessment of contemporary TV as "a vast wasteland" filled with violence, boredom, and banality. But he spoke of other issues. He talked of TV serving the public interest, rather than corporate profits. "It is not enough to cater to the nation's whims," he chided, "you must also serve the nation's needs." Minow also spoke of his concern over the increasing power being exercised by the networks over their affiliate stations. He called for programming that was imaginative, creative, experimental, and excellent. To underscore his call for responsible TV, Minow even quoted the words of the NAB's own Code of Television Practices, a noble declaration of principles drafted a decade earlier, but often forgotten in the business of running the television industry.

While such exhortation might be dismissed as the easy rhetoric of a new political regime, Minow raised an issue which added deadly seriousness to his words. Mentioning the practice of renewing station licenses every three years, the FCC chairman suggested that such renewals would no longer be pro forma. Instead, Minow declared, "there is nothing permanent or sacred about a broadcast license." To add further weight to his threat, he promised during renewal considerations to hold "well-advertised public hearings right in the communities you have promised to serve."

Such admonitions from a governmental leader were especially foreboding to broadcasting executives in the early 1960s. In the last years of the previous decade, the television and radio industries had been shaken seriously by two national scandals. The first concerned the fixing of quiz shows. Stories of rigged questions, contestants told when to lose, and confessions by participants who had been either coached or given the correct answers, all helped to precipitate governmental intervention. In October and November 1959, the House of Representatives, through its Special Committee on Legislative Oversight, conducted highly publicized hearings into quiz show fraud. Surrounding the investigation, moreover, were frequent demands for greater regulation and control of TV by the federal government.

If quiz programs were not enough, a "payola" scandal also emerged in 1959. Although the bribing of disk jockeys to play cer-

tain records concerned radio more than television, the scandal touched several hosts of teenage rock-and-roll TV shows. Further, because of the structure of broadcasting in the United States, many station and network executives had ties to the radio industry. Thus, when Minow chided American broadcasting leaders, he was speaking to a vulnerable group.

If Newton Minow's new prescription for broadcasters was confusing and unnerving, President Kennedy's political priorities offered television executives a direction in which to exert their energies and placate the new administration: the civil rights movement. Although through boycotts, demonstrations, and court decisions the movement had gained important early victories over segregation, not until the inauguration of Kennedy did the federal government begin to take an active role in assisting African Americans to overcome the heritage of centuries of racism. Whether it was from motives which were crassly political or morally courageous, the activist president directed federal efforts to ensure for blacks a democratic role in American life. The administration used its Department of Justice to help desegregate southern schools. Kennedy supported legislation to use federal power to ensure blacks in southern states the right to register and to vote. The president was seen prominently in the company of civil rights leaders, and his deputies were photographed occasionally marching with black and white protestors.

In several instances, particularly when racist state laws were used to prevent the integration of public universities in the South, Kennedy appeared on television threatening to nationalize the state militias or dispatch federal troops to ensure the right of academically qualified African Americans to attend these educational facilities. Still, the President personally remained a reluctant public advocate. As TV historian Mary Ann Watson has noted, by mid-1963 even Martin Luther King, Jr. openly criticized Kennedy's efforts as "inadequate." Appearing on David Susskind's *Open End* discussion show on June 9, King urged JFK to exert personal leadership in the civil rights movement, to revive the Fireside Chat format popularized by Franklin D. Roosevelt on radio, but to speak now to the nation via television. According to King, JFK needed to discuss civil rights as a political matter and as a moral concern.

Significantly, the following day President Kennedy re-

quested and received a quarter-hour of network prime time to address the American people on the racial question. His speech was a masterful statement of moral principle, hailed by historian Herbert Parmet, who wrote, "No other Chief Executive had ever talked that way about human rights in America." The president was frank: "The heart of the question is whether all Americans are to be afforded equal rights and equal opportunities." And he linked the civil rights movement to the U.S. posture in global politics.

> We preach freedom around the world, and we mean it. And we cherish our freedom at home. But are we to say to the world—and more importantly to each other—that this is the land of the free, except for the Negroes? Now the time has come for this nation to fulfill its promise. . . . It is time to act in Congress, in your state and local legislative body, and, above all, in our daily lives.[1]

Although sometimes needing to be pushed into action, New Frontier support for civil rights was important in encouraging and popularizing the movement. No doubt, too, it played a role in precipitating assessments within the TV networks of the performance of television in this crusade for racial justice.

While a decreasing number of blacks were used in increasingly stereotyped entertainment roles, TV was not guilty of overlooking black activism in the news of the day. In its current events programming, television began early to cover the exigencies of the civil rights movement. Talk show hosts like Mike Wallace on *Newsbeat* and David Susskind on *Open End* welcomed black leaders to their programs. Moderate spokespersons like Martin Luther King, Jr., Roy Wilkins, and A. Philip Randolph were engaged in insightful conversations intended to present their ideas to a broad audience.

Although network TV was usually respectful of moderate black leaders, they were not always sheltered from racist confrontation. In his insightful biography of Martin Luther King, Jr., historian Stephen B. Oates has described a verbal clash between King and the arch-conservative editor of the *Richmond News-Leader,* James J. Kilpatrick. Appearing on an NBC discussion program, *The Nation's Future,* broadcast November 26, 1960, the

Intelligent, articulate, handsome, and moderate in his espousal of nonviolent tactics, the Reverend Martin Luther King, Jr. was the perfect civil rights leader for the age of television. Possessing great personal charisma and a TV image of integrity and moral determination, King became the national spokesman for the civil rights movement from 1955 until his assassination in April 1968. (*Courtesy of the Schomburg Center for Research in Black Culture*)

As with Paul Robeson before him, American TV proved inhospitable for as articulate and unconventional a black leader as Malcolm X. Except on a few black-hosted programs long after his assassination in February 1965, television has portrayed Malcolm X as a hate-filled racist radical. (*Courtesy of the Schomburg Center for Research in Black Culture*)

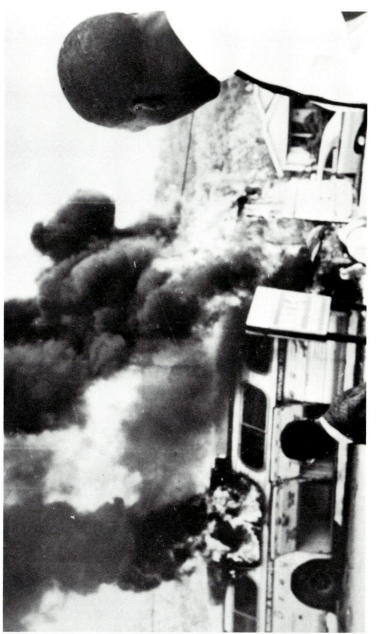

Throughout the 1960s, television news showed the nation the violent reactions that were often triggered by the nonviolent civil rights movement. Here a Greyhound bus is burned by hostile whites near Anniston, Alabama in 1961. (*Courtesy of the Schomburg Center for Research in Black Culture*)

On his several musical specials in the 1950s and 1960s, Harry Belafonte drew consistently high ratings and critical acclaim. (*Courtesy of the Schomburg Center for Research in Black Culture*)

One of the most significant roles in the history of blacks in TV was Bill Cosby's portrayal of the American undercover agent, Alexander Scott, on *I Spy*. Co-starring with Cosby was Robert Culp. Cosby's part broke the "color line" in television drama, and made a national hero out of a mature black secret agent defending the United States around the world. (*Courtesy of the Schomburg Center for Research in Black Culture*)

Throughout the 1960s black talent, such as the Four Tops (above), consistently appeared on the *Ed Sullivan Show*. (*Courtesy of the Schomburg Center for Research in Black Culture*)

Ed Sullivan welcomes Leslie Uggams to his weekly variety program. For more than two decades Sullivan insisted on spotlighting black performers on his CBS showcase. (*Courtesy of the Schomburg Center for Research in Black Culture*)

Cicely Tyson portrayed Jane Foster, an office secretary and a series regular, on *East Side/West Side* during the 1963–1964 television season. Since that time she has remained popular in film and on TV. (*Courtesy of the Schomburg Center for Research in Black Culture*)

Two of the promising black talents who emerged in the 1960s were Diana Sands and Al Freeman, Jr. Sands was nominated in 1964 for an Emmy for her performance in "Who Do You Kill?," on *East Side/West Side.* Tragically, she died of cancer in 1973 at the age of thirty-nine. Freeman found his acting home in 1972 on the daytime soap opera, *One Life to Live,* where he portrayed policeman Ed Hall into the next decade. (*Courtesy of the Schomburg Center for Research in Black Culture*)

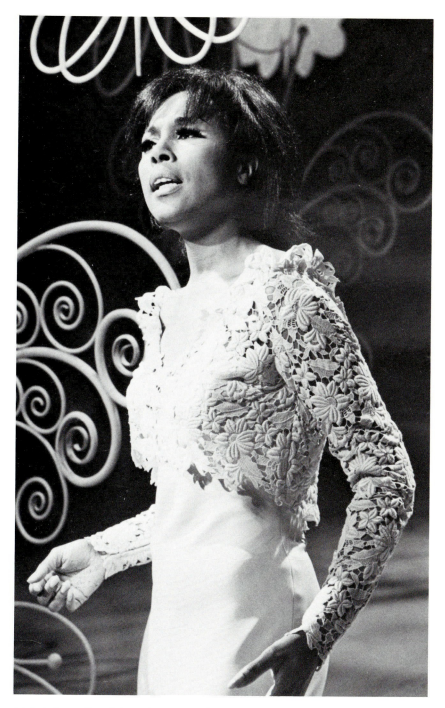

A talented comedic and dramatic actress, Diahann Carroll has also appeared on TV as a singer. (*Courtesy of the Schomburg Center for Research in Black Culture*)

In his portrayal of a virile and impatient black bounty hunter on *The Outcasts*, Otis Young offered the most threatening image of black anger in the history of TV drama. At a time of increasing white backlash, the forceful demand for racial equality communicated by this series was too unnerving for mass America. It lasted on ABC only one season, 1968–1969. (*Courtesy of Columbia Pictures Television. Copyright 1981 Columbia Pictures Industries, Inc.*)

narrow-minded Virginia newsperson attacked King's defense of sit-ins and support for integration. Kilpatrick defended the right of store owners to refuse service to blacks, and he belittled student-led sit-ins at southern restaurants, claiming "the question of who eats integrated hot dogs seems to me greatly exaggerated." As for racial integration, Kilpatrick suggested that the logical result of King's integrationist politics would be to create in the United States "the coffee-colored compromise, a society in which every distinction of race has been blotted out by this principle of togetherness."

Although he answered with precision and rectitude, King was stung by Kilpatrick's forceful prejudice—his ridicule of the African-American leader's claim that disobedience of immoral laws constituted obedience to the moral law of the universe, and his rude rhetorical wondering about why blacks "by and large seem to take so little pride" in their race. According to Oates, when the televised debate ended, "King left the studio feeling that he had not done very well."[2]

Still, moderate assimilationists like King had an access to national video that escaped those black leaders espousing more confrontational responses to white racism. The perimeters of television's black focus mitigated against African-American spokespersons with radical viewpoints. The sensitivities that had banned Paul Robeson in an earlier time were still operative. In July 1958, for example, Mike Wallace presented a five-part series on what was termed "Negro racism." Dealing with the Black Muslim religion, Wallace called it "the hate that hate produced," and dismissed this black nationalist phenomenon as an aberration of the times. Several years later Malcom X recalled the program as "a kaleidoscope of 'shocker' images. . . . Every phase was edited to increase the shock mood." And he described the hostile reaction toward the Muslims precipitated by the program.

In a way, the public reaction was like what happened back in the 1930s when Orson Welles frightened America with a radio program describing, as though it were actually happening, an invasion by "men from Mars". . . . Hundreds of thousands of New Yorkers, black and white, were exclaiming "Did you hear it? Did you see it? Preaching *hate* of white people!" Here was one of the white man's most characteristic behavior

patterns—where black men are concerned. He loves himself so much that he is startled if he discovers that his victims don't share his vainglorious self-opinion. . . . First came the white newspapers—feature writers and columnists: "Alarming" . . . "hate messengers" . . . "threat to the good relations between the races" . . . "black segregationists" . . . "black supremacists," and the like. And the newspapers' ink wasn't dry before the big national weekly news magazines started: "Hate-teachers" . . . "black racists" . . . "black fascists" . . . "anti-Christian" . . . "possibly Communist-inspired."[3]

TV coverage of the daily news by the early 1960s dealt perforce with protests for racial desegregation. For a nation grown used to lily-white communities set apart from pockets of black people, television transcended residential boundaries and brought the civil rights movement directly into the living rooms of white America. Because of TV, nonviolent demonstrators, brutal police responses, heckling bigots, and white officials exploiting ignorance and intolerance to gain election became commonplace images on the evening news. Perhaps better than any fictionalized drama, these actualities brought home the necessity for, and intensity of, the black social movement.

The most fully developed presentations of the civil rights issues were to be found in network documentaries. One of the most memorable productions in this period was "Walk in My Shoes," aired September 19, 1961, on the *Closeup* series. With input from the noted black journalist Louis E. Lomax, this hour-long documentary was a stark look at the world of impoverished African Americans. A. William Bluem has captured most impressively the artistic and moral power of the program:

We begin to share the noise, the anger, and the dark corners of the Negro world. Then we are in a cab, where the driver is talking to us over his shoulder. He is an angry man of simple, blunt speech—committed to the belief that the "white man" has too long dominated him. We move next to a filthy apartment in a crowded tenement, where a woman answers a question about her future with . . . sad resignation. . . . But the free camera is always in focus and carefully deployed as it explores the darkness of tenement life.

Now there is a departure in technique. In the tenement a

young man arises and makes ready for the routine labor of his day. Narration over this action describes his work and his hopes—but as he goes into the streets, the narration becomes his—his own thoughts in first person, voice-over narration. . . . The young man is our point of involvement, but it will not be *his* drama. Instead, the balance of this program becomes a vehicle by which the Negroes of America *tell*, not *live*, their stories. In a series of semi-interview situations recorded in Los Angeles, Chicago, and other places, we see a number of intense discussions of Negroes' problems and dreams. We see the wealthy and the middle class, as well as the poor. We listen to Martin Luther King as he talks directly to us, and hear Percy Sutton—in what must remain the singly most revealing interview ever recorded for TV—describing his feelings during his earlier "freedom ride." . . . The people are made important and they are presented to us in *reflection* upon crisis rather than in the frenzy of it.[4]

Even before Kennedy became president, the three networks were increasing their commitment to airing documentaries in prime time. During the 1959–1960 TV season (October through April), there had been thirty-two such programs accounting for sixteen sponsored hours. The next season that figure was sixty-two sponsored programs totalling thirty-nine hours. And by 1963–1964, it reached 112 programs covering ninety-seven hours. Thus, at the moment the civil rights movement was emerging and a sympathetic chief executive entered the White House, network television was experiencing a "war" between documentary makers.[5]

The race question was an occasional topic of pre-Kennedy TV documentaries. For example, an NBC special, "The Second Agony of Atlanta"—aired February 1, 1959—probed the quandary in which citizens of Atlanta found themselves—faced with the prospect of court-ordered integration of public schools in a city where state law threatened to close all city schools if one were integrated.

In 1960 black issues continued to be treated by the networks. "Sit In" was an *NBC White Paper* telecast December 20. It dealt with one of the first nonviolent sit-ins, in a Nashville, Tennessee restaurant the previous February. "Cast the First Stone" was broadcast on *Closeup* on September 27. It examined bias against

minorities from a unique perspective. It bypassed the South and focused instead on discrimination in the North.

With most African colonies moving toward national independence by 1960, *CBS Reports* treated black freedom in Africa. "The Freedom Explosion," on February 15, dealt with Nigeria, scheduled to become an independent country on October 1, following the withdrawal of British rule. "The Dark and the Light" was an ABC special on January 31, which surveyed the struggle for independence in Kenya and Tanganyika—which would both eventually attain their independence—and in the Union of South Africa, where racial apartheid still treated the nonwhite majority as second-class citizens.

Two of the most poignant racial documentaries of 1960 came from the production team of Edward R. Murrow and Fred W. Friendly. "Who Speaks for the South?"—aired May 27 on *CBS Reports*—concerned the swelling crisis over school integration in Atlanta. It presented a wide spectrum of southern whites speaking of the problem, offering solutions ranging from the intolerance of the Ku Klux Klan to pleas for toleration and understanding.

In "Harvest of Shame," telecast on November 25 on *CBS Reports*, Murrow and Friendly exposed the exploitation of migrant farm workers in the United States. The majority of those shown on the farms in Florida and along the East Coast were African Americans. The picture of low wages, squalid living conditions, and resignation to drudgery and abject poverty was powerful. Even more striking was the plight of the children of these workers. With educations disrupted by continuous migration and forced into debilitating stoop labor at early ages, the children seemed more like victims of poverty in an earlier century than like American youth in the middle of the twentieth century. "Harvest of Shame" made for reflective viewing, televised as it was on Thanksgiving weekend.

Even before these programs, however, the CBS team of Murrow and Friendly had probed civil rights matters. "Clinton and the Law: A Study in Desegregation" was a significant *See It Now* episode on January 6, 1957. It was one of the first documentaries to consider the motivations of violent racial confrontation—this one involving the integration of public schools the previous fall in rural Clinton, Tennessee. In "The Lost Class of

'59," telecast on January 21, 1959, the focus was on mounting so-
cial tension in Norfolk, Virginia, caused by the governor's order
to close six public schools rather than see the city's high schools
integrated.

As was the case with most Murrow-Friendly documentaries,
the strength of these reports was Murrow's refusal to take sides,
while his cameras permitted spokespersons from all sides to tell
the nation of the sincerity of their convictions. And although in
the case of "The Lost Class of '59" they were speaking of prob-
lems in Virginia, the speakers could have come from any south-
ern locale facing federal court orders to end segregation prac-
tices, and thereby take the first steps toward reevaluating
patterns of white racial superiority. Here was a dismayed high
school teacher telling the nation that "to say we are disheart-
ened, to say that we feel insecure, is the understatement of the
evening." Here also was a white mother who felt integration was
wrong and that "if we have to sacrifice our public schools to over-
come this, then I think that's the thing to do."

Murrow spoke, too, with white school children. There was
the high school student who rationalized racism, arguing:

> I don't dislike Negroes that much. I just don't care to associate
> with them. I am for the Negro race. I'd like to see them ad-
> vance, but among themselves. And I don't believe that they
> have to mingle with the white people to make themselves
> equal.

In moderating contrast, another student wondered aloud:

> Don't you think that if we could start integrating, slowly and
> calmly without running around in circles—that all we'd be
> teaching the children in the lower grades would be tolerance?
> Not that they have to go out and marry the first Negro boy that
> goes to school with them, just like that.

If these common people spoke for average whites in the
South, then Governor J. Lindsay Almond articulated the posi-
tion of all southern governors, faced with legal pressure from
Washington, who offered intransigence instead of leadership, as-
sertions of local prerogative instead of adherence to the law of

the republic. Rallying behind the segregationist opinion of white voters, Almond told Murrow that "after all, the people elect the governor and the members of the general assembly, and they have repeatedly spoken in no uncertain terms that we cannot maintain public education on a racially mixed basis."

While programs such as those produced by Murrow and Friendly were impressive analyses, they were seen by an insufficient number of viewers; this in part because they were not aired on all stations in the network. Broadcast documentaries never were overwhelmingly supported by viewers. For that reason, networks often scheduled them for unpopular hours or opposite unbeatably popular programs on other networks. Two important series, *See It Now* and *The Twentieth Century,* were CBS features on Sunday afternoons, telecast in what was cynically called "the cultural ghetto." On ABC in prime time, such nonfiction programs as *ABC News Reports, Editor's Choice, ABC Scope, Howard K. Smith with News and Comment,* and *Closeup* were scheduled opposite hit programs like *What's My Line?, Garry Moore Show, Mannix, Gunsmoke, Danny Kaye Show,* and the *NBC Wednesday Night Movie.*

Documentaries often were not seen in many areas of the nation. Since affiliated stations were not obliged to accept every show the networks transmitted, low-rated or controversial documentaries were expendable. Murrow's biographer has pointed out that the award-winning *See It Now* series was not carried by all CBS stations. When it reported on civil rights matters, moreover, only fifty-seven CBS stations aired *See It Now.*[6]

Although they were placed in poor time periods and attracted audiences that were relatively small, these news and documentary reports on the black social movement were necessary to American TV. Such programming added a fragment of reality and credibility to a medium that specialized in fantasy and escape. Amid the comedic, Western, detective, and musical sameness that typified television in the early 1960s, these periodic network adventures into actuality were often the only opportunities viewers had to see and evaluate events happening in the real world. Among others, Murrow was not pleased with the job TV was doing in informing viewers. He spoke in October 1958 of the generally unsatisfactory record television had compiled in reporting on reality. "If there are any historians . . . a hundred years

from now and there should be preserved the kinescopes for one week of all three networks," he told his audience, "they will find recorded in black-and-white or color, evidence of decadence, escapism and insulation from the realities in which we live."[7]

While the interest of television in reporting the vicissitudes of the civil rights movement increased by the early 1960s, this did not translate into plentiful coverage of the minority situation. According to *TV Guide*, during 1960–1962 network TV aired 1,580 news and public affairs programs. Of that number, only 695 were concerned with domestic matters, and only thirty of these were concerned directly with the racial conflict within American society. That figure represented 4.3 percent of all domestically oriented programs, and only 1.8 percent of the total news and public affairs shows during the three-year period.[8]

The intensification of the civil rights movement, however, increased the interest of programmers and viewers. One of the first priorities for the networks was to break decades of discrimination and hire the first black correspondents in national broadcasting history. In September 1962, Mal Goode, formerly a journalist with the *Pittsburgh Courier*, was employed by ABC News as the first black correspondent on national TV. A few weeks later CBS announced the hiring of Ben Holman, a former newsman with the *Chicago Daily News*. In March 1963, NBC followed suit and signed Bob Teague, with experience at the *New York Times* and the *Milwaukee Journal*, as a news writer for TV and radio.

By 1963, the movement had blossomed into an unprecedented national crusade for minority rights. With articulate leaders like Martin Luther King, Jr., and with just goals which were popularly supported, an amalgam of black and white activists was challenging ways of life rooted in centuries of bigotry. The fact that 1963 was also the centennial year of the Emancipation Proclamation added an aura of legitimacy and immediacy to this powerful grassroots crusade.

Fundamental to this demand for reform was television and its function as a mass communicator. Never in history had so many Americans seen the effects of chronic racism as on TV in the summer of 1963. Unlike the anti-slavery movement of the mid-nineteenth century, television presented the issues of this new abolitionist cause in unbiased, reasonable terms. No pas-

sionate rhetoric here. Viewers were able to decide for themselves as they encountered on TV the consequences of Jim Crow laws, bigotry, and race hatred.

The coincidence of television and the black social revolution was advantageous for the reformers. According to William B. Monroe, Jr., a news director from New Orleans and later head of the NBC News Bureau in Washington, "television is their chosen instrument." In Monroe's view, TV was the most effective medium for relating the civil rights movement for several reasons. First, by the early 1960s, video was "coming of age as a journalistic medium;" it covered the movement "not because television set out to integrate the nation or even to improve the South," but because the civil rights movement was taking shape and TV was there to cover it. Further, Monroe suggested, TV was a national medium possessing "the courage—in most cases, a courage drawn from the old tradition of the American press—" to face the issues squarely and report the brutal encounters which often faced marching and protesting blacks. Moreover, because of the aesthetic realities of television, it conveyed the emotions of the movement more dramatically than radio or print. To Monroe, the black social revolution was "a basically emotional contest," and television conveyed the values of that contest "with a richness and fidelity never before achieved in mass communications."[9]

Many times that centennial summer the focus was on the negative effects of racism in specific cities or locales. *New York Illustrated* on WNBC-TV reported on "Trouble in Harlem" (June 24); a two-part documentary on "Washington—A City in Trouble" aired on WRC-TV (July 4 and 5). Local manifestations of the Black Muslim religion were treated on "My Name Is Mr. X" on Dallas station KRLD-TV (August 18). The impoverished all-black town of Bayou Mound, Mississippi was the focus of a national report on *David Brinkley's Journal* on NBC (July 15). And the plantation politics that kept blacks subjugated in Plaquemines parish, Louisiana, were given network exposure on *CBS Reports* (September 18).

In the summer of 1963, network TV treated varying dimensions of the civil rights issue. National Educational Television pursued the plight of African Americans on nonfiction series like *Heritage, Decision, Perspectives,* and *Desegregation.* The situation was touched indirectly, too, in the scholarly NET series,

Anatomy of a Revolution, a program utilizing leading American historians to discuss the dynamics of historic social revolutions.

Coverage by the commercial networks was intense. CBS presented a self-appraisal of the role played in the movement by journalism, "The Press and the Race Issue" (August 21). Spokesmen on all sides were examined. *Issues and Answers* on ABC brought together liberal Senator Jacob Javits of New York and archconservative Senator Allen J. Ellender of Louisiana to argue the merits of the civil rights legislation urged by President Kennedy (June 16). Senator Richard Russell of Georgia appeared on *Meet the Press* to attack the president's proposed legislation (August 11). James Meredith, the first black student to be enrolled at the University of Mississippi, appeared on *Meet the Press* (May 26). One week later George C. Wallace, the segregationist governor of Alabama, was a guest on the same NBC interview program (June 2).

Two network initiatives, however, stand out for their comprehensiveness and commitment to public enlightenment: the five-part ABC series *Crucial Summer* (August 11 to September 8), and the NBC special *The American Revolution of '63,* for which the network preempted three hours of prime time on September 2. No doubt, these documentary presentations, occupying five and one-half evening hours within a period of five weeks, represented one of the most intensive examinations of a national issue ever presented by television.

ABC News attempted to be balanced and national in its five-part study of the civil rights struggle in America. It presented black spokesmen for change like Roy Wilkins and Martin Luther King, Jr., as well as white advocates of segregation such as Senators Sam Ervin of North Carolina and J. Strom Thurmond of South Carolina and Governors Wallace and Orval E. Faubus. But more than as a regional problem, *Crucial Summer* analyzed racism throughout the country. In a penetrating fashion, viewers saw northern expressions of bias in employment, segregation in public accommodations, racial discrimination in housing, and problems with black voting rights.

Most importantly, *Crucial Summer* showed black Americans struggling to overcome prejudice and exclusion. In contrast to the "lovable" stereotypes on TV in the 1950s, the message of Willie Best, George "Kingfish" Stevens, and Beulah seemed to

crumble before real black articulators. Typical of the men and women who appeared on *Crucial Summer* was Lucius Pitts, president of all-black Miles College in Birmingham, who spoke of the future for blacks.

> I'm a preacher, so I would say I see a new heaven and a new earth, on the basis of demonstrations and of negotiations. I don't think it's going to come within a year, but I'm positive that Negroes are not going to wait for years again. You see, if we move at the rate that we've moved in the past fifty years, it will be around 2053 before we get a like amount of progress. Negroes are not going to wait that long. I hope white people— moderates, whatever they are in the North or South—will not be fooled by thinking that a dribble of this or that is going to stop the Negro march, nor to satisfy a small group. This isn't going to stop it. It has to move. And Negroes are willing for it to move with a certain amount of patience. But they're not willing for it to drag. Even an old man like me: you see, I got four children. I can't wait for Alabama, 25 or 30 years from now, to offer my children an opportunity for freedom in education and freedom of movement. This I can't do. My manhood just won't stand it.

NBC's massive undertaking on Labor Day, *The American Revolution of '63*, fully exploited the network's news facilities to present a well-rounded picture of the civil rights problem in the United States. News correspondents moved from Montgomery and Little Rock to Los Angeles and Englewood, New Jersey— from the ghettos of Chicago and New York City, to the rural environs of Greensboro, North Carolina, and Albany, Georgia. The program included reports on seventy-five different areas of the country.

In addition to geographical comprehensiveness, *The American Revolution of '63* offered a broad range of thematic approaches to the civil rights issue. It probed matters by now familiar in television considerations of civil rights, including housing, employment, public accommodations, voting rights, and education. But the report moved in newer directions, exploring such fresh topics as the stereotyping of blacks in Hollywood productions, the paucity of black influence in the critical advertising industry, and the contemporary applicability of

Henry David Thoreau's nineteenth-century philosophy of civil disobedience.

And the NBC report allowed all sides of the social issues to be heard. As *Variety* reported on *The American Revolution of '63*, "the bigot had his say; and so did the the champions of integration; the politician, the labor leader, the educator, the civic leader, the minister, even the critic of the 'frightened little people on Madison Ave.' "[10] One of the most passionate critics of the movement was Ross Barnett, the governor of Mississippi. He issued a scathing attack on television as the real culprit in creating the ground swell of black protest. Barnett blasted TV for presenting inflammatory pictures and lending itself to the designs of President Kennedy to create a strong role for the federal government in resolving racial matters.

If in his critique Governor Barnett meant that what TV did most effectively was to communicate through its pictures, this NBC special illustrated the power of video. Especially in recounting the preceding decade of civil rights confrontations, *The American Revolution of '63* allowed its viewers to comprehend the brutality and inhumanity that plagued the movement. Here were images of incensed white mobs battling with federal troops because nine black children were being enrolled in a Little Rock high school in the fall of 1957. And while the tense situation called for enlightened leadership, here was Governor Faubus of Arkansas on TV, showing provocative photographs of bayonets aimed at white protestors and proclaiming:

> We are now an occupied territory. Evidence of the naked force of the federal government is here apparent in these unsheathed bayonets in the backs of school girls. And in the bloody face of this railroad worker who was bayonetted and then felled by the butt of a rifle in the hands of a sergeant of the United States 101st Airborne Division.

Here, too, were protests on the campuses of the universities of Mississippi and Alabama as a few black students sought entry. At the former, there were clashes between white supremacists and law enforcement agencies. At the latter, Governor Wallace stood ceremoniously in the doorway of a university building and defiantly informed federal officers:

I stand here today as Governor of this sovereign state and refuse to willingly submit to illegal usurpation of power by the central government. I claim today for all the people of the state of Alabama those rights reserved to them under the Constitution of the United States. Among those powers so reserved in claim is the right of State authority in the operation of the public schools, colleges, and universities.

At a time when Americans sought answers to civil rights problems, NBC cameras showed southern leaders proffering solutions that distorted the realities of time. For Senator James O. Eastland of Mississippi the movement was neither popular nor authentic, but the product of activists, since "the whole thing is stirred up by a group of agitators." In his view, this was especially pernicious because "the Negro in the South has economic equality and is well-treated." Governor Wallace went one step further, claiming that "local agitators" were tied to international Communism, since "the Communist movement is behind all the racial demonstrations in this country." And Leander Perez, a reactionary political leader in Louisiana, offered his prescription for combatting the civil rights movement. Speaking of the integration of Roman Catholic schools in New Orleans, he told applauding white parents what to do.

It's the simplest thing in the world. It'll give us some trouble, but it'll give them a whole lot more. All you have to do is shut their water off. And the moment a Negro child walks into the school, every decent, self-respecting, and loving parent should take his white child out of that parochial school.

As powerful as such pronouncements were, the most brutalizing images came from Birmingham when city officials in May 1963 turned high-powered fire hoses on protesting blacks. Then, directed by Police Chief "Bull" Connor, law enforcement officers used leashed German shepherd dogs to disperse the crowds. Juxtaposed to such dehumanizing pictures was a quietly ironic interview conducted with Martin Luther King, Jr. Speaking from Birmingham during this brutality, King explained his continued leadership of such demonstrations, even though his own residence had just been bombed.

> And I go on with the feeling that this is a righteous cause, and that we will have to suffer in this cause, and that if physical death is the price that some must pay—if it's the price that I must pay—to free my children and the children of my brothers and sisters and my white brothers from a permanent psychological death, then nothing can be more redemptive. I have always believed that unearned suffering is redemptive. And if a man has not discovered something so dear and so precious that he will die for it, then he doesn't have much to live for.

With no breaks for commercials, NBC had dedicated its entire evening schedule to a consideration of the crisis facing the United States in mid-1963. It was an unprecedented act of programming. "It isn't likely that television will see a more definitive portrayal of the momentous civil rights issues," *Variety* concluded, "or a more skillful and professional exposition of the events attendant to 1963's history-in-the-making as that which NBC-TV undertook."[11]

While productions such as *The American Revolution of '63* and *Crucial Summer* were outstanding journalistic creations, the climax of civil rights developments in the summer of 1963 was the massive rally held in Washington, D.C., on August 28—the "March on Washington for Jobs and Freedom." It was a historic gathering rendered all the more significant because television made it a national manifestation. Sharing equipment and personnel, the networks showed more than 200,000 marchers crowded into the national capital to make known their sympathy with the cause of minority rights.

What viewers also saw was apparent consensus among the generations of black leaders, all lending support to social change through nonviolent protest and moral witness. The venerable A. Philip Randolph—the union activist who had been organizing black protest for half a century, and whose creation in 1941 of a March on Washington Movement was an important first step toward this day twenty-two years later—now led thousands of marchers in an oath to return home and carry on "the revolution." The youth generation was represented by John Lewis, national chairman of the Student Non-Violent Coordinating Committee (SNCC), who declared impatiently that "we don't want our freedom gradually, but we want our freedom now."

Chapter 8

But this day was the crowning triumph for the philosophy and leadership of Martin Luther King, Jr. The man who first organized the boycott of city buses in Montgomery eight years earlier used this present occasion to tell of his dream of racial harmony in the United States. With compelling cadence King implored the nation to "rise up and live out the meaning of its creed: 'We hold these truths to be self-evident—that all men are created equal.' " He foretold a day when children of slaves and slaveholders could "sit down together at the table of brotherhood." And using Mississippi as a microcosm for all states in which racial injustice was rampant, he envisioned a time when it would "be transformed into an oasis of freedom and justice." In his final phrases King, the political leader and Baptist minister, tied the nonviolent protest movement to the plight of all Americans inhibited by racial discrimination:

> From every mountain side, let freedom ring. And when this happens, when we allow freedom to ring, when we let it ring from every village and every hamlet, from every state and every city, we will be able to speed up that day when all God's children—black men and white men, Jews and Gentiles, Protestants and Catholics—will be able to join hands and sing in the words of the old Negro spiritual: "Free at last, free at last, thank God Almighty, we're free at last!"

9

The Emergence of "Relevancy" in TV Production

Although news and public affairs programming greatly increased the TV focus on African Americans in the early 1960s, a similar surge did not develop in dramatic productions. Two years after its initial report castigating American television, the New York Ethical Society published results of a second monitoring of the medium in search of black representation. From findings issued in December 1964, the society concluded that the industry was not keeping abreast of national political and social developments, and that "continued glaring deficiencies outweigh the few improvements. The improvements stem from the fact that the industry has no place to go but up."

The report was critical especially of network TV for failing to match the levels of integration encountered on local video. Local shows in New York City, the society contended, were more favorable to blacks than network offerings. In the words of the report, this was "not accidental." It resulted in part because regional and local racial confrontation influenced national programming, and when "faced by conflict, the networks play it safe."

In statistical terms, the paucity of African-American representation was striking. According to the society, on an average evening of television in April 1963, a viewer in New York City would see about three blacks—only one for longer than a minute. In only one-fifth of all appearances would a black performer be on the screen for more than three minutes. And in some types of

programming—children's productions, daytime soap operas, and dramatic shows—the use of blacks had risen only slightly over its low level two years earlier.

The single area in which a strong improvement was noted was in the use of blacks in advertisements and public service announcements. Where there had been an average of two blacks in such spots every five hours in 1962, there were now thirty-six.[1] If the major producers still avoided employing African-American talent, at least network and advertising agency executives were responding to the realities of what D. Parke Gibson called "the $30 Billion Negro."

The economic power of the black consumer market increased dramatically in the 1960s. Blacks spent more than $30 billion annually on goods and services. Significantly, because of demographic patterns this purchasing power was concentrated mostly in urban areas of the nation. During the period 1940–1960, three million African Americans left the South and moved elsewhere in the United States. Most moved to the big cities of the East Coast, the Midwest and Far West. Gibson estimated that by 1970 blacks would constitute 40 percent or more of the citizenry of fourteen major cities—including Baltimore, St. Louis, Detroit, Gary, Newark, and Washington, D.C. Further estimates suggested that blacks soon would be 25 to 68 percent of the population in fifty major markets having a total black and white population of 100 million. According to Gibson, this was a compelling reality for American business.

> This means, simply that on a straight population basis if a company wants to sell effectively to 40 percent of one of the named markets, it has to sell effectively to Negro consumers. . . . if Negroes are above average purchasers of a product—say the 40 percent of the population that is Negro buys 60 percent of the product in that market—Negro consumers will decide if the product is to succeed or if it is to fail.[2]

Despite the gloomy statistics announced by the New York Ethical Society, TV had not since its earliest years been as open to black talent as it became during the 1963–1964 season. And it was inevitable that blacks would appear more frequently because this was, in the words of critic Richard Schickel, "the year of the

problem." Reflecting actual social criticism and protest, video turned to stories involving social problems. As Schickel pointed out, by the fall of 1963 television had refocused many of its dramatic programs from concern with usual human dilemmas, to provocative involvement with relevant themes. Such programming, moreover, would counteract the assessment of television as a vast wasteland. Hopefully, too, it might ease criticism emanating from the national government.

Medical series such as *The Eleventh Hour, Ben Casey, The Nurses, Breaking Point,* and *Dr. Kildare* now explored contemporary values and social morality as they told their weekly stories. *Mr. Novak* and *Channing,* set in a high school and a university, respectively, now unfolded plots drawn from newspaper headlines of the day. In this way, tales touched on such topics as civil rights issues, students facing the Vietnam war, and a blacklisted professor trying to hide his past.

The series which most inspired this trend toward relevancy was the courtroom dramatic program produced by Herb Brodkin, *The Defenders.* A CBS series which ran from 1961 to 1965, *The Defenders* presented various sides of complex social issues. In a style later championed by shows like *Lou Grant* and producers like Norman Lear, *The Defenders* was more than a whodunit in which lawyers instead of detectives or police officers solved crimes. Now story lines revolved around such realistic problems as literary censorship, lynching, the morality of the death penalty, the admission of wiretap evidence in court, the right of a student to advocate atheistic ideas in public school, and the antidemocratic politics of the contemporary American radical right. This was a literate program, often enacting scripts by noted dramatists, among them Ernest Kinoy, Reginald Rose, and Howard Fast. Its success, moreover, encouraged producers and writers of other series to deal more frankly with the most controversial issue of the day: the place of blacks in American society.

At least one "racial" story appeared on each of the major dramatic programs in the 1963–1964 season. On *Ben Casey,* Sammy Davis, Jr. played a dramatic role in "Allie." In it he portrayed a baseball player whose adjustment to the loss of an eye was easy compared to his confrontation with a black doctor, played by Greg Morris, whose antiwhite racism was virulent. Ossie Davis appeared as a judge in "The Star-Spangled Ghetto," an episode

of *The Defenders*. Ruby Dee portrayed Harriet Tubman in "Go Down, Moses," on the historical *Great Adventure* series. James Earl Jones played a bigoted professor in "Freedom Is a Lovesome Thing, God Wot!" on *Channing*. James Edwards, Hari Rhodes, and Ruby Dee starred in a boxing story, "Decision in the Ring," on *The Fugitive*. Barbara McNair and Diahann Carroll appeared in separate episodes of the psychological series, *The Eleventh Hour*. Gloria Calomee appeared as a black student terrorized by whites in an episode of *Mr. Novak*. And Diana Sands made several major appearances, including significant roles on *The Breaking Point, Outer Limits*, and *The Nurses*.

African Americans performed on other types of network programming. Count Basie was a guest on the *Judy Garland Show*. Jazzman Billy Taylor became musical director of the satiric comedy revue, *That Was the Week That Was*. NBC aired a prime time documentary about baseball great Willie Mays, entitled, "A Man Called Mays" (October 16). And several blacks were on the folksong series, *Hootenanny*, including Bill Cosby, Josh White, Brock Peters, and Clara Ward and her gospel singers. Further, two series that season featured black actresses in permanent roles. Hilda Simms joined the CBS program, *The Nurses*, to portray nurse Ayers; and Cicely Tyson starred as Jane Foster, a secretary in a city welfare office, in *East Side/West Side*. Most enduring of all was Arthur Duncan, who in 1964 began seven years as a regular, featured dancer on the *Lawrence Welk Show* on ABC—and who continued for another decade after 1971 when Welk made his show a non-network, syndicated offering.

The most promising new production featuring blacks during the 1963–1964 season, however, was *East Side/West Side*. The program was a product of David Susskind's company, Talent Associates. It was clearly a series with a "mission"—to portray the depressed human condition in inner-city America. The show featured George C. Scott as Neil Brock, a social worker in New York City. Although it eventually changed its format and cast Scott as an assistant to a liberal-reformist congressman, *East Side/West Side* is best remembered as presenting a dismaying picture of life and social values in decaying urban America. In a medium grown used to the requisite happy ending, this program was disconcertingly different. Rather than a champion to right the wrongs of social life, Neil Brock was an antihero, often pow-

erless to correct the ills of society and unable to rectify perma-
nently the abused lives he encountered. Nevertheless, at the
time critic Cleveland Amory called *East Side/West Side* "un-
doubtedly the boldest, bravest and most original new series now
on your screen this new season."[3]

Despite the continuing character played by Cicely Tyson,
East Side/West Side was not oriented exclusively toward black
problems. It probed issues involving the elderly, social derelicts,
non-black racial minorities, and other exploited groups. Yet, two
of its most memorable episodes dealt with contemporary
African-American life. "No Hiding Place" was a powerful indict-
ment of the real estate industry. It concerned unscrupulous real-
tors trying to panic white residents into selling their suburban
homes once a black couple moved into the neighborhood. The
program aired December 2, and featured Ruby Dee and Earle
Hyman as the interlopers. As much a condemnation of spineless
white liberalism as it was an attack on white bigotry, the program
reached its climax when Neil Brock berated his indecisive white
friend, telling him, "You got to make a personal decision.
Doesn't matter what anybody else does, it's what you do. You've
got to stop playing 'Larry Liberal' and make up your mind!"

This episode was written by Millard Lampell, a neglected
playwright whose "Lonesome Train"—a moving cantata about
the funeral train bringing the body of Abraham Lincoln from
Washington, D.C. to Springfield, Illinois—was one of the most
celebrated productions of network radio during World War II. Al-
though he had been blacklisted during the anti-Communist hys-
teria of the 1950s, Lampell again had become an accepted writer
of relevant social drama.

Where "No Hiding Place" attacked bias and exploitation by
the unscrupulous, "Who Do You Kill?" was a more generalized
condemnation of the attitudes that placed and kept blacks in
poverty. Written by Arnold Perl and telecast on November 4, this
was an emotional story concerning a frustrated ghetto resident,
played by James Earl Jones, unable to get the break he felt he de-
served. His wife, played by Diana Sands, turned of necessity to
hustling drinks in a sleazy bar to support her family. The climax
was reached in a stark sequence in which the couple's infant
child, while sleeping in his crib, was fatally bitten by a rat. The
scene of the baby being torn from the rat was poignant. The

shriek of remorse emitted by Jones was fundamental human agony. This was not the stuff of which successful weekly series were made. *East Side/West Side* was canceled in April 1964 after twenty-six episodes.

As well as quantitative improvements, black entertainers gained critical triumphs because of their increasing exposure on television. In 1960, Harry Belafonte was the first black to win an Emmy from the National Academy of Television Arts and Sciences. He won the award for *Tonight with Belafonte,* telecast December 10, 1959, the first of two NBC variety specials he headlined. The second, *Belafonte . . . New York 19, N.Y.,* was aired October 20, 1960.

By the early 1960s, recognition came more frequently for African-American actors. Diahann Carroll received an Emmy nomination as best actress in a single performance for her role in "A Horse Has a Big Head . . . Let Him Worry," an episode of *Naked City* televised November 21, 1962. The following year, three blacks were nominated for Emmy awards. These were James Earl Jones and Diana Sands for their roles in "Who Do You Kill?" and Ruby Dee for "Express Stop from Lenox Avenue," a drama on *The Nurses* aired May 9, 1963.

As distinguished as were many of the programs featuring black actors, predictably they were still racial dramas. African-American actors were being typecast in black stories. In a time of relevancy, dramatic series shifted from issue to issue. Inevitably each series would focus on the racial issue. Here, blacks would be employed. But just as inevitably, a series would shift focus the following week to another social concern, one which did not involve the black question. Few black actors appeared in these subsequent episodes. Blacks might have appeared in excellent dramas, but the color line was still in effect.

10

The Golden Age of Blacks in Television: The Late 1960s

"Golden Age" is a term to label that period in the history of a nation, movement, artistic medium or the like during which its greatest achievements were realized. It is not an absolute term since it does not intend to describe the best *possible* epoch. That being the case, there can be no doubt that for blacks in American television, the last half of the 1960s was a Golden Age.

Speaking in July 1964, Frank Stanton, president of CBS, called upon broadcasters to launch a "mighty and continuing editorial crusade" in support of civil rights. In an address to the National Broadcast Editorial Conference of the Columbia University Graduate School of Journalism, Stanton called for commitment and advocacy. President Lyndon B. Johnson having recently signed the landmark voting rights act of 1964, Stanton spoke now of the "pivotal point in our history" and of the need for television to utilize its "editorial strength boldly, imaginatively and with insight and wisdom."

This was a significant speech, for it revealed the sensitivity and involvement many TV executives felt toward the civil rights movement, and toward the fact that the government and the nation supported civil rights reform. Stanton suggested this when he directed broadcasters to "use their 5,000 voices heard on 156 million radio sets and 61 million television sets, in a mighty continuing editorial crusade to make this new law work."[1]

In part, the changing complexion of TV in the late 1960s was a reflection within the industry of the changes wrought by the

civil rights movement. Until this date there had been few sponsored network shows headed by black actors. Serious entertainers such as Billy Daniels in 1952 and Nat King Cole in 1956–1957 had failed to gain or maintain popularity. The only successful programs, *Beulah* and *Amos 'n' Andy*, may have amused enough people to keep them viable for several seasons, but they resurrected minstrel-show stereotypes thought by many to have been abandoned following World War II.

Series Featuring Blacks as Stars or Co-Stars

I Spy (1965–1968)
Sammy Davis, Jr. Show (1966)
Mission: Impossible (1966–1973)
N.Y.P.D. (1967–1969)
Julia (1968–1971)
The Mod Squad (1968–1973)
Bill Cosby Show (1969–1971)
Leslie Uggams Show (1969)
The Outcasts (1968–1969)
Room 222 (1969–1974)

The Protectors (The Bold Ones) (1969–1970)
The New People (1969–1970)
Flip Wilson Show (1970–1974)
Barefoot in the Park (1970–1971)
The Young Rebels (1970–1971)
The Young Lawyers (1970–1971)
The Interns (1970–1971)
Mary Tyler Moore Show (1970–1973)
The Silent Force (1970–1971)

Series with Continuing Supporting Black Characters

Sing-Along with Mitch (1961–1966)
Lawrence Welk Show (1964–1971)
Rawhide (1965)
Hogan's Heroes (1965–1970)
Star Trek (1966–1969)
Daktari (1966–1969)
Hawk (1966)
Ironside (1967–1975)
The High Chaparral (1967–1970)
Cowboy in Africa (1967–1968)

Rowan and Martin's Laugh-In (1968–1973)
Mannix (1968–1975)
Gentle Ben (1968–1969)
Peyton Place (1968–1969)
Daniel Boone (1968–1970)
Land of the Giants (1969–1970)
Matt Lincoln (1970–1971)
The Storefront Lawyers (1970–1971)
Make Room for Granddaddy (1970–1971)

Now, in the second half of the 1960s, there were more than two dozen programs featuring black actors as leading characters, or in prominent, regular supporting roles. As in most of commer-

cial TV, many of the series achieved limited success and were eventually canceled. Several programs, however, were ratings favorites and lasted for years. It is important, too, that relative to their counterparts in earlier decades, the shows in this period were practically free of racial stereotyping. The above list indicates the scope of network programming featuring black stars in this Golden Age.

As it affected the history of blacks in American television, the most crucial series in the latter half of the 1960s was *I Spy*. The program premiered in 1965 and co-starred Bill Cosby and Robert Culp. It was clearly intended to capitalize on the popular interest in espionage dramas created by Sean Connery's success in several James Bond feature films, and by *The Man from U.N.C.L.E.*, a successful TV series of the previous season. *I Spy* related the exploits of two secret agents operating around the world to protect U.S. national interests. But unlike other spy shows on network TV—*Honey West, The Avengers, Secret Agent,* as well as *The Man from U.N.C.L.E.*—this program mixed its international intrigue with a slight touch of American wit. This was because of the presence of Cosby.

I Spy was the first network dramatic series to star a black actor. Not since the demise of *Harlem Detective* in 1954 had television attempted to feature a black detective hero. And *Harlem Detective*, of course, was a local show in New York City, not a network production. When *I Spy* appeared, NBC officials seemed pleased that only three stations—in Savannah and Albany, Georgia, and Daytona Beach, Florida—refused to carry the show. It was seen, however, on 180 other stations covering 96 percent of the country.[2]

The casting of Bill Cosby was a bold decision by producer Sheldon Leonard. While Culp came to the series as a veteran television actor who had starred in a Western program of moderate success, *Trackdown,* Cosby was a story-telling comedian whose greatest exposure on TV had been on Johnny Carson's *Tonight* program. Cosby was not only an unknown dramatic quantity, his role could have been played by a white man. Casting Cosby as Alexander Scott, the tennis trainer and traveling companion of Culp's character, fellow agent Kelly Robinson, broke the color line as had no series in TV history.

Cosby proved uniquely qualified for the part. His talent for

subtle comedy was matched by a dramatic skill which allowed
him to range with apparent ease between emotions of patriotism
and self-doubt, romance and intrigue. Cosby was successful in
the series. During the three seasons *I Spy* was telecast, he won
three Emmy awards as the most outstanding actor in a continu-
ing dramatic role. And he was popular with audiences. Accord-
ing to a TVQ performer-study by the Home Testing Institute in
1966, Cosby was one of the most popular stars in video—ranking
first with children twelve to seventeen years old, third with those
eighteen to thirty-four years of age, and tying for eighth with the
total audience.[3]

Ironically, the program's ratings did not match Cosby's tri-
umphs. Credit must go to NBC for maintaining the series for
three years when its highest seasonal rating was twenty-ninth
place, attained in its second year. During the other two seasons,
it failed to finish among the top thirty-five.

As well as being the first network drama with an African-
American star, *I Spy* was a landmark program for blacks in other
respects. Alexander Scott was placed solidly beyond the borders
of the United States, swept up in the dynamics of world affairs.
Often filmed in foreign locations, the weekly drama unfolded in
places like Hong Kong, Kyoto, and Mexico City—and in coun-
tries like Morocco, Greece, and Italy. In one program shot in
Greece, the picture of Bill Cosby walking amid the ruins of the
Parthenon, symbol of the Western democracy first nurtured in
ancient Athens, was a powerful testimony to the nature of the
entire series. For black and white viewers, it was an educational
experience to see an African-American hero operating construc-
tively abroad in the service of the United States.

Cosby's character was always equal to his encounters with
foreign agents, heads of state, beautiful women, and would-be-
murderers. He was unlike Shaft, Superfly, and other exaggerated
"superspade" characters developed in the so-called "blaxploita-
tion" films of the next decade. Alexander Scott was a real, ma-
ture human character—able to feel and express emotions histori-
cally forbidden to black characters in mainstream entertainment
media. In an early episode, Cosby actually kissed a Japanese
woman, a revolutionary act that was well beyond the perimeters
established for blacks in television.

More intimate still was Cosby's part in the episode, "Laya,"

aired September 25, 1967. Here Alexander Scott fell in love with a rival agent portrayed by Janet MacLachlan. While boundaries in film and radio traditionally ruled out physical expressions of interracial romance, even between blacks kissing and other demonstrations of affection were proscribed. Thus, when Scott romanced Laya, touching, caressing, and kissing her, another barrier to black artistic expression was shattered.

I Spy became an important program for other black actors. Many African-American performers played dramatic roles in the series. Among them were Eartha Kitt, Barbara McNair, Greg Morris, and Nancy Wilson. These guest stars often appeared in nontraditional parts. Diana Sands, for example, portrayed an Israeli agronomist. Ivan Dixon and Cicely Tyson played African royalty caught up in the propaganda war between East and West. And Leslie Uggams was an active part of a Communist conspiracy in Italy.

Directions in TV programming tend to relate to the values popular in American political life. To a great degree the slow but inexorable mixing of blacks into television in the early 1960s was a reflection of President Kennedy's activist and reformist mentality. And as Kennedy found support in public opinion, out of their need to placate government and please audiences, network and production executives began to respond with relevant programming.

During the presidency of Lyndon B. Johnson the cause of civil rights gained further governmental support. Succeeding the assassinated East Coast liberal Kennedy, Johnson was the first American president from a Confederate state (Texas) since Andrew Johnson a century earlier. Yet, LBJ was even more supportive of civil rights than his predecessor. Johnson envisioned the "Great Society," a reordering of social values to ensure minority rights and economic opportunity through the massive intervention of the federal government. New bureaus were created, and new programs were enacted in Johnson's "War on Poverty." New measures to protect black voting rights in the South were passed by a Congress that the president seemed to control. As an heir to the legacy of American progressivism, Johnson was forging his Great Society with the same fervor and vision with which Franklin D. Roosevelt had shaped the New Deal.

This was a time of intense reevaluation of racial attitudes.

From the outpouring of white support for civil rights legislation to the self-realization experienced by many African Americans, the late 1960s was a time of "black is beautiful." There were academic expressions of the new era, from black studies curricula and the rewriting of history to include strategic African-American personalities, to the training and employment of great numbers of black instructors. Culturally, the reevaluation was noticeable in such matters as the new sense of brother- and sisterhood among blacks, increased participation by blacks in intercollegiate and professional sports, the creation of a "black handshake," and the disuse of the terms "Negro" and "colored" and the substitution of "black" and "Afro-American." It was in this atmosphere that the Golden Age was achieved by blacks in television.

Not all black productions were successful in TV. Unlike *I Spy*, for instance, the *Sammy Davis, Jr. Show* was a disaster. As innovative as was Bill Cosby's dramatic series, the *Sammy Davis, Jr. Show* was the first musical variety program hosted by a black entertainer since the *Nat King Cole Show* had been canceled a decade earlier. Certainly, black stars like Lena Horne and Harry Belafonte had hosted specials since then, but in January 1966, Davis had his own program on the NBC network. And although it lasted only four months before being dropped, it established a model for programming later filled with varying degrees of success by Flip Wilson, Redd Foxx, Pearl Bailey, George Kirby, Bill Cosby, Leslie Uggams, Ben Vereen, the Jackson Five, and Marilyn McCoo and Billy Davis, Jr.

In critical terms, Davis' program was a failure. From the beginning Davis was hampered by contractual problems emanating from a previous arrangement with ABC. The rival network allowed him to host the premier show, but then compelled him to miss the next four telecasts. The show also lacked a national sponsor and was scheduled on Friday nights opposite such hit series as *Gomer Pyle, USMC* (the second most popular show of the season); *Hogan's Heroes* (ranked number nine that year); and *The Addams Family*. Although the program later improved its presentation, reviews of its premier telecast on January 7 were less than complimentary. *Variety* panned the program for its "shoddy production values—ranging from dull, cheap sets to sloppy editing and dubbing—or unimaginative scripting, feeble

scoring and a weak song catalogue."[4] And Cleveland Amory in *TV Guide* later criticized the program for its undistinguished production values, adding that "though there were many things wrong with this show, there are many more things right with it— and it is getting better every week."[5]

In its short run the *Sammy Davis, Jr. Show* opened the door for many black entertainers to gain national exposure. Some, like Diana Ross and the Supremes, Nancy Wilson, Leslie Uggams, and Diahann Carroll, were already well known because of TV and phonograph records. Others, such as the Nicholas Brothers and the Will Mastin Trio, were vintage performers seldom seen on television. And Davis introduced new talents—Lola Falana, Johnny Brown, George Kirby—whose careers would later flourish.

Ultimately, the *Sammy Davis, Jr. Show* failed because of the inadequate ratings it received. In the ratings and share-of-audience percentage figures—the guideposts by which television achievement is measured—Davis' program was unimpressive. While the show did attract millions of viewers, it did not appeal to sufficient millions to remain viable. This is not to suggest, however, that such measurements were accurate indicators. Various minorities and social groups often criticized A. C. Nielsen, Arbitron, Pulse, and the other market research companies which supplied the ratings. Among other charges, it was frequently suggested that these companies did not measure black viewers adequately, since an insufficient number of minority households was included in the measurement. While companies were quick to defend their figures and methods, by the end of the 1960s they did take steps to insure a broader representation by blacks and other minorities.

Whatever the shortcomings of the industry ratings figures, they remained the criteria by which popularity and continuance were decided. And in the case of several programs with black stars, they revealed an unprecedented popular approval. Never in video history had three shows with black central characters enjoyed success simultaneously. But by the end of the decade the ratings showed this to be the case with *Julia*, the *Bill Cosby Show*, and the *Flip Wilson Show*.

There is an aspect to most black performance in popular culture which is unique. Because there is comparatively little mi-

nority representation in radio, film, and television, and because each performance by an African American is regarded as a chance to make a statement about black realities, each appearance takes on added weight. Since few African Americans have as yet enjoyed the recurring exposure granted to the stars of hit TV series, when the black actor does achieve such success he or she is vulnerable to special criticism. If a role seems too accepting of white social dominance, the star as well as the character he or she is portraying may be attacked as too acquiescent. If the role is one of a middle-class suburban black, it may be assailed as too bourgeois and unsympathetic to inner-city "brothers" and "sisters." If the role involves no racial politics, it may be censured as not "black" enough. And if it is critical of social injustice, it may be assailed as hostile, radical, or heavy-handed.

In effect, in the late 1960s, whenever a black entertainer appeared, he or she was expected to represent all African Americans, embodying the panorama of black life from slum to suburb. Because of its patent failure to do this, no successful black series was more controversial than *Julia*.

As portrayed by Diahann Carroll, Julia Baker was the most assimilated black character ever to appear in the American mass media. Beyond the stereotyped mammies and maids of early TV, Julia was everything that Beulah, Sapphire Stevens, Madame Queen, and Oriole were not. She was middle-class and beautiful. She spoke English perfectly. She was a liberated woman, a self-supporting professional nurse living in a racially integrated apartment building. As a war widow, moreover, she was responsibly raising a wholesome "little man" son in a homey environment.

Julia made no pretense of dealing with contemporary social issues. Indeed, it studiously avoided them. A weekly visit with the Bakers involved the same simple problems encountered for decades on such shows as *I Love Lucy, Family Affair,* and the *Donna Reed Show.* Although Julia eventually coiffed her hair in an Afro and had black boyfriends played by Paul Winfield and Fred Williamson, the series refused to be topical. If there were racial references, they were one-line gags such as the question by her employer, a white doctor: "Have you always been a Negro, or are you just trying to be fashionable?" More typical of the series was the following telephone dialogue between Julia and her seven-year-old son, Corey, played by Marc Copage:

Corey: It's me, Mom.

Julia: And just who are you, sir?

Corey: Your son.

Julia: Mr. Corey Baker?

Corey: He's the only son you've got, aren't I?

Julia: Can you prove you're Corey Baker?

Corey: Just a minute, I'll go check in the mirror (musical interlude). It's me all right.

Julia: Are you sure this is the very same Corey Baker who's going to get on a plane tonight with his mother and fly all the way to Kansas for a vacation?

Corey: Yeh, and I just wanted to know if Earl J. Wagedorn can come with us.

Julia: Oh, Corey.

Julia could not have emerged at a less fortuitous time. With racial frustrations at a peak and with urban police often in a veritable state of war with inner-city rioters, the comfortable image of black success on *Julia* was in stark juxtaposition to the images seen on local and national newscasts. There was no H. Rap Brown, or SNCC, or Poor People's March in the world of *Julia.* Instead, in the words of Carroll, Julia Baker was a "white Negro," the overly good, overly integrated fantasy projection of white writers acting, they felt, in a manner sensitive to decades of TV prejudice. Carroll best summarized this situation when in 1968 she told an interviewer:

> With black people right now, we are all terribly bigger than life and more wonderful than life and smarter and better— because we are still proving. For a hundred years we have been prevented from seeing ourselves and we're all overconcerned and overreacting. The needs of the white writer go to the superhuman being. At the moment we're presenting the white Negro. And he has very little Negro-ness.[6]

From the time it premiered in the fall of 1968 until it was canceled in mid–1971, *Julia* was the focal point of criticism. Blacks ascribed a range of negatives to the series. Because the central character was female and husbandless, some felt it continued the matriarchal stereotype—the antimale, emasculating

pattern of traditional prejudice. Others felt it was unrepresentative of social reality and, therefore, subversive to the aims and methods of the civil rights movement. To others the program was a sellout intended, now that Richard M. Nixon was president, to assuage white consciences and make the curtailment of social programs and the repression of riotous ghetto dwellers palatable to white society.

Many whites also felt uncomfortable with *Julia*. Because it was produced by whites, the series seemed patronizing to blacks— a saccharine projection of the "good life" to be achieved by those blacks who did not riot, who acted properly, and worked within the system. Producer-creator Hal Kanter might protest that "this is not a civil rights show. What we're driving at is escapist entertainment, not a sociological document."[7] But the fact remained that given the added social implications present in all black performance, *Julia* could not be just another situation comedy.

Despite all these conflicting pressures, *Julia* was well received by viewers. It was the first black-starred series since *Amos 'n' Andy* seventeen years earlier to score well in the Nielsen ratings. It was the seventh most popular show in its premier season. In its second season it was ranked twenty-eighth. During its best year, *Julia* weekly reached an average of more than 14 million homes.

Sharing much of the same formula as *Julia* was the *Bill Cosby Show*, which ran for two years, 1969–1971. It, too, featured a nonmarried black character as its lead, as Cosby portrayed Chet Kincaid, a high school track coach and a bachelor. Similar to Julia Baker, Kincaid was middle-class, professional, and educated. Like *Julia*, moreover, the *Bill Cosby Show* placed its central character in an integrated environment.

Nonetheless, the *Bill Cosby Show* was obviously different from *Julia*. From the opening credits which featured Quincy Jones' earthy rhythms as background to Cosby's own soulful groans and jive lyrics, viewers were assured that although the program projected life in racial harmony, this program was extracted from the black experience, and possessed an esoteric quality African Americans alone could understand.

On the surface Chet Kincaid handled the problems faced by other heroes of situation comedy: helping a friend to quit smoking, trying to settle an argument between an aunt and uncle,

helping an intoxicated magician rearrange his life, dealing with personal jealousy over a coy girlfriend, trying to recruit a promising athlete to join the track team. Kincaid shook hands in a traditional way, never spoke in slang terms, and seemed equally at ease with wealthy whites and poor blacks.

But there was a black ambiance to the *Bill Cosby Show* that was missing in *Julia*. Rather than a "white Negro," Kincaid was black and proud. He might be pictured with a Ray Charles record album, or with a photograph of Martin Luther King, Jr. on the wall of his apartment. He courted attractive black women and worked with underprivileged children. White characters on the program were frequently stereotyped, as were his teaching colleagues—the sloppy and absent-minded Mr. Cutter and the intractable Mrs. Drucker, a shrewish woman hostile to male assertiveness. From the jazz musical score which occurred throughout the show, to the Afro coiffure and casual dress which typified Kincaid's appearance, the series was a statement about black life, an endorsement of the middle-class, educated black man who has not deserted the ghetto but moves gracefully between both worlds. Through his character, Cosby served to defang the contemporary familiar image of riotous blacks. He also suggested to blacks still in poverty that they were not forgotten by those who had obtained an education and credentials to operate in the wider, primarily white society.

The *Bill Cosby Show* was not a "black" show in the sense of attempting to project realities of inner-city life. During its first season, while Cosby did much to bring African-American workers into the craft and labor unions servicing the program, only one episode was written by a black writer. Further, because it was necessary to appeal to as broad an audience as possible, the program could not hope to show a discomfiting image to its viewers. So, with a cast integrated with blacks, whites, Asians, and Latinos, Cosby told an interviewer that the series sought to tell "an American story." According to Cosby, who was also executive producer of the series:

> I'm aware that the show will have a negative meaning for people who are really militant about any story with a black person in it—black viewers included. But you can still pick a guy's pocket while he's laughing, and that's what I hope to do.[8]

Despite the pattern of success established by *Julia, I Spy,* and the *Bill Cosby Show,* not all series featuring black stars were popularly accepted. *Barefoot in the Park* was a black situation comedy which lasted only thirteen weeks in the fall of 1969. It starred Scoey Mitchlll and Tracy Reed as a young middle-class couple living in a New York City apartment and struggling through the first years of marriage. The series had adequate supporting characters played by Thelma Carpenter and Nipsey Russell, and it was based on Neil Simon's hit Broadway play and motion picture. Nevertheless, *Barefoot in the Park* was a TV failure. Even before it premiered, trade papers reported dissension on the set between actors, directors, and producers. Further, the comedy in the series was uninspired, and the image of an attractive young couple kissing and joking their way through married life was already an overused format.

Equally ill-fated was the *Leslie Uggams Show,* a musical variety program that failed in the fall of 1969. The show featured Uggams as a singer, dancer, and host to guest stars. She also appeared weekly in a running skit called "Sugar Hill," in which she and Lincoln Kilpatrick played a middle-class black couple putting up with each other, as well as with her mother, brother, and sister. Intended by CBS as a replacement for the controversial and canceled *Smothers Brothers Comedy Hour,* the variety show lasted only three months. Its demise was due in part to Uggams' limited experience. As a singer on *Sing-Along with Mitch* for several years she was a creditable performer, but she was neither a comedy actress nor a variety show host. Further, resentment generated by the cancellation of the *Smothers Brothers Comedy Hour* practically guaranteed failure for whatever program replaced it.

As well as those programs featuring African-American stars as central characters, by the late 1960s there were several important series with blacks in co-starring or supporting roles. Clearly responding to the political, social, and economic dynamics of the time, the networks and production companies in unprecedented fashion brought black talents into highly visible roles in television.

These roles covered a wide range of characterizations, some familiar, some inventive. One of the major developments of the period was a return to the African locale as a setting for continuing series. Not since the days of *Ramar of the Jungle* and *Sheena, Queen of the Jungle*—both children's shows from the early

1950s—had a program set its white champions in the jungles and savannahs of Africa. *Daktari* concerned the activities of a white veterinarian working in East Africa to protect indigenous animal life. During the three-year history of the series, Hari Rhodes played a zoologist and assistant to the central character. *Cowboy in Africa* dealt with a white American rodeo star hired to bring modern ranching techniques to a large ranch in Kenya. The only black recurring character in this program was a ten-year-old native boy portrayed by Gerald Edwards.

These programs shared a familiar theme: the superiority of technological Western civilization over the backwardness of African society. Since the imperialistic nations took up the "white man's burden" in the nineteenth century, the image of civilized white people encountering black "heathens" who were "half-devil and half-child" was familiar in literature—and later in film and radio. In TV in the late 1960s, it reached its greatest realization in *Tarzan.*

Tarzan was an anachronism. In the midst of the African-American movement toward fuller civil rights, here was a picture of a light-skinned hero single-handedly bringing peace and justice to the "dark continent." At a time when former African colonies were independent and influential nations, the picture of actor Ron Ely in a loin cloth walking as the white champion among dark-skinned natives was racially disparaging and patronizing. Certainly, the program gave employment to talented but rarely utilized black actors, including William Marshall, Roy Glenn, Woody Strode, Brock Peters, Raymond St. Jacques, and Yaphet Kotto. But there was something unsettling about distinguished African-American actors speaking in broken English or wearing Hollywood conceptions of native African clothing.

Nowhere was this misuse of talent more visible than in "The Convert," a *Tarzan* episode that aired January 12, 1968. The story concerned three Roman Catholic nuns, played by Diana Ross and the Supremes (Mary Wilson and Cindy Birdsong), who attempted to persuade a stubborn village leader, portrayed by James Earl Jones, to allow construction of a hospital to serve his jungle tribesmen. The plot allowed the popular rock-and-roll group to sing two songs—"The Lord Helps Those Who Help Themselves" and "Michael, Row the Boat Ashore." And the story ended on a "happy" note. In the final scenes Jones an-

nounced that he had changed his mind and would allow the hospital to be built. Then, Ross and the Supremes joyfully began to teach him and his tribesmen to sing "Michael." Knowing that another African problem had been solved, Tarzan walked off into the jungle with a smile of satisfaction.

Ironically, even in its fictional entertainment programming television could present a more accurate image of Africa. "The Third Choice," an episode of *The Name of the Game* telecast March 7, 1968, exemplified this. The program depicted Ossie Davis, Janet MacLachlan, and Roscoe Lee Browne as deeply involved in African revolutionary politics, caught between the West and the East in an emerging new nation. From the opening scenes filmed in Lagos, Nigeria, this program was at odds with the simplicity of *Tarzan*. Viewers saw a modern Africa epitomized in a large coastal city with high-rise buildings, factories pouring out smoke, large ships in the harbor, modern bridges, railroads, and automobiles. The political dimension of the story also projected a more authentic interpretation of African society than that seen in the struggle between the Supremes and James Earl Jones. Stories like this—and others seen intermittently on adventure series such as *Mission: Impossible* and *It Takes a Thief*—suggest that American television was capable of escaping outmoded stereotypes when dealing with third world nations and peoples.

There may have been examples of network and producer insensitivity, but the fact remains that in this Golden Age blacks were used frequently—often in roles unfamiliar to African-American actors. In the wake of Bill Cosby's success in a dramatic series, several blacks appeared in police and private-detective series. Where in the past they might have been portrayed as victims or perpetrators of crime, blacks were now part of the law enforcement process. Whether it was Clarence Williams III as Linc Hayes, the reformed Watts rioter, now an undercover police officer on *The Mod Squad*, or Gail Fisher as Peggy Fair, the secretary and helper on *Mannix*, American audiences rarely had seen blacks in so flattering a light.

And African-American heroes worked for all types of legal agencies. On *Mission: Impossible*, Greg Morris portrayed Barney Collier, an electronics expert and member of the team of CIA-like agents who roamed the world thwarting evil developments

in foreign governments. In *N.Y.P.D.*, Robert Hooks played a police detective operating in New York City. In *Hawk* the location was also New York City, but here Wayne Grice played Detective Carter, the partner on the night beat of a police lieutenant of Iroquois ancestry, John Hawk (Burt Reynolds). Hari Rhodes abandoned his lab gown and zoologist's role on *Daktari*, and appeared now as a big-city district attorney on *The Protectors*, one of three programs composing NBC's *The Bold Ones* series. Related to this format also was Don Mitchell's characterization of Mark Sanger, the assistant and bodyguard to Raymond Burr's police consultant heroics on *Ironside*.

By the late 1960s, it was apparent that to be representative and appealing to a wide audience, TV series required black characters. This was most obvious in programs which spotlighted a group of Americans confronting various types of conflict and/or misunderstanding. Ivan Dixon played Sgt. Kinchloe, one of the soldiers held humorously in Stalag 13 on *Hogan's Heroes*. *The New People*, a short-lived series about a group of young American men and women stranded on a deserted island and forced to establish a new social order based on their 1960s values, featured David Moses as one of those struggling to make reality out of theory. The evening soap opera *Peyton Place* was integrated during the 1968–1969 season, when Percy Rodrigues and Ruby Dee, as Dr. and Mrs. Harry Miles, and Glynn Turman as their son joined the cast. And the ill-fated *Matt Lincoln* program, starring Vince Edwards as a psychiatrist, featured two blacks, Felton Perry and Chelsea Brown, as his assistants.

Blacks also entered genres traditionally closed to them. In the science fiction series *Star Trek*, Nichelle Nichols was the only recurring female and black member of the cast. Her role as Lt. Uhura, the communications officer of the starship *Enterprise*, was a sexual as well as racial breakthrough. Similarly, a black character was included in the science fantasy series, *Land of the Giants*. Struggling to survive in a world where everything except the crew of an American spaceship was twelve times larger than on earth, Don Marshall played the copilot of the aircraft which had crashlanded on a foreign planet in the year 1983. And Angelo Rutherford's role as the young black friend, Willie, on *Gentle Ben* took blacks into family-oriented adventure programming.

During the flowering of the Western in the late 1950s and

early 1960s, blacks seldom appeared on the dozens of series on television. In less than a decade, however, matters began to change. During the fall of 1965, Raymond St. Jacques appeared as Simon Blake, a drover on the faltering *Rawhide* series. St. Jacques appeared for only four months before the seven-year-old program was canceled. Between 1967 and 1970, however, Frank Silvera portrayed Don Sebastian Montoya, a distinguished Mexican nobleman and father-in-law of John Cannon, the central character on *High Chaparral*. In 1969, moreover, Roosevelt Grier, the former football star for the New York Giants and Los Angeles Rams, became a regular on the last season of *Daniel Boone*. Cast as Gabe Cooper, Grier portrayed a runaway slave who lived with the Tuscarora Indians and was accepted by them as Chief Canawahchaquaoo.

Considerably more significant, however, was the co-starring role of Otis Young on *The Outcasts*. During the 1968–1969 season, Young played Jemal David who, with a white partner, Earl Corey, played by Don Murray, was a bounty hunter in the post-Civil War wild West. Of all TV series featuring African-American actors, *The Outcasts* was the most intense and explosive. David was no socially adapted Chet Kincaid or patriotic Barney Collier. Bitter about the slavery experience and hostile to racism and the brutalization of blacks, he was a sensitive and combative man.

While the series was set in the frontier days of the nineteenth century, its attitudes were clearly reflective of racial sensibilities in the late 1960s. David's distrust of whites occasionally included even his partner Corey. In an episode entitled "Gideon," aired February 24, 1969, those feelings exploded after Corey met and reminisced with an old ex-slave, Gideon (played by Roscoe Lee Browne), who was once owned by Corey's father. The shuffling and servility shown by Gideon was offensive to David. And Corey's apparent pleasure in seeing the old man triggered a hostile scene between the partners.

David: Listen, Corey, I don't need you to stand up for me. I can fight my own fights.
Corey: What's the matter with you today? You're touchier than a lizard with sunburn. First you start pickin' on old Gideon, then you start callin' me "Massa Earl," like some endman in a riverboat show.

David: It wasn't meant to be funny. I just ain't interested in hearin' about him or any of your other used-to-be darkies.
Corey: And I'm not responsible for what a man calls me.
David: Oh, is that a fact? He just dreamed it up all by himself one day, decided that "Massa Earl" sounded better than "Mr. Corey" or "Earl" or any other way a man talks to a man.

In many respects *The Outcasts* was revolutionary. It challenged the traditional formula of the TV Western, treating innovative themes such as the place of black cavalry units—the so-called "Buffalo Soldiers"—in the history of the West; the brotherhood between two oppressed racial minorities, blacks and Indians; racial prejudice on the frontier; and life on a chain gang controlled by brutal and bigoted guards. Furthermore, never had TV projected a black champion in the Old West. But as such, David was forced to face such soul-searching issues as being falsely accused of having killed a white woman; coping with a hooded night rider intent on pillaging the countryside in revenge for the Confederate loss in the Civil War; and temporarily becoming the sheriff of a racially prejudiced town.

The series also broadened the expression of black manhood on television. In one episode, David risked his life to save a white child from death. In another, he fell in love with a black woman, only to discover she was involved in a robbery scheme masterminded by a white man. In still another episode, he was compelled to deal with an old black servant who became angry when David ate at the table with whites and "acted like a white man." The old man later explained that his own son had been murdered for acting like a white man.

One of the most revolutionary scenes in the entire series occurred in "Gideon." It showed a black man unwrapping a long hunting knife and calmly plunging it into the chest of a white bounty hunter. Several years later a black writer recalled the impact of this incident upon one black viewer:

> One of the best shows I used to like was *The Outcasts*, and it wasn't too long before they cast it out and off the air. It had a feeling of truth to it somehow or other. I especially liked that time when Roscoe Lee Browne was on that show and killed that *White* man. That was beautiful.[9]

While film historians have spent much energy pointing out the emergence of the strong, macho black character so crucial to the blaxploitation films of the 1970s, Otis Young as Jemal David was clearly the first modern black hero to lash out at white society when he felt it to be oppressive or unjust. Long before the "superspade" films like *Sweet Sweetback's Baadasssss Song* (1971) and *Shaft* (1971), David as a central character in *The Outcasts* projected an image that was self-sufficient, virile, and threatening.

Personally Young seems to have harbored as much distrust of white society as his character. *TV Guide* in 1969 reported that his refusal to cooperate with his producers—in one case, refusing to say the line, "Ain't nothin' like darkies for prayin' "—led to considerable tension on the set of *The Outcasts.* Young defended his editing of the script, noting that "the line is an insult to Negroes." In language reminiscent of Paul Robeson's defiance, Young continued:

> If this line went through, the next thing they'd have up there is Stepin Fetchit. If I compromised myself on this script, it would be a little easier next time, and in three or four years I'd wake up one morning and be a wealthy Negro who forgot who he was. . . . The thing that affected my decision about this line was my responsibility to Negroes in this country. White people think there's nothing like darkies for dancing, there's nothing like darkies for singing, and there's nothing like darkies for praying. Well, that's a lie. The segment of Negroes that is praying instead of *doing* is dying off. We have a new Negro that hasn't even been to church. One of the things that has hung the Negro up is that he's been too busy praying in the white man's church. This has kept him under the hand of the white Establishment. Any Negro today who is praying instead of *doing* is a damn fool.[10]

The Outcasts failed for several reasons, among them its poor scheduling on ABC opposite feature films on NBC and *Mayberry, R.F.D.* on CBS. Westerns themselves were no longer popular with TV viewers by the late 1960s. The program also failed because of the hostile quality of its black characterization. Although the product of white script writers, Jemal David was one of the most threatening black fictional figures since D. W. Grif-

fith introduced a black would-be rapist lusting after a white girl in his film, *Birth of a Nation* (1915). That image of a strong and assertive black male, which film historian Don Bogle has termed "the brutal black buck,"[11] had been absent from the mainstream of American popular culture until the appearance of the brooding, quick-tempered bounty hunter created by Otis Young. *The Outcasts* and David anticipated by three years the violent and intensely angry black males in feature films in the 1970s.

The rage apparent in the words and actions of David and Young suggests a militancy traditionally proscribed from network television. The pattern of excluding black anger had been established early in TV history with the banning of Paul Robeson from the medium. While the participatory perimeters of video had expanded since the days of Nat King Cole, the ideological boundaries remained intact. TV could adopt moderate performers like Diahann Carroll, Bill Cosby, and Sammy Davis, Jr. But there was still little place for those entertainers or characters, real or fictional, who brought strongly political perspectives to their performances.

This is not to disparage those African-American talents who found success in television. It is to suggest, however, that American mass culture continued to operate as a conservative, assimilative force, seeking to maintain social stability while gradually merging people of differing backgrounds into the cultural mainstream.

The process had worked effectively with the waves of immigrants who had come to the United States in the nineteenth and early twentieth centuries. While they maintained vestiges of their old cultures—dress, food, dance, music, secondary language skills, and observance of holidays—they eventually were Americanized and became socially indistinguishable from other citizens.

American blacks, the offspring of reluctant immigrants who in earlier centuries were brought forcefully to the New World to be slaves, faced a different set of circumstances in the process of assimilation. Hampered by an institutional racism that stripped them of their African culture while disallowing their absorption into the mainstream of American social life, blacks had been kept historically rootless. To ensure their servility after the laws of slavery were abolished in the mid-nineteenth century, blacks

were isolated, culturally circumscribed, and made objects of derision within the dominant white culture. In this way, American popular culture ensured second-class political status for the offspring of ex-slaves.

The significance of the civil rights movement which flowered in the mid-1960s was that for legal, economic, political, and moral reasons, the dominant culture began to reevaluate its proscription against full participation by blacks. As never before in history, African Americans now had a chance to enter the social mainstream, to find educational and professional opportunity, and to achieve personal and familial satisfaction working within the system.

Given this situation, it is obvious that an immoderate series such as *The Outcasts* could not survive on television. Beyond the limits of popular acceptability, its anger was out of harmony with the cultural process. Much more congruent with American cultural dynamics was the successful ABC series, *Room 222*. Better than any other program focusing on blacks in the Golden Age, *Room 222* mirrored the ambiance of social change that was a part of the late 1960s, while operating within the boundaries of cultural possibility. In this regard, *Room 222*, and not *The Outcasts*, stands as the "best possible" black-starred show to emerge in the late 1960s.

Room 222 was a schoolroom dramatic series set in urban Walt Whitman high school. It featured Lloyd Haynes as a compassionate teacher whose lessons in black history were often interrupted by the real-life problems of the integrated student body. Stories dealt with issues affecting contemporary American teenagers: drug addiction, cheating on exams, sexual attitudes, recalcitrant and nonconformist students, insensitive teachers, limitations on student rights, and social issues such as women's liberation, consumerism, and the environmental crisis. Frequently, the program dealt specifically with racial themes: President Lincoln's racial views, tutoring a ghetto youngster, the varieties of prejudice, and the like.

The program, however, did not have to approach racial problems directly to deliver its egalitarian point. The fact that Haynes, the main actor, was black, and that the prominently displayed school counselor played by Denise Nicholas was also African American, made *Room 222* a series with a reformist mes-

sage. The sympathetic characters portrayed by Haynes and Nicholas represented a positive statement about black middle-class success. In charge of young lives, here were responsible black adults making all the right moves. The basic integrity and law-abiding nature of the African-American students in class also communicated a hopeful lesson about those struggling to leave the urban ghetto and enter the flow of American life.

There was no rage here. The professionals in *Room 222* had achieved. They were laboring now so that black youngsters could follow them to the American Dream. The black heroes were allowed vestiges of African-American culture—Afros, colorful clothing, and a sensitivity toward younger "brothers" and "sisters" seeking equal opportunity. But the same central characters were well adjusted to the suit-and-tie regimentation of their careers and identities within the mainstream. Not simply principals in a TV series, these were role models of what "the good life"—a world of rational thought, attractive people, and financial sufficiency—offered for those who would abandon bitterness and work to overcome within the system.

Despite the cancellation of *The Outcasts* and the success of *Room 222, Julia,* and the like, anger was an integral part of black existence in the late 1960s. If the intensity of that anger were to be encountered on television, it would not appear on entertainment shows. It would have to be seen in nonfiction TV, in that realm of news, documentary, and public service programming which—despite boundaries established early in the case of Paul Robeson—still had helped make the civil rights issue a problem of national scope.

11

TV in the Age
of Urban Rebellion

As a medium of communication, television both reflects and creates public consciousness. Public opinion is formed in great part through the images and information transmitted by video. There can be no doubt that scenes of protest against racial injustice communicated nationally through TV in the early 1960s did much to win popular support for meaningful reform. While Supreme Court rulings and the actions of black leaders would have occurred without television, the existence of the visual medium ensured that protests against bigotry would transcend race and religion. To a great degree, the awarding in 1964 of the Nobel Peace Prize to Martin Luther King, Jr. was a testimony to the global implications of the civil rights movement created via television.

During its first decade, the movement was tied firmly to a strategy of nonviolence and civil disobedience. Television showed blacks and sympathetic nonblacks undertaking sit-ins, freedom rides, protest marches, and the like. The gospel music which often accompanied such images revealed the strong attachment of the early movement to black religious organizations, particularly the Southern Christian Leadership Conference (SCLC) of Reverends King, Ralph David Abernathy, Jesse Jackson, Andrew Young, and Hosea Williams.

During this first decade television focused overwhelmingly on the racial problem in the South. This is where the movement began. The first black leaders were from the South. And with its

brazen Jim Crow laws and public examples of segregation, racism was most obvious in that region. Although the Supreme Court case outlawing "separate but equal" schools concerned educational facilities in Topeka, Kansas, it was in the South that the first confrontations occurred on matters of school integration.

But change was slow. There were political promises, but few fundamental social changes to end racism, open doors of opportunity, and render blacks politically, socially, and economically equal. Importantly, too, frustrations mounted precisely in those areas of the United States where racial problems were not frequently seen on television—the urban centers outside the South. Following the climactic summer of 1963, however, TV began to reflect this new phase of the black social movement.

Certainly there would be other black triumphs in the South. Among these would be the registration of African-American voters during the Mississippi Summer of 1964, and the Selma-to-Birmingham march in early 1965. But beginning with the riots in Harlem in the spring of 1964, the geographic focus and internal structure of the civil rights movement changed. The urban North, Midwest, and West now experienced violent reactions as impatient blacks demanded immediate rescue from second-class citizenship. As rage grew throughout the late 1960s, many major American cities erupted in racial rebellion.

The cities traumatized by race riots during this period constitute a list of the principal urban and industrial areas in the nation. In the search for jobs and a better way of life, millions of blacks had migrated to these centers for two decades. Leaving the poverty and segregation of the South, these migrants had come to cities like Chicago, New York City, Cleveland, Los Angeles, and Detroit to achieve their American Dream. What they encountered, however, was often more nightmarish than the conditions they had left. Faced with unemployment, dilapidated ghettos, unfamiliar and subtle forms of discrimination, and handicapped by inadequate technical skills, by the mid-1960s many migrants abandoned moralistic Christian leadership and drifted into leaderless, spontaneous rebellion. Looting and burning often replaced passive resistance and religious principles. In 1967 alone, there were eight major disorders, thirty-three serious outbreaks, and 133 minor disorders. Only 16 percent of these

outbreaks occurred in the South. The following list of major racial rebellions of the 1960s clearly places the riot phenomenon in the industrial North.

New York City/Harlem—1964	Plainfield, New Jersey—1967
Los Angeles/Watts—1965	Tampa—1967
San Francisco—1966	Newark—1967
Milwaukee—1967	Rochester—1967
Detroit—1967	Chicago—1968
Cincinnati—1967	Washington, D.C.—1968
Minneapolis—1967	Memphis—1968

As black anger grew, old leaders lost influence and were replaced by more bellicose younger spokespersons. By 1967, phrases like "black power," "burn, baby, burn," "freedom now," and "off the pig," replaced earlier appeals to black and white consciences. Now leaders like Stokely Carmichael, head of the Student Non-Violent Coordinating Committee, spoke openly of blacks arming for purposes of self-defense. This was the time when Eldridge Cleaver, information minister of the Black Panther party, conducted his national campaign for the presidency of the United States under sponsorship of the duly registered Peace and Freedom party. During this period James Foreman of the Black Economic Development Council issued a controversial "black manifesto" and demanded—and received—large sums of money from American churches as atonement for centuries of white exploitation of African Americans. This was also a time when H. Rap Brown of SNCC justified urban rioting with the phrase, "violence is as American as cherry pie" and terrified many with the prediction that inner-city violence was only a "dress rehearsal for the revolution."

To many people revolution seemed at hand following the assassination of Martin Luther King, Jr. in April 1968. Rage spilled into the streets, and armed troops were needed in many locations to reestablish social order. Pictures of American soldiers bearing rifles in front of the Capitol, while streams of smoke rose in the background from the ghetto of Washington, D.C., told most dramatically the depth of racial anger. Such pictures also revealed how disenchanted urban blacks had become with the passive resistance tactics of the early civil rights movement.

TV not only covered the inner-city rebellions as they erupted, it occasionally predicted their occurrence. Six months before the Harlem riots, *CBS Reports* looked frankly at "The Harlem Temper." Aired on December 18, 1963, this documentary looked at the poverty and anger in the New York City ghetto. It showed the recruiting under way for direct action groups like the Congress on Racial Equality, and for the nationalist Black Muslim religion. The program warned that as Harlem blacks became increasingly disenchanted with the pace of social progress, extremist solutions became more attractive.

In a similar vein, two and one-half years before San Francisco experienced racial rioting in its Fillmore District ghetto, author James Baldwin rocked the self-complacency of that "liberal" city when he attacked San Francisco's racism in a National Educational Television program, "Take This Hammer." In the program, which was aired in February 1964, Baldwin accused the city of racial hypocrisy. "In San Francisco it's all whitewashed," he commented, "it's under the rug. I suppose no one in San Francisco has any sense of what a dangerous area this is."[1] Rioting in San Francisco began in September 1966.

Televised coverage of domestic rebellions in the late 1960s ranged from pictures gathered safely behind police or national guard lines, to live "battle action" obtained in helicopter flights into the thick of the rioting. Independent station KTLA in Los Angeles won awards for its spectacular helicopter coverage of the Watts riots in 1965. Evading bullets aimed at the aircraft, KTLA personnel emerged with dramatic pictures of homes and commercial buildings in flames, of looters sacking department stores, and of social anarchy. Coverage by KTLA, however, provoked criticism. To many, such pictures only encouraged further arson and looting. Others felt it also created widespread panic among the white population.

Similar praise and criticism were heard about the video coverage of the San Francisco rioting. During that violence, TV newsmen were so close to the action that several were attacked and beaten. Station automobiles and television equipment were destroyed by rioters. Yet in addition to showing the riot in progress, TV lent itself as a forum for the discussion of ideas and pacifying communications from Mayor John F. Shelly. At the request of Governor Edmund G. Brown, a major league baseball

game between the San Francisco Giants and the Atlanta Braves was televised from Atlanta, even though it was not scheduled to be seen in San Francisco. The fairness with which local TV handled the violence prompted Dick Gregory to remark that "compared to the bigotry and blindness of other riot cities, this honestly is something else."[2]

Not all Americans shared Gregory's opinion of the effectiveness of the media, particularly of television and its role in covering unrest. Many viewers, city officials, and even TV news personnel charged that the presence of TV cameras in a riotous situation actually inflamed the situation. According to one network newsman, John Schubeck, "today a good many scenes have been created by the cameras." Of the riots in Detroit and Newark, he contended that "the television cameras had a great deal to do with it."[3]

Others assailed the sensationalistic nature of television pictures from a riot area. Still others attacked the distortions and misrepresentations competing video newsmen perpetrated in their competition for TV visuals. The mayor of Chicago, Richard J. Daley, articulated the feelings of many in local government when in 1966 he told a conference of broadcast news directors:

> Regardless of how objective radio or television news editors may wish to be, they cannot present a fair presentation, a fair evaluation, of an important and complex issue in two or three minutes. This, perhaps, is the crux of the "communications dilemma." . . . Coupled with this is conformity to the axiom of applying the standard: "Where is the action?" This has become nearly an obsession with some news editors.[4]

Ironically, as the civil rights movement degenerated into urban rebellion, television's interest in black social problems diminished. One reason for this was the growing attack on video for popularizing the idea of rioting. TV was clearly sensitive to the white backlash which materialized nationally. As many grew tired of civil rights issues and fearful of racial unrest, television became the target of those who felt that the medium was planting seeds of rebellion via its news stories and documentaries. Some felt the medium was too lenient with black protesters. Others alleged that without the catalytic presence of TV cam-

eras, local disturbances would not have become full-fledged riots with national implications.

There were, furthermore, new social issues occupying the energies of Americans. In particular, white middle-class reformers who had been crucial to the civil rights movement in the early 1960s turned now to fresh crusades, among them ecological concerns, consumer issues, and the budding women's liberation movement. Even more pressing was the matter of the war in Vietnam. Scarcely an issue when the black social movement was making its first gains, the Vietnam war became the nation's most divisive concern by the mid-1960s. For many years American troop commitments had been small in Southeast Asia. The bulk of early draftees had come from poor white, black, and Latino social elements. With the escalation of hostilities under President Johnson, and with the cancellation of college deferments and the conscription of middle-class, college-enrolled white males, critical attention was increasingly focused on the Vietnam war. Indicative of this new orientation, by 1967 *ABC Scope*—a distinguished prime-time documentary series notable for its coverage of the civil rights movement—was devoting each weekly program exclusively to developments in the war.

The decreasing TV interest in black social problems was also a reflection of the disintegration of the civil rights movement. Despite a decade of significant legal and moral victories, the movement was collapsing. By the last years of the decade, SCLC, CORE, SNCC, NAACP, and other black groups were weakened. The Black Muslim religion was split between advocates of Elijah Muhammad and those who still supported the slain Malcolm X. Many key members of the Black Panther party were dead, in exile, or in jail. And former firebrand leaders like Stokely Carmichael, Floyd McKissick, and James Farmer had either left politics or now worked for the white Establishment.

The degree to which leaderless blacks remained segregated within American society was powerfully summarized in the Kerner Commission report published in 1968. Responding to urban violence, President Johnson in July 1967, had appointed a Commission on Civil Disorders to analyze the causes of the rioting. Headed by former Governor Otto Kerner of Illinois, the commission discovered a society drifting headlong toward apartheid. It blamed white racism for the violence of black protest.

"What white Americans have never fully understood—but what Negroes can never forget," the commission reported, "is that white society is deeply implicated in the ghetto." The report continued, "White institutions created it, white institutions maintain it, and white society condones it."[5]

While there were increasingly fewer documentary considerations of black social problems after the early 1960s, nonfiction television did offer several significant reports. These broadcasts, moreover, reflected the directions and relevancy of the civil rights movement by this date. An *NBC Special* on June 11, 1967, "After Civil Rights . . . Black Power," contrasted the views of radicals like McKissick and Carmichael with moderates like King and Charles Evers of the NAACP. The white backlash phenomenon was treated in two outstanding *CBS Reports* programs: "Ku Klux Klan" on September 21, 1965, and "Black Power—White Backlash" on September 27, 1966. Riot cities were frequent topics immediately after violence exploded. Even months after such outbursts, their implications were probed. Such was the case with the *CBS Reports* program, "Watts: Riot or Revolt?" aired on December 7, 1965, four months after racial rioting in the Los Angeles ghetto resulted in 35 dead and 947 wounded.

More comprehensive as a study of urban rebellion was the NBC documentary, "Summer '67: What We Learned," which was aired September 15, 1967, and told the story of the race riot in Detroit. Produced by Fred Freed and featuring newsmen Frank McGee and Bill Matney, this program sought to explain the conditions which caused such a devastating toll: 43 dead, 386 injured, and 477 buildings damaged or destroyed. With images of Detroit that resembled Germany in 1945, this documentary immediately tied this rebellion to uprisings throughout the nation that summer.

> There is a great temptation to become shrill about what happened here in Detroit in July. That is a temptation we wish to avoid. Today, more than at any time any of us can remember, is a time for truth, and hysteria is no friend of truth. Some of what you will see may make you angry. But if it does no more than make you angry, we will have failed in our purpose. If it does not expose you to the desperation that breeds the outrageous and lawless things being said and done by some Ne-

groes, if it does not impress you with the absolute urgency of relieving that desperation, we will not have communicated what Black America is trying to tell White America. For we believe that the greatest single need in America today is for communication between blacks and whites. But there can be no communication between minds closed by anger.[6]

Urban poverty, increasingly seen as a root cause of violent demonstrations, was the subject of several programs in 1967. "The Tenement" was a CBS program on February 28, in which producer Jay McMullen lived for nine months in a Chicago slum tenement and recorded how impoverished living conditions— large families, insufficient food, loneliness, and lack of relationship with the white society—trapped otherwise religious and hopeful African Americans who still expressed dreams of a better life for their children. An *NBC News Special* on October 27 analyzed the attempt by the Office of Equal Opportunity to establish a legal services program. "Southern Accents, Northern Ghettos," an ABC *Summer Focus* documentary aired July 6, dealt with the plight of southern blacks who had migrated to the ghettos of the urban North where they were forced by circumstances to subsist on welfare payments.

Also of importance was "Same Mud, Same Blood," an *NBC News Special* aired December 1, 1967. It concerned the role of black soldiers in Vietnam. Focusing on the Army's 101st Airborne Division, its battle scenes made this more an antiwar program than a discussion of integration in the military. There were pictures of an integrated platoon being led by a black sergeant, but as *Variety* reported, "the blood and the mud—the plain inferno—which emerged in the pure graphics of the piece indeed swallowed the race theme."[7]

Significant, too, were the many explorations of the race problem telecast in the last 1960s by National Educational Television, and its later incarnation, the Public Broadcasting Service. Although production budgets and audiences for ETV/PBS documentaries were small, public TV offered some of the frankest treatises on the subject. The limited run series *NET Journal* probed the sociology of domestic unrest in "Black Militancy— Color Us Black"; the dilemma of the African-American bourgeoisie on "Still a Brother—Inside the Black Middle Class;" the

war on poverty in "The Cities and the Poor;" and the dysfunctional criminal justice system on "Justice and the Poor." On the controversial showcase *Public Broadcasting Laboratory (PBL)*, public TV treated the problems of student busing in the suburbs of Chicago on "Hear Us, O Lord!," and the frustrations of poor black families in "Gordon Parks' Diary of a Harlem Family." And on *America's Crises*, the inferiority of education in slum schools was examined on "Marked for Failure."

In the midst of its considerations of African-American problems, network television occasionally treated the African connection. Nowhere was the newly recognized importance of Africa more fully explored than in an ABC four-hour special devoted to the political, social, and economic significance of the continent, and narrated by Gregory Peck. The network, on September 10, 1967, devoted an entire Sunday evening to analyses of such matters as the historic depth of African civilization, tribal influences in modern politics, African arts, lingering white domination in several countries, the African role in the slave trade, and the American political stake in the international politics of the emergent continent.

As revealing as these documentaries were, they were among only a small number of nonfiction broadcasts devoted to black issues. For several reasons, however, commercial TV rediscovered African-American problems in 1968, when an unprecedented number of news documentaries poured from the networks. One reason for this reevaluation was the issuance of the Kerner Commission report. Government officials called in network executives for lengthy meetings on the report, urging the executives to devote more coverage to black problems. This was also an election year, and the candidates—particularly Robert F. Kennedy—were especially vocal regarding such problems. Further, in the wake of the assassination of Martin Luther King, Jr., and the national wave of racial violence it precipitated, civil rights surpassed Vietnam as the most pressing domestic concern. In this atmosphere, the three commercial networks focused public affairs programming on the African-American situation. At no time was this scrutiny more intensely noticeable than during the summer months.

As figure 11.1 suggests, the interest of network television in black problems in the summer of 1968 was unprecedented. Dur-

Figure 11.1: Network Documentary Programming, Summer 1968

Date	Series and/or Program Title	Network
6/24	*The Cities I:* "A City to Live In"	CBS
6/25	*The Cities II:* "A Dilemma in Black and White"	CBS
6/26	*The Cities III:* "To Build the Future"	CBS
6/27	*Time for Americans I:* "Bias and the Media—Part I"	ABC
7/2	*Of Black America I:* "Black History: Lost, Stolen, or Strayed?"	CBS
7/9	*Of Black America II:* "The Black Soldier"	CBS
7/11	*Time for Americans II:* "Bias and the Media—Part II"	ABC
7/12	*What's Happening to America?* I	NBC
7/14	*Time for Americans III:* "Newark: Anatomy of a Riot"	ABC
7/15	*Time for Americans IV:* "Prejudice and the Police"	ABC
7/16	*Of Black America III:* "Black World"	CBS
7/19	*What's Happening to America?* II	NBC
7/23	*Of Black America:* I (repeated)	CBS
7/26	*What's Happening to America?* III	NBC
7/27	*Time for Americans V:* "Can White Suburbia Think Black?"	ABC
7/28	*Time for Americans VI:* "White Racism and Black Education"	ABC
7/30	*Of Black America:* IV "Body and Soul"	CBS
8/9	"Justice for All?"	NBC
8/13	*Of Black America V:* "The Heritage of Slavery"	CBS
8/16	*What's Happening to America?* IV	NBC
8/20	*Of Black America VI:* "In Search of a Past"	CBS
9/2	*Of Black America VII:* "Portrait in Black and White"	CBS

ing this period of what *Variety* termed "video's rush to black,"[8] each network produced at least one distinguished series surveying a wide variety of relevant topics. None was more striking than the seven-part CBS production, *Of Black America.*[9]

This series had a two-fold purpose: to illustrate to white viewers the ramifications of chronic American racism, and to show black viewers their legitimate place in the United States and in the world. The first goal was accomplished most powerfully in the premier broadcast, "Black History: Lost, Stolen, or Strayed?" With Bill Cosby narrating in a tone of understated impatience, viewers encountered the distortions of black history so long accepted by the white majority. Cosby quoted historical inaccuracies from one of the most popular college textbooks. He raised to consciousness the names of black achievers that history books seldom mentioned. But most memorably, Cosby pre-

147

sented a lengthy pastiche of excerpts from Hollywood films illustrating the dehumanizing stereotypes of African Americans that white moviegoers had accepted for so long.

The montage of vintage film clips was an indictment of Hollywood motion pictures and American popular culture. Here was the white child actress, Shirley Temple, standing fearlessly in the face of danger and giving commands while a shuffling black man stood trembling and babbling nonsense. Here were the racist distortions of more than a century—the watermelon-eaters, chicken-stealers, razor-toters, dancin' and grinnin' darkies, coons, Uncle Toms, mammies, and pickaninnies. These offensive caricatures were usually portrayed by decent African-American actors. But since they were the only images acceptable in motion pictures produced for white audiences, they were the only roles open to black actors in Hollywood, and the principal self-images and role models blacks were asked to accept in motion pictures.

However, juxtaposing these older film segments with scenes from *Guess Who's Coming to Dinner*—a recent movie in which Sidney Poitier played a doctor in love with the beautiful daughter of a liberal white couple—the program suggested that a new world was in the process of being born.

"Black History: Lost, Stolen, or Strayed?" hit a responsive chord with the American public. Its writers, Perry Wolff and Andy Rooney received Emmy awards. The episode was so well received that CBS reran the program in prime time three weeks later. The program was later sold on 16 mm film to high school and college film libraries and is still seen by thousands of students yearly.

Other installments in the *Of Black America* series dealt with the accomplishments of African-American athletes, musicians, and soldiers. One featured a conversation between black leaders Floyd McKissick and Congressman John Conyers, and two African statesmen, Tom Mboya of Kenya and Dr. Alex Kwapong of Ghana. Another treated the history and legacy of slavery which, in its contemporary manifestations, ranged from a black militant declaring that "Mississippi is gonna either have to change or there can be no more Misissippi," to a white Chicagoan proudly describing himself as a "practicing bigot."[10]

A unique dimension of the African-American question was probed in an episode entitled "In Search of a Past." Here CBS

148

sought to prove that while American blacks had not been integrated into American society, neither could they reaffiliate with Africa. The program suggested that, caught between worlds, blacks might appreciate their ancestral continent, but could not escape their struggle for equality and purpose in the United States. For this episode, the network selected three black high school students to spend several weeks in Ghana. In that West African nation the students soon realized that to the Africans they were simply black-skinned foreigners, welcome as visitors, but not as co-nationalists. In their closing remarks, the students and CBS correspondent Hal Walker made a telling point.

1st Student: You see, what we have to do is take care of what we've got, where we're at. . . .

2nd Student: If you were born in America, and you work in America, and you fought for America, it'd be kinda hard to just get up and come to Africa. Everything you fought for is in America. . . .

1st Student: We, as black men, are proud of being black men. We are not gonna run over here now, because the white racism is so strong up there. We're gonna get ourselves together and we're gonna change it.

Walker: On June 20th, Mattie, Gail, and Steve left for home—a home that still denied them equality with other Americans, but their home nevertheless.

Many spokespersons and issues were presented in the unprecedented coverage of the racial condition during the summer of 1968. In its four-part series, *What's Happening to America*, NBC invited a black leader, Dr. Harry Edwards, to discuss black politics in sports, in the wake of the "black power" clenched-fists raised by John Carlos and Tommie Smith during the awards ceremony at the Olympic Games in Mexico City. The noted psychologist Kenneth Clark in another installment argued that America's problems had finally caught up with the nation, and that as for the violence so spectacularly seen on television, "America has always been able to stomach large amounts of violence against minorities. The outrage juices flow easier when violence is directed at upper status folks."[11]

Nonfiction TV examined the African-American condition

from various angles: housing and employment discrimination, the decay of the American city, legal inequality, police brutality in the black community, and the future of blacks in the United States. No program was more compelling, however, than the discussion of "Bias and the Media" aired June 27 as part of ABC's six-part study of American racism, *Time for Americans*. At the request of Harry Belafonte, the guests were separated, allowing black speakers to make their charges on a first program. White defenders responded two weeks later on a second program.

In the first installment, a national audience heard a bitter complaint about the lack of opportunity in the entertainment field for minorities. The four black guests were Belafonte, Lena Horne, Harvard sociologist Dr. Alvin Poussaint, and poet-scholar Lawrence Neal. Belafonte attacked the lack of black input in network programming, the failure of TV to utilize black talent, and network preoccupation with profit margins instead of human concerns. Horne assailed the advertising industry for not selling black performance to advertisers. While Poussaint seemed more moderate in his perception that black achievers in entertainment were still the exceptions, Neal angrily noted that until blacks possessed their own stations and networks, the problem of bias would persist. What had been billed as a discussion became a heated denunciation of the white-dominated mass media for their "viciousness and bestiality" toward African Americans. To critic Les Brown, "It was as though the stopper has been pulled on years of bottled-up resentment."[12] And when six white representatives of the mass media—including two ABC executives, an official from an advertising agency, and three journalists—made their response on July 11, another reviewer concluded that "if their confused, naive rationalization of the status quo plus slow progress constitutes the sum of media corporate policies on the race question . . . equality is not even on the American agenda.[13]

It would be an overstatement to say that no gains by blacks occurred in TV's relative Golden Age in the late 1960s. Gradually, if grudgingly, stations and networks made moves to employ blacks before and behind the cameras. In local stations, black news reporters appeared, occasionally as anchors, more often as correspondents, community relations personalities, or sports reporters. On network TV, black reporters like Mal Goode, Hal Walker, Bob Teague, Bob Ried, Bill Matney, and George Foster

were seen regularly reporting stories not only related to race. Interestingly, however, racial rioting throughout the decade compelled stations and networks to hire more black reporters and cameramen as white personnel often feared to enter racially explosive areas.[14]

As well as the entertainment programs on which blacks increasingly were starred or co-starred in the late 1960s, a small number of African Americans were making important inroads as writers, directors, producers, and station executives. These were strategic first steps because they held forth the opportunity of sharing with all American viewers new artistic and informational insights into the black experience.

Black spokespersons had long contended that African-America was different from white America. John Oliver Killens promoted that idea when he wrote in 1970 that:

> White writers, intentions notwithstanding, cannot write about the Black experience, cannot conjure up a true Black image, cannot evoke the wonderful—sometimes terrible—beauty of our Blackness. . . . only club members can sing the blues because we're the one's who paid the dues—of membership in the Brotherhood of Blackness.[15]

Even earlier a white writer, Arnold Perl, in his *East Side/West Side* episode "Who Do You Kill?" had George C. Scott speak similar words to James Earl Jones: "I don't know what any man would say who looks like I do. I don't think any white man knows what it's like, the life of a Negro—sympathize, project, understand, but know?"

As was suggested by George Norford—the first black producer and executive in network television when he joined NBC in the late 1950s, and later a general executive with Group W (Westinghouse Broadcasting Company)—by the end of the 1960s "the television picture had been changing, albeit not rapidly enough."[16] And statistics from the three major networks in 1971 reveal important changes underway in minority employment in all aspects of the television industry (figure 11.2).

If it would be too simple to dismiss this "rush to black" as insignificant, it would be naive to assume that it represented either fundamental changes in race relations, or the realization of

151

Figure 11.2: Minority Employment in the TV Industry, 1971

Title	1967 Black Percentage	1971 Minority Percentage Network		
		A	B	C
Managerial and Executive	1	5.7	7.0	4.5
Sales	2	4.0	9.1	10.3
Crafts	3	12.8	11.1	8.0
Office Employees	9	18.0	24.5	30.3

the great promise of color-blind equality and opportunity that TV made to African Americans in its earliest years. In this Golden Age the seeds of bias-free participation in video were re-planted. Unfortunately, the seeds would fall on fallow ground.

At its height in the fall of 1968, this embracing of black America by white television meant that at least one African-American recurring character appeared in twenty-one of the fifty-six prime time dramatic series. As a black writer explained it at the time, "Black people are hot! You could almost go roller skating in the street and they'd put you on television."

But actress Ruby Dee understood the deeper truth. She knew well that this was only a marketing phase, not a fundamental reevaluation of racial prejudice in TV. "We're in the most commodity-conscious nation in the world," she explained to an interviewer that fall, "and the black man is the commodity this year. If black people sell, they'll be back. If they don't, they won't."[17]

As far as blacks were concerned, the election of Richard M. Nixon to the presidency in 1968 signaled a basic change in American politics and social thought. During the administrations of Kennedy and Johnson, government had responded to black grievances. Insufficient though they proved to be, the civil rights programs of JFK and LBJ marked the first concerted attempt by the federal government to address black problems since the Civil War. Further, there can be no doubt that much of the success of the civil rights movement in the 1960s resulted from sizable numbers of white supporters joining the nonviolent crusade. The appearance of blacks and whites protesting together held out the possibility of reform through racial harmony.

The election of Nixon, however, meant not only the elevation of a moderate politician, it suggested the ascendency of a new attitude among whites. "The Silent Majority" or "Middle America," as Nixon's political base was often called, in many cases was synonymous with antiblack backlash. When Nixon moved early in his tenure to dismantle much of the social services apparatus of Lyndon Johnson's War on Poverty, it was apparent that as the nation entered the 1970s, blacks were entering a new era, too.

Underscoring black social protest in the 1960s had been a national economy that was generally prosperous. Money and career opportunities were abundant in wartime America. The affluence of the decade was also a powerful lure to African Americans seeking to improve their own lives. It was particularly important to middle-class white youths who, confident of their financial futures, expended energies on marches, sit-ins, voter registration drives, and the like. As inflation developed and the economy declined by the time of Nixon's election, however, the financial safety net that had assured white youth for so long disappeared. And as careers became increasingly more competitive, many would-be protesters abandoned the streets in favor of the libraries.

By the end of the decade, moreover, the optimism of the demonstrators had dissipated. There had been so many crusades, but there were still racism, war, pollution, and exploitation. Little seemed to have been accomplished. Flower children abandoned their bouquets. Faith in changing the system underwent a metamorphosis and emerged as faith in cults, Eastern religions, and a new intensity in fundamentalist Protestant belief. In this new era, young people now struggled for positions in the corporate world. Hair was cut, faces shaved, values reevaluated, and self-centered attitudes gained new respectability. And as the United States entered the age of the "Me Generation," black reformers found themselves abandoned by idealistic white supporters.

There were gains made by African Americans in the 1960s. Television reflected changes in entertainment and nonfictional programming. It was clear by the next decade, however, that matters were deteriorating. With black leadership already in disarray because of violence and factionalism, a new combination of political conservatism, a faltering economy, and a generalized

sense of personal insecurity and social impotence robbed the black reform movement of most of its vitality. Nixon did not create this atmosphere. He was elected, in great part, because of it; and his policies would not disappoint his supporters. All of these developments would have a profound effect in the following decade on the history of blacks in television.

PART THREE

THE AGE OF THE NEW MINSTRELSY, 1970–1983

However imperfectly, American television by the late 1960s had been moving toward an equitable treatment of blacks. In a decade of racial reassessment and new domestic priorities, TV was propelled toward the realization of that color-blind promise so long a part of the medium. With nonfiction television focusing in depth on the racial question, with African-American talent starring in dramatic, comedic, and informational programming—and with small but significant inroads being made into technical and executive aspects of the industry—in the last years of the decade there was reason to anticipate the ultimate realization of bias-free video.

The promise, however, was not fulfilled. The evolution toward nonprejudicial television came to an abrupt end in the early 1970s. For reasons which were political, economic, and social, the role of blacks in TV was refashioned to reflect the popular attitudes and national directions that arose in the 1970s. The result was still another stage in the history of blacks in American television.

This third stage represented a curious synthesis of historical and contemporary influences. While not reverting to the virtual exclusion that marked the end of TV's first decade, the movement toward fairness made possible by programming achievements in the 1960s was abandoned. Blacks remained visible, but usually in stereotyped and subordinate roles.

From 1970 to 1983 blacks participated in most aspects of TV

155

programming—from newscasts and situation comedies, to various dramatic formats, commercials, and made-for-TV movies. As entertainers, blacks often achieved greater ratings and popularity than earlier African-American video celebrities.

Something, however, was missing. The quality of African-American performance was debased. Black sensibilities were ignored. Concern with minority social problems was largely absent from entertainment and nonfiction shows. While blacks were consistently used in comedies, serious characterization in detective, Western, science fiction, romance, dramatic anthology, and serialized drama, programming was limited and predictable. Black movement into production and management functions also was minimal. And the use of recognized African-American talent, as well as the nurturing of new performers, was slight.

One cannot brush off casually the contributions of blacks in TV from the early 1970s to 1983. But neither can one feel satisfied with the manner in which the medium received blacks. In this third stage, television was less than honorable in its treatment of African Americans.

12

TV and the Politics of the Early 1970s

The election of Richard M. Nixon as president of the United States was a watershed in American history. With his appeals to "the Silent Majority," and for "law and order," Nixon was a moderating influence on the reformist energies awakened in the United States by Presidents Kennedy and Johnson. With Nixon, the legacy of progressivism—the spirit of social reform and reorganization that began with Theodore Roosevelt and reappeared in the policies of Presidents Woodrow Wilson, Franklin D. Roosevelt, Harry S. Truman, Kennedy, and Johnson—came to a halt.

To Nixon and his administrators, inner-city riots were acts of insurrection to be met with increased power. Marching antiwar protesters were, in the view of Nixon's attorney general, reminiscent of the anarchistic mobs whose hostile demonstrations precipitated the Bolshevik revolution in Russia in 1917. Dissidence was considered disruptive. Activism was disloyal. To a great degree, moreover, the new administration blamed television for the social disorder that marked the United States when Nixon was inaugurated in January 1969.

During the first years of the Nixon presidency, the TV industry endured the wrath of the administration. Most articulate among the critics of the medium was Vice President Spiro T. Agnew. Mouthing bitter condemnations and alliterative phrases, the vice president articulated the frustration and disgust he perceived in "Middle America."

Agnew's attack on television—particularly on TV news—began with his speech to Midwestern Republicans meeting in Des Moines on November 20, 1969. Here the vice-president spoke of the "virtual monopoly of the whole medium of communication" possessed by the three national networks. According to Agnew, because of this domination the news which Americans viewed nightly was determined by "a handful of men responsible only to their corporate employers and . . . filtered through a handful of commentators who admit to their own set of biases." If the evening news showed images of protesters and urban violence, Agnew argued that this was a function of biased newsmen working for undemocratic and insulated TV news operations. If viewers were upset by continuing pictures of campus unrest, antiwar marches, lawlessness on picket lines, police brutality, and the apparent bankruptcy of the American political system, these were only new stereotypes created "in the studios of the networks in New York" by a "small and unelected elite."

In Agnew's view, much of the racial violence in the United States was a result of network glorification of "embittered" black radicals. In words reminiscent of those used to ban Paul Robeson decades earlier, Agnew railed against newsmen who elevated Stokely Carmichael "from obscurity to national prominence." Instead of recognizing such anger as an expression of black frustration and social impotence, the vice-president assailed television news for giving the false impression that "the majority of black Americans feel no regard for their country," and for preferring "irrational" radicals over "rational" moderates. In Agnew's argument, the networks had decided that "one minute of Eldridge Cleaver is worth ten minutes of Roy Wilkins."

Most importantly, Agnew broadened his critique by inviting the American people to "let the networks know they want news straight and objective." He castigated network executives, and then reminded them of the power of the president in matters of licensing stations. Although the motives were dissimilar, not since Newton Minow's "vast wasteland" speech in 1961 had such threats against license renewal been publicly pronounced by a government official. And Agnew's target was obvious: the "tiny, enclosed fraternity of privileged men elected by no one and enjoying a monopoly sanctioned and licensed by government."[1]

These were menacing words to network television. But Agnew was not finished. Writing in *TV Guide* six months later, the vice-president again brandished his stick—but this time he also produced a carrot. Agnew now blasted network news as "manufactured news: revolutionary theater brought into millions of living rooms by the networks." But he extended the prospect of administration approval for those networks responding favorably to his criticisms:

> I feel sure that most of the leaders of this great industry are willing to accept the responsibility of citizenship along with its benefits. And I am confident that in the next few years, the television industry will emerge as an even more powerful and beneficial influence on all of our lives.[2]

By mid-1970, it was clear that Agnew's comments were not isolated expressions of the new administration's desire to exert a moderating influence on American television. There were other manifestations of what *Variety* termed a "state-managed . . . subtle reign of terror" emanating from the White House.[3] Nixon's chief adviser, H. R. "Bob" Haldeman, announced his belief that there was a conspiracy involved in news critical of the Nixon administration. "Somewhere in the jungle labyrinth of Manhattan Island," he told an audience at the University of California at Los Angeles in 1970, "there is a secret nerve center where, every Sunday afternoon, an enormously powerful group of men gather to decide what the Eastern Establishment media line for the coming week will be."[4] Agnew, himself, was not silenced. He informed a Houston audience that "wild, hot rhetoric pours out of the television set and radio in a daily torrent."[5]

President Nixon stayed above the public debate over television. Yet, his exploitation of presidential access to network TV time was most disconcerting to his political foes. In particular, to explain his actions in widening the Vietnam war to include Cambodia, Nixon made frequent prime-time appearances in speeches and press conferences in the spring of 1970. Although Democratic opponents of his war policies demanded equal free time to respond, such largess was not forthcoming from the networks. When critics of the president wanted national TV exposure, they usually had to purchase it on one of the national networks.

Through his appointive powers, Nixon in his first years also exerted a moderating influence via the Federal Communications Commission. His appointment of Dean Burch, former aide to Senator Barry Goldwater, as chairman of the FCC did little to allay suspicious TV executives. By the end of 1970, furthermore, the FCC had already made its influence felt on network news. The commission rigidly refused to allow the networks more than three hours of prime-time programming, thus quashing plans to expand news coverage to a full hour. Further, rigid enforcement of the Fairness Doctrine compelled stations to present counter-arguments to every controversial subject covered. Applying stricter rules of libel to documentary programming also helped steer broadcast journalists away from muckraking.

Several broadcasting executives attested to the moderating influence emanating from the FCC. According to Vincent T. Wasilewski, president of the National Association of Broadcasters, "the FCC is so restrictive, demanding that the opposing sides of everything that is controversial be sought out and presented, that broadcasters are finding it easier to avoid controversy."[6] A similar protest was heard from Hartford Gunn, Jr., head of the Public Broadcasting Service (PBS). In his view, broader application of the Fairness Doctrine and other FCC decisions could "mean commercial TV will be forced by pure economics to stay out of controversial political waters." He explained that "When presenting political and topical programs means uncontrolled loss of valuable air time and large legal expenses for lengthy FCC fairness hearings, the stations will simply stop presenting those programs."[7]

As well as those questioning the implications of FCC decisions, there were several articulate critics of the Nixon administration and its battle against television news. The president of CBS News, Richard Salant, protested in 1970 against "an official smear campaign under way to dissuade us from telling the truth as we see it."[8] Senator J. William Fulbright of Arkansas charged that Vice President Agnew had successfully "intimidated the media," and he cited as an example the diminishing of anti-Agnew editorials in the *Washington Post* when that newspaper's TV station in Miami, WPLG-TV, had its license renewal challenged before the FCC.[9]

Nicholas Johnson, an outspoken member of the FCC and an

appointee of Lyndon Johnson, was even more strident in his crit-
icism of Nixon and the attack on network TV. According to
Commissioner Johnson, the networks by late 1969 had already
capitulated to the Nixon administration. He charged that by fail-
ing to provide live coverage of demonstrations by the National
Mobilization Against the War, corporate television had surren-
dered to the government's desire to suppress dissent by denying
it video coverage. In Commissioner Johnson's words, "Broad-
casters are kept off-guard by the one-two punch of barely camou-
flaged intimidation and acts of censorship, together with the
promise of an economic payoff for those who cooperate."[10]

Television news operations were especially affected by the
government's campaign against TV. Throughout the early
1970s, a popular reaction to stories of crime, protest, warfare, ri-
oting, and other evidences of national disarray was the demand
that TV start reporting "good news." Understandably confused
and tired of nightly reports of turmoil, many Americans de-
manded news that was not distressing. Although someone as in-
fluential as Reuven Frank, president of NBC News, could argue
that those who want TV news "to make a better world" are seek-
ing to use the television news reporter "as a conscious instru-
ment of social control,"[11] the criticism continued.

On the local level, network affiliates and independent sta-
tions responded more favorably to mounting public and govern-
mental pressure. At KHJ-TV, Los Angeles, for example, news di-
rector Baxter Ward announced in May 1970 that the station
would no longer show pictures of campus violence. The new sta-
tion policy was to cover campus demonstrations to the point of
physical confrontation. Then, "if it reaches a point of ugliness,"
according to Ward, "we'll cover our cameras and leave."[12]

More successful than simply avoiding violence, however,
was the conscious creation of warm, friendly feelings in the
minds of viewers. This was the goal of the so-called "happy talk"
or "do-good" news format developed most profitably by local
ABC outlets. Stations now relaxed their dedication to covering
"doom and gloom" news and offered instead a blend of solid sto-
ries and light, uplifting features, presented by bantering anchor-
people, entertaining reporters, and joking sports reporters and
weathermen. Happy talk news did not avoid important events,
but it made actualities more palatable to viewers who wanted a

161

little entertainment and informality in the delivery of their news. The happy talk format—which critic Ron Powers described as "exaggerated joviality and elbow-jabbing comradeship"[13]—first emerged in 1969 at WLS-TV in Chicago. It quickly was adopted by ABC stations throughout the nation. In the process, it made ABC outlets the most popular local news operations in most American markets.

The debate over television and its relationship to social turmoil in the United States had a particularly chilling effect on the role of blacks in the medium. As early as 1969, local stations reported diminishing advertiser interest in programs featuring blacks or focusing on black realities. "It just isn't chic anymore," according to a spokesman for WNEW-TV, New York City, "for advertisers to sponsor a black show."[14] This attitude caused many to wonder if the surge in black programming in the late 1960s emanated more from feelings of guilt following the death of Martin Luther King, Jr., and the issuance of the Kerner Commission report, than from a solid commitment to bias-free informational and entertainment programming.

On the network level, it was apparent by the end of 1970 that in all types of shows black interests were being ill-served by developments in the new decade. Most of the new series launched in the fall of 1970—many of which featured or starred black talent— failed to gain popularity. According to network analysts, this failure was the result of too many dramatic series seeking to be relevant. Relevancy—social and political reality brought into a TV story line—may have been popular with viewers in the 1960s, but in the new era it was a liability. Real-life dramas, with or without black characters, died a quick death in the ratings, as the American public demonstrated a distaste for issues-oriented entertainment. James E. Duffy, president of ABC, attempted to explain the collapse of relevancy programming when he spoke to a group of broadcasters in late 1970. According to Duffy, "We have been roundly scored, spanked, slaughtered, slandered. . . . Did we overreact to, overpromote, overkill 'relevancy'—both the word and the concept? Yes, my friends, we did."[15]

As is apparent from the preceding chapter, socio-political relevancy was a significant factor in the TV drama of the 1960s. Instead of routine plots in which good invariably triumphed over evil, protagonists on programs like *The Bold Ones, East Side/*

West Side, The Name of the Game, and *Star Trek* often faced per-
plexing realities that prevented total triumph. For example, on
East Side/West Side the hero might have won his own personal
battle against ghetto life—but the ghetto endured, and viewers
could expect that similar problems would continue. On a science
fiction series like *Star Trek,* the relevant issue might have been
philosophically or allegorically stated. Such was the case in "Let
That Be Your Last Battlefield," a *Star Trek* episode telecast on
January 10, 1969. This program concerned the destructive na-
ture of racial hatred and pitted two adversaries, one man whose
face was black on the right side, white on the left, and another
man with the opposite pattern of coloration. As representatives
of two warring races, these men pursued each other through cen-
turies until their hostilities had destroyed all other life on their
planet. As the story ended with these sole survivors continuing
their senseless battle in space, the implications for contemporary
America were obvious.

In the new decade, however, problems of racial prejudice,
social injustice, and an insensitive bureaucracy became increas-
ingly unpopular with viewers. Instead of moral lessons and social
insights, Americans demanded escapism in their television en-
tertainment. No longer responding to heroes who might capture
evildoers but were overwhelmed by social problems and inequi-
table standards, viewers now wanted champions who triumphed
weekly over thoroughly negative antagonists. As Les Brown per-
ceptively noted in *Variety* in 1972, "Doctors can save a patient
every week, and lawyers can get a client off a bad rap, but no sin-
gle politician or social worker can correct social injustices or
change the system that produced them."[16]

Just as the death of relevancy helped ensure the stifling of
series or stories treating serious issues affecting African Ameri-
cans, the practical disappearance of the news documentary in
the early 1970s further helped to isolate blacks from meaningful
video exposure. There seems little doubt that the demise of the
documentary was related to the popular mood which swung the
1968 election to Richard M. Nixon and which was soon manipu-
lated by the new administration to moderate TV criticism of so-
cial realities. Tellingly, in late 1969 a report issued by Columbia
University noted that during the previous television season,
"documentary programming in the traditional sense of the term

had hit a new low."[17] And by the 1971–1972 season, the three net-works aired only sixteen documentaries treating major issues, only four of these focusing on busing and other aspects of black-white race relations.[18]

One reason for this development was that in their newscasts and newsmagazine shows, networks increasingly presented dis-tilled analyses instead of half-hour and full-hour documentaries exploring a single subject in depth. Also, in an atmosphere of po-litical circumspection, when neither sponsor nor network wished to be identified with liberal or with conservative political values, financing for such programming was not often forthcom-ing. In the words of one network documentarian, "You can't get a documentary on the air unless you get a sponsor, and if you get a sponsor, you've got to do a bland show."[19]

Ironically, in the previous decade the television documen-tary had been one of the strongest vehicles for explaining social problems. Its disappearance left African Americans with issues still unresolved, and with much less access to public opinion through network nonfiction programming. It is interesting, too, that these developments occurred at a time when blacks were placing their trust in television as the social institution most sym-pathetic to their plight. According to a Lou Harris poll in the summer of 1971, 43 percent of American blacks felt that TV had a genuine concern for their desire for equality. Video ranked ahead of the Supreme Court (39 percent), the federal govern-ment (30 percent), and newspapers (27 percent).[20]

Within a few years, social concern for African Americans was gone from television. As blacks passed through the 1970s, the range of utilization and characterization they might face in TV was obvious. At best, they could hope for an occasional breaking of form which might permit a program, movie, or series to reintroduce relevancy into an otherwise escapist medium. As a norm, blacks could anticipate benign neglect in which video entertained its mass audience without reference to African Americans or racial problems. At its worst, television might aban-don its residual concern for social issues and review older, more derisive formats and stereotypes. To a great degree, the history of blacks in TV during the 1970s and into the 1980s is marked by a fluctuation between these postures.

13

Blacks in Television in the Early 1970s

As American television abandoned relevancy and its concomitant themes, there were noticeable shifts in programs involving blacks. Dramatic series featuring solid black characters vanished. The mature comedic series which typified the late 1960s now gave way to bolder situation comedies purporting to be racial satires but actually reviving chronic racist stereotypes. Such changes in programming tastes and in attitudes toward minorities were apparent in the earliest years of the new decade.

In the fall of 1970, there were nineteen prime-time network series employing blacks in prominent roles. Excluding motion picture showcases such as the *CBS Friday Night Movie*, this figure represented 26 percent of prime-time programs. Among the total were several series from the previous decade, including *Julia, Mission: Impossible, Rowan and Martin's Laugh-in*, the *Bill Cosby Show, The Mod Squad, Room 222, Ironside, Mannix*, and the *Lawrence Welk Show*. Among the new shows with blacks in recurrent, supporting roles were *Make Room for Granddaddy* (Roosevelt Grier), *The Storefront Lawyers* (Royce Wallace), *Matt Lincoln*, and the *Mary Tyler Moore Show* (John Amos).

Significantly, many of the new series that season cast blacks as stars or co-stars. As well as in comedies like *Barefoot in the Park* and the *Flip Wilson Show*, African Americans were cast in a variety of dramatic series. On *The Silent Force*, Percy Rodrigues played federal agent Jason Hart who, with two other investiga-

tors, formed a secret undercover force fighting organized crime. In the Revolutionary War series, *The Young Rebels*, Louis Gossett, Jr. was Isak Poole, a member of the Yankee Doodle Society fighting in 1777 for freedom and against the British "system."

In a more modern vein, on *The Young Lawyers* Judy Pace played a law student who, with other young legal idealists, formed a neighborhood law office in Boston. Blacks even entered the medical-drama genre as Hal Frederick appeared as one of five young interns featured on *The Interns*.

What is striking about these series, however, is that only one lasted longer than its premiere season. With the exception of the *Flip Wilson Show*, all the new programs featuring blacks—plus *Julia* and the *Bill Cosby Show*—were canceled by the fall of 1971. Add to that figure the cancelation after thirteen weeks of the *Pearl Bailey Show*, a musical variety series which appeared on ABC's second season in January 1971. By the fall of that year, there were only ten prime-time network series with blacks—only three of them new shows. Indicative of the future direction for blacks in American TV, these new series were comedies: *The Funny Side* which included John Amos and Teresa Graves, *The Partners* which co-starred Rupert Crosse, and *All in the Family*, a show which had actually premiered the previous January on the CBS second season.

Along with relevancy, black actors and social issues left television by the end of 1971. As the nation slipped easily into a mood of self-delusion, encouraged by the politics of the time, soul-searching disappeared from network video. Tired of demonstrations and confrontation, viewers preferred seeing "the good things" about America. Ratings figures told the networks that most citizens wanted escape instead of education, support in place of questioning.

An example of the series that could not survive the change in popular mood was *The Storefront Lawyers*. It concerned the adventures in the ghetto of three young white liberals, a sort of legal Mod Squad, who abandoned lucrative law practices in order to help oppressed minorities. A typical case developed in an episode entitled "The Emancipation of Bessie Gray," broadcast on October 14, 1970. Here the trio of youthful idealists came to the rescue of an elderly black woman, played by Claudia McNeil, who was being swindled by an unscrupulous job trainer.

McNeil's character, Bessie Gray, had spent her hard-earned money—earned scrubbing floors—in a training program that promised her a career in nursing when she graduated. Having completed the course, however, Gray received no nursing job, and found her complaints ignored by the man in charge of the training school. Reminiscent of the human-interest dramas of the 1960s, *The Storefront Lawyers* suffered a quick demise. Most American TV watchers seemed disgusted, indifferent, or bored with stories about underprivileged blacks being rescued by do-good white liberals. The series was clearly a product of the civil rights era. In this new decade it was not the type of programming enough viewers wanted.

As sensitive social melodramas dwindled, so too did the liberal rhetoric which exemplified much of the Golden Age. Hopeful, egalitarian, and often naive, such rhetoric reiterated the goals of the civil rights movement and expressed the notion of social assimilation and racial pride. One of the last statements of this kind was encountered in an episode of *The Young Rebels* entitled "Unbroken Chains" and aired December 27, 1970. The story concerned the moral and physical courage of a runaway slave (played by Paul Winfield), who helped the young Revolutionary War heroes of the series to destroy a British munitions supply. Not only did the program feature Winfield as the slave, Pompey, but with Louis Gossett, Jr. as Isak Poole, a series regular, and with its obvious emphasis upon youth and rebellion, the program was clearly tied to the political attitudes of the previous decade.

In its closing scene, this show made its moral statement. Pleased that Pompey had helped them blow up the enemy arsenal, the three young heroes and their mentor, the Marquis de Lafayette, offered Pompey his legal freedom and the right to a last name. The following conversation ensued.

Pompey: Thank you, General, But if it's all the same to you, I
 think I'll keep my one name. Just to remind me that no men
 are free unless all men are free.
Poole: Pompey, can you read?
Pompey: Can I read? What you want me to read, boy?
Poole: A poem. Henry gave it to me when I was feeling kinda like
 you do right now.

Pompey: (reading)
 Oh, come the time
 And haste the day,
 When man shall man no longer crush;
 When reason shall enforce her sway,
 Nor these fair . . .
Poole: (completing poem)
 Nor these fair regions raise our blush,
 Where still the African complains,
 And mourns his yet unbroken chains.
Pompey: Yeah. You write this, Henry?
Henry: No. A poet of the Revolution, Philip Freneau.
Lafayette: I thought it sounded French.
Pompey: Sounded black to me. *(laughs)*
Rebel: Sounds like maybe some day it won't matter. *(music swells)*
Announcer: In 1977 a slave named Pompey was instrumental in capturing the key British fort at Stoney Point, New York, giving the Americans control of the Hudson River. He was only one of over 10,000 black men who served gallantly in the Revolutionary Army.

Not only did this type of optimism perish in the 1970s, but one week after "Unbroken Chains" was broadcast, *The Young Rebels* was seen for the last time—canceled after thirteen poorly viewed weeks. It is interesting, however, that while African-American roles in prime-time network series were diminishing or becoming stereotyped in comedy, black actors were making mature dramatic contributions in two distinct types of TV programming. On daytime soap operas blacks made important, if limited, advances into a chronically segregated genre. In made-for-television motion pictures, too, African-American actors demonstrated powerful acting skills, often in remarkably mature characterizations and plots.

Despite the human and familiar quality of daytime serials—the so-called soap operas—these series had never been hospitable to black actors. During the three decades in which the soaps thrived on radio, few blacks appeared as regulars. During World War II, black characters were written temporarily into at least two series, *Our Gal Sunday* and *The Romance of Helen Trent*.

But since listeners were unaware of the race of those providing the voices, most black roles were enacted by white actors.

The record of soap operas in TV had been similar. During the mid-1960s, however, as producers, networks, and sponsors encountered criticism from civil rights groups, there were attempts made to introduce black parts in established series. Blacks were used, for example, as background walk-ons, or were seen seated in restaurants or passing through hospital corridors. By the end of the decade, moreover, full-fledged African-American roles were being written into several soaps.

When it premiered in October 1968, Agnes Nixon's series, *One Life to Live,* focused on the problems facing a first-generation American family trying to achieve social success. This orientation allowed the program to be concerned with relevant issues. On occasion this concern involved black characters. But there were limitations to soap-opera involvement with blacks. When the light-skinned actress Ellen Holly played Carla Gray—a black secretary in love with her white boss—viewer distress was strongly registered with the producers and network. Although the writers caused Carla's mother (played by Lillian Hayman) to condemn the interracial romance, one Texas station canceled the series, and several southern stations threatened similar action. Carla eventually recognized the "error of her ways"—and the importance of viewer protests—and married a black police lieutenant, Ed Hall (played by Al Freeman, Jr.). Into the 1980s, moreover, the Halls remained the only black family in Llanview, the mythical Philadelphia suburb in which *One Life to Live* was set.

The nature of the soap opera mitigated against any kind of meaningful black participation. Concerned as they became in the 1970s with romance, love affairs, and great amounts of personal remorse—what *Time* magazine concisely termed, "sex and suffering in the afternoon"[1]—soap writers and producers were sensitive to viewers protesting scenes of black intimacy, especially when such romance was interracial and led to marriage. Although mindful of the result when *One Life to Live* treated love between a black woman and a white man, the writers introduced a similar theme in the mid-1970s on *Days of Our Lives*. Here Valerie Grant (played by Tina Andrews), daughter of the only black family in town, almost married a white character. Before the en-

gagement was dissolved, the plot caused considerable torment for the families involved, especially to Valerie's father (played by Lawrence Cook), mother (Ketty Lester), and brother (Hassan Shaheed). The romance lasted a year and involved four on-screen kisses between the couple. Fan mail hotly protested the arrangement, however, and four days before wedding vows were to have been exchanged, the engagement was broken. In mid-1977, Valerie ended the love affair, left her ex-fiance, and moved to Washington, D.C. to accept a medical scholarship at Howard University. She also left *Days of Our Lives*.

Despite such limitations, several important black actors had short-lived roles in soap operas. In the late 1960s, for example, James Earl Jones and Cicely Tyson (and later Ruby Dee) played Dr. Jim Frazier and his wife, Martha, on *The Guiding Light*. Jones also portrayed Dr. Jerry Turner on *As the World Turns*. Billy Dee Williams played another soap opera professional, an assistant district attorney, in the late 1960s on *Another World*.

There were other blacks in significant roles in soap operas. During the 1970s Palmer Deane played Dr. Hank Iverson on *The Doctors*. His romantic interest was portrayed by Marie Thomas. John Danelle appeared as Dr. Franklin Grant, with Lisa Wilkinson cast as his wife, Nancy, on *All My Children*. Herb Davis was a regular on *One Life to Live* and *The Edge of Night*. In the latter series he played a police lieutenant, Luke Chandler. Laurence Fishburne on *One Life to Live* portrayed Joshua West, the foster son of Ed and Carla Hall. Before he joined the cast of *The Jeffersons*, Damon Evans appeared on *Love of Life*. The same was true for Ja'net DuBois who played Loretta Allen on *Love of Life* before becoming Willona Woods on the prime-time series, *Good Times*.

These actors notwithstanding, the use of blacks in soap operas was minuscule. The genre had been popular in television for more than thirty years. There were scores of soaps, usually broadcast five days a week, with no repeats, and some running as long as ninety minutes. In the process, thousands of actors appeared in major and secondary parts. Yet no more than a few dozen were African American. Television soap operas were lily-white dramatic vehicles, intended to sell household products to an audience that was primarily female. No matter that about one-quarter of the viewers was black, the complaints of bigoted

fans and the reluctance of local stations to carry a regular diet of strong black characterization helped to keep soap operas virtually segregated.

There was no attempt, moreover, to deny the obvious. According to one student of the genre, "Inattention to poverty subcultures and to black Americans may be explained by the fact that the soaps are, and claim to be, a reflection of white middle-class America."[2] As such, racial issues were rarely discussed or integrated into story lines. In fact, soap opera blacks were usually so middle class and assimilated, their problems are not those of average African Americans. This was a situation which in part caused Ellen Holly to complain bitterly to an interviewer in 1972:

> Media are like mirrors. . . . You look in a mirror and you see what you are. And for generations the black man has looked into the mirror of this society, and been thrown back an image so absolutely *grotesque* that it's a wonder he could even get together even the minimum ego necessary to survive.[3]

Network television responded slowly and inadequately to racial segregation in daytime serial drama. One remedy suggested, but continually rejected, was the black soap opera. As early as 1964, executives at ABC turned down such a project intended primarily for African-American audiences. Throughout that decade and into the 1970s, black soaps with titles like *A Day in the Life* and *Between Horizons* were proposed to the networks, but were never accepted and put into production.

The closest network TV came to airing a black soap opera occurred with *Bird of an Iron Feather*, a daily prime-time serial which appeared on National Educational Television (NET) in early 1970. The program was funded by the Ford Foundation and was written by Richard Durham, the same writer whose radio series *Destination Freedom* two decades earlier was a milestone in the history of black broadcasting. *Bird of an Iron Feather*, however, received neither critical praise or sizable viewership before being canceled quickly.

More than a decade later, network TV remained adverse to black soap opera. Except for two series focusing on African-American life—*Righteous Apples* and *Up and Coming*, both on PBS in the 1980s—television continued to produce serialized

dramas that were dominated by white actors and offered few opportunities for black participation.

Similar to their treatment in dramatic series and soap operas, blacks had limited involvement in made-for-TV movies. Yet on many occasions African-American performance and characterization were significant in such films. In fact, from 1970 to 1983, some of the most memorable depictions of blacks in American popular culture occurred in such video films.

In the 1970s the Hollywood movie industry itself discovered the black consumer market. Much of the energy of the film studios went into making so-called "blaxploitation" films. These were usually low-budget, action features having a strong emphasis on violence, sex, antiwhite hostility, and hatred of the police and bore such flamboyant titles as *Willie Dynamite, Boss Nigger, Black Caesar, Hell Up in Harlem, Super Spook, Soul Soldier, Blacula,* and *Blackenstein.* By 1975 *Variety* counted almost two hundred such black-oriented feature films—more than half released in 1973.[4]

Blaxploitation films were filled with images of evil whites being bested, beaten, or blown away by cool blacks. Romantic escapades abounded with women of all nationalities, helping to earn the macho heroes of such movies the label "superstud." These were films of revenge and catharsis. They allowed audiences to strike vicarious blows against white oppression. They also exploited for profit the legitimate anger and frustration of African Americans trapped in the inner city by prejudice, poverty, ignorance, and fear. And they did this with handsome, muscular, clever black champions whose taste for the good life was enticingly displayed. Further, this was not a pattern that was exclusively masculine. Many blaxploitation films—with titles like *Savage Sisters, Coffy, Sheba Baby, Cleopatra Jones,* and *Foxy Brown*—proffered sexy female versions of this emergent "superspade" stereotype.

Importantly, in most cases these movies were the product of white producers and writers, white film studios, and white-controlled distribution companies. Although African-American actors were seen on the screen, from concept to realization blacks had little to do with the development of the vast majority of blaxploitation films.

Only on occasion did Hollywood abandon the sex-and-

172

violence motif and produce serious, nonstereotyped theatrical films with black themes. When they did so, in movies like *Sounder, The Learning Tree, Five on the Black Hand Side, Black Girl, Lady Sings the Blues,* and *The River Niger,* the studios proved that sensitive insight could be gained into the African-American social experience. Few of these more sophisticated motion pictures, however, fared as well at the box office as the blaxploitation films.

As far as television was concerned, there was little place for the sex-and-violence black film. With its traditional aversion to profanity, brutal violence, and sexual explicitness, TV did not present a ready market for such films. If black-oriented films were to be shown on television, they would have to be the more serious theatrical releases or those made especially for the medium. Out of these circumstances would come several powerful motion pictures. Furthermore, because of the small pool of black actors available for such films, the talent in these made-for-TV movies became as recognizable as it was skilled. Two of the most effective actors were Cicely Tyson and Paul Winfield.

Tyson frequently appeared in movies based on black history. In *A Woman Called Moses,* broadcast on NBC on December 11 and 12, 1978, she portrayed Harriet Tubman, the nineteenth-century organizer who helped liberate hundreds of runaway slaves. In February 1978, Tyson was featured as Coretta Scott King—opposite Winfield as Martin Luther King, Jr.—in the NBC miniseries, *King.* And in *Wilma,* telecast December 19, 1977 on NBC, she portrayed the renowned college and Olympic track star, Wilma Rudolph.

Tyson's most acclaimed role, however, was in *The Autobiography of Miss Jane Pittman,* an Emmy-winning film broadcast January 31, 1974 on CBS. Here she played at all ages—from a young woman of 19 years to a 110-year-old—highlights in the life of an ex-slave who lived to see in 1962 the first modern steps toward racial equality and social dignity. Although her final gesture, to drink from a water fountain reserved for whites, was a small action, the power Tyson brought to the role made Miss Jane Pittman's act a symbol of racial victory over Jim Crow laws and chronic prejudice.

Winfield also appeared in several substantial made-for-TV motion pictures. As well as the leading role in the miniseries,

King, he played Roy Campanella in *It's Good to Be Alive*. The film, broadcast on CBS on February 22, 1974, dealt with Campanella's physical and emotional adjustment to paralysis following an automobile accident that ended his baseball career. In another introspective role, in *Green Eyes*, aired January 3, 1977, Winfield portrayed an ex-soldier returning to Vietnam to find the child he fathered while stationed there.

While biographical movies focused widely on historical blacks—from political achievers to criminals—the favorite theme was black sports figures. In addition to *Wilma* and *It's Good to Be Alive*, there were other significant sports motion pictures made for television in the 1970s. In *Brian's Song* (aired November 30, 1971 on ABC), Billy Dee Williams portrayed Gale Sayers, the Chicago Bears halfback who agonized as his white friend and teammate, Brian Piccolo, died young of cancer. In *Ring of Passion* (February 4, 1978 on NBC), Bernie Casey played boxer Joe Louis in a drama about Louis' two heavyweight bouts in the 1930s with the German champion, Max Schmeling. And in *One in a Million: The Ron LeFlore Story* (September 26, 1978 on CBS), LeVar Burton portrayed a young street punk who rose from a life of petty crime to become a star of major league baseball.

In the decade, several notable made-for-TV movies also placed blacks in fictional human and romantic predicaments. *Roll of Thunder, Hear My Cry*, which aired in June 1978, was an ABC miniseries dealing with a closely knit black family facing racial animosity in Mississippi during the Great Depression. It featured Janet MacLachlan and Robert Christian, but its principal player was Claudia McNeil, who portrayed a strong-willed grandmother whose personality and sacrifices helped maintain her family in a time of great stress.

This theme of love within a black family was found also in *Ceremonies in Dark Old Men*, an ABC presentation on January 6, 1975. Starring Douglas Turner Ward, Robert Hooks, and Godfrey Cambridge, the play focused on a Harlem family striving to achieve success and social freedom.

In *Just an Old Sweet Song*, the noted black writer and director Melvin Van Peebles wrote of the differences for African Americans between life in the South and North. The film was broadcast September 14, 1976 on CBS, and featured Cicely Ty-

son and Robert Hooks as the heads of a black family which left its urban northern existence to return to its southern roots. Through his script, Van Peebles argued that for contemporary blacks, life in the South was preferable to the indignity of ghetto life in the North. *Just an Old Sweet Song*, as a racial drama and a human story concerning the search for purpose and self-definition, was epitomized in Robert Hooks' statement at the end of the film:

> This New South probably ain't what it's cracked up to be, but it's better than it used to be. Everything we wanted up there is down here. I still hate the South. The South is up North in them ghettos, but the program is still the same—ripping off the black man.

In the mature world created occasionally by made-for-TV films, on more than one occasion interracial love was treated. One of the most controversial films of the decade was *My Sweet Charlie*, seen on NBC on January 20, 1970. The story concerned Patty Duke as a southern white woman who fell in love with a black intellectual from the North played by Al Freeman, Jr. Before it was aired, the film precipitated a national debate over its propriety. More than anything else, this controversy created viewer interest. The film was the top program in the weekly Nielsen ratings, as nearly half the national TV audience tuned in to see in this unique motion picture a depiction of something seen daily in real life.

Less sensational in its reception, but equally sensitive, was *Wedding Band* on ABC on April 24, 1974. The interracial love in this feature was between an older couple. Ruby Dee and J.D. Cannon played the principals in a ten-year love affair in rural South Carolina in 1918. Written as a theatrical drama by Alice Childress, *Wedding Band* was produced as a play in the *ABC Theater* showcase. Despite its preemption by several affiliates, the drama was one of the more memorable programs of the season, *Variety* terming it, "an unusual combination of courage and taste in the welter of the prime-time pulp grind."[5]

Compared to its predecessors, *A Killing Affair* made the theme of interracial love more passionate and explicit. Aired on CBS on September 21, 1977, it starred O.J. Simpson and Eliza-

beth Montgomery as police officers who fell in love while work-ing together on an investigation. The plot was complicated by Simpson's wife, played by Rosalind Cash. Included in the movie were embracing, kissing, and several bedroom scenes. According to one writer for *Jet* magazine, "Black skin lovingly pressed against white skin on television screens is a delicacy rarely seen."[6]

Despite their popularity, serious dramas starring blacks were rare in the 1970s. Certainly in made-for-TV features there were quality stories and performances. But these films represented a small proportion of the movies—either theatrical releases or made-for-TV films—shown on television. Counting reruns, for example, during the 1976–1977 season there were 398 feature films shown on TV. This figure included 168 made-for-TV films. While some of those movies provided secondary roles for black actors, only a miniscule portion placed African Americans in starring roles. With the demise, moreover, of dramatic series fea-turing blacks, access to video was evaporating for serious minor-ity actors. It is interesting, however, that at exactly the time Afri-can Americans were disappearing from dramatic programming, they gained unprecedented exposure in prime-time situation comedy. It was a curious synthesis allowing blacks more visibil-ity, but channeling them into more frivolous and traditionally ac-ceptable molds.

As the civil rights movement collapsed and mature black rep-resentation on television dwindled, African-American comedi-ans experienced overwhelming success. To a degree, this can be explained as a reflection of the general switch by viewers in the early 1970s from dramas to situation comedies. Eschewing rele-vancy, violence, and dramatic confrontation, Americans through the ratings showed that they wanted more fun and di-version in their TV shows. This preference for comedy, further-more, eventually became dominant in prime-time video. During the 1974–1975 season, the top seven programs were half-hour sit-uation comedies.

As far as black characterization was concerned, however, there was a striking difference in this new wave of hilarity. No longer were black stars cast as assimilated, middle-class achievers offering as many moral lessons as laughs. With Diahann Carroll and Bill Cosby in decline, the black comedians of the 1970s were brassy, sassy, and obvious. More importantly, the new black TV

comics were self-deprecating, continually joking about being black, and bringing to bear on themselves many of the stereo-typed prejudices long considered racist. It now became riotously funny to joke about skin color, hair texture, race riots, poverty, welfare checks, and minority social customs. Inhibitions disap-peared, and writers and comedians seemed to ignore racial sensi-tivities. It now became a mark of fashionable outspokenness to deliver jokes based on old bigoted slurs. In bringing this new type of humor to popular video acceptance, the transitional series was the *Flip Wilson Show.*

Where Nat King Cole, Sammy Davis, Jr., and Leslie Uggams had failed, Flip Wilson triumphed. He was the first black to host a successful variety program. In its four years on NBC, 1970–1974, his program was highly popular and critically well received. Dur-ing its first two seasons, the *Flip Wilson Show* was rated second only to *All in the Family.* The following year it was rated twelfth. In 1971, moreover, the program won an Emmy as the outstand-ing variety series of the year.

The freshness of the *Flip Wilson Show* lay in its unique blending of the traditional and the new. It contained many quali-ties found in the popular comedy-variety series hosted by white entertainers. The program was headed by Flip Wilson, a versatile and engaging talent whose comic delivery was accompanied by great likability. In his story-telling humor, Wilson was described by one critic as "effervescent, contagiously irreverent—and funny."[7] He also played host to many of the leading white enter-tainers of the day, among them Lucille Ball, Carol Channing, Johnny Cash, Roy Clark, and George Gobel. Importantly, too, as well as welcoming leading black personalities like Bill Cosby, Mu-hammad Ali, Lena Horne, and Sammy Davis, Jr., Wilson gave TV exposure to many black stars unfamiliar to most American viewers. Included in this latter group were B. B. King, Slappy White, the Modern Jazz Quartet, Melba Moore, the Staples Singers, Mahalia Jackson, and Willie Tyler and Lester.

The strength of the program, however, was Wilson's own comedy. He was most celebrated for the bold black characters he developed. Unlike the bourgeois images offered in situation comedies in the late 1960s, his Geraldine Jones, Reverend Leroy, Sonny the janitor, Freddy Johnson the playboy, and Charley the chef were draw from inner-city stereotypes. In his own assertive

way, Wilson reached back to an earlier era and revived many of the pejorative clichés associated with a less sensitive time in American history. Not since *Amos 'n' Andy* had television portrayed blacks in such stereotypic ways.

Wilson's characters were not timid. His female personality, Geraldine Jones, could shriek: "The devil made me do it," as well as Sapphire Stevens, Beulah, or any of the other video mammies of the past. The exaggerated, rhythmic roll of his Reverend Leroy, the effusive gospel-shouting pastor of the Church of What's Happening Now, was a solid reminder of Johnny Lee's nefarious and loquacious character on *Amos 'n' Andy*, the lawyer Algonguin J. Calhoun. And his other slick personalities were throwbacks to those demeaning models of black insecurity, incompetence, and libido.

At the time, Wilson's supporters argued that his humor was drawn from black culture. Unlike earlier prejudicial series, it was felt this brand of comedy was not the product of whites interpreting the black experience in minstrelsy types. That Wilson was "authentic" seemed to fit the mood of the time when black pride was swelling, and patterns of equal opportunity appeared to be opening the American economy to black would-be achievers.

Drawn from the African-American life or not, the *Flip Wilson Show* helped reinstate the racist joke in television. When delivered to a black audience in a night club or inner city theater, perhaps the exaggerated traits of his black characters and the themes of his humorous stories might well be appreciated as satire and not racial derision. But on national TV, with a predominately white audience in a time of changing social priorities, Wilson's humor looked and sounded antiblack. Like the endmen and coon comedians of the minstrel show, Wilson always brought the humor to bear upon himself, making himself the butt of the joke because of his blackness. He jested about his gaudy sport coat—"my riot jacket, you saw my riot jacket, the one I got in Buffalo out of the window." Or he spoke of a black man he met in Detroit during that city's race riot: "In fact, he walked up to me and said, 'Take a television, they ain't gonna miss it.'"

Dressed in women's clothing and speaking in a falsetto voice, Wilson played Geraldine as pushy and impulsive, a black

female without tact or willpower. Part hussy and part wheeler-dealer, Geraldine seemed to confirm for many bigots long-held prejudices about black women.

What Geraldine did to black femininity, Reverend Leroy did to African-American religion, its practitioners, and leaders. Leroy delivered verbose, self-serving sermons on topics such as "On the Creation of the Hilton Hotel" and why God wanted him to drive a Cadillac. And Leroy could become animated when he felt black rights were being abused. This happened once when he mistook a gorilla in a zoo cage for a fellow black man being held in jail and forced to eat from a trough on the floor. Lecherous and dishonest, Leroy was no exemplary black parson.

Certainly Wilson was no racist. But his humor was too familiar, too trusting, and too soon. In a harmoniously integrated America, such comedy would have been less offensive. But in the early 1970s, the nation was turning away from values of brotherhood and toward self-interest and renewed prejudices. This was no longer the age of Julia Baker and Chet Kincaid; this was the time of Don Rickles and his insult humor that baited instead of appreciating ethnic difference.

There were other prominent black comedians at the time. And frequently they, too, exploited race in their routines. But in humorists like Godfrey Cambridge and Dick Gregory, racial comedy was used to make stabbing, ironic statements about discrimination and social injustice. Flip Wilson, however, avoided politics. He did not use his humor to strike the conscience of the nation. Typically, one of his jokes dealt with a black couple on welfare receiving a robot as part of its government handout in 1984. Lacking a note of the sardonic or moral, the joke simply suggested that years into the future blacks would still be receiving welfare—one racist stereotype confirmed! In the minds of many who had struggled in the 1960s to improve race relations, the *Flip Wilson Show* was at best a lost opportunity. At worst, it was an exploitation of white prejudice for the sake of the Nielsen ratings.

Television critic Les Brown has suggested that rather than satirize black culture, the *Flip Wilson Show* actually mocked it. And like the racist TV series of the 1950s, this type of comedy "fed, rather than dispelled, racial bigotry."[8] Nevertheless, the enormous

popularity of Wilson and his brand of hilarity was compelling. To others in the competitive television industry, Wilson's achievement was suggestive. Soon, video would be flooded with black comics joking about their racial ancestry and ethnic characteristics. Thanks to Wilson, Americans fell in love with racial comedy. And nowhere would the style be more perfected or prolific than in the programs created by Norman Lear and Bud Yorkin.

14

Norman Lear, Bud Yorkin, and the Flourishing of Racial Humor

If the wide approval of Flip Wilson and his self-deprecating style of comedy suggested the acceptability of exploitive racial humor, the programs created by Norman Lear and Bud Yorkin turned this suggestion into an industry. In so doing, the "new" comedy they produced in the 1970s radically altered the boundaries of permissible expression in American television.

Working together as Tandem Productions, Lear and Yorkin developed several successful series which included *All in the Family*, *Maude*, and *Sanford and Son*. Even in their own separate production companies each continued to enjoy prosperity. Lear and his T.A.T. Communications developed such acclaimed situation comedies as *Good Times*, *The Jeffersons*, *One Day at a Time*, and *Mary Hartman, Mary Hartman*. Yorkin, as part of TOY Productions, produced *What's Happening!!*, *Carter Country*, and *One in a Million*.

The comedic formula developed by Lear and Yorkin was a microcosm of that historic synthesis achieved during the 1970s with regard to blacks in TV. On the one hand, there was exposure of black actors—more roles, more employment, more black-centered programs than in the past. Yet, there was an almost total relegation of blacks to comedies. Just as African Americans had been playing the clowns and buffoons of American entertainment since the early nineteenth century, they appeared in the 1970s as the latest embodiment of a format traditionally acceptable to white audiences.

Whatever quantitative achievement there was for blacks in such programming, it was compromised by the quality of humor in the shows. By content and characterization, African Americans in television comedy entered what might be called the Age of the New Minstrelsy. Here was the coon character, that rascalish, loud, pushy, and conniving stereotype, strongly achieved in types such as Sherman Hemsley's boisterous George Jefferson, Jimmie Walker's grinning J. J. Evans on *Good Times*, and Whitman Mayo's lethargic Grady Wilson on *Sanford and Son* and *Grady*. Here, too, was the resurrection of the loud-but-lovable mammy, its roundest modern embodiments being Isabel Sanford's shrill Louise Jefferson, LaWanda Page's overbearing, purse-swinging Aunt Esther on *Sanford and Son*, and Marla Gibbs' caustic character, Florence, the wisecracking maid on *The Jeffersons*, and later in her own short-lived show, *Checking In*.

Unlike *Amos 'n' Andy* and *Beulah*, the comedies of the New Minstrelsy presented more than simple clichés. The element which, in the minds of Lear and Yorkin, redeemed their use of questionable images was the involvement of their series with pressing social issues. Unlike the facile plots of earlier situation comedies featuring blacks, the story lines in Lear-Yorkin shows tested controversial national concerns. Where in American television had situation comedy ever handled such problems as venereal disease, abortion, alcoholism, rape, mastectomy, and black bigotry toward whites? Yet, these were themes on episodes of *Good Times, Maude, All in the Family,* and *Sanford and Son*. Politics, poverty, welfare, black ambitions, sexual conduct, and sexual preference were projected now as legitimate topics for jokes and plots. It was a bold gesture by the two producers. And its success restructured the content of situation comedy and redefined the medium as a vehicle of family entertainment. In the words of critic Michael Arlen, the works of Lear and Yorkin were "our first true 'media' dramas," presentations which

> are probably new in that they seem to depend mainly neither on jokes nor on funny stories, nor even on family—although they often give the appearance of depending on all three—but on the new contemporary consciousness of "media." By this I mean that the base of Lear's programs is not so much the fam-

ily and its problems as it is the commonality that seems to have been created largely by television itself, with its outpouring of casual worldliness and its ability to propel—as with some giant, invisible electric-utility feeder line—vast, undifferentiated quantities of topical information, problem discussion, psychiatric terminology, and surface political and social involvement through the national bloodstream.[1]

The program which launched the Lear-Yorkin revolution in video comedy was *All in the Family*. It premiered on CBS on January 12, 1971. Perceiving the time to be ripe for confrontational humor, the two producers adapted to American realities a popular British TV series about a bigoted cockney. For the first time on network television, Americans found their comedy laced with words like "spic," "dago," "coon," "jig," "jungle bunny," "spade," "Hebe," "Polack," and "Chink," all spewing from the mouth of a "lovable" central character, Archie Bunker.

It is interesting, however, that *All in the Family* avoided some racial epithets—specifically "kike," "sheeny," and "nigger." Lear explained this omission as a conscious policy, since he felt these words were "from another decade," and were "words that connote real hatred, and Archie . . . is not motivated by hatred but by fear."[2] Once, however, Lear broke his own rule and caused Archie to use the word "nigger." In an episode entitled, "Two's a Crowd," aired February 5, 1978, an inebriated Archie explained to Mike—while the two were locked overnight in a bar storeroom—how as a boy a black youngster had beaten him up because he called the black child a nigger. Sensitively recalling his painful childhood, Archie explained that, "That's what all them people was called in them days. I mean everybody we knew called them people 'niggers.' That's all my old man ever called them, there."

As well as being prejudiced, Bunker espoused every conservative-to-reactionary political opinion of the decade. He favored escalating the Vietnam war, segregated housing, the death penalty, and sexually and racially restricted private clubs. Bunker also opposed handgun registration, homosexual rights, free medical clinics, women's liberation, the sexual revolution, abortion, and busing for purposes of school integration. Lear argued that these views were effectively offset by the liberal values of Ar-

chie's son-in-law, Mike "Meathead" Stivic. In Lear's words, "Mike is always the one who is making sense. Archie at best will work out some kind of convoluted logic to make a point. But it's always foolish."[3] Nevertheless, the lovable quality of Bunker's personality seemed often to overshadow the anger and irrationality in his postures. Although Archie's creators did not share his political values, "Archie Bunker for President" bumper stickers and political buttons in 1972 and 1976 indicated that many viewers identified with his opinions. And the death of liberal politics in the early 1980s indicates that rather than an obstreperous purveyor of intemperate ideas, Archie Bunker was a diviner of the political temper and a harbinger of future politics in the United States.

All in the Family was controversial before it was ever broadcast. Although it was developed for ABC, executives at that network shied away from accepting the series. At CBS, officials insisted on script changes in the premier broadcast. Even then, the network prefaced the first several programs with a statement from management assuring viewers that the show was not intentionally demeaning and was, instead, responsibly presented. CBS for several seasons would not broadcast the program before 9 P.M. (EST) because it deemed the show "adult."

In April 1972, the *Philadelphia Inquirer* asked readers if Bunker reflected the thinking of the average American blue-collar worker. More than 61 percent felt that he did. And the opinions regarding his character reflected the spectrum of intense feelings sparked by most Lear and Yorkin characters. Typical comments of readers ranged from "He expresses the opinions of all whites," and "I am prejudiced and proud of it, and I don't know anyone who acts like him," to "He is crude and should be taken off the air," and he is like most whites "except that when colored folks move next door, he doesn't move."[4]

Archie Bunker was the first racial bigot to be taken to the collective heart of mass America. And by mid-1973 with the commercial rate of $120,000 per minute on *All in the Family*, he was also the most expensive racist on TV. Himself a stereotype of blue-collar social and political values, Bunker trumpeted all the derisive epithets whites have chronically used to label the black minority. He described how white missionaries Christianized the Africans, having "dragged them outta the trees and right

down to the river." He marveled at how black religion had copied white Western faith, amazed at "the way you people worked yourselfs up from the snakes and the beads and the wooden idols, right up to our God." And when blacks threatened to move into his neighborhood in Queens, he argues, "What are they gonna do for recreation? There ain't a crap game or a pool hall in the whole neighborhood—there ain't a chicken shack or a rib joint within miles."

Certainly, Lear and Yorkin meant comments such as these as satirical barbs at white racism. In a television special saluting the broadcasting of two hundred episodes of the series, Lear flatly concluded that, "However much we may laugh at the way Archie expresses his outrageous prejudices, and however lovable he may be in other respects, we are content that American people know very well that Archie Bunker, the bigot, is basically a horse's ass!" But to many black families Archie Bunker was something else: the epitome of white racism. *All in the Family* was used in some families as a teaching tool whereby black children were introduced by their parents to white bigotry via Archie's tirades.[5]

The acclaim given to *All in the Family*, with its mixture of prejudice and topicality, led to many new series from Lear and Yorkin. Several of these programs profitably placed African Americans in central roles. Included here were *Sanford and Son, Good Times, The Jeffersons, What's Happening!!, Carter Country,* and *Diff'rent Strokes.* Not all black-centered series from Lear and Yorkin succeeded. Among their failures were *Grady, Sanford, The Sanford Arms, One in a Million, Checking In,* and *Hot l Baltimore.* The latter program in 1975 co-starred Al Freeman, Jr. as a philosophical soul, the only black character living in a sleazy hotel filled with comedic prostitutes, a homosexual couple, a feeble-minded old man, an unemployed waitress, and other assorted types. The series, however, lasted only four months before being canceled.

Another unsuccessful Lear situation comedy was *All's Fair.* Although this politically oriented show featured white actor Richard Crenna as a United States senator, it also employed J. A. Preston as his black assistant, and Lee Chamberlain as Preston's girlfriend. The series, however was one of the most poorly rated of the 1976-1977 season.

One Lear series, *Mr. Dugan,* was withdrawn in 1979 before CBS was able to televise even the premiere episode. This series concerned a black congressman, portrayed by Cleavon Little, whose characterization was so offensive that members of the Congressional Black Caucus advised Lear against airing the show. Lear later admitted that the series was withdrawn, "because in the context of comedy it just wasn't happening with the kind of importance and dignity that the first black Congressman on TV should have."[6]

Many programs produced by Lear and/or Yorkin, however, were well received. Figure 14.1 illustrates the annual Nielsen rankings of their series since the emergence of *All in the Family.*[7]

African-American viewers particularly enjoyed the Lear-Yorkin comedy product. In the summer of 1976, the Arbitron market-research organization surveyed blacks in the fifteen leading market areas. According to its findings, the top three programs with blacks were *Sanford and Son, The Jeffersons,* and *Good Times.* The list of leading shows suggests that urban detectives and situation comedies, genres which occasionally featured black actors, were preferred.[8]

In all fairness to Lear and Yorkin, their comedic formula was not the product of reactionary writers and producers. Throughout the 1970s and 1980s, for example, Lear was an outspoken champion of progressive political issues. Often his corporations donated time and money to causes supporting racial and sexual justice. He also maintained an open door policy, in that he openly solicited scripts from black writers, hoping to discover and groom young comedy writers for programs like *Good Times* and *The Jeffersons.* Similarly, Yorkin often used black writers and production personnel, especially on *Sanford and Son.*[9]

In Paddy Chayefsky's biting screenplay about the television industry, *Network,* the author chided TV series as being formulaic in their perennial search for "crusty but benign" central characters. To a great degree, that personality typified the black series heroes created after the triumph of *All in the Family.* Crusty but benign Fred Sanford, played by Redd Foxx, was an irascible Watts junkman trying to cajole or outfox everyone, even his responsible son Lamont, played by Demond Wilson.

George Jefferson was crusty but benign as well. Although Lance Morrow in *Time* magazine described Sherman Hemsley's

Figure 14.1: Annual Ratings and Overall Ranks per A. C. Nielsen of Network Series Produced by Norman Lear and/or Bud Yorkin, 1970–82

1970–1971
 All in the Family 18.9 (#34)

1971-1972
 All in the Family 33.4 (#1)
 Sanford and Son 25.2 (#6)

1972–1973
 All in the Family 33.1 (#1)
 Sanford and Son 27.2 (#2)
 Maude 24.6 (#4)

1973–1974
 All in the Family 31.2 (#1)
 Sanford and Son 27.6 (#3)
 Maude 23.3 (#7)*

1974–1975
 All in the Family 30.2 (#1)
 Sanford and Son 29.8 (#2)
 The Jeffersons 27.6 (#4)
 Good Times 25.6 (#8)
 Maude 24.9 (#9)
 Hot l Baltimore 14.7 (#68)*

1975–1976
 All in the Family 30.2 (#1)
 Maude 25.0 (#4)
 Sanford and Son 24.5 (#7)*
 One Day at a Time 23.0 (#13)
 The Jeffersons 21.5 (#21)
 Good Times 21.0 (#24)
 The Dumplings 13.6 (#76)*
 Grady 12.2 (#88)

1976–1977
 One Day at a Time 23.4 (#7)
 All in the Family 22.6 (#11)*
 The Jeffersons 21.0 (#22)
 What's Happening!! 20.9 (#23)*
 Good Times 20.9 (#23)*
 Maude 20.0 (#30)
 Nancy Walker Show 17.6 (#54)*
 All's Fair 16.1 (#70)*

1977–1978
 All in the Family 24.3 (#4)*
 One Day at a Time 23.0 (#10)
 Carter Country 19.6 (#29)*
 What's Happening!! 18.4 (#44)*
 Good Times 17.4 (#53)
 The Jeffersons 17.1 (#56)
 Maude 14.7 (#78)
 Sanford Arms 13.0 (#100)

1978–1979
 All in the Family 24.9 (#10)
 One Day at a Time 21.6 (#19)*
 Diff'rent Strokes 19.9 (#29)*
 What's Happening!! 19.8 (#31)
 The Jeffersons 17.5 (#49)
 Carter Country 14.9 (#78)
 Good Times 14.4 (#84)

1979–1980
 The Jeffersons 24.3 (#7)*
 One Day at a Time 23.0 (#10)
 Archie Bunker's Place 22.9 (#11)
 Diff'rent Strokes 20.3 (#27)
 Palmerstown, U.S.A. 19.3 (#38)
 Sanford 16.2 (#64)
 One in a Million 15.4 (#71)*

1980–1981
 The Jeffersons 23.4 (#7)
 One Day at a Time 22.0 (#11)
 Archie Bunker's Place 21.4 (#14)
 Diff'rent Strokes 20.5 (#26)
 Facts of Life 19.1 (#30)
 Checking In 17.6 (#40)*
 Sanford 14.5 (#72)*
 Palmerstown 14.0 (#75)

1981–1982
 The Jeffersons 23.4 (#3)
 One Day at a Time 22.0 (#11)
 Archie Bunker's Place 21.6 (#13)
 Facts of Life 19.1 (#25)*
 Diff'rent Strokes 17.5 (#35)*

*denotes tie

Figure 14.2: Arbitron Survey of Shows Preferred by African Americans in the Summer of 1976

Rank	Program	Rank	Program
1	Sanford and Son	8	Welcome Back, Kotter
2	The Jeffersons	9	The Practice
3	Good Times	10	Doc
4	Starsky and Hutch	11	Happy Days
5	The Bionic Man	12	Barney Miller
6	Kojak	13	All in the Family
7	Baretta		

character more specifically—"entrepreneur, black bigot, a splenetic little whip of a man who bullies like a demented overseer, seldom speaks below a shriek and worships at the church of ostentation"[10]—Jefferson shared his formulaic personality with Fred Sanford. The formula was found in uptown blacks like Grady Wilson, and downtown blacks like Gary Coleman's impish Arnold on *Diff'rent Strokes*. It was there, too, in middle-class urban blacks like Mabel King's "all business" character, Mama Thomas, on *What's Happening!!*

No Lear or Yorkin character, however, received as much criticism as J. J. Evans, the open-mouthed coon on *Good Times*. Played by comedian Jimmie Walker, James Evans, Jr. (J. J.), was an unemployed eldest son of a black family struggling to survive—and even succeed—in Chicago's notorious Cabrini-Green housing project. Within this serious setting, Lear introduced J. J., again in the words of Lance Morrow, as "a bug-eyed young comic of the ghetto with spasms of supercool blowing through his nervous system, a kind of ElectraGlide strut."[11] J. J. was cut from the same pattern as George "Kingfish" Stevens decades earlier. His stock phrase, "Dy-no-mite!," was reminiscent of the Kingfish's "Holy Mack'l" heard so often on *Amos 'n' Andy*. J. J. also displayed his large white eyeballs and tooth-filled Cheshire cat grin. A womanizer, unintelligent, and always wisecracking or mugging for a laugh, this endman of the New Minstrelsy was ultimately related to Mr. Tambo and Mr. Bones, those demeaning coons of another century.

As with most Lear and Yorkin situation comedies, however, the rank stereotypes of *Good Times* were blended with uncom-

mon humanity and seriousness. The series presented a loving and commanding father played with restraint by John Amos. As quick with a hug for actions he approved as he was with a belt for those he condemned, James Evans, Sr., was a proud, strong and determined image of African-American fatherhood. Complementing him, moreover, was Esther Rolle's portrayal of Florida Evans, a loving mother respectful of her husband's familial prerogatives, a sympathetic parent but still not intimidated by her spouse's bluff manner.

The mix of racial exploitation and forceful role-modeling found in Lear-Yorkin comedy was a fragile one. An imbalance of the components could prove disastrous. Such was the case with *Good Times*. During its first seasons, 1974–1976, the series maintained its equilibrium and enjoyed enormous acceptance, reaching its highest rating as the eighth most popular program in the 1974–1975 season. But as scripts increasingly pandered to J. J.'s buffoonery, Amos and then Rolle left the series. Interestingly, J. J. then was employed as a commercial artist and became the leading character on the deteriorating program. With no strong family values to redeem it, however, what had been a highly successful series in its first years degenerated into a boisterous racial farce. It was canceled in 1979, ending the season ranked eighty-fourth.

Seldom does one film production company berate another publicly, but in "The Outcast," an episode of *Strike Force* that aired January 8, 1982, a stinging rebuke of the Lear-Yorkin product emerged in a blunt conversation between a black police detective, played by Dorian Harewood, and his young son. The episode was written by T. J. Miles and Gene Hanson; it was produced by Aaron Spelling Productions, another of the industry's major program suppliers. In a scene arising from the child's use of the word "nigger," Harewood lectured the boy for his indiscretion. What followed constituted Spelling's critique of Lear and Yorkin.

Son: (looking into bedroom mirror menacingly) Watch out! This nigger's coming at you, man.
Father: Hey, hey. What's that talk?
Son: I saw you on the news last night.
Father: Well, I wasn't at my best, my friend.

Son: I was so proud of you, daddy.

Father: Yeah, well, I don't want that word in this house. You don't use it here or anywhere else.

Son: It's all right if we say it.

Father: No, it's not.

Son: I hear it all the time on television, daddy. I hear it on *The Jeffersons* and *Good Times.* If it's black people saying it, it's OK.

Father: No, it's wrong. That just keeps that word alive.

As well as providing success for their own production companies, Lear and Yorkin offered a model for others in video comedy to emulate. Above all, the Lear-Yorkin formula brought relevancy back into television. Their programs clearly illustrated that when placed in humorous contexts, issue-oriented themes were agreeable to viewers. And developments of the mid-1970s provided TV writers with a rich source of material. This was the period of the Watergate scandal and its compromising of governmental politics. The war in Southeast Asia became an American military defeat. Steep interest rates, rapid inflation, and mounting unemployment also marked the era. For the first time in many memories, citizens paid high fees for a dwindling supply of gasoline, heating oil, and natural gas. More personally, the time was also marked by reevaluations of traditional professional, moral, and sexual mores.

TV comedy series approached these national problems with unprecedented frankness. With its premier in the fall of 1972, *M.A.S.H.* was almost as antiwar as it was humorous. *Barney Miller*, beginning in 1975, treated social issues within the framework of a New York City police station. *Chico and the Man*, beginning in 1974, was the first series to deal with problems emulating from the Latino inner city, the barrio. Themes of women's liberation were integrated in the *Mary Tyler Moore Show* and its spin-offs, *Phyllis* and *Rhoda*. Certainly, there continued to be new programs with nontopical comedy—from the nostalgic *Happy Days* and *Laverne and Shirley* to the variety-format of the *Sonny and Cher Comedy Hour* and the adult, middle-class *Bob Newhart Show*—but these were now countered by more moralistic, relevant comedy such as in *Eight Is Enough*.

As comedy flourished in the mid-1970s, so, too, did black ac-

tors. Among those appearing in hit programs were Ron Glass as detective Ron Harris in *Barney Miller,* Scatman Crothers and later Della Reese in *Chico and the Man,* and Robert Guillaume as Benson the savvy butler on *Soap.* Throughout the last half of the decade, moreover, Garrett Morris was cast as the sole black regular on *Saturday Night Live.* While these were all supporting parts, Clifton Davis and Theresa Merritt, plus a group of other black character actors, were the central figures on *That's My Mama.*

There were roles for blacks in less successful comedies. Hal Williams portrayed an inmate, and Mel Stewart a hard-nosed correctional officer, at the Alamesa Minimum Security Prison in the one season of *On the Rocks.* During its three versions, Cleavon Little played a jive medical intern—as good with booking bets on the horses as he was with pulling pranks in the hospital—on *Temperatures Rising* (later called the *New Temperatures Rising Show*). William Elliott was a regular on *Bridget Loves Bernie.* Joe Keyes portrayed a "liberated" cook on *The Corner Bar.* And Harrison Page, although cast as a naval officer, was still a foil for Don Rickles' racial jokes on *C.P.O. Sharkey.* Among those African-American actors in more quickly canceled series in the mid-1970s were Ren Woods in *We've Got Each Other,* Richard Ward in *Beacon Hill,* Ted Ross in *Sirota's Court,* and Harrison Page and Janet MacLachlan in *Love Thy Neighbor.* Ralph Wilcox suffered this fate twice in *Busting Loose* and *Big Eddie.*

One of the most disappointing black-centered failures of the period was *Roll Out.* It lasted only three months on CBS in the fall of 1973. Produced by Gene Reynolds and Larry Gelbart as a black version of their hit series, *M.A.S.H.,* the program concerned the men of the Army's 5050th Quartermaster Trucking Company in World War II, the predominantly black "Red Ball Express." Instead of sensitive comedy or inventive characterization, however, *Roll Out* presented a noisy and stereotyped scenario with a screaming top sergeant (Mel Stewart), a jive-talking urban corporal (Stu Gilliam), and naive rural private (Hilly Hicks). This was all accompanied by the din of growling ignition systems, roaring truck engines, and backfiring carburetors. Although it gave supporting roles to many black actors, including Darrow Igus, Garrett Morris, Theodore Wilson, and Sam Laws, the series was "out of gas before it cleared the starting gate."[12]

As much the victims of unpopular formats as of their own

performances were those African-American entertainers who failed in comedy-variety shows. Typical was the *New Bill Cosby Show* in the 1972–1973 season. Although headlined by one of the most accomplished TV stars in recent years, even Cosby could not generate viewer interest in the traditional format of monologues, a few skits, and a little singing and dancing. Cosby was also unsuccessful four years later with a similar format. With *Cos* the idea was to produce a comedy-variety program in prime time for preteenagers. *Cos* was canceled by ABC after less than two months in the fall of 1976.

But Bill Cosby had company. Also failing to survive in shows with comedy-variety formats were Diahann Carroll, Gladys Knight and the Pips, Redd Foxx, the Jackson Five, Melba Moore and Clifton Davis, Marilyn McCoo and Billy Davis, Jr., and Ben Vereen. A noteworthy exception to this pattern was the popularity of Telma Hopkins and Joyce Vincent Wilson, two halves of the singing group Dawn, who appeared for two seasons on the CBS program, *Tony Orlando and Dawn.*

Several black talents found it more profitable to bypass network television. They produced their own musical-variety series and syndicated them directly to local stations. Among these productions were the *Rosey Grier Show* and the *Barbara McNair Show*, both created in the early 1970s. *Half the George Kirby Comedy Hour* was a half-hour series featuring the noted black comedian with musical guests in 1972–1973. Perhaps the best received first-run syndicated program hosted by an African American was Sammy Davis, Jr.'s venture in 1975, *Sammy and Company.*

It is interesting, however, that the most inventive black comedian of the decade hosted one of the most disastrous comedy-variety programs in TV history. When Richard Pryor debuted on his own NBC show in the fall of 1977, he brought to television an amalgam of bawdy ethnic comedy—not unlike the nightclub humor for which Redd Foxx was famous before he entered TV—and youthful black rage, channeled into a singular style of delivery. Still, Pryor had merited his own TV show due to a burgeoning motion picture career—*Car Wash* being released in 1976 and *Silver Streak* and *Greased Lightning* in 1977—and because of his moderately successful NBC special, the *Richard Pryor Special?*, which had aired in May 1977.

Fat Albert and his comic friends changed the focus of Saturday morning programming for children. Created by Bill Cosby and based upon recollections of his childhood in Philadelphia, *Fat Albert and the Cosby Kids* became a vehicle for teaching social and moral lessons to youngsters. (*Courtesy of Bill Cosby and Filmation Studios*)

Ellen Holly appeared on *One Life to Live* beginning in the late 1960s. Here she portrayed Carla Gray—later Carla Hall—until departing the serial in the mid-1980s. (*Courtesy of the Schomburg Center for Research in Black Culture*)

As actor, writer, and director, Melvin Van Peebles has made an indelible mark on American popular culture. His *Sophisticated Gents* miniseries on NBC in 1981 broke many racial taboos. (*Courtesy of the Schomburg Center for Research in Black Culture*)

Television has not been hospitable to dramatic series starring black actors. There have been few such programs, and they are canceled quickly when high ratings do not materialize. As detective Captain Woody Paris, James Earl Jones in his *Paris* series in 1979 failed to break this controversial pattern of failure. Not until 1990–91 with his Emmy-winning lead in *Gabriel's Fire*—and its sequel the following season, *Pros & Cons*—did Jones get another chance to star in his own series. (*Courtesy of MTM Enterprises and Lucy Kroll Agency*)

For more than two decades Tony Brown has probed aspects of the black experience usually overlooked by commercial TV. Into the 1990s *Tony Brown's Journal* remains a forum in which racial issues are addressed frankly and constructively. Whether as a syndicated series or a regular PBS offering, his program has made television relevant to the concerns of African Americans. (*Courtesy of Tony Brown Productions*)

As the author of *Roots*, an autobiography of his own family, Alex Haley helped shape the *Roots* phenomena—two overwhelmingly popular miniseries which traced the history of racism in the United States and offered the illusion of great dramatic opportunity for black actors in TV in the future. (*Photo by Alex Gotfryd. Courtesy of Doubleday and Company, Inc.*)

Louis Gossett, Jr. has been one of the more visible black actors in television. Since the 1970s he has been featured in regular series and has starred in several made-for-TV movies. Gossett won an Emmy in 1977 for his role as Fiddler in *Roots*. (*Courtesy of the Schomburg Center for Research in Black Culture*)

Yaphet Kotto (left) and Bernie Casey starred in the story of a slave revolt in nineteenth-century South Carolina when PBS aired *A House Divided: Denmark Vesey's Rebellion* in 1982. (*Photo by William Struhs. Courtesy of WPBT/Miami*)

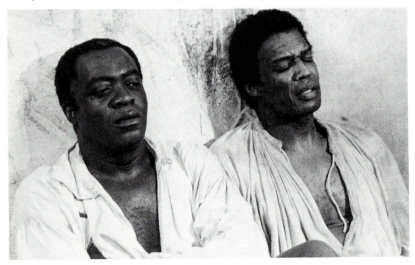

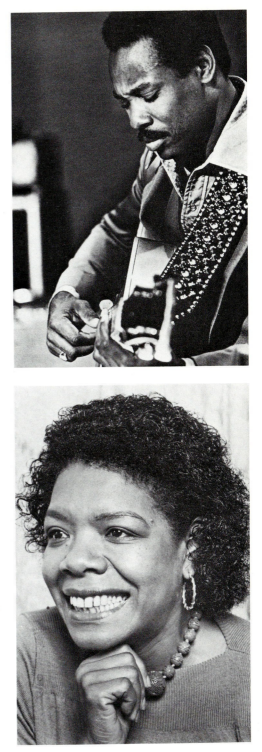

A production of WTTW in Chicago, the PBS series *SoundStage* for several years provided a national outlet for black musicians such as George Benson. (*Photo by Jon Randolph. Courtesy of WTTW/Chicago*)

Maya Angelou has contributed to American TV as a writer and actress. The personal portrait of her presented in 1982 on the PBS series *Creativity with Bill Moyers* was a sensitive documentary which probed her creative genius as it emerged from formative years in rural, segregated Arkansas. (*Photo by Don Perdue. Courtesy of WNET/New York*)

One of the most accomplished broadcast journalists in network television, Ed Bradley emerged on CBS as a correspondent covering the Vietnam War. He has become anchorman on the CBS weekend news, a producer of network documentaries, and co-editor of *60 Minutes*. (*Courtesy of CBS News*)

As a co-anchor of the ABC network's prime-time newscast from 1978 to 1983, Max Robinson reached the highest on-camera position in TV journalism. The three networks did not employ black reporters until ABC hired the first African-American newsman in 1962. (*Courtesy of ABC News*)

Despite limited access to careers in TV news, black reporters and anchors such as Renee Poussaint of WJLA-TV in Washington, D.C., have made significant contributions to broadcast journalism on the local, non-network level. (*Courtesy of WJLA-TV/ Washington, D.C.*)

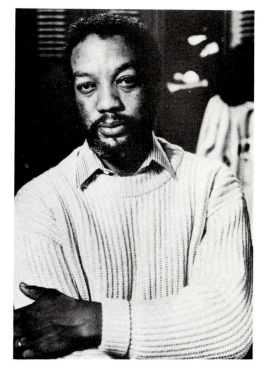

Paul Winfield has appeared in many TV productions as guest, featured star, and narrator. In the PBS special *Only the Ball Was White*, Winfield narrated a documentary about the great black baseball players who were condemned to all-black minor league teams because major league baseball refused until 1947 to employ African Americans. (*Photo by Jon Randolph. Courtesy of WTTW/ Chicago*)

Successful as a local TV personality for more than a decade, Gil Noble (right) in New York City used his urbane, Emmy-winning discussion program to probe varied aspects of black achievement and concern. Here Noble speaks with boxing champion Sugar Ray Leonard. (*Courtesy WABC-TV/New York City*)

In his documentary, *Men of Bronze,* William Miles introduced Americans to the 369th Regiment, an all-black army unit in World War I. The film was first aired on PBS in 1977. (*Courtesy of William Miles*)

Pryor's television series failed for several reasons. Scheduled for Tuesdays at 8:00 P.M. (EST), the network had placed Pryor and his adult, politicized comedy in the early-evening hour reserved for family viewing. It was difficult to tone down Pryor's aggressive humor to fit the needs of this time slot. It was also difficult to compete with *Happy Days*, the top ranked show of the previous season, on ABC. Further, Pryor had problems with censorship. On the premier program, he had planned to appear in simulated nudity—actually naked from the waist up, wearing skin-colored tights with no sexual definition, giving, thereby, the illusion of nakedness and emasculation—to suggest what he had to surrender to NBC in order to get his own series. The skit was edited from the show by network censors. Still, two NBC affiliates (in Winston-Salem and Grand Rapids) refused to carry the program, and two delayed its telecast. The following week the show was preempted in Winston-Salem and Detroit. Many stations also demanded to preview the programs before airing them.

As if these matters were not contentious enough, Richard Pryor called a press conference to denounce NBC for thwarting his artistic creativity and for improperly scheduling the show. Despite positive reviews from critics, with a recalcitrant host and a fearful network, the *Richard Pryor Show* lasted only five telecasts—one of them being a rerun of the *Richard Pryor Special?* (a show again rerun in prime time by NBC five years later on May 11, 1982!). In terms of ratings, moreover, the series failed to command viewer interest. It was the ninety-fifth most popular series (out of 109 shows) of the 1977–1978 season.[13]

There was, however, another dimension of the *Richard Pryor Show* which mitigated against its mass acceptance. As seductive and popular as Pryor was with live audiences, his humor possessed a racially political quality which was foreign to network television. In one skit, Pryor gazed at three attractive white women and then reflected—with the help of six beautiful African-American models—on the beauty of black women in all skin hues, from peach, honey gold, caramel, and persimmon, to chocolate, molasses toffee, and blackberry. More politically, he portrayed the first black president of the United States at a press conference. Here he admitted, after an announcement filled with political double-talk, that he was considering appointing Black Panther leader Huey P. Newton as director of the FBI; he

193

also announced his intention to continue dating white women now that he was in the White House; and before a racial brawl disrupted the conference, he ignored white reporters and showed favoritism to black questioners.

Pryor had the ability to satirize black culture without elevating white society as a model to be emulated. He played a TV evangelist who merely wanted to raise as much money as white television preachers. He played a stereotyped black drunk returning home to a scornful wife (played by Maya Angelou) who, after he collapsed on the sofa, delivered a soliloquy filled with anguish about her deeply felt love for her husband. At his political best, Pryor played Ugandan dictator Idi Amin Dada, delivering a rebuttal to a TV editorial. Here he captured Amin's brutal disregard for life, complete with blazing pistols and machine guns. But he also used Amin to mock self-complacent whites, reminding them that as bad as his country was, "Uganda is not Cleveland—you cannot apply Cleveland principles to Uganda"; that "in Africa nobody call you 'nigger' "; and that "V.D. stand for, in my country, victory dance—someday all over the world black man do victory dance." For all its inventiveness, Pryor's type of comedy and the mass audiences consistently sought by broadcast television were incompatible.

Canceled or not, African-American programs were quantitatively an important dimension of TV in the mid-1970s. Clearly, however, when blacks were employed, they were cast overwhelmingly as comedians. Nonetheless, even in this age of the New Minstrelsy it would be incorrect to conclude that blacks were totally absent from noncomedic programming.

15

Blacks in Noncomedic Television

To be truly creative and strategic to society, television needs to be more than jokes and laughter. Yet, with the demise of the sociopolitical melodrama in the Nixon years, networks and producers turned to comedy, particularly situation comedy, to please an audience which, according to those crucial ratings, more and more preferred laughter to seriousness.

There were indications, however, that the perceived national taste for situation comedy was not as unalterable as it appeared. First, the most successful series of the decade were those produced by companies headed by Norman Lear and Bud Yorkin. And rather than avoid reality, these programs clearly exploited topical humor drawn from controversial issues of the day. Second, the growing popularity of news-magazine shows like *60 Minutes* and *20/20* indicated mass interest in real issues. Finally, the case of a series like *The Jeffersons*—which enjoyed popularity for a few years, then plummeted in the ratings for several seasons, only to emerge near the top by the early 1980s—suggests that with the proper time slot, the right promotion, and much patience, network TV could make a program viable and even popular. Giving up quickly on dramatic series which garnered mediocre ratings in their first telecasts—only to replace them with more comedies—the networks helped ensure that national TV would seek to tickle rather than teach its audience.

There was a certain irony surrounding the part played by blacks in video in the mid-1970s. Outside of comedy, the black

imprint on prime-time TV was not of great consequence. African Americans were present in evening television, but they were neither crucial nor influential in noncomedic programming meant for adults. It is interesting, however, that African Americans at this time became vitally important to one dimension of national TV which had been traditionally lily-white: children's programming. Not only did blacks gain roles in most productions aimed at youngsters, but they precipitated a basic alteration in the relationship between television and American children.

The history of African Americans in network children's programming is an uncomplicated one. Before *Sesame Street* premiered on public television in 1969, few blacks appeared on children's shows, and no programs were ever produced with ghetto youngsters in mind. More than any other mass medium, TV excluded blacks from juvenile entertainment. All of those landmark children's shows during the first twenty years of video—*Howdy Doody, Romper Room, Mr. Wizard, Ding Dong School, Captain Kangaroo*; and adventure series like *Space Patrol*, the *Mickey Mouse Club*, and the *Adventures of Rin-Tin-Tin*—seldom, if ever, involved blacks.

The attitude suggested by this pattern reached its highpoint in 1961 with the cartoon series, *Calvin and the Colonel*. Freeman Gosden and Charles Correll, originators on radio of *Amos 'n' Andy*, provided their minstrel voices for the prime time series. With no complications, the voices that whites for decades had accepted as the natural sound of typical American blacks now became accepted as the voices of a conniving fox named the Colonel, and a dumb, oafish bear called Calvin.

The racist legacy was challenged by *Sesame Street*. Three years in the making, *Sesame Street* was the most acclaimed and important racially integrated series to emerge in the Golden Age of blacks in TV. Long after *I Spy, Júlia*, the *Bill Cosby Show*, and other series from the Golden Age had been canceled and syndicated, *Sesame Street* continued to project positive images of white and minority children and adults interacting constructively.

The goal of *Sesame Street* was to reduce the achievement gap between advantaged and disadvantaged youngsters. According to Joan Ganz Cooney, president of the Children's Television Workshop, the producers of *Sesame Street* sought "to move all

children across the basic literacy line which is the key to educa-
tion and later entering the mainstream of American life."[1]

Sesame Street was an imaginary city block near 104th Street
and Second Avenue in East Harlem. Within this inner-city mi-
lieu there existed a racial melange of happy children and adults.
Frequently, black entertainers, notably Bill Cosby and Nipsey
Russell, appeared for segments of the program. While critics as-
sailed the show for encouraging passive tolerance rather than ac-
tive social change, and for "sugar-coating" ghetto life and teach-
ing "minority children to accept quietly middle-class America's
corrupt demand to subjugate themselves,"[2] the lengthy and pop-
ular run of the series suggests that it struck a responsive chord
with preschool youngsters.

In addition to its educational goal of teaching cognitive skills
in a direct fashion, *Sesame Street* sought to teach social attitudes
in an indirect manner. Its presentation of adult blacks as educa-
tors and role models exercised a positive influence on minority
children, and promoted tolerance among white juveniles. It is
important that amid the exciting puppet shows and cartoons in-
tended to teach elementary reading and arithmetic skills, there
were frequent glimpses of life on Sesame Street, wherein low-
keyed social messages about brotherhood were suggested but
not overtly stated.

Despite the example of *Sesame Street*, the commercial net-
works were slow to reevaluate their own juvenile offerings. As
late as October 1972, a survey commissioned by Action for Chil-
dren's Television and conducted by Black Efforts for Soul in
Television (BEST), concluded that Saturday morning network
TV was spreading "stereotyped thinking and bigoted informa-
tion" regarding racial minorities. Studying programming in 1971
such as the *Bugs Bunny Show*, *The Jetsons*, *The Funky Phantom*,
The Jackson Five, and *Sabrina the Teenaged Witch*, BEST argued
that the subject of race never was mentioned and the locale was
invariably the white community. Further, BEST noted, wher-
ever there was a black leader he was always accompanied by a
white co-leader, and all sources of authority and information
were white. To one researcher, "Network television is guilty of
the worst kind of racist attitudes in the area of blacks and other
minorities on children's programming."[3]

With *Fat Albert and the Cosby Kids*, however, CBS pio-

neered a meaningful network response in children's program-
ming.[4] Premiering in the fall of 1972, this animated Saturday
morning series featured Bill Cosby as host to the adventures of a
group of black youngsters growing up in an urban environment.
The show was drawn in part from Cosby's memories of his own
childhood in Philadelphia. From those remembrances came
unique black characters that included Fat Albert and friends
Mush Mouth, Crying Charlie, and Dumb Donald.

But *Fat Albert* was not purely an entertainment series. Work-
ing with a panel of social scientists and educators, CBS and
Cosby used the program as a vehicle for teaching ethics, social
values, judgment, and personal responsibility. Here was a fusion
of education and entertainment, precipitated for the most part
by Cosby, who, although a noted TV comedian, was also a gradu-
ate student at the University of Massachusetts working toward a
doctorate degree in education which he later obtained.

As well as presenting black characters in a positive perspec-
tive, *Fat Albert* treated issues such as lying, tolerance, coping
with death in the family, playing hooky, cheating on tests, and
ganging up on a child because he or she is different. In a typical
program, "Four Eyes," broadcast in 1974, the Cosby kids contin-
ually poked fun at a boy because he had poor vision and had to
wear glasses. After getting glasses, however, the boy became the
best hitter on the local baseball team—able now to see clearly
and to gain the admiration of his pals, even to the point of their
confession that glasses made the wearer look distinguished.

The wide acceptance of *Fat Albert and the Cosby Kids*, with
its values-laden messages and educational purposes, precipitated
a major realignment of Saturday morning programming at CBS.
In the fall of 1974, the network introduced five new programs
that—according to network president Robert Wood, speaking in
a closed-circuit telecast for network stations and affiliates—imi-
tated the formula of *Fat Albert* by purposely communicating a
perspective on social responsibility and ethics.

Valley of the Dinosaurs was a cartoon series placing a mod-
ern family in prehistoric times, dealing thereby with the problem
of recognizable people having to live with totally different hu-
man beings. *Shazam* featured Captain Marvel helping to resolve
such youthful problems as going along with the crowd, suffering
the consequences of wrongdoing, respecting oneself and other

people, and making value decisions with respect to peers, parents, and community. A third show, *The Hudson Brothers Razzle Dazzle Comedy Show,* was a variety program that mixed music and comedy with messages of personal responsibility. *The U.S. of Archie* took the *Archie* comic book characters and placed them within American history, where they encountered problems like women's equality and historical figures such as Harriet Tubman. The final new show was *The Harlem Globetrotters Popcorn Machine.* It was a live-action stage show featuring eleven members of the famed basketball team, plus child actor Rodney Allen Rippy, in a blend of basketball tricks and slapstick comedy, together with themes of brotherhood, good health, regard for the environment, sportsmanship, and good citizenship.

Though most of these CBS programs eventually were canceled, values-orientation in children's programming was not fully abandoned. Further, the watershed series, *Fat Albert,* continued on CBS into the early 1980s. And other shows on network television reflected the fundamental reevaluation inspired by Bill Cosby's contribution. In shows like *Bubble Gum Digest, Zoom, Kids Are People, Too, The Big Blue Marble, 30 Minutes, The Electric Company, Weekend Special,* and *Marlo and the Magic Movie Machine,* blacks appeared with regularity, and lessons of social responsibility continued to be communicated. Blacks even appeared in 1977 as regular cast members of the syndicated *New Mickey Mouse Club,* an updated version of a children's variety program from the 1950s and 1960s.

Related to the popularity of children's shows with black characters were prime-time series featuring black youth. While the success rate for black adults in prime time was low between 1970 and 1983, such was not the case with black children cast in network programs. Featured almost exclusively in situation comedies, African-American youngsters in the preschool through high school age groups enjoyed considerable acceptance. The fact that these series were invariably scheduled in the early evening, a time with the largest youthful audience, suggests that young viewers were less hostile to black representations than had been adults.

A favorite format was the half-hour comedy set in a high school environment. Certainly, not all shows in this category were viable. *Lucas Tanner, Hollywood High, Szysznyk,* and *The*

Waverly Wonders were short-lived programs. But *Room 222*, set in a Los Angeles high school, enjoyed a run of more than four years. And *Welcome Back, Kotter*, set in a Brooklyn high school, featured Lawrence-Hilton Jacobs as Freddie Washington throughout its four year run in the last half of the 1970s. *What's Happening!!* focused on three urban high school students and was based freely on the popular black film, *Cooley High*. In the TV series, Ernest Thomas (as Roger "Raj" Thomas), Fred Berry (as Rerun), and Haywood Nelson (as Dwayne) played a trio of wholesome, if somewhat mischievous, black kids. Three of their greatest impediments to youthful expression were the strong and assertive Mama Thomas; a sympathetic soda-shop waitress, Shirley (Shirley Hemphill); and a sarcastic younger sister, Dee Thomas (Danielle Spencer). *What's Happening!!* lasted three seasons on ABC, running from 1976 to 1979.

The most significant series highlighting black high school youngsters was *The White Shadow*. In that it was a dramatic show and not a situation comedy, *The White Shadow* was different. The program concerned a white basketball coach in a predominantly black high school. Plots usually revolved about the members of his team, often probing important social and racial concerns in the process. Among these issues were high school pregnancy, interracial dating, incorrigible students, the dropout phenomenon, student homosexuality, and sports as a means of escaping the ghetto. Headed by Ken Howard—and including young black actors Kevin Hooks, Byron Stewart, Thomas Carter, Nathan Cook, and Eric Kilpatrick, with Ed Bernard and Joan Pringle as school administrators—*The White Shadow* ran for three seasons on CBS before being canceled in 1981. Its demise relegated black children to comedic roles only.

Equally as popular as high school blacks in situation comedies were sitcoms featuring precocious preteen black children. Such characterization was not unique to the 1970s. Gerald Edwards had his light moments in the adventure series, *Cowboy in Africa*, in 1967–1968. And Marc Copage as Corey Baker was a crucial part of *Julia* during its three seasons (1968–1971). The street-wise black child, however, flourished in the mid- and late 1970s. One of the first was Tierre Turner as Lucas Adams, an African-American orphan with an Irish policeman as his guardian in *The Cop and the Kid* on NBC during the winter of

1975–1976. Danielle Spencer's part in *What's Happening!!* fit into this mold. So, too, did Todd Bridges' character, Loomis, a hip street-kid, in 1977–1978 on the ABC series *Fish*.

The most prepossessing actor in this role, however, was Gary Coleman. Cast as Arnold on Norman Lear's *Diff'rent Strokes*—with Todd Bridges as his brother, Willis—Coleman played the hipper and more flippant of two orphaned brothers from Harlem poverty, adopted by a white widower and living now in Park Avenue wealth. The series gave range to Coleman's show-off acting talent, but still presented a stereotype akin to the pickaninnies who populated vintage *Our Gang* and *Little Rascals* comedy films. Like the black children in those two-reel comedies from the 1920s and 1930s, the youngsters in *Diff'rent Strokes* were meant to be seen and exploited as blacks. Many of the plots and jokes on the program revolved around being African American in a white world. While there were rhetorical attempts at racial pride and human love, Arnold was condemned by his writers and his social context to be self-consciously black. Never able to be simply another child in another situation comedy, Arnold was a black kid before he was a human being.

Willis was also spiritually confined. He was a stereotype, cast to fill a preconceived model explained by the executive producer of *Diff'rent Strokes*: "We needed a kid who had a kind of rough edge to him. Streetwise, if you will, who could show a little hostility at being pulled into a rich white neighborhood after his parents died, but wouldn't appear so hostile that audiences wouldn't like him."[5] Thus, Arnold and Willis forever had to be black and "act black" for their relatives and friends. In this regard they were clearly tied to those old-time comedies where white audiences rolled with knowing laughter when Farina and a chimpanzee played together, or when Buckwheat sat in a washing machine trying to be washed white.

Black children strongly influenced television in the 1970s. Whether for social values or stereotypes, African-American youths were accepted where many black adults were rejected. This rejection was most noticeable in noncomedic programs. When contrasted to the popularity of the clowns of the New Minstrelsy, the failure to produce substantial black roles in prime-time dramatic shows points up the plight of African-American TV actors in the 1970s. To be successful in the nation's principal me-

dium of communication, adult blacks had to be funny. Whenever there were hit noncomedic series—focusing as they invariably did on a lawyer, doctor, educator, police officer, cowboy, spaceman, private investigator, pioneer, middle-class executive, military officer, journalist, or any of the other professionals in whom Americans have found their dramatic entertainment—the best an African American could expect was a recurring part in which he or she operated in a noncritical way to support the heroic actions of a white central character.

In an earlier time, such ancillary roles were as butlers, maids, janitors, and porters. In television in the 1970s, the characters may have been enhanced somewhat, but blacks still played the secretaries, chauffeurs, bodyguards, and informants for white series champions. For every Percy Rodrigues and Brenda Sykes in *Executive Suite*—a prime-time dramatic serial about corporate intrigues, sexual encounters, and emotional clashes—there were many more traditional roles such as Antonio Fargas as the jive-talking informant, Huggy Boy, on *Starsky and Hutch*, Ed Bernard as James Farentino's personal pilot (chauffeur) on *Cool Million*, Tony King as a police sergeant to Jack Palance's starring lieutenant on *Bronk*, Hari Rhodes as a mayor supporting Robert Stack as a heroic police captain on the short-lived *Most Wanted*, and Dawn Smith as Lloyd Bridges' female friend and entrée to the ghetto in *Joe Forrester*. One of the most promising castings was Carl Franklin as a university scientist and focal point of the science fiction series, *Fantastic Journey*. The program and the role, however, lasted only two months in early 1977. Television in the 1970s was unable and unwilling to support blacks in anything but supporting dramatic roles. This was most apparent in detective programming.

The detective story is generally an urban drama. As such, one might have expected blacks to have been integral to the genre since the beginning of television. Such was not the case. Not until the mid-1960s did African Americans appear as regulars in detective programs. Invariably, however, they were never the heroes of such shows. And this pattern persisted throughout the 1970s when blacks were quantitatively more obvious, but qualitatively still unfulfilled.

There were many detective series wherein white private detectives, police officers, or international crime fighters were as-

sisted by black characters. Gail Fisher was the loyal secretary on *Mannix* for seven seasons. As Sergeant Joe Broodhurst, Terry Carter played Dennis Weaver's sidekick on *McCloud.* Bernie Hamilton was the gruff Captain Dobey whose understanding permitted the white stalwarts of *Starsky and Hutch* to capture gangsters in the mid-1970s. Ed Bernard was helpful, but not crucial, to the apprehension of criminals during four seasons of *Police Woman.* Although on *Caribe* Carl Franklin co-starred as a sergeant on an international crime-fighting organization called Caribbean Force, most of the attention went to a white actor, Stacy Keach, who played the lieutenant. The most distasteful black role in the genre, however, was Michael D. Roberts' portrayal of Rooster on the *Barretta* series. Rooster was a cool-talking black pimp who, through his "street smarts" and his stable of women, for more than three seasons gathered information to sell to the white detective, Tony Baretta.

More distinguished was Georg Stanford Brown's role on *The Rookies.* On ABC from 1972 until 1976, Brown played officer Terry Webster, part of a trio of energetic police rookies working in a city in Southern California. At the time, Brown's character was the most critical part for an African-American actor in the history of network detective shows. When few blacks had yet to be cast in the lead of serious police dramas, Brown portrayed a solid and professional law enforcement official. As such, Terry Webster was more authentic than Linc Hayes, the hip undercover police officer enacted by Clarence Williams III on *The Mod Squad.* Further, the role Brown played was more crucial to the series' viability than Greg Morris' part as the expert in machines and electronics, Barney Collier, on *Mission: Impossible.*

The attractiveness of Brown in *The Rookies* helped persuade CBS and NBC to cast blacks in starring roles in their own detective series. What developed, however, was not simply programming failure, but an expression of the chronic inability of television to imbue a single, black hero with a personality true to his cultural background, yet appealing enough to command the viewer approval needed to survive as a series lead. In the cases of the CBS venture, *Shaft,* and the NBC series, *Tenafly*—both premiering in the fall of 1973—the first black detective heroes to work alone in network TV made little impact on white society, black society, or the medium itself.

Chapter 15

In the blaxploitation films of the early 1970s, Richard Roundtree played private detective John Shaft in a triology of financially rewarding feature films: *Shaft* (1971), *Shaft's Big Score* (1972), and *Shaft in Africa* (1973). Here, he was tough, sexy, slick, and savvy, working and loving in New York City. In the latter film, Shaft even switched locales, returning to the "mother country," sweeping through African crime "like a black tornado." Sleek leather clothing, beautiful women of all nationalities, a tough demeanor around criminals and police alike—these were the hallmarks of the blaxploitation Shaft. On television, however, John Shaft's character was tamed. No profanity, moderated sex, toned-down violence, no expression of being black in a white world, the video Shaft was more formula than flair. For white audiences, Shaft on TV was just another private eye, albeit an African-American one, with no distinction except racial ancestry. *Variety* called the program "formula," "an absurd melodrama," and "a strong lead in Richard Roundtree and not much else."[6] Cleveland Amory in *TV Guide* lamented over the program: "It would seem the least you could expect . . . is that they would occasionally offer an alternative to those seemingly endless private eyes." He concluded, moreover, that Roundtree and John Shaft were compromised on television—"either they shortchanged him or the character itself got shortchanged in the transition from movies to TV."[7]

For black audiences, *Shaft* was a disappointment. No matter how brutal and pandering the blaxploitation films had been, at least on the theater screen John Shaft was a black hero in black terms. Now on television, he lost that defiant sensuality which had attracted black moviegoers. Writing in *TV Guide*, a college professor summarized the cultural barrenness of *Shaft* on TV.

> There is nothing in the premise of *Shaft* or its execution that is *black*. In other reviews of this show, I have seen this colorlessness lauded as a healthy sign. But as a black person, I find it offensive. I feel that I am being erased. As if blackness were not to be desired, had nothing to offer. As if all colors in this Nation should be bleached into a sickly gray.[8]

Even more revealing was the reasoning by the producer of *Shaft*, who explained the moderating of John Shaft's character.

"We were very conscious of the movie image and deliberately worked against it," according to William Woodfield. "We knew we would get bad reviews," he added, "but we thought the American people would accept this man as a friend."[9]

If the video John Shaft was a pale imitation of his filmic persona, James McEachin's character, Harry Tenafly, on NBC's *Tenafly*, was the classic "white Negro," made so bumblingly middle-class and recognizable as to become too familiar and not entertaining. In its promotions for the series, the network emphasized his frenetic blend of chasing criminals and coping with a wife and two children. "Tenafly is a detective who can't find the butter," said an announcer as McEachin fumbled through the refrigerator and complained to his wife. "But," continued the voice, "he solves crimes." Although as a private investigator in Los Angeles Tenafly demonstrated touches of sensitivity, the character and the series were victims of its WASP projection of the black detective, and its inadequate scripts which alternated between formulaic detective drama and domestic farce. Bob Knight in *Variety* captured the fundamental weakness of the program:

> The concept of bumbling your way to a solution while fighting the added battle of personal home life interruptions borders more on sitcom than dramatic fare. . . . It would seem rather obvious that a black private detective could best create viewer appeal by displaying a distinctive style of operation that drew on his ethnic background for its insight and modus operandi. . . . As it stands now, *Tenafly* is an ordinary detective skein trying to get past on the novelty of having a black playing the lead.[10]

Shaft and *Tenafly* were part of rotating package-series. Having to share their time slots with other recurring programs, the black detective shows received monthly exposure at best. Only eight episodes of *Shaft* and six installments of *Tenafly* were ever produced. With their cancelation, the male African-American detective, as the single star, was abandoned by television until James Earl Jones appeared in the fall of 1979 in the short-lived *Paris* series.

Ironically, the first weekly detective show placing a black

hero in a starring role dealt with the exploits of a beautiful black woman. *Get Christie Love!* featured Teresa Graves as a sexy, hip, and independent-minded undercover officer on the Los Angeles police force. Unfortunately, Graves' physical attractiveness alone was insufficient to maintain an audience. During its one-year run, 1974–1975, the series was marred by an unbelievable character acting out poorly written scripts in a tired genre. Due to her personal religious beliefs, moreover, Graves demanded less and less violence in her show. This forced her to face danger with only wisecracks and quick karate moves.[11] The program ended its run rated seventy-second out of the eighty-four series that season.

The question arises whether black dramatic series were abandoned quickly because they were inherently flawed or because the networks misread national preference and failed to nurture such series with propitious time slots, adequate promotion, good writers, and ample time to develop an audience. If black talent was good enough to populate situation comedies, why was it not acceptable in starring dramatic roles? If African-American intelligence was profound enough to alter the relationship between youngsters and the medium, why was it not profoundly a part of prime-time programming? If blacks were inventively utilized in children's programming in the morning and afternoons, why in adult shows in the evening were they either stereotyped or successful only in subordinate roles? Whatever the answers, if African Americans desired TV which would consistently and fairly treat their interests, they would have to turn to those black-oriented entertainment and public service shows that were usually produced and distributed outside commercial network TV.

16

The Black Television Program

When semanticist S. I. Hayakawa wrote in 1963 about the effects of TV on African Americans, he argued that to maintain white supremacy, blacks would have to be segregated from existing television. To stop the progress of the civil rights movement, he suggested, white segregationists had the impossible task of providing blacks with their own stations, channels, transmission frequencies, and programs. Moreover, blacks would need special TV sets unable to receive signals from white stations.

It is ironic that in less than a decade someone as prestigious as Whitney Young of the National Urban League would demand, in the name of black progress, several of the conditions Hayakawa saw as unrealizable prerequisites for segregation. Speaking in 1970, Young felt that the only way for blacks to overcome bias in the TV industry was to establish their own production companies and produce their own programming. Television was clearly not serving the best interests of blacks, Young noted, because African-American employment in video was actually regressing.[1] In this regard, Young was one of the first to recognize that in the new decade the black-and-white-together days of the civil rights movement were gone, and African Americans more than ever were alone in pressuring for their social goals.

The struggle for television that was meaningful to black Americans was a particularly heated residual from the Golden Age. During the early 1970s, throughout the nation black ad hoc organizations presented demands to local stations, protested to

the networks, and lobbied at the FCC for increased minority involvement. In Kansas City, the group was called the Peoples Communication Commission; in Youngstown it was the Black Broadcasting Coalition; in Houston it was Black Citizens for Media Access; in Greenville, South Carolina, it was The Cause; in Cincinnati it was Blacks Concerned for Justice and Equality in the Media and in New York City it was called Black Citizens for Fair Media. Whatever such local groups called themselves, they shared common goals: more jobs, more service from industry, and positive black images in TV programming.

An example of the work of a typical organization was that of Black Citizens for Fair Media (BCFM) which in 1972 filed with the FCC a petition to deny the license renewal of the CBS flagship station, WCBS-TV in New York City. BCFM demanded that the station recruit and train blacks in all phases of production. It held protracted discussions with station management to obtain programming it felt to be relevant to such community problems as crime, drugs, health, poverty, housing, and welfare. The group also demanded more black news reporters and more black cultural programs. Although WCBS-TV executives complained that realization of these demands would create "apartheid programming," and would so fragment the broadcast day that the station would be "serving no one while disserving the vast majority,"[2] such lobbying efforts by black special interest groups seemed the only way to make the medium relevant to minority viewers. And in two instances during the 1960s—with WLBT-TV (Jackson, Mississippi) and with the Alabama Educational Television Commission and its eight statewide public television stations—these efforts were effective enough to cause the FCC to refuse to renew broadcasting licenses because of racial discrimination in programming.[3]

Throughout the decade, moreover, responsible social and academic institutions continued to criticize the unresponsiveness of TV to the systematic exclusion of minorities. In 1970, the New York State Civil Rights Commission investigated chronic discrimination in the trade unions servicing the film and video industries. According to the head of that commission, the fact that only 12 of the 667 members of one union, the International Alliance of Theatrical Stage Employees, were from racial minorities was "rank discrimination."[4]

In 1972, the Congressional Black Caucus heard testimony berating institutional racism in broadcasting. Here it was pointed out that no public TV stations had black managers, that blacks owned no stations, and that hiring practices never were geared to the minority population figures in station areas.[5]

The same year the Office of Communication of the United Church of Christ assailed the television industry for its "dismal efforts at absorbing minorities." The major findings of this organization, based on a survey of 609 TV stations, were the following:

1. Seventy percent of commercial stations were totally white in managerial positions.
2. Fifty percent of all stations hired no minority employees in professional capacities.
3. Fifty-five percent of all stations did not hire minorities as technicians.
4. Eighty-one percent of all stations hired only whites in sales positions.
5. Thirty-four percent of all stations hired no blacks in any of these four capacities.[6]

Significantly, according to the Office of Communication, there was little improvement in minority hiring throughout the remainder of the decade. In 1974 and 1978 that group reported only slight rises in minority employment in commercial and public TV stations. It noted, further, that those reporting the statistics were probably manipulating the figures, presenting inaccurate numbers to place the best light possible on continued discrimination. One apparent ploy, it revealed, was for stations to reclassify minorities in low-echelon jobs as managerial-level employees, creating the illusion, thereby, of hiring more minorities in executive jobs. By 1978, 80 percent of the jobs at TV stations were being reported as upper-level, thus creating a ratio of four executives to each staff support worker. In the words of the director of the Office of Communication, "it is hard to avoid the conclusion that a number of broadcasters are denying women and minorities power by creating the illusion that everyone has it."[7]

Although the FCC strengthened its equal employment op-

portunity operations and affirmative action policies, blacks failed to make significant inroads in video in the 1970s. Even the appointment in 1972 of Benjamin Hooks as the first black FCC commissioner did little to alleviate the discriminatory practices. The frustration inherent in such a situation is illustrated in the actions of the National Black Media Coalition, a nationwide black interest organization demanding more employment opportunity and fairer depiction for blacks in television. In 1973, this lobbying group complained to the FCC that adherence to affirmative action policies by local broadcasters was "fraudulent." The coalition contended, further, that much of the nation's TV programming was "racist."[8] By 1978, however, it had abandoned hope in the FCC, now criticizing that government body for doing "the closest thing to nothing" in regard to civil rights issues.[9]

As with the critique from the National Black Media Coalition, various social groups in the 1970s continued to denounce black representation *on* the screen as well as *in* the industry. One such vocal group was the National Black Feminist Organization, which in 1974 roundly denounced the pejorative portrayal of blacks on TV. It cited six major criticisms of the manner in which blacks were shown in prime-time shows.

1. Black shows are slanted toward the ridiculous with no redeeming counter images.
2. Third World people are consistently cast in extremes.
3. When blacks are cast as professional people, the characters they portray generally lack professionalism and give the impression that black people are incapable and inferior in such positions.
4. When older persons are featured, black people are usually cast as shiftless derelicts or nonproductive individuals.
5. Few black women in TV programs are cast as professionals, paraprofessionals, or even working people.
6. Black children, by and large, have no worthy role models on television.[10]

The respected Annenberg School of Communication of the University of Pennsylvania continued the attack on TV. It reported in 1979 that little had changed in the decade. After a

study of ten years of television programming, it concluded that minorities—as well as women, children, and older people—were being short-changed by stereotyping in network dramatic shows.[11] An analogous study by the United States Civil Rights Commission, published in 1977 under the title *Window Dressing on the Set*—and in 1979 in a supplementary volume entitled, *Window Dressing on the Set: An Update*—concluded among other matters:

> Stereotyped portrayals of minorities and women, which have been part and parcel of successful program formats, are perpetuated by the networks in their pursuit of higher ratings and higher profits. The surest route to a successful and highly profitable program is to create a new series based on formats that have already proven popular. . . . Moreover, network programmers are afraid of offending the sensibilities—whether real or imagined—of large segments of the viewing audience. Programming designed to reach the widest possible audience, coupled with the demands of the ratings race, constrain writers and producer from introducing more realistic and diverse images of women and minorities to the television screen. Thus, network programmers with one eye on successful old formulas, the other on the offensive, and with both hands in their pockets, are not oriented toward serving the public interest.[12]

If African Americans continued to be victimized by bias in network TV during and after the 1970s, there were, nevertheless, several exceptional programs that served blacks constructively. This was particularly true of those black-oriented productions—usually produced by, or syndicated to, local stations, or offered on PBS outlets—focused on news and public affairs. Not only did these shows treat neglected aspects of the black experience, they generally involved minority producers, directors, writers, and technical assistants.

One of the earliest formats to emerge in this regard was the short-run series treating black history and/or culture. As early as 1965, NET produced *History of the Negro People,* a limited series hosted by Ossie Davis. This program utilized actors like Frederick O'Neal and Roscoe Lee Browne to dramatize critical events and personalities from the history of American blacks. A

more contemporary focus was found in the Westinghouse Group W series *Rush to Freedom*. This six-part program was hosted by Georgia state senator Julian Bond and in 1970 presented a detailed analysis of the civil rights movement.

More cultural in orientation were productions such as *Black Omnibus*, a thirteen-part series hosted by James Earl Jones in 1973. This show mixed black celebrities from the entertainment world with excursions into black history, sports, religion, dance, and the like. Similarly, *Doin' It* was a nine-part variety series on public television in 1972 that blended entertainment with enlightenment.

Less pedagogic in its intent, but overwhelmingly more successful was *Soul Train*, a show that mixed popular music and dance for black teenagers. The program was produced locally in Chicago in the early 1970s where its creator, Don Cornelius, envisioned it as a black version of *American Bandstand*. Two decades later, *Soul Train* is thriving, seen in most American market areas, and still an important vehicle of exposure for rhythm and blues entertainers.

There were other series with similar orientations from *Just Jazz* on PBS in 1971 to *Positively Black*, an NBC public affairs series in the mid–1970s. By the end of the decade *Today's Black Woman* and *For You, Black Woman* were syndicated shows with a female focus. And in the 1980s, *With Ruby and Ossie* was a PBS series treating black history and culture through the reflections of Ruby Dee and Ossie Davis, and *America's Black Forum* was a syndicated public affairs show hosted by Julian Bond.

More prevalent still were black-oriented programs produced and shown exclusively on local stations. These programs, reminiscent of the early days of television, tended to feature talent, interviews, news, human-interest materials, and music and dance, all directed toward the local black community. Such programs appeared throughout the nation under titles like *Soul Scene* (WCAU-TV/Philadelphia), *Black Book* (WFIL-TV/Philadelphia), *Free Play* (WTVS-TV/Detroit), *Like It Is* (WABC-TV/New York City), *Right On* (WBTV/Charlotte), *Ebony Beat* (WQXI-TV/Atlanta), *Soul Searching* (WFLD-TV/Chicago), *Solid Black* (WTTW/Chicago), and *Black on Black* (KMTV/Omaha). There were also local experiments with news programming by and for the black community. While such features did not endure over a period of time,

their persistent reappearance—under such titles as *Black News* and *Black Perspective on the News*—suggests that established news programs were not meeting the needs of local blacks.

In the process of bringing such community-oriented programs to video, many series hosts became prominent local celebrities. Such was the case, for example, in Chicago with Edwin "Bill" Berry, Jim Tilmon, and Ouida Lindsay. In New York City, Gil Noble developed his show, *Like It Is*, into a formidable example of local journalism. A winner of several Emmy awards, since the late 1960s Noble challenged the perimeters of television. He used *Like It Is* as a vehicle of probe and explanation for black political figures like H. Rap Brown, Stokely Carmichael, Eldridge Cleaver, Angela Davis, and the reform Democratic political leader from Mississippi, Fannie Lou Hamer. Noble devoted individual broadcasts to the ideas and accomplishments of Paul Robeson and Malcolm X. He interviewed cultural achievers like Harry Belafonte, Dizzy Gillespie, and Duke Ellington. And Noble tied the black community of New York City to the broader third world experience, bringing to his public affairs program such black-world leaders as Prime Minister Michael Manley of Jamaica, President Kenneth Kaunda of Zambia, Prime Minister Robert Mugabe of Zimbabwe, and President Ahmed Sekou Touré of Guinea.[13]

Of all the black public service and cultural shows, however, the most distinguished and enduring was *Black Journal* (later, *Tony Brown's Journal*). The series emerged on public television in mid-1968, a period after the assassination of the Reverend Martin Luther King, Jr. that *Variety* later called "videoland's Golden Age of racial remorse."[14] Although network motivations may have been related to the murder of the humanitarian leader, *Black Journal* was a stridently independent production that looked frankly and candidly at black life.

Like no national series before or after, *Black Journal* broke the perimeters of political expression established in the experience with Paul Robeson in the 1950s. This program gave air time to black leaders such as Angela Davis, Malcolm X, Imamu Baraka, and Bobby Seale. It probed controversial issues like housing discrimination, prison conditions, interracial marriage, and the assassination of Malcolm X.

The program was first produced by William Greaves. For

two years Greaves handled *Black Journal* as a monthly hour-long feature. During its last five years the series was produced by Tony Brown. Particularly under Brown's leadership, the program evidenced a distinct political quality. When he announced in 1970 that *Black Journal* would henceforth have its own correspondent stationed in Addis Ababa, Ethiopia, Brown explained that black viewers needed an ethnic perspective on the continent. "We as Africans in America need to see the positive side in Africa," remarked the former dean of communications studies at Howard University, "so that we can develop a much needed psychological identity with Africa to develop our roots of identification." Further, according to the producer, blacks in the United States were chronically fed self-destructive images of Africa. "The 'white press' goes to Africa and seeks out sensationalism," Brown argued, "and we get the picture of Africa as a Tarzan and Jane land and a constant bed of revolution."[15]

As a pioneer of controversial black-oriented programming with a nationwide audience, Brown was necessarily diffident and defensive. When the Ford Foundation dropped its funding, and the Corporation for Public Broadcasting (CPB) threatened to cancel *Black Journal*, Brown defended his philosophical slant as an attempt to balance the white thinking and interpretation that dominated TV. When NET announced in 1970 that it had no records revealing which southern outlets were not airing the show, Brown named a number of educational TV stations in Alabama, Louisiana, Florida, Arkansas, Tennessee, North Carolina, South Carolina, Virginia, Mississippi, and Puerto Rico. He also pointed out that as well as *Black Journal*, some of these stations were also preempting *Sesame Street*, the historical series *On Being Black*, and the entertainment feature *Soul*. And when *Black Journal* was finally dropped from public TV in 1975, Brown assailed the Nixon administration for influencing the appointment of CPB board members who were antipathetic to *Black Journal*.

Undaunted, Brown took the program concept to commercial TV where in 1977 it became *Tony Brown's Journal*, a syndicated half-hour weekly show sponsored by Pepsi-Cola. With its goal of seeking "to explain the black experience in the country as an American experience,"[16] *Tony Brown's Journal* explored a wide range of African-American topics. Mixing location and studio interviews with still photography, performances, assorted

graphics, and filmed materials, Brown treated matters as diverse as blacks in the military, the musical career of Eubie Blake, the antiblack genetic theories of Professor William Shockley, blacks in radio and television, and the wave of murders plaguing black communities in Rochester and Atlanta in the early 1980s. *Tony Brown's Journal* also was the first public service series to employ the Qube facilities of Warner Amex. With this electronic technology, up to 25,000 specially wired homes in Columbus, Ohio, were able to register, and have instantaneously tabulated, their opinions on an important racial issue being discussed on individual telecasts. With this background, *Tony Brown's Journal* returned to PBS in February 1982, where a decade later it continues to probe black conditions.

As vital as they might have been to African-American communities, national and local black-oriented programs could not substitute for the color-blind promise of early TV. More often than not, such shows were aired so stations could satisfy public service obligations required by the FCC. They usually appeared at obscure times. Frequently, time slots were changed several times in a season. Weekend daytime hours and late Sunday evenings were favorite hours, particularly for those shows not telecast on public television outlets. And because these series often operated with low production budgets, their scope and theatrical qualities—and, therefore, their viewer appeal—were compromised.

There is also a question about the number of blacks who watched these shows. Nielsen ratings among African-American viewers in Washington, D.C. in early 1974 suggest that black-oriented public service programs failed to attract sizable minority audiences. Figures show that while network evening series with black stars attracted a large minority viewership, community programming and black news shows fared poorly. *Sanford and Son,* for example, had a sixty-nine rating and an 86 percent share of the audience. Even *Soul Train* did well with a forty rating and a 70 percent share. But a black news show on Saturday evenings on WTTG drew only an eight rating and a 14 percent share, while *Harambee,* a community interest program aired weekday mornings on WTOP, earned only a two rating and a 13 share. Even *Sesame Street,* aimed particularly at inner-city children, gained only a two rating—the same rating drawn by vintage *Little Rascals* films broadcast opposite *Sesame Street.*[17]

17

The *Roots* Phenomena

If the history of blacks in American television is replete with in-
stances of exclusion, bias, and discrimination, it seems paradoxi-
cal that the most popular programs in the history of the medium
were concerned with the African-American experience. It is also
interesting to remember that while the small number of blacks in
TV usually have been stereotyped as comedians and musical en-
tertainers, for eight evenings in 1977 and seven nights in 1979, it
was black dramatic actors who held American viewers spell-
bound with their realization of Alex Haley's best-selling family
autobiography *Roots*.

The twelve-hour *Roots* (January 23–30, 1977) and its four-
teen-hour sequel, *Roots: The Next Generations* (February 18–23
and 25, 1979), were the most widely viewed miniseries in TV his-
tory. *Roots* averaged a forty-five rating and a 66 share, and its se-
quel series averaged 30.1 and 45. (Not until September 1980 was
this record broken when *Shogun* became the second most widely
viewed miniseries in American television history.) An estimated
140 million viewers saw all or part of *Roots*, and 110 million
watched at least part of *Roots: The Next Generations*. As noted in
figure 17.1, these *ABC Novel for Television* productions ac-
counted for the two most widely viewed network weeks in TV
through 1979.

In *Roots*, audiences encountered African-American history
in a remarkable context. Tracing the story of a black family over
two and one-half centuries, the miniseries presented pictures of

216

Figure 17.1: Top Viewing Weeks in American TV History to 1980

Rank	Week Ending	Program	Rating	Share
1	Jan. 30, 1977	*Roots*	35.5	52
2	Feb. 25, 1979	*Roots: The Next Generations*	27.0	41
3	Aug. 1, 1976	Summer Olympics from		
		Montreal (ABC)	26.0	49
4	Sept. 17, 1978	ABC Premiere Week	25.9	
	Oct. 15, 1978	World Series (NBC)	25.9	

the destruction of normal, loving African families and the enslavement and/or murder of family members. Here were the dehumanizing experiences of kidnapped Africans being shipped to servitude in the American colonies; of enforced illiteracy to ensure subjugation; of abuses and brutality against recalcitrant slaves. But viewers also found the constant theme of the survival of human dignity, the will to maintain self-esteem by whatever means practical. In Haley's progenitors, this inner strength took many forms, from Kunta Kinte's refusal to recognize his new slave name, "Toby," to Alex Haley's obstinate desire to become a writer.

The *Roots* dramas delivered powerful human emotions in outstanding theatrical performances. As Kunta Kinte, "the old African" who endowed his posterity with the indomitable sense of self-worth and liberty, LeVar Burton and John Amos presented the strongest black character ever realized on American television. In her role as Kizzy, daughter of Kunta Kinte, Leslie Uggams sensitively portrayed a slave woman eager for learning, loving and loyal to family and tradition, yet victimized by white prejudice and lust.

Ben Vereen's characterization of Chicken George, the bastard offspring of Kizzy and her white master, added another dimension of the African-American legacy. Now audiences met the slave of special talent whose expertise in the white man's vices—in this case cockfighting—allowed him to enjoy fame and a degree of freedom unknown to other blacks, but still left him bereft of real equality or control over his own life.

Tom Murray, the son of Chicken George—and great-grandson of "the old African"—was a strong, rational man experiencing the last years of slavery in the South, and the first duplicitous

decades of emancipation following the Civil War. As enacted by Georg Stanford Brown, Tom the blacksmith faced white-robed vigilantes and smartly dressed white patricians, all intent upon thwarting black freedom. With dignified courage, he encountered the loss of his voting rights and the establishment of Jim Crow laws legalizing his inequality.

Tom Murray possessed, however, an instinct to survive, an ability to recognize reality and adapt. But his survival was never achieved with the loss of self-esteem. This was an inherited trait, and a tradition realized in one way or another by ensuing generations—through strong women and proud men—until it culminated in James Earl Jones' portrayal of author Alex Haley as he strode into a Gambian village to discover his ancestral roots and mark the spot from which Kunta Kinte had been abducted 250 years earlier.

In many ways *Roots* and *Roots: The Next Generations* were monumental productions. They offered more than just their story lines for television executives to ponder. Black actors in the series demonstrated impressive dramatic skills. Two black cast members—Louis Gossett, Jr., who played the pragmatic slave Fiddler, and Olivia Cole, who portrayed Chicken George's durable wife Mathilda—received Emmy awards for their performances. In a medium long used to projecting African Americans as singers, dancers, musicians, athletes, and comics, it was ironic that the largest audiences in TV history now approved the dramatic skills of comedy actors like Gossett, John Amos, Lawrence-Hilton Jacobs, Scatman Crothers, Lillian Randolph, Hilly Hicks, and Ja'net DuBois. Until this time, Ben Vereen, Leslie Uggams, and Avon Long had only been on TV as dancers and singers. And O. J. Simpson and Rafer Johnson were still familiar to viewers as athletes. If, indeed, the acting talent of such players was impressive, the question arises as to why television producers and networks had not recognized and employed those skills until now. The answer, of course, rests in the historic relationship between TV and black America.

As well as revealing the artistic loss resulting from the stereotyping of actors, the two miniseries also suggested the viability of serious programming featuring black themes. It was a new genre of video entertainment. Americans had never been consistently exposed to the drama inherent in black history or to the issues

related to minority survival in a racist nation. As a new type of programming, it seemed to renew the original TV promise of bias-free opportunity.

But the *Roots* phenomena failed to catalyze a new Golden Age for blacks in American television. When the applause ended, black actors returned to the familiar roles. There were many like the scholarly critic who concluded, "The people, if *Roots* is any indication, are clearly prepared for more important material than the media have, up to this point, been willing to provide."[1] And there were others who offered statistical surveys to show that the majority of whites wanted more programs like *Roots*.[2] Yet, less myopically, there were people like Brock Peters—who played a poor black farmer in *Roots: The Next Generations*—who understood reality. Appearing on *Tony Brown's Journal* on May 13, 1979, he explained his disappointment and understanding.

> I think that the footing we thought we'd gained in the past decade isn't as substantial as we'd hoped it would be. I was always fearful of that because it's one thing to have lots of roles handed out to actors in front of the camera. But my real concern—and the concern of most of us who are in this industry—is in the area of decision-making: the kinds of roles that could be done, the kinds of projects that should be mounted, and the money to do that. We've not been in that position in any substantial degree. I am not surprised that with backlash and changing sentiments that we have to fight harder now to maintain whatever ground we've gained. It's not easy because we did not get a good, solid footing. In front of the camera isn't finally where it's at. It's what that subject is going to be, and who decides that it should be done.

The failure of *Roots* and *Roots: The Next Generations* to usher in a new era should have been anticipated. Inherent in its inspiration and realization were significant qualifiers which undermined the promise in the series. Ultimately, the programs served only to underscore the pattern of quantitative representation and qualitative restriction which typified blacks in television during the 1970s and early 1980s.

The *Roots* series represented a massive business undertaking. For David L. Wolper Productions and Warner Brothers Television, it meant the expenditure of millions to film the pro-

grams. For ABC, which gambled crucial prime time hours on speculation that all Americans would be attracted by the struggles of a black family, it was also a business venture. Certainly, the productions had a libertarian dimension. Only three months before *Roots* premiered, Leonard H. Goldenson, chairman of the board of directors of ABC, tied his network to the liberal cause when he warned the entertainment industry that it must lead the fight against racism.[3] But such noble and self-serving thoughts were secondary to the fact that ABC, pleased that the miniseries *Rich Man, Poor Man* had been so profitable in 1976, scheduled *Roots* because it felt that in Haley's family story there were themes which would attract and hold viewers, obtain high ratings, boost advertising rate schedules, and make money.

As a business undertaking, the programs were riskier than *Rich Man, Poor Man*. Serious racial themes were unfamiliar to mass America. Had the series failed to generate sizable audiences, they would have compromised the producers and weakened network earning power for the rest of the TV season. For *Roots* the history of blacks in TV gave no indication that Americans would be interested in African-American social drama for eight consecutive evenings. For *Roots: The Next Generations*, the uncertainty was twofold. First, there was the question of whether or not Americans had been saturated by *Roots*, as it also had been rerun in prime time in September 1978. Although the rerun drew unprecedentedly large audiences—averaging a 25.4 rating and a 42 share, and attracting an estimated eighty million viewers—the sequel, which picked up Haley's story in 1882 and carried it to the present, risked being superfluous.

Further, there was the chance of offending mass sensibilities with a sequel perceived as purely exploitive of the original *Roots*. In film, and to a lesser degree in TV, sequels seldom have matched the quality or popularity of their predecessors. That had been the case with *Rich Man, Poor Man—Book Two* in 1976. When Ben Vereen refused to return in the role of Chicken George (Avon Long assumed the role), he compounded the problem by using the term "rip-off" in explaining his decision. Even *TV Guide* headlined the question: "Is the sequel to *Roots* a valid continuation or a rip-off?"[4]

As well as a calculated business venture by white corporations, the crucial aspects of production were carried out by non-

blacks. Alex Haley read and approved all scripts and publicly assumed responsibility for the "black integrity" of the final product.[5] Yet two experienced white screenwriters, Ernest Kinoy and William Blinn, adapted Haley's book for the miniseries. In the case of *Roots: The Next Generations,* moreover, most of the script was culled by screenwriters from Haley's notes and personal recollections since it was inspired by only the last forty pages of his book.

Stan Margulies, a white man, was the producer of both programs. Although black directors Gilbert Moses and Georg Stanford Brown directed individual episodes, the principal director of *Roots* was a white man, David Green; and John Erman was the principal director of the sequel series. Blacks were not totally absent from *Roots,* however, as eighteen African Americans worked in lesser technical capacities in photographic and audio aspects of the production.

If the technical aspects of the program opened few doors for blacks, white viewers were not attracted because they wanted more black dramatic shows. Most tuned in because the *Roots* series were good television. They were historical costume dramas, interesting and exotic adventure stories with compelling plots. Seldom had TV offered such an array of whips and chains, sex, brutal murder, two wars, and the eventual triumph of "the good guys." This was great soap opera. It was not, however, a telegenic equivalent of Harriet Beecher Stowe's *Uncle Tom's Cabin,* meant to inspire a new abolitionist crusade.

Roots and *Roots: The Next Generations* brought forth few white apologies for centuries of injustice. If anything, the programs allowed whites to absolve themselves of racial prejudice without feeling contrite. Few whites would equate their own biases with the offensive racism of heartless slave merchants, brutal overseers, and slave owners; or of lower-class whites mercilessly manipulating racial intolerance to gain personal political and economic power. In these melodramas, acts of bigotry were overwhelming. Few could approve the severence of Kunta Kinte's foot to prevent further attempts at escaping slavery. To burn a black man at the stake because he tried to collect a debt from a white man was an unbelievably gruesome response. And the denial of a motel room to war hero Haley, dressed in full Coast Guard uniform and traveling with his pregnant wife, was

not only unpatriotic, it also projected an image reminiscent of the New Testament story of Joseph and Mary unsuccessfully seeking room at the inn. In measuring their prejudices against those in the *Roots* programs, most whites could feel better about themselves—and less tolerant of those who still complained about daily racial biases that inhibited, but did not physically maim or kill, blacks in contemporary America.

The story lines in both miniseries were also familiar and un-threatening to white audiences. It was Horatio Alger in black, a darker version of immigrants and poor people in search of the American Dream. Despite those sinister racists who would thwart that quest, here was the recognizable theme of working for respect and wealth in the New World. Racial issues aside, watching the programs allowed viewers to rededicate themselves to a secular myth fundamental to American culture and society.

In telling their stories, however, the series left serious misunderstandings. Interested more in the adventures of the Haley family through the centuries, *Roots* and *Roots: The Next Generations* reduced institutionalized injustices to mere roadblocks on the road to familial triumph. The programs might have treated slavery and de facto racial segregation as a way of life that dehumanized its victims and brutalized its enforcers. It also might have projected racism as an invidious mind-set that continues to relegate most African Americans to economic, social, political, and intellectual poverty. Instead, the indomitable human will of Haley and his ancestors overshadowed the monstrous reality of enforced racial subordination. The bleakness arising from being black in a white racist society, where laws and traditions chronically suppress black achievement, seemed to pale before the theatrically engaging hopes for a better tomorrow which the miniseries proclaimed.

Rather than understanding Haley's bourgeois success story as an exception to the rule, white viewers could leave the series blaming impoverished contemporary blacks for their own social deprivation. Instead of being a serialized Hollywood essay preaching "if at first you don't succeed, try, try again," the *Roots* dramas might have treated the African American experience more fully and more honestly. No slave ever asked to be transported to the New World. Few blacks or their descendents ever had the opportunity to leave. Trapped in degradation in a nation

that justified its existence in terms of personal liberty, democracy, and human dignity, blacks in the United States have taken more than three centuries to reach their present condition. Television, however, was again misleading. Here the experience was streamlined, taking place in twenty-six hours spread over fifteen days of prime time, with appropriate climaxes to allow for commercials and station breaks.

Black viewers who might have expected an indictment of the American system were disappointed in *Roots* and *Roots: The Next Generations.* Instead, they encountered evil individuals who personally subjugated blacks. The economic and moral system which produced and tolerated such brutal citizens was never adequately presented. If anything, with the middle-class prosperity seen ultimately in Alex Haley's personal affluence, the system was applauded. Blacks who wanted the series to explain their present world found that the programs actually questioned the personal and family initiative of modern African Americans who still had not attained wealth and status.

White viewers, on the other hand, could leave the programs with a feeling of "knowing" black America, of realizing that contemporary black poverty was the product of individual weakness and lack of application. No longer guilty of complicity in suppressing a racial minority, whites could see the *Roots* dramas and be content that the American Dream was still attainable. The civil rights movement fully ended when James Earl Jones entered that settlement in Gambia and found the original home of "the old African." Knowing from where they came and to where they needed to go, blacks were now on their own.

The truth is, no program could fully and honestly approach the problem of slavery and its aftermath. To do so would be to condemn the system which produced and maintained it. Just as no miniseries have lauded Lenin, Trotsky, Khomeini, Ho Chi Minh, Hitler, or Mussolini, American television will not lionize men or offer explanations that might undermine general faith in the American socioeconomic system. Popular culture in the United States—controlled as it is by ethics that are corporate and self-protective—does not produce viable commercial products that are destructive to the system. *Reform* is possible through popular culture, but *revolution* is out of the question.

18

The Broadcast Synthesis: TV and African Americans by the Early 1980s

Twice during the 1970s renewed black hopes for equitable treatment in television were crushed. At the beginning of the decade, the victory of white backlash and political conservatism—embodied in the election of Richard M. Nixon by the so-called Silent Majority—quickly subverted the Golden Age that had only begun to emerge. Again, at the end of the decade, rejuvenated expectations were destroyed when the two *Roots* miniseries failed to inspire a wave of serious dramatic programming, imitative but mature, featuring blacks in nonstereotyped roles.

Disappointment in the black creative community was keen. Actor-director Georg Stanford Brown expressed confusion when in 1979 he told *Tony Brown's Journal*, "I don't know. I have no answer because I've seen the representation of black people on all the series television as diminishing over the past three years." A year earlier, several black industry executives revealed their dismay. Stanley Robertson, a producer with Universal Television, complained that "because of the preponderance of comedy, the American people have got the idea that black people are funny... except for *Roots* we haven't had the opportunity to see blacks get emotionally involved." Charles F. Johnson, a co-producer with *The Rockford Files*, lamented that "television to me is behind the times. There are so many prototypes who can serve as models for television." For Yvonne Demery, an associate producer at Universal, the situation was also frustrating. "I'm not happy with the black image on television," she told an inter-

viewer. "The image was successful so long as we were being laughed at in comedy," she continued, "we felt the public was ready to accept more. . . . Our life-style is not stereotypical of anything."[1] And as late as mid–1981, the successful star Robert Guillaume, of *Benson,* could summarize changes in black TV representation since *Roots* with the remark, "The networks have a shameful record in portraying blacks in prime time. They portray blacks in stereotypical fashion or overlook their existence entirely in, say, a series set in midtown Manhattan."[2]

The continuation of prejudicial practices in television was all the more exasperating because by the end of the 1970s blacks had fulfilled the most crucial criterion for video success: they represented a consumer market expending more than $70 billion annually on goods and services. With this much money to spend, the 24.1 million African Americans constituted a consumer market larger than most member states of the United Nations.[3] Such numbers might have been expected to generate more network respect.

Yet, traditionally racist patterns remained intact. While blacks still were quantitatively visible, the lack of quality in their roles persisted. Blacks continued to portray the loyal followers and supporters of great white heroes. Herb Jefferson, Jr. was a stoic pilot and Terry Carter was a dependable assistant on Lorne Greene's space craft in *Battlestar Galactica* and its later incarnation, *Galactica: 1980.* Richard Williams was one of several submarine crewmen in *Man from Atlantis,* Roger E. Mosely was Tom Selleck's loyal black assistant on *Magnum, P.I.,* just as Aldine King was a loyal secretary on *Project U.F.O.* Long used to such secondary roles, Greg Morris came to *Vega$* as a police officer, but a colorless character compared to Robert Urich's attractive and dashing private detective, Dan Tanna. Other such ancillary roles included Cleavon Little on the ill-conceived *Supertrain,* Ji-Tu Cumbuka as a runaway slave on *Young Dan'l Boone,* and Madge Sinclair and Brian Mitchell as hospital employees on *Trapper John, M.D.* On *Hill Street Blues,* Michael Warren and Taurean Blacque played the requisite black policemen who occasionally were the focus of a subplot. And even with a steel claw for a hand, Ji-Tu Cumbuka as the menacing Torque was still only a muscular "man Friday" for Robert Conrad on *A Man Called Sloane.*

Blacks continued to enjoy their greatest acceptance when they appeared in comedy shows. The age of the New Minstrelsy survived Jimmy Carter and flourished in the presidency of Ronald Reagan. Ted Lange was a comic bartender on *The Love Boat*. Samuel E. Wright was a street-wise cliché as a policeman named Turk on *Enos*. Tim Reid portrayed a hip disk jockey called Venus Flytrap on *WKRP in Cincinnati*.

All the old stereotypes were there. The overbearing and emasculative mammy was not dead. Nell Carter revived that classic character, portraying a shrill policewoman on *Lobo*. And Shirley Hemphill on *One in a Million* took the stereotype into the boardroom of capitalistic America when she played a ghetto-dweller who suddenly became a millionaire executive of a large corporation. The ranks of cute black children grew with the appearance of Kim Fields as the only black in a boarding school for girls on Norman Lear's *Facts of Life*. And the butler, another familiar black rendition, had his own series, *Benson*, as Robert Guillaume starred as a wise-but-funny manservant in a governor's mansion—a big white house on a hill.

Even in late-night comedy revues like *Saturday Night Live* and *Fridays*, black comics were cast in predictable characterizations. Although usually cast with more dignity on *Saturday Night Live*, Garrett Morris gained his greatest national attention by personifying a stupid Latino baseball player, Chico Escuela, whose broken-English answer to everything was "Baz-bol's bin berry berry goud to mi!" On the same show Eddie Murphy appeared usually in mocking skits set in Harlem or dealing with criminality. On the ABC series *Fridays*, Darrow Igus was most celebrated for his hip parody of a Jamaican cook, dressed like reggae singer Bob Marley, and stuffing all his Rastafarian recipes with plenty of ganja (marijuana).

The most offensive comedic stereotype, however, appeared in the winter of 1978 on *Baby, I'm Back*. In this series Demond Wilson portrayed Ray Ellis, a fancy, black wheeler-dealer who had deserted his wife (played by Denise Nicholas) and children seven years earlier, and now returned to rejuvenate his marriage. Here was black parental irresponsibility. Here was the black hustler, fancy dresser, sweet-talker, and gambler, all punctuated with approving responses from the laugh track. And Ellis—whom Lance Morrow described as "a feckless black creep"[4]—was all the more

glib and attractive when compared to his wife's bumbling new boyfriend (Ed Hall), stiffly attired in his Marine officer's uniform.

In those instances when African Americans were the principal stars of network series, success was more fleeting. One of the more promising shows in 1980 was *Tenspeed and Brown Shoe,* a light drama about two private detectives. It gave Ben Vereen the opportunity to mix comedy and more serious characterization as a con man *cum* private eye. Although the product of Stephen J. Cannell whose other credits included *The Rockford Files,* the series was never serious enough to survive as a detective show, or humorous enough to be accepted as comedy.

Two of the more impressive actors from *Roots,* Louis Gossett, Jr. and James Earl Jones, also failed in serious dramatic shows in the fall of 1979. In *The Lazarus Syndrome,* Gossett was cast as a cardiologist, Dr. MacArthur St. Clair, in a medical series intent upon relevancy. Written and co-produced by William Blinn, who had won an Emmy for his writing in *Roots,* the program ambitiously sought to give Gossett a troubled married life, contacts with temptations that tested his personal honor, and involvement, according to one series official, "more with contemporary issues than with the disease of the week."[5] Despite positive reviews, audiences seemed unwilling to accept a black heart surgeon and his human predicaments. *The Lazarus Syndrome* received poor ratings and was canceled after six broadcasts. It was replaced on ABC by *Hart to Hart,* a white detective program that completed the season with respectable ratings and continued in prime time for four more years. Further, another medical drama, *Trapper John, M.D.,* premiered the same month as the Gossett series. It ended the 1979–1980 season as the twentieth most popular series with a 21.2 Nielsen rating and remained on CBS for another six TV seasons. *The Lazarus Syndrome,* however, earned only a 16.2 rating and was ranked sixty-fourth.

James Earl Jones, as Woodrow "Woody" Paris, portrayed a police captain with a personality that included part-time university teaching and an understanding wife. Yet his series, *Paris,* was poorly received on CBS. For several reasons—most prominent among them the failure of the network to schedule or promote the series creatively—*Paris* was a disappointment for fans of James Earl Jones and a failure for CBS and MTM Enterprises, producers of the series.

227

After being seen five times on Saturday evenings and six times on Tuesday evenings, with a four-week hiatus between these time slots, *Paris* was canceled. It ended the season with an average Nielsen rating of 12.7 and ranked ninety-second. In such a disastrous series, however, one of the most powerful indictments of capital punishment in TV history occurred in an episode entitled "Dead Men Don't Kill." The episode was aired on December 4, 1979, and was written by Stephen Bochco, who later created the successful series *Hill Street Blues* and *L.A. Law.* The story featured Georg Stanford Brown as a wrongly convicted prison inmate awaiting execution. Although Woody Paris discovered the prisoner's innocence, the state governor refused to halt the execution. Brown graphically enacted the last moments in the prisoner's life as he sat strapped to a chair, eyes bulging, muscles tensed, agonizingly holding his breath and sweating profusely, then screaming his final exhalation as a cyanide capsule released its toxic justice into the gas chamber.

There were other black-centered programs that fared as poorly as *The Lazarus Syndrome* and *Paris.* Many people had expected *Roots* to inspire a network series focusing—in the manner of *The Waltons*—on a black family and its struggle for survival. The first attempt at such a project was a made-for-TV film, *A Dream for Christmas,* aired December 24, 1973. The film starred Hari Rhodes, Lynn Hamilton, and Clarence Muse. It was written by Earl Hamner, Jr., the man who drew from his own childhood to create and script *The Waltons.* The film was poorly received, however, and the project was abandoned.

There were other attempts to fashion a black version of *The Waltons.* As a result of his impressive TV movie, *Just an Old Sweet Song,* writer Melvin Van Peebles with MTM Productions crafted two pilots for CBS, *Kinfolks* and *Down Home.* In both shows Robert Hooks and Madge Sinclair portrayed Nate and Priscilla Simmons, a husband and wife from the urban North who had recently moved their family to the South. Both projects were stillborn: *Kinfolks* was never televised, and *Down Home* received discouraging reviews when it aired in August 1978.

Critical commentary was immaterial, however, to the project. When *Love Is Not Enough* aired as a pilot film in June 1978, *Variety* declared it "a worthwhile family drama that deserves a chance to find an audience. . . . a straight representation of an

appealing family unit would seem to be in order to balance the scales that have been veering toward caricature."[6] This TV film told the story of a widower, played by Bernie Casey, who moved his large closely-knit family from Detroit to Los Angeles. The following year this pilot began the series, *Harris and Company*, again starring Casey. In turn, the series received positive reviews. *Variety*, for example, called it a "straight and dignified representation of a black family unit . . . with every indication that [it] could hold an audience."[7] But with little promotion and apparently less concern about the fate of the program, NBC unceremoniously dropped four episodes of *Harris and Company* into its spring schedule and canceled the show. A sensitive family drama that needed network nurturing, it was scheduled ironically opposite *The Waltons* (ranked number thirty-seven that year), and *Mork and Mindy* (ranked number three). Expectedly, *Harris and Company* was a ratings failure. Its average rating of 7.6—and ranking as number 112—made it the least-popular regular series for the 1978–1979 season.

The most ambitious attempt at producing a black *Waltons*, was Norman Lear's cooperative venture with Alex Haley, *Palmerstown, U.S.A.* With the foremost employer of black TV actors working in cooperation with the creator of *Roots*, the series seemed certain to be a hit. The program focused on a black family and a white family living in rural Georgia during the Great Depression. It dealt, certainly, with segregation and the virtual caste system then operative in the South. But it also treated general social problems—from men struggling to get ahead, to illicit love affairs. In its limited run (five weeks) in the spring of 1980, *Palmerstown, U.S.A.* earned only moderate ratings. It reappeared the following spring for eleven weeks. Now with the shorter title, *Palmerstown*, the program sometimes dealt exclusively with problems of the white family, playing down or avoiding altogether the racial tension built into the format. By mid–1981, however, *Palmerstown* was an anachronism. With *The Waltons* canceled and with *Roots* relegated to the status of an edited-down afternoon movie, the optimistic energies which had created such a series were exhausted. In ratings that made *Dallas, 60 Minutes, The Dukes of Hazzard,* and *The Love Boat* the top shows of the 1980–1981 season, there seemed to be little room for a rural melodrama with racial overtones.

As TV once more abandoned the color-free and bias-free promise it had made so many years before, it turned again to old models. On the popular miniseries, *Backstairs at the White House,* aired in January 1979, Americans learned the personal secrets of their recent presidents through the eyes of the black maids, cooks, and butlers who worked in the presidential residence. More virulent, however, was the miniseries, *Beulah Land.* A weak imitation of *Gone with the Wind,* the program was aired in three installments on October 7–9, 1980. This six -hour NBC epic was a gothic romance set amid plantation life in the South before and after the Civil War. Even before the series was aired, producer David Gerber was the object of considerable controversy. Black organizations were particularly vociferous in calling for cancelation of the series or, at least, considerable moderation of its depiction of slave existence. Although Gerber considerably edited the final version, *Beulah Land* was filled with stereotyped embodiments of the "old folks at home." In his review for *Variety,* Morry Roth delineated the production distortions and network insensitivity in the program.

> It is plainly insensitive to rub salt in the blacks' slavery wounds with this live cartoon version of history—no matter how correct. There is as much myth-making in history as there is in fiction, and the myths selected for this tele-play look tired and down-at-the heels. All of this "massa" talk and eye-rolling supplication may or may not be the way blacks acted then, but we have now read and seen enough to know that not all of the plantation South was cast out of white *Dallas* rejects or walking black symbols.[8]

In chronological terms the space between *Amos 'n' Andy* and *Beulah Land* was considerable. But in terms of characterization, those three decades appear to have produced little meaningful change. American television was not doing justice to blacks. There was no substantial difference between a medium of entertainment and information which offered *Amos 'n' Andy,* with its minstrel show stereotypes mixed with an occasional serious story or supporting role, and video by the early 1980s, which offered comedy roles in quantity, but only on occasion delineated blacks in mature, respectful, and in-depth portrayals.

As viewers and consumers, African Americans were ill-served by video. Studies confirmed that in entertainment TV, the medium continued to project images of individuals and families that were injurious to the self-image of black viewers, and misleading to whites. In a real world where hundreds of thousands of blacks had university educations, where minority aspirations for self-improvement had been alerted, and where a black bourgeoisie was a formidable entity, what was the significance of a situation where:

> Blacks on television were found to be younger, leaner, funnier, and flashier. Economically, they were poorer, jobless or in jobs below the top echelons. . . . Black youngsters may see an imagery of desirable physical attributes but be disenchanted with the continuing low status features. White youngsters may learn to perceive blacks as buffoons who, by and large, stick to themselves, or else get lost in a white crowd.[9]

And what did it suggest about American broadcasting when a minority group had achieved economic strength and constituted a desirable consumer market, but still was unable to see itself portrayed honestly and intelligently on TV? Even in the thirty-second and one-minute commercials which proliferated on the medium, the inequitable treatment of African Americans continued. According to a black psychiatrist, Dr. Chester Pierce, TV commercials evidenced a destructive pattern of "subtle, stunning, often automatic and non-verbal exchanges which are put-downs of blacks by offenders." In one study, Pierce reported on the manner in which commercials reinforced the "never-ending burden" of racial disparagement found in TV. According to his conclusion:

1. Blacks are seen less frequently than animals.
2. Blacks never teach whites.
3. Blacks are seen eating more often than whites.
4. Blacks have fewer positive contacts with each other than whites have with each other.
5. Blacks have less involvement in family life.
6. Blacks more often work for wages and are nonprofessionals.
7. Blacks do not live in the suburbs.

8. Blacks entertain others.
9. Blacks never initiate or control actions, situations, or events.
10. Blacks evidence less command of technology.
11. Blacks have less command of space.[10]

In all fairness, some television programming at the end of this era was outstanding in its portrayal of African Americans. There were made-for-TV films that treated the historic, social, and cultural aspects of black life. In *Don't Look Back,* on ABC on May 31, 1981, Louis Gossett, Jr. played the celebrated pitcher, Leroy "Satchel" Paige, who became one of the first blacks to play major league baseball. *Minstrel Man,* on CBS on March 2, 1977, starred Glynn Turman and Stanley Clay as part of a black minstrel family coping with life in American show business in the last quarter of the nineteenth century.

Bittersweet memories of a childhood spent in rural Arkansas during the 1930s was the focus of *I Know Why the Caged Bird Sings,* a CBS motion picture aired April 28, 1979. Based on the autobiography of actress-director-screenwriter Maya Angelou, it featured Constance Good as a young girl separated from her divorced parents (Roger E. Mosely and Diahann Carroll) and raised by a willful grandmother, portrayed by Esther Rolle. The southern black experience was also the focus of *Freedom Road,* a poorly-received but conscientious filming of Howard Fast's novel about an emancipated black man elected to the South Carolina legislature following the Civil War. When it aired on NBC on October 29–30, 1979, Muhammad Ali starred as the freedman-senator who was exploited and abused by whites during the Reconstruction.

Public television acted responsibly in dignified series and film specials it aired during the age of the New Minstrelsy. William Miles, the renowned filmmaker, brought two singular documentaries to PBS. *Men of Bronze* centered on the "Harlem Hellfighters," the much-decorated black 369th Army Regiment which fought in World War I. *I Remember Harlem* was as much a personal remembrance as it was a four-hour treatment of the evolution of the New York City neighborhood during the twentieth century. Short stories by Richard Wright and Ernest J. Gaines were produced in the *American Short Story* series. PBS highlighted black music and dance in such special programs as Oscar Brown, Jr.'s *From Jump*

Street series, various broadcasts in its *SoundStage* production, and *With Ruby and Ossie*. In a single broadcast, the dramatic creativity of Lorraine Hansberry was displayed in *To Be Young, Gifted and Black*, starring Ruby Dee. *The World of My America* featured writer-actress Pauline Myers in a one-woman show in which she played twenty-five roles covering two centuries of African-American experience. *Only the Ball Was White* was a filmed tribute to the great black baseball players who, because of their race, were barred from white-only major league baseball until the late 1940s. And *A Bayou Legend* was a PBS production of William Grant Still's celebrated opera.

From the old films of Paul Robeson, and James Earl Jones' one-man show on Robeson, to coverage of the 1980 and 1981 national conventions of the NAACP and *Go Tell It . . . Ben Hooks Reports*, a news show hosted by the former FCC commissioner and later executive secretary of the NAACP, public television compensated partially for the lack of responsible performance by the commercial networks.

PBS and a few made-for-TV films notwithstanding, into the 1980s there was no consistently mature response by television to African Americans. One answer might have been to abolish stereotypes and produce only complex, realistic images of blacks. Another response might have been to maintain stereotype programs, but offset their impact with an equal amount of dignified characterizations of blacks. Neither course of action, however, was taken by commercial television.

Some suggested that the only way TV would act responsibly toward blacks was when minorities infiltrated the creative aspects—as writers, directors, producers, and top executives—of programming and turn their sensitivities into policies. There were only slight inroads made in this direction. Norman Lear and Bud Yorkin, for example, sought black writers for their productions. Illunga Adell was one of their earliest black scripters for *Sanford and Son*. Other African-American writers in Hollywood included Lonne Elder III, Cecil Brown, Eric Monte, and China Clark. Yet as of 1981, the number of blacks writing for TV and motion pictures was small. Of the 5,569 members of the Writer's Guild that year, only 65 were black; and of the 1,540 writers who earned a weekly salary, only 4 were black. It was a situation which prompted writer Cecil Brown to conclude:

Hollywood, in essence, is afraid to see blacks for what they are. It is only the blacks who can tell their own story on screen. Whites cannot tell their story, and since the whites cannot and the blacks are not permitted to, the story has not been told. . . .we are all ultimately the victims of an electronic plantation mentality which filters out the real world and turns its characters into caricatures.[11]

As with writing for TV, African Americans had not reached influential positions in executive production capacities. The result was that, while blacks may have been seen on camera, they were still following orders and implementing policies made by non-black superiors. In the case of network TV news, this remained the case into the 1980s. Certainly, there were black faces on the video screen. There were network correspondents like Lem Tucker, George Strait, Carole Simpson, Jacqueline Adams, Emery King, and Sam Ford. Ed Bradley anchored the *CBS Weekend News* and co-hosted *60 Minutes*. At ABC, Max Robinson was the only black anchorman in network weekday news. On PBS, Carl T. Rowan, the influential newspaper columnist, appeared regularly on political discussion shows; and Charlayne Hunter-Gault was a featured part of the *MacNeil/Lehrer Report*. But behind the scenes, where corporate and program directions were fashioned, blacks had little impact.

By the early 1980s, there was a growing concern among blacks that they had hit their peak in nonfiction TV, and that progress toward integrating video news would remain incomplete. According to an ABC News special *Viewpoint*, aired July 23, 1981, after more than a decade blacks had made little headway in reaching the upper echelons of TV news. Of the nineteen senior-producer executive positions in network TV news, none was held by an African American. In fact, few blacks were even in line for such jobs. As of that date only twenty-eight of 625 employees in the network producer corps were black. Of this number, ten of 219 were at CBS, six of 206 were at ABC, and approximately twelve of two hundred were at NBC. The highest ranking of these was the one news bureau chief—Frieda Williamson in Chicago—employed by NBC.

Several reasons might account for this imbalance. Most of the blacks who entered television in the late 1960s and 1970s

were hired for the more glamorous roles on camera. As reporters and anchors in local news, or as correspondents in network news, those early recruits followed the quicker route to fame and large salaries. Stations and networks, eager to assuage hostile community representatives, also guided blacks away from executive positions and toward on-camera roles because that was what black pressure groups seemed to want. During those years of demanding equal treatment in TV, black special interest and lobbying organizations pushed for employing minorities in highly visible capacities. The result, however, robbed blacks of involvement in exactly that aspect of TV news where power exists.

Other figures suggest that more than short-sighted decisions in the late 1960s and 1970s account for the contemporary frustration felt by blacks in television news. Had the networks really desired to integrate their operations, blacks would have been hired specifically for executive operations. Further, during the late 1970s and early 1980s, according to the report on *Viewpoint*, there was no appreciable increase in the number of blacks reporting the news on network TV. Although the total number of reporters rose, there remained only eighteen or twenty black network correspondents. New blacks were being hired essentially as replacements for those who left for other jobs. To some, this suggests an overt pattern of racial discrimination. In the words of Renee Poussaint, a black anchorwoman at WJLA-TV in Washington, D.C.:

> I think it's a function of this society. I think that broadcast journalism is a reflection of the whiter society. The whiter society has certain racist patterns that are repeated in our industry.[12]

The history of blacks in American television continued to be one of honorable promises and noble intentions, constantly compromised by realities of the medium. Above all, TV is a business. Although only fifteen of the 726 independently-operated commercial stations were owned by the three networks, they exerted an enormous influence on the overall nature of the medium. And ABC, NBC, and CBS were three large capitalistic corporations all intent on making money and rewarding their investors. Despite the honorable declarations, the bottom line in this multi-

billion dollar industry remained making money. Lawrence K. Grossman, the president of PBS, argued in 1978 that greed was the motor force of television. "Greed is what runs TV, the avaricious pursuit of ratings, the insane battle to be No. 1, the lust for even higher profits," he contended. And this hectic picture was affirmed by the president of NBC-TV, Robert E. Mulholland, when he claimed that "in competing for audiences, the networks right now are in the most frantic horserace since Ben Hur. Win, place or show, the results are no longer predictable from season to season."[13]

Perhaps in this frantic atmosphere it was unrealistic to have expected televison to be fair to minority Americans while serving the demands of its predominately white mass audience, as measured by the Nielsen ratings. Television utilizes the public airwaves, it may be argued, hence the necessity to serve the people—all the people. But until the 1980s TV was a medium of *broad*casting. It aimed broadly, at the largest viewership possible. Moral concepts such as "conscience," "obligation," and "trust" might have been operative during obscure hours in the video day, but in prime time—where the meaningful ratings are obtained, where advertising rates are the highest, where most profits are maximized—the competitive nature of U.S. broadcasting mitigated against programming not intended to deliver the largest possible audiences.

Certainly, the general public was at fault. If network television still preferred the minstrel comics and stereotyped black subordinates, was it not because most Americans, specifically nonblack Americans, found more enjoyment in stereotyped characterizations than they did in respectful images of African-American men and women? If Uncle Toms, coons, mammies, and pickaninnies still flourished, was it not because the audience served by network video still liked this racial minority presented in recognizable, minstrel-show style? Was it not comforting to the majority race to believe that the minority was filled with simpletons and inferiors?

But the networks must share the censure. Since the 1940s they had forged and perfected a monopoly of the public airwaves. It was their corporate decision makers who worked to limit the number of channels, to fashion a national video system that undermined local and regional initiatives, to dominate that

nationwide industry with an ever-narrower range of program choices. The networks had the power to change matters for the better, but in the name of sponsors and stockholders they resisted until pressure from the restive public and government necessitated improvement.

The television industry could continue to proclaim its noble intentions. As late as July 1981, for example, Roone Arledge, the president of ABC News, appeared on *Viewpoint* and told the world that his network sincerely desired to bring African Americans into the business. "The power of television today in our society is so immense and so all-pervasive," he explained, "that conscious efforts must be made to allow all the groups in society to participate in this instrument." In empty rhetoric long familiar to African Americans seeking fairness from TV, Arledge continued: "None of us ever wants to fall back on the argument that blacks aren't qualified, and so what we have to do is set up the mechanism that allows blacks to be qualified so that the argument doesn't even come up."

By the end of the 1981–1982 season, a new balance had been achieved for blacks in network broadcasting. African-American participation was now synthesized somewhere between the expanding and honest involvement of the Golden Age, and the exclusion that was inherent, if not completely realized, in the racial backlash of the 1970s. Significantly, by the early 1980s there were few tangible reasons to expect improvements in this condition.

Blacks remained a visible and strategic part of television comedy. As well as those who continued in series such as *The Jeffersons, WKRP in Cincinnati,* and *Diff'rent Strokes,* there were several notable comics in familiar characterizations. Nell Carter, whose shrieking and intimidating performance was a mainstay of *Lobo,* now took her mammy characterization to *Gimme a Break,* where she portrayed the hip and sassy housekeeper of a white father and his two motherless daughters. A former professional football player and star of several commercials for Lite beer, Bubba Smith appeared as a comedic night manager in an all-night grocery store on *Open All Night.* On *Benson,* Robert Guillaume's central character ceased being a butler, and became a government bureaucrat—but still within a humorous context of wisecracks and put-downs.

Chapter 18

In the often-revised *Saturday Night Live* comedy revue on NBC, Eddie Murphy scored well in two minstrel favorites. In a parody of Buckwheat, the wiry-haired pickaninny in the *Our Gang* comedies of the 1930s, Murphy delivered monologues in childish pidgin English while wearing a minstrel-show fright wig. Even more questionable were his spoofs of TV commercials in which he appeared as a black pimp, Velvet Jones, peddling books on how to train and discipline whores. With a sign for the Velvet Jones School of Technology over his shoulder, the wigged Murphy in broken English told his audience on the telecast of November 7, 1981:

> Due to the overwhelmin' response to my last book entitled, *I Want to Be a Ho*, there is yet another high-payin' job in demand. Hi, I'm Velvet Jones. Are you a male high school dropout between the ages of 18 and 42? Do you have three or more gold teef in front of you' mouf? Do you like flashy clothes, big cars, and like kickin' wimmen in the butt? If so, stop doin' all these things fo' free. Because thanks to me, Velvet Jones, you too in six short weeks can be taught to be a high-payin' pimp. That's right, it's a well-known fact that a good pimp can make up to $250,000 a year. And just think, because it's off the books, you can still get your welfare checks. Sound too good to be true? It is. And basically all you do is drive around in a big pink Cadillac, kick wimmen in the butt, and take their money. Sound simple? It is when you know how. Just send for my new book entitled, *I Want to Drive a Big Pink Cadillac, Wear Diamond Rings, and Kick Women in the Butt*. In it you'll find all the latest in clothes and special leg exercises you can use, so when you kick your ho's, they know you mean business. If you order now, I'll throw in absolutely free this pamphlet called "12 Easy Ways to Stomp a Ho." Here's how to order: Rush $83.95 to I Want to Drive a Big Pink Cadillac, Wear Diamond Rings, and Kick Women in the Butt.

Blacks were virtually excluded from starring roles in dramatic series in the 1981–1982 season. There were, however, several strategic castings. Moses Gunn had a sensitive supporting part in *Father Murphy*. The Procter and Gamble soap opera *Another World* brought African-American characters firmly into the story line. In the continuing series *Hill Street Blues*, black charac-

ters increasingly appeared in mature representations, yet such roles usually involved seamy images of crime, poverty, and brutality.

One of the most innovative uses of black talent occurred on *Fame*. Patterned after the hit motion picture of the same name, *Fame* presented stories of gifted and ambitious students—white, black, and Latino—coping with personal problems and the academic demands of the School of the Arts in New York City. Starring Erica Gimpel, Gene Anthony Ray, and Debbie Allen (who also choreographed the dance routines), the program offered an inventive blend of sensitive human drama and colorful musical and modern dance productions. Further, with its emphasis on themes of student discipline, self-improvement, sacrifice, and the will-to-succeed, *Fame* reflected the conservative social and political mood of the early 1980s.

The few other series spotlighting blacks seemed to have been cast by affirmative action officers sensitive to minority quotas. In *Strike Force*, Dorian Harewood played a black plainclothes policeman operating within a specially trained unit headed by Robert Stack and including one white woman and two other white men. In exactly the same ratio, 3:1:1—a casting formula first popularized by *Mission: Impossible* more than a decade earlier—on *Today's FBI*, Harold Sylvester portrayed a black FBI agent, part of a team headed by Mike Connors, and including two other white men and a white women.

The success of black athletes in professional sports by 1982 began to threaten their appearance on television. When the chief scout for the Pittsburgh Pirates announced that his baseball team had to recruit young white players because "we're not going to be able to play nine blacks,"[14] he was speaking of the loss of support by white sports fans when open competition results in the domination of a professional team by black (Latino players being considered black by fans) players. This pattern has been most keenly felt by the National Basketball Association. The NBA was 7 percent black in the 1955–1956 season; it was 74 percent black in 1982, and 80 percent of the league's starters were black. In the NBA All-Star game in 1956 there was only one black player, but in the game in 1982 twenty-one of the twenty-four players were African American. As a result of this racial reality, fan attendance and TV viewership and revenues began to dimin-

ish. For the 1982–1983 season, CBS announced a television schedule which relegated NBA coverage "almost exclusively to springtime playoff games."[15]

The condition of blacks in television by the 1981–1982 season caused *Ebony* magazine to question whether or not African Americans were being forgotten by white-owned and white-oriented TV. In an article entitled "Has TV Written Off Blacks?" Charles L. Sanders painted a distressing picture of black participation in the most popular medium of entertainment and information. He quoted Charles Floyd Johnson, a black producer with credits on *The Rockford Files* and the NBC series *Bret Maverick*. In Johnson's view, TV has abandoned African Americans—except as comedians, historical figures, and subcharacters—because "the people who put up the enormous sums of money to make TV series don't believe they can make profits by casting Blacks in any other way—especially in serious, Black-oriented dramas."[16]

The situation was not totally bleak for African Americans in the new TV season. There continued to be major achievements in PBS programming. PBS devoted the premier program in its intelligent series *Creativity with Bill Moyers* to Maya Angelou and her ambivalent memories of growing up in rural Arkansas. Impressive, too, were two dramatic productions. *For Colored Girls Who Have Considered Suicide/When the Rainbow Is Enuf* was Ntozake Shange's profound "choreopoem" about the pains and triumphs of life as a black woman. And Yaphet Kotto and Bernie Casey probed an area seldom explored in television drama, African-American revolutionaries, in *A House Divided: Denmark Vesey's Rebellion*—a character study of the former slave who in 1822 attempted through armed uprising to free the slaves in Charleston, South Carolina.

Also on PBS, black musicians and singers continued to appear on the performance series, *SoundStage*. Contemporary black social and political problems were probed with regularity on network news and informational programs. And *Tony Brown's Journal* inaugurated its return to PBS with an interview with President Ronald Reagan. Typical of producer Tony Brown's provocative style, however, the second program in the series investigated the relationship between Black Muslim leader Elijah Muhammad and slain black nationalist spokesman Malcolm X.

On commercial network TV, there were several notable developments related to blacks. Newscasters Bryant Gumbel and Ed Bradley earned distinction in their craft, Gumbel as a new anchorperson on NBC's *Today* show, and Bradley as a correspondent on *60 Minutes* and as a reporter on several significant documentaries. Cicely Tyson appeared in yet another historic role, this time as Chicago school teacher Marva Collins, battling insensitive bureaucrats and skeptical parents to teach her ghetto pupils. In *The Marva Collins Story*, seen on CBS on December 1, 1981, Tyson not only struck a familiar chord with her return to biographical drama, but her portrayal of Collins refusing to take government funds and attacking governmental regulations and bureaucracy clearly tied this made-for-TV film to the antiregulatory and anti-government ethic of the Reagan presidency.

Few television dramas featuring black characters have been as humanly moving and racially unexploited as *Sister, Sister*, aired June 7, 1982 on NBC. Written by Maya Angelou, this made-for-TV film drew from many standard black social institutions—religion, civil rights, family, and the return to ancestral roots in the South. But *Sister, Sister* was primarily a mature drama about three adult sisters, affected in differing ways by the memory of their stern deceased father, who are reunited when one of the sisters returns after years to their family house in a small southern town.

As portrayed by Diahann Carroll and Irene Cara, with Rosalind Cash as the sister returning from Detroit, the women fought, rejoiced, rejected, and recollected, all within the bonds of sisterhood. Although there were men in their lives, it was the relationship between sisters and the mystique of family—all sisters and all families—which were scrutinized in this singular presentation.

Notable among the few deviations in network prime-time TV in the new season was an explosive miniseries, *The Sophisticated Gents*. Seen on NBC over three evenings, September 29 and 30, and October 1, 1981, it starred an array of talented black actors in the story of a reunion of men who grew up together and last were together twenty-five years earlier. Among the stars of this production were Ron O'Neal, Robert Hooks, Roosevelt Grier, Bernie Casey, Thalmus Rasulala, Paul Winfield, Dick Anthony Williams, and Raymond St. Jacques. The teleplay was written by and also starred Melvin Van Peebles.

Certainly, the "gents" had evolved into middle-class achievers

not generally seen in television productions. One was a successful politician, another an internationally known singer, still another was a college professor. Only Van Peebles' character, a pimp, was a stereotyped role. The others lived in pleasant homes with wives and children. But what made *The Sophisticated Gents* an iconoclastic television experience was the sexuality—especially the interracial sexuality—which marked the production. Included in the program were two graphic bedroom scenes between a black man and a white woman. There was also black homosexuality and interracial marriage and kissing in the miniseries. Van Peebles admitted that he considered the program the TV equivalent of his revolutionary movie, *Sweet Sweetback's Baadasssss Song*, which in 1971 broke conventions by projecting a black man as a sensual, rebellious, aggressive urban hero—a film that ended with the warning, emblazoned across the screen in large letters, "A BAADASSSSS NIGGER IS COMING BACK TO COLLECT SOME DUES."

While *The Sophisticated Gents* lacked the overtly rebellious quality of Van Peebles' cinematic achievement, the miniseries was unprecedented on TV. Even NBC seemed cautious with the program, since it had been completed more than two years before it was shown. In terms of attracting viewers, however, the production did poorly. It earned an average 11.1 rating and a 19.0 share—this compared to the 23.2 and 36 gained earlier by *Beulah Land*, and the 32.6 and 51 earned a year earlier by *Shogun*. In fact, the only miniseries in the 1980–1981 season to fare worse than *Sophisticated Gents* were reruns of *Beggarman, Thief* and *Roots: The Next Generations*, the latter producing a dismal 7.0 rating and a 15 share.

As with much in the history of blacks in white television, the situation in which African Americans found themselves by the 1981–1982 season was a reflection of broader social and political attitudes in the society at large. The election of Ronald Reagan to the presidency brought to power a man and a philosophy intent upon curtailing governmental activity in social matters. In the Reagan view, federal intervention destroyed individual initiative. This thwarted business, hampered the rights of states and localities, and compromised the values to which the United States has always given lip service. With Reagan's new federalism came a dismantling of social service agencies and drastic cut-

backs in federal funding for those agencies, both state and federal, that managed to survive. Added to that were increasing unemployment and economic disarray felt most keenly in black communities, and a lack of African-American political power within the new administration, since Reagan was elected with little black support.

There was also a rising wave of racial intolerance in the nation at this time. Organizations such as the Ku Klux Klan enjoyed renewed popularity. The incidence of racial violence increased. And the sagging national economy promised only more aggravation. These themes were communicated most forcefully in two network documentaries in late 1981. An ABC News *Closeup*, "Wounds from Within," sought to understand this new "emerging pattern of racial attacks around the country." It focused on the KKK and its hate campaign against Vietnamese fishermen along the Gulf Coast in Texas. It treated the torching of a synagogue in Southern California by members of the American Nazi party. And it reported on two acts of violence against blacks: the bombing of a suburban home owned by African Americans in the San Francisco area, and the senseless slaying of a fourteen-year-old black girl by a white boy only two years her senior. "Wounds from Within" was aired on October 18, and indicated that such acts of violence were occurring "at a time when many sensed a new, general mood of rancor toward minorities." It suggested that by this date a strange twist had developed in the way many perceived the civil rights issue. From approval in the 1960s through suppression in the 1970s, the program now suggested that the "legislation and affirmative action that came out of the great civil rights struggles of the sixties had produced a curious backfire: a bitter sense among a number of hard-pressed whites that they were now the oppressed minority."

Starker still was an *NBC White Paper* entitled, "America—Black and White," which was televised on September 9. This ninety-minute study of racial attitudes in contemporary society was one which narrator Garrick Utley called "a story too few whites pay attention to today." It dealt with racial anger precipitated in a New York City suburb because of the integration of schools. It focused also on apparent discrimination at the University of North Carolina. From Los Angeles, Detroit, and elsewhere "America—Black and White" offered a dismal look at

American realities. And there was something depressing and nostalgic of the earliest days of the civil rights movement when a black female student at Davidson College in North Carolina sadly rebuked a white fellow student:

> You'll never know what it's like to watch your children or your parents not be able to reach their goals. You'll never know what it's like to see them so frustrated they give up and leave you. You'll never have a part of your human dignity taken because of your color. And that's what it's like to be black.

Even more sobering was Utley's final comment in which he noted that for most blacks "that elusive thing called the American Dream" was still "an impossible dream." According to Utley, "205 years since Jefferson wrote the Declaration of Independence, 119 years since Lincoln signed the Emancipation Proclamation, and seventeen years since Congress passed the Civil Rights Act, America still remains in many ways two nations, black and white." It is a situation fully understood through a study of the history of African Americans in television.

Once a great promise of equality and a catalyst for positive social change, TV by the early 1980s ceased to play an active role in the improvement of racial understanding in the United States. Certainly, there were exceptions to the rule. But in general, television had surrendered its social initiative. It had returned to the safer and more profitable utilization of ethnic stereotypes and unoffensive social rhetoric. As late as 1982, one influential white TV critic could applaud the stereotypes in the NBC series, *Gimme a Break*, and conclude:

> Nell [Carter] is black, built like a medicine ball, and emphasizes her lines by tossing her enormous torso from side to side. . . . Oddly, blacks have become the last ethnics in popular entertainment. In radio days, ethnic types were rampant: Charlie Chan, Parkyakarkas, The Mad Russian . . . but the immigrant generation disappeared. . . . Black people, maybe because they didn't melt into the pot so readily, kept some of their folkways and speech styles—with a lot of help from screenwriters. Anyway, I guess it's a sign that we have all loosened up on a touchy matter that a black person can be cast as a household domestic.[17]

At the same time, the distinguished producer of *Roots* and *Roots: The Next Generations,* David L. Wolper, could admit TV's shortcomings and call upon the industry to use the most popular programs "to transmit ideas of a socially significant nature." Recalling that more than a quarter-billion viewers throughout the world learned of slavery through the *Roots* miniseries, Wolper suggested that by introducing relevant themes into shows such as *Magnum P.I., The Love Boat, Dallas,* and *Laverne and Shirley,* television "can significantly elevate the knowledge and enrich the lives of the entire population of this country."[18]

Between these two possibilities—the glorification of minstrel conventions and the use of TV as an educative social force—the history of blacks in television had evolved. It had been a story both of significant accomplishments and of massive insensitivity and neglect. But after four decades of promises and platitudes, it seemed clear that little more could be accomplished—either effectively or profoundly—to advance the participation of blacks in white TV unless the industry were radically rearranged. It was not enough to demand or plead for reconsideration. Persuasion did not work. Anticipating changes of the heart or corporate contrition for racial sins was likewise unrealistic. Instead, lasting improvement could occur only if fundamental changes were made in the way television operated in the United States. TV had to serve black Americans because it financially needed them, not because it was morally supposed to be fair. And this could occur only through the destruction of broadcasting—with its scarcity of channels and its network monopoly—and the restructuring of the medium as a narrowcast entity with scores of stations serving the diverse audiences that comprise the American people. Importantly, U.S. television since the early 1980s has begun to realize this prescription for social progress.

PART FOUR

BLACKS IN THE NEW VIDEO ORDER, 1983–PRESENT

After more than forty years in which three broadcast corporations and their affiliates monopolized what Americans saw on TV, the predictable stability of American television has been destroyed. The industry dominance forged by ABC, CBS, and NBC has been shattered; and the social-cultural role of this Big Three has diminished. As the importance of the networks declines, a new video order is materializing.

The weakening of network TV came swiftly during the 1980s. In less than a decade the Big Three lost one-third of their cumulative audience. In the early 1990s network ratings continue to decline, and none of the experts knows fully when the decline might end and what its ultimate consequences will be on American television.

This is because the disintegration of the monopoly was triggered not by an economic slump or massive audience disenchantment with programming, but by technological advances that are revolutionizing the meaning of TV in the United States. New electronic devices have redefined the relationship between viewers and their television sets. A multiplicity of new channels has appeared and offers expanded choice. "Pay TV" has begun to supplant "free TV." Of necessity, programmers have narrowed the focus of what they deliver in order to reach smaller target audiences. These are radical changes that are leading not only to the restructuring of the video industry but also to major

alterations in the homogenized, white middle-class culture so overwhelmingly propagated via the networks.

In the 1980s, millions of American homes experienced a quantum leap into the age of personalized technology. Affordable new electronic gizmos such as the videocassette recorder turned viewers into programmers. Off-air recording allowed them to be more discriminating about spending time watching television. The consumer boom in prerecorded videotapes for purchase and rental increased the availability of video fare and challenged network dominance of the TV set. And other electronic products, from laser discs for movies and compact discs for music, to video games and personal computers, provided the public with seductive alternatives to TV as it had existed since the late 1940s.

But if television has changed substantially, it is primarily because of cable TV. Long a delivery system for people living in rural or mountainous areas where good reception was impossible, cable by the early 1980s had resolved the legal and technical impediments thrown in its way by over-the-air broadcasters. Quickly, the liberated medium began to transform the entire industry.

By bouncing TV signals off communications satellites orbiting in the heavens, cable programmers circumvented the networks and created their own national linkages. Delivering these signals directly to local distributors throughout the country, suppliers soon provided dozens of new, made-for-cable channels for subscribers who lived not only in rural areas but also in the largest American cities and their well-populated suburbs. And cable filled its channels with attractive programs—from vintage reruns to original productions and exclusive live-action events. Importantly, this augmentation of home entertainment seemed to reenergize all U.S. television, forcing greater competition, creating wider program diversity, and necessitating greater appreciation of viewer sensibilities.

By early 1991 cable TV had 55 million subscribing homes, representing 59 percent of all American households. Many in cable predicted even greater levels of penetration, possibly reaching 70 percent within a few years. With the wiring of the United States came enhanced choice. Whereas in 1964 only 8 percent of television households could receive nine or more channels, a

quarter-century later 64 percent could receive at least fifteen stations and 45 percent could pick up at least thirty channels.[1]

Instead of adopting the strategy of network broadcasting—luring broad, undifferentiated audiences with programs appealing to widely-held attitudes and tastes—cable outlets aimed at narrower constituencies. Whether aimed at country music fans, Spanish speakers, women, or Roman Catholics, whether formatted as all-news, all-sports, all-music, all-movies, all-educational, or all-comedy, cable channels ushered in the age of narrowcasting.

Crucial to this emerging arrangement has been the globalization of the entertainment business, which has been spearheaded by several multibillion-dollar transnational corporations. More than the simple distribution of old U.S. television films to foreign countries, the movement toward globalization has meant the control of the world's entertainment by a few megacorporations responsible for production, distribution, and marketing of finished products. Massive enterprises such as Sony and Matsushita from Japan, Maxwell Communications based in Great Britain, Rupert Murdoch's News Corporation from Australia, Pathé Entertainment from France, and Time Warner in the United States have been amalgamating diverse media companies to form global information empires that are vertically integrated and synergistically interrelated.

While Hollywood remains a city in Southern California, the "Hollywood" that produces television shows and motion pictures has been bought by corporations and billionaire investors headquartered throughout the world. Among recent acquisitions, Sony has purchased Columbia Pictures, Matsushita now owns MCA/Universal, Twentieth Century-Fox is controlled by Murdoch, and Pathé has acquired MGM-United Artists. In this arrangement, U.S. television gradually is being subsumed within an interlocking planetary system of commercial popular culture. While U.S. laws forbid noncitizens from owning American radio or TV stations or networks, the case of Rupert Murdoch—who quickly acquired U.S. citizenship, then purchased the Metromedia network with its TV stations and used them as a foundation for his new Fox television network—suggests that even U.S. broadcast properties are being merged into global conglomerates.

Globalization is shifting the focus of entertainment produc-

tion. When massive corporations like Sony and Time Warner control movie, publishing, phonograph, radio, television, and other media facilities, supplemented by production, distribution, and marketing subsidiaries, all located around the globe, they have indicated that their audience is no longer just the predominantly white United States with its persistent racial prejudices. Entertainment transnationals seek to amuse the world; they need products that can be sold easily everywhere on the planet. While such merchandise may seek to entice American customers, their ultimate audience is multiracial and international.

In this reality, negative racial qualities in a TV show can cost money because they compromise the marketability of the finished article. Demeaning racial messages can drive disapproving viewers to other video forms, and satellite- and cable-delivered narrowcasting practically insures that at any hour on the TV schedule there will be an acceptable substitute for offensive programming. Moreover, since the majority of the Earth's population consists of people of color, racial disparagement can limit the acceptability and, therefore, profitability of a television production.

19

African Americans and the New Video Realities

After decades of racial misrepresentation and damaging bias in U.S. television, the situation for blacks in white TV has been changing significantly since the early 1980s. With networks in decline and national television evolving toward a new relationship with its public, the medium is slowly evidencing a new racial attitude. This is because the infrastructure of the industry is changing. Ultimately, TV is a medium of advertising, and money is its mother's milk. Since American television has always been fueled by sponsors' dollars, it has been dedicated to attracting large audiences for the commercials of its advertisers. If material forces alter this fundamental arrangement, then those in the business must adapt or perish.

New business conditions by the 1990s have made African Americans a prized target audience, one to be respected by programmers and appreciated by advertisers. Although the secondary characterizations and stereotyping of the Age of the New Minstrelsy may endure, before the camera blacks are gradually emerging from predictable, subordinate roles. Behind the camera minority presence remains small, but here, too, there have been modest developments in which blacks have begun to exert influence over program production and content. Together, these changes constitute a breach in the racial logjam that chronically has blocked African Americans from fair and open access to the video industry. These changes also represent a move toward fulfilling the original promise of prejudice-free TV, a condi-

tion that seems more realizable in the final decade of this century than at any time in the history of the medium.

But there remains serious weakness in the new attitude of television toward black America. As director Melvin Van Peebles noted on the CNN *Showbiz Today* telecast of April 28, 1989, "Now, television has offered a substantial opportunity—not as substantial as we would like, not as equitable. But on the whole it's moving a little bit." Although created by substantial changes in the structure of television, this movement toward an honest treatment of minorities is still recent and fragile. The improvements of the last several years do not constitute an immutable transformation. The improvements remain defenseless against pressures created by economic calamities, deteriorating international relations, and social and political tensions within the United States.

It is significant that these material changes have not been complemented by any moral reevaluation of racism within U.S. society. When a former Grand Dragon of the Ku Klux Klan and American Nazi Party leader garners almost two-thirds of the white vote in the Louisiana senatorial election in 1990—then nearly wins the governorship of that state in 1991—it is obvious that racial bigotry remains virulent and obvious and rewarding. When civil rights protections find stiff opposition from the President of the United States, Congress, and the Supreme Court, black Americans cannot be reassured that equality and justice are on the horizon. When it is more dangerous for a young black man to walk the streets of urban America than to fight his nation's battle in the Persian Gulf, social fact must sound a sobering counterpoint to any advancement for African Americans in television. And when 43 percent of black children are born officially poor—when black unemployment is more than double that of whites—when a black boy is seven times more likely to be murdered than a white boy—when nearly half the African-American teenagers in Chicago are high school dropouts and there are more black men in Washington, D.C. jails than are graduated from the city's high schools in a year, the United States has clearly failed a sizable portion of its citizens. As a recent British assessment of ghetto conditions has declared, "The slums in America's great cities are shameful. They are a damning indictment of the richest country in the world. The problems

that fester in them are not peripheral: they constitute America's main domestic challenge today."[1]

In understanding the place of blacks in contemporary TV, there is also a lesson from recent history to consider. Just as social, economic, and political developments in the early 1970s eroded the Golden Age for blacks in the industry, so too might future realities adversely affect the positive trends of the past several years. Unless their presence takes root in the infrastructure of the business, blacks will always be vulnerable.

Adding to the ambiguity of this improving situation is an apparent confusion among blacks about their own image in popular culture. With a greater potential for honest African-American representation, questions are being debated within the black community. Should blacks be shown only as middle class and assimilated, as are most whites, or is this a denial of racial authenticity? Should blacks be portrayed in terms of the urban underclass, especially when such imagery might appear as crude or unaccomplished? Should the folk images of rural blacks—often with characteristics that have fed the distorted, racist stereotypes so familiar in American pop culture—be propagated now as authentic, or should they be buried as anachronistic and self-defeating? Can African Americans dare to accept a full range of racial characters—from the dynamic chairman of the corporate board to the dimwitted buffoon—when the predominantly white audience has a persistent history of prejudice, when black socioeconomic mobility remains constricted, and when television still has not opened its doors to full and unfettered participation by minorities?

In the new television arrangement most people of color have been assimilated into the middle class where they now display the behavioral norms of bourgeois white America. Yet, this "Bill Cosby" image has received its share of criticism, attacked for being unrealistic, unrepresentative, and misleading. Certainly, there is a substantial black middle class whose housing, dress, language, education, income level, value system, and life-style are little different from its Caucasian equivalent. In fact, the black bourgeoisie rose from about 10 percent of the African-American population in 1960 to more than one-third of it by 1991. Moreover, many scholars have long asserted that social class is more crucial than race or ethnicity in determining social behavior.

Still, as it did at the time when *Julia* was a popular series, such representation invites criticism for proposing an unauthentic model for blacks.

Importantly, there is a substantial portion of the African-American population that does not meet middle-class criteria. Blacks still earn fifty-six cents for every dollar earned by whites. Many live in substandard housing located in "black sections" of the nation's large cities. Here these disadvantaged people constitute a lower class, even an underclass. They attend devitalized schools, and are victimized by an oppressive political and economic system still unwilling to address adequately their needs. Too often, they are further hampered by broken homes, drug abuse, poverty, and insufficient job skills.

The frustrating reality of this social element is infrequently depicted in the new video order. Seldom does TV portray the indignities that blacks routinely encounter, regardless of social or economic status. Seldom, too, does the medium present life in the inner city with compassion or understanding. In a report issued in 1989, the National Commission for Working Women of Wider Opportunities for Women concluded that blacks on television were being unrealistically represented. "Real-world racism, which is pervasive, subtle, and blatant, is commonplace in America but virtually invisible on entertainment television," according to the report. It pointed out, too, that 90 percent of the minority characters on TV—and most of these were African Americans—were middle-class and rich, while the working class and the poor made up less than 10 percent of those images. Yet, according to the report, more than 40 percent of minority men and 60 percent of minority women subsist on less than $10,000 annually. The report also criticized TV entertainment for misleading viewers by suggesting that racial harmony and an egalitarian work place were everyday realities, and by offering racial injustice as a matter of individual immorality instead of the result of oppressive social structures.[2]

Nevertheless, there is little doubt that U.S. television has begun to change. After a half-century of moral protestation, some in the industry may have been persuaded that African Americans must be treated fairly because it was the "democratic" or "right" thing to do. But the driving force behind this new video reality is more substantial than any spiritual conversion. When

he appeared on a segment of the CBS program *West 57th Street* on May 27, 1989, director Spike Lee well illustrated that the basis for the new openness in Hollywood rested in economics, not ethics. Although he spoke of the motion picture industry, his comments were applicable to TV production as well. "Hollywood only understands economics. I mean, they could hate you, I mean they could call me 'nigger this' and 'nigger that' behind my back, they probably do—you know, 'young nigger upstart,' whatever. But they look at it, when they get their reports from the office, and they see my films are making money." Lee continued, "No matter what they think of me, they're still going to continue to fund them because the films are making money. But if the time ever arises where you stop making money, 'You're outta here!' "

In essence, improved African-American representation in modern television is the result of a simple equation: first, there are many more stations and consequently greater competition for viewers and profits; second, there are sizable minority audiences, the most prominent of which is the black viewership, whose loyalty is now highly desirable; and third, each minority audience appreciates positive depiction of itself on TV. When added together, the resulting programs will attract viewers, make money, and inspire others to create respectful images of minorities.

One influential organization leading the way toward improved racial representation has been Black Entertainment Television (BET), a national cable channel that targets African-American viewers. Established in 1980 by Charles Johnson, BET has been supported by three cable corporations interested in attracting African Americans: Tele-Communications, Inc., Great American Broadcast Company, and the Time Warner subsidiary, Home Box Office (HBO). In its first years, BET programmers relied greatly on weekly football and basketball games of small black colleges, as well as on network reruns and music videos. Among the old series finding new life on BET were heralded, but short-lived offerings such as *The Lazarus Syndrome, Paris,* and *Frank's Place.* By the early 1990s, however, BET moved decisively into original programming. Here, shows have ranged from an evening newscast with a black perspective and a nightly entertainment-gossip program (*Screen Scene*) to a weekend music and talk show for teenagers (*Teen Summit*).

Despite the swelling popularity of BET and other cable operations, over-the-air broadcasting continued to dominate viewing patterns in the 1980s and early 1990s. Certainly, audience figures plummeted at the three networks, dropping from a cumulative 56.6 rating/90 share in the 1979–80 season to a 41.5 rating/67 share by 1988–89, to a 37.5 rating/63 share for 1990–91, but no single cable channel could match ABC, CBS, or NBC in terms of audience size. It is significant, moreover, that advertisers did not desert free TV. Convinced that the three networks still delivered the largest audiences for their sales pitches, sponsors by late 1988 still placed 81 percent of their advertising dollars in network shows.[3]

Although cable success and network attrition delivered the message that African Americans constituted a desirable target audience, this was still no insurance against inflammatory racial representation. No character inflamed the argument over black TV imagery more than Bosco "B.A." (Bad Attitude) Barracus, the muscle-bound mechanic who with several white misfits formed the rugged and popular mercenaries of *The A-Team*. As portrayed by the highly-publicized bouncer and bodyguard, Mr. T, Barracus was a caricature of the action-adventure hero when he appeared on NBC from early 1983 to mid-1987. B.A. had his soft spots: he may have been big and black and menacing, but he drank milk, loved children, and was afraid to fly in airplanes. Such subtleties of character paled, however, before his foreboding, sometimes snarling presence. With his Mohawk haircut, several pounds of gold jewelry, and physical strength, B.A. was the scary black man no white person ever wanted to meet in an alley late at night. Still, he was a controllable angry black man, a Vietnam veteran, a growling warrior who was smart, inventive, and tame—a patriot who now waged "our" just struggle against "their" evil threat.

NBC tried to soften Mr. T's image. As the hero of his own animated children's program, *Mr. T*, seen on Saturday mornings in 1984, he was much less menacing. At Christmas time in 1984 and 1985, the network paired him with *petit* Emmanuel Lewis in *Christmas Dream*, a tender story of a sidewalk Santa Claus attempting to rekindle the Christmas spirit in a lonely little boy. Publicity stressed the actor's popularity with youngsters. *TV Guide*, for example, "unmasked" him in mid-1984, noting that "Mr. T's exterior may be rough, tough and gruff—but the kids of

America know that beneath all that jewelry on the chest of *The A-Team* star beats a heart of gold."[4] The magazine then printed the generally worshipful assessments of Mr. T written by children in the third, fourth, and fifth grades.

But it was already too late. Mr. T as B.A. Barracus had become the symbol of the industry's chronic failure to depict African Americans constructively. In testimony given in the fall of 1983 before the House Subcommittee on Telecommunications, Consumer Protection, and Finance, Mr. T and his video persona became metaphors for the distorted portrait of black Americans offered by network TV. Actor Bernie Casey railed against white industry executives who continued to produce misinformed and mendacious programs—against "those men [who] continue to give us the collective Mr. T." According to Casey, "We as people of color cannot afford the callousness exercised upon us by insensitive people making decisions that are thoughtless . . . decisions that continue to perpetuate the kind of imagery that warps the psyche of the viewership for generations."[5] In a similar vein, Robert Hooks reminded the same House committee that the networks determine what black images appear on TV. "We don't own the networks, we don't own the airwaves, so we can't come back at NBC if they say Mr. T is it. Then the world embraces Mr. T, and it is unfair to blacks. . . ."[6]

Derisive racial depiction appeared in two basic forms: occasionally, in episodes of network shows that were otherwise benign, and fundamentally, when built into a recurring series character. There was considerable outcry generated, for instance, by the broadcast of the situation comedy *Buffalo Bill* on December 22, 1983. In this NBC offering, the lead character dreamed that his TV talk show was assaulted by an entourage of angry black men and women—including a frightening band of spear-toting African natives dressed in loin cloths—all lip-synching Ray Charles' recording of "Hit the Road, Jack." Although it provoked little controversy this time, in September 1983, NBC quietly reran the demeaning *Beulah Land* miniseries. As Kathryn Montgomery described the scheduling tactic in *Target: Prime Time,* her book on advocacy groups and the struggle over entertainment television, "black activists were caught off-guard by the show's sudden reappearance, and it was too late to organize a campaign against it."[7]

With more consequence, two white sports personalities lost their jobs when they unguardedly expressed their antediluvian racial opinions on TV. Baseball executive Al Campanis of the Los Angeles Dodgers suggested on *ABC News Nightline* (April 6, 1987) that there were few African-American managers or front-office executives in baseball because they were intellectually inferior, because "they may not have some of the necessities. . . . I don't say all of them, but they certainly are short. How many quarterbacks do you have, how many pitchers do you have that are black?" He carried his comments further, asking "Why are black men, or black people, not good swimmers? Because they don't have the buoyancy."

Less than a year later, gambling expert Jimmy "The Greek" Snyder of CBS Sports offered a bizarre genetic history lesson to a reporter for WRC-TV in Washington, D.C. (January 15, 1988). According to this highly-paid odds-maker and football analyst, black athletes were physically superior to white athletes. This, he explained, was because slave owners in earlier centuries had practiced selective breeding programs, mating strong black males with strong black females to produce the most rugged workers possible.

While egregious displays of racism might be dismissed as occasional tastelessness or the personal ignorance of individuals, there was something deeply sinister when familiar racial stereotypes appeared premeditatedly as series regulars. During the first two seasons of *Miami Vice*, Charlie Barnett played a silly street informant, Noogie Lamont, whose facial grimaces and addled banter were more appropriate for a minstrel-show endman than an occasional character in this polished Florida police drama. Moreover, his juxtaposition to the other sophisticated black and white personalities in the series only accentuated the distortion inherent in "the Noog man."

Another flagrant case of insensitivity in minority characterization occurred in the fall of 1983 on the short-lived situation comedy *Just Our Luck*. Here, T. K. Carter played Shabu, a black genie liberated from a green bottle, who now proclaimed his willingness to serve his white master "for 2000 years or until your death." Media authority Don Bogle accurately termed Shabu "a 1980s-style slave" and "an embarrassing throwback to past eras of movie coons."[8]

In the hit series *Webster*, the endearing black child, the picka-

ninny, was reprised by precocious Emmanuel Lewis. Like Gary Coleman and Todd Bridges in *Diff'rent Strokes,* Webster offered a picture of the deracinated youngster living the good life because whites adopted him. Although for one season Webster had a black relative, Uncle Phillip (played by Ben Vereen), during its four-year run (1983–87) this uprooted child's world was defined by the white couple that "rescued" him after his parents had perished in an automobile accident. The racial condescension in this scenario was obvious. The implications for black parenting were damning. At a time when network TV had no series featuring black families, this cute African-American boy was being raised by Caucasians. Predictably, U.S. television has never scheduled a series where a loving black couple "rescued" a white child by adopting him.

As much as the minstrel-show coon or the endearing picka-ninny, the sexually neutralized black man possesses a rich history in American popular culture. In this classic characterization, African-American males were rendered romantically unappeal-ing to white women, thereby constituting no rivalry to white male prowess. This was done via exaggerated physical unattrac-tiveness, or diminished intellectual capacity, or a general disin-terest in white femininity. Often this image was enhanced with dominating black women who bullied and belittled their weak men, an activity sure to reassure whites that the black male libido was being controlled by this substitute overseer.

Like the other minstrel-show caricatures, this emasculated social type appeared often in U.S. television—from the sexually harmless males depicted on *Amos 'n' Andy,* to their brethren in contemporary video. Nowhere in modern TV was such neutral-izing of black manhood more obvious than in *Designing Women.* In a series filled with flirtatious Southern white women, the ac-complished Chicago actor Meshach Taylor played the loyal friend and helper, Anthony, to four sexy and available Dixie belles. Always there with assistance or sympathy, Anthony oper-ated around them like an ebony eunuch in a harem of white flesh, never able to touch the tempting merchandise, never even fantasizing about romantic liaison.

But recent series television has not just resurrected vintage stereotypes, it has popularized a new negative type. Although the crime rate in African-American society remains a deplorable reality, there has been little attempt by entertainment TV to ex-

plain this social crisis in terms of its roots in poverty, ignorance, discrimination, unemployment, frustration, alienation, and anger. Instead, in television fiction black crime has taken on an exciting mystique. Outlaw behavior has become an asset, in fact, as many black characters have been created as reformed criminals now working for "the system." Even harmless Anthony on *Designing Women* is an ex-convict. From a streetwise con man turned investigative reporter on *The Insiders,* to a comical escapee from a Texas chain gang on *Stir Crazy,* to a paroled murderer now investigating cases for a white female lawyer on *Gabriel's Fire,* entertainment TV has propagated the message that no one knows crime like blacks know crime. Such imagery also has suggested that lawlessness is generic to African-American manhood, and that criminality has its rewards since it provides a useful street education to these crooks-turned-good-guys.

Compounding the linkage of racial minorities to crime, network and local newscasts constantly focus on lawlessness among African Americans. While black-on-black crime statistics are staggering, the constant stream of distressing TV pictures—a bloody corpse on the ground and a drive-by shooting investigated, robbery or rape suspects jailed, drug pushers and addicts, vandalism in the projects—present black urban communities as virtual war zones. Add to this the rash of police actuality shows such as *Cops* and *America's Most Wanted* that entered television in the 1990s, and the impression received is one of rampant inner city outlawry created by uncontrollable black marauders.

The writer Ishmael Reed has lashed out at such imagery, reminding Americans that reality communicated through network television news is a distortion. According to Reed, while TV news associates blacks with drugs 50 percent of the time, in actuality 15 percent of the drug users in the U.S. are black and 70 percent are white. Although the majority of Americans affected by homelessness, welfare, unwed parenthood, child abuse and rape are whites, again TV journalism disproportionately associates these conditions with minorities. In damning "the chief source of information that Americans receive about the world," Reed was blunt. "The networks' reasoning seems to be that if blacks weren't here, the United States would be a paradise where people would work 24 hours a day, drink milk, go to church, and be virgins until marriage."[9]

20

Toward a New Relationship in the Age of Cable

Were such negative projections the most plentiful minority images on television, there would be little hope for improvement of African-American representation. But there have been developments in television that cautiously augur well for the future, indications that some industry executives understand that the new video order has made the old racial prejudices counterproductive. This is not to suggest that the response of television to African Americans has been quick or sufficient or equitable; the mentality that excluded and stereotyped the race for so long still dominates the industry. Nonetheless, the pattern of black representation emerging since the late 1980s suggests that U.S. television is becoming racially more responsible.

One indication of such change is noticeable in new, positive stereotypes that have appeared. Popular entertainment will never abandon stereotypes. They are shorthand theatrical devices that quickly inform an audience about a character. Stereotypes may be oversimplified and unrealistic, but they need not be negative. Only historical circumstances caused abusive characterization to be employed as a weapon of oppression. Negative racial stereotypes served the economic, social, political, moral, and cultural conditions of the people who created and accepted them. Such distortions explained reality to the ignorant and justified the repression of an entire race.

That American television and society might be shedding these disreputable old ways was evident by the success of an un-

usual characterization: the handsome and virile black hero. Rugged black champions were first manifest on TV in the late 1960s when the likes of Bill Cosby on *I Spy*, Clarence Williams III on *The Mod Squad*, and Otis Young on *The Outcasts* engaged viewers. But these types soon disappeared, and except for a few characters like Richard Roundtree's underdeveloped John Shaft and several loyal sidekicks in the 1970s, these attractive men disappeared for more than a decade.

Since the mid-1980s, however, TV has highlighted an array of black action heroes who have been as handsome, intelligent, and daring as any Caucasian champion. While they have not been as plentiful as their white counterparts, their undiminished appearance has constituted a meaningful departure from earlier projections of African-American manhood. Among these breakthrough performers have been Billy Dee Williams as the suave husband of Diahann Carroll's imperious Dominique Devereaux during the 1986-1987 season of *Dynasty*—Carl Weathers portraying a muscular special investigator in *Fortune Dane*—Blair Underwood as a perceptive young lawyer on *L.A. Law*—Howard Rollins, Jr. playing a skilled police detective and sensitive family man on *In the Heat of the Night*—Mario Van Peebles as an energetic private eye on *Sonny Spoon*—Denzel Washington cast as a serious-minded medical intern in *St. Elsewhere*—Louis Gossett, Jr. as a university professor who solves crimes in *Gideon Oliver*—and Avery Brooks as an enigmatic private detective dedicated to justice on both *Spenser: For Hire* and his own series, *A Man Called Hawk*.

For all their physical magnetism, however, none of these characters approached the human sensuality generated by Philip Michael Thomas as Ricardo Tubbs on *Miami Vice*. Bedecked in the latest European fashions, Tubbs solved crime with stylish panache. He was cool and correct under stress, slick and self-confident when in action. Tubbs was sexually primed, too, attracting and attracted to beautiful women of all races. On occasion, his passionate love scenes—especially with Pam Grier in a series encounter in 1985, and in a return visit in 1989—shattered traditional video depictions of African-American virility.

Still, dramatic shows headed by African-American heroes constitute only a small proportion of the TV dramas produced since the mid-1980s. More typically, the practice has been to cast

blacks as supporting characters within the constricted range of network program types offered to American viewers: in action-adventure shows such as *China Beach* and *Tour of Duty*; in crime series such as *Hill Street Blues, The Trials of Rosie O'Brien, Law and Order,* and *Matlock*; and in other "profession" dramas like *WIOU, Hotel,* and *St. Elsewhere.* But even this utilization is not without racial consequences. While African-American actors appeared prominently in most military series—from Yaphet Kotto as tough U.S. Army drill instructor Sgt. James "China" Bell on *For Love and Honor* and Robert Hooks as U.S. Navy Captain Jim Coleman in *Supercarrier,* to LeVar Burton as Lt. Geordi La Forge, a blind spaceship navigator in the twenty-fourth century on *Star Trek: The Next Generation*—they appear less frequently in stories centering on romance and family. While they always are cast in urban crime shows, it is usually as lawbreakers or in secondary roles such as John Amos portraying police Captain Dolan for one season of *Hunter,* Steven Williams as the tolerant police captain, Adam Fuller, guiding a quartet of young officers on *21 Jump Street,* and Richard Brooks as assistant district attorney Paul Robinette on *Law and Order.* There were even a few black singing policemen on the crime-musical series *Cop Rock.*

While fewer and less central than their male counterparts, when given the opportunity black women have produced strong and attractive characterizations in dramatic series. Impressive portrayals could be found in the steadfast wife and helpmate played by Anne-Marie Johnson on *In the Heat of the Night,* and the reliable police detective that Olivia Brown enacted on *Miami Vice.* Daphne Maxwell Reid portrayed Micki Dennis, the head of the protocol office of the U.S. State Department, who helped her professor husband to solve crimes on *Snoops.* Alfre Woodard's depiction of a dedicated, respected physician on *St. Elsewhere* also widened the boundaries of black performance, as did the quiet sensitivity in Madge Sinclair's Emmy-winning role as a restaurant owner and love interest for James Earl Jones in *Gabriel's Fire.* While Diahann Carroll's portrait of the devilishly self-centered Dominique may not have been a praiseworthy calling, in her short reign on *Dynasty* she was the equal of the other *femmes fatales* who for years enchanted audiences on the prime-time serials.

Perhaps the most authoritative role for a black actress in recent television was Holly Robinson's enactment of the savvy po-

lice investigator Judy Hoffs on the Fox series, *21 Jump Street*. As the only woman in a foursome of undercover officers fighting youth crimes, Robinson's character combined flexibility and fortitude with a womanly understanding that was especially evident when dealing with troubled teenage girls.

Such consistently mature representation of African Americans was new to prime time in the latter half of the 1980s. Interestingly, it had been a part of daytime TV since the early 1970s. Although black characters usually remained only a short while in soap opera story lines, daytime serials provided minority actors an important training ground that prepared newcomers and reintroduced established performers. Among those who passed through soaps on their way to prominence in the 1980s were Phylicia Rashad (*One Life to Live*), Jackee Harry (*Another World*), and Howard Rollins, Jr. (*Another World*). Veteran actors who played in soaps during this period were Sammy Davis, Jr. (*General Hospital*), Adolph Caesar (*The Guiding Light*), Brock Peters (*The Young and the Restless*), and Lola Falana (*Capitol*). Importantly, into the 1990s daytime serials continued to showcase aspiring black talent. Among the apprentice stars appearing in contemporary soaps were Nathan Purdee, Toyna Lee Pinkins, and Victoria Rowell on *The Young and the Restless*, Amelia Marshall and Vince Williams of *The Guiding Light*, and Stephanie Williams on *General Hospital*.

Although most African Americans in soap operas played secondary figures who filtered in and out of the lives of white central characters, they were not portrayed as racial stereotypes. Many black characters experienced the same exhilaration and anguish familiar to white characters. Be it a wedding, divorce, or adoption, be it love or hate or insincerity, daytime TV allowed black characters to feel the passions of adult life in the soaps. On *All My Children* Darnell Williams' popular character, Jesse Hubbard—a reformed street punk turned policeman and loving husband—was murdered in 1988, and his widow Angie (played by Debbi Morgan) was left a shattered woman until she became romantically involved with a white lover, a relationship soon called into question when a black businessman moved into her life. Going one step further, *General Hospital* in 1988 created the first interracial marriage in soap history when black pediatrician Simone Ravelle (played by Laura Carrington) became the bride

of white psychiatrist, Tom Hardy. Significantly, the story line was not quickly killed, and the twosome was allowed to face the exaggerated problems of marriage that must confront all serial couples.

Compared to racial minorities, however, whites still dominate soap operas, and striking examples of black characterization should not obscure the fact that the genre remained racially imbalanced. As the executive producer of *Days of Our Lives* justified it in 1989, "I don't feel the solution is to impose a 'minority' story on the viewer; by that I mean something that forces an issue." And the executive producer of *General Hospital*, Wes Kenney, explained that "most minorities on soaps are in minor roles," because of their rootlessness in stories where the core families are Caucasian. According to him, "They do some interacting with major characters, but you don't really know much about them as individuals. . . . I think we've seen great progress on television, but there is still great prejudice. It's hard to have a relationship between two characters of different races and not have race be an issue. We have a long way to go before we have something like that as the norm."[1]

A survey conducted by *Soap Opera Digest* in 1989 left little doubt that daytime serials remained biased in their utilization of racial minorities.[2] Assigning grades to the leading soaps for their depiction of African Americans and Hispanics, the magazine felt the series performed as follows:

All My Children: A	*The Young and the Restless*: C
Another World: B +	*One Life to Live*: C
General Hospital: B +	*The Guiding Light*: D
As the World Turns: B	*Loving*: D
Days of Our Lives: B	*The Bold and the Beautiful*: F
Santa Barbara: B	

Directly confronting the racial disparity in soap operas, NBC launched a new serial, *Generations*, in March 1989. This program revolved around three generations of two core Chicago families: the white Whitmore and the black Marshall clans. It was the first time African Americans were built directly into the foundation of a daytime serial. According to Sally Sussman, creator and head writer for the program, because the Marshalls were germane to

the premise of the drama, blacks in *Generations* would no longer be short-lived or secondary characters. "We're writing about the reality of life. Reality of life in Chicago includes black families." Sussman noted, "This is a soap for the 1990s. This isn't about a trend or writing appropriate stereotypes. This is about people. I think it's the next step in soaps."[3]

To actress Lynn Hamilton, the series promised new dimensions in black theatricality. "We haven't had the opportunity to do well-rounded roles, where you see generations of people so you can get the feeling of their humanity and their hopes and dreams and their negatives and positives." She continued, "Usually we just get one side of the story. That's why I think *Generations* is going to make a big difference in our social behavior. Television is a powerful medium. It's crazy, but some people actually believe what they see on that little tube. I've always felt that television has tremendous responsibility."[4]

Although *Generations* did return several prominent black actors to the TV screen—among them Joan Pringle from *Room 222* and *The White Shadow,* and Taurean Blacque from *Hill Street Blues*—it failed to generate viewer interest. First, it was poorly scheduled. As a half-hour serial in a universe of hour-long soaps, it appeared in New York City and much of the East Coast at 12:30 PM opposite the CBS blockbuster, *The Young and the Restless*—the top-rated soap on television, and the leading soap opera with black viewers. In Chicago, it was aired at 12:30 PM opposite ABC's highly-rated *All My Children,* a serial noted for its popular black characters, and CBS' *The Bold and the Beautiful* with its lily-white story line.

Moreover, *Generations* was afforded little chance to attract a loyal audience. According to Mimi Torchin, editor-in-chief of *Soap Opera Weekly* magazine, "A new show always gets off to a slow start. They're always terrible in the beginning. Until you are in these people's lives, know the background, it's hard to get involved until you care about them." Where the customary incubation period for a new serial has been two years, *Generations* was canceled in January 1991 after thirteen months. As an NBC executive justified the move, "It was the lowest-rated soap opera on the air. It had the smallest audience; it didn't deliver for advertising and it wasn't attractive to affiliates." But as Torchin explained it, "It was known as 'the black soap' in the heartland.

There's still a lot of racism and whether it was racism per se, there was resistance."[5] Significantly, BET purchased syndication rights to *Generations* and began a complete run of the serial beginning in the fall of 1991.

It is ironic that while blacks occupied only a small portion of soap opera roles, they formed an influential percentage of the audience for such programming. A Nielsen survey of the first two months of 1986 showed that African Americans watched morning/afternoon TV (14.7 hours per week) at a rate 50 percent higher than the rest of the population (9.8 hours per week). More specifically, black households (12.3 rating) watched soap operas almost twice as much as white households (6.3 rating), and blacks totalled 21.7 percent of the entire audience for such dramas. And Nielsen surveys in the years following continue to demonstrate the loyalty of black viewers to daytime TV and soaps.[6]

Blacks are not only a formidable audience for the soaps, but also on a per capita basis they watch more TV than whites. Nielsen reports in 1985 and 1986 demonstrated that on a daily basis African-American households viewed television 40 percent more than others.[7] By early 1988 black households watched TV for an average of 10.6 hours daily, while others viewed for 7.3 hours. They also tuned in to free over-the-air stations at a rate 80 percent higher than other households in the daytime, and 19 percent higher in prime time.[8]

African-American viewers also had distinct tastes that did not always match those of white viewers. Above all, they responded well to shows highlighting black characters. As illustrated by figure 20.1, black viewers definitely had their own favorite programs.[9]

Significantly, a large or small black response could strongly affect a series in terms of its rating and relative rank, figures that mean life or death for a TV program. The statistics in figure 20.2 demonstrate how the fate of some series in 1988 was reflected in their acceptance or rejection by the African-American audience.[10]

When there was only network broadcasting, comparative racial ratings may have been interesting, but they were not crucial. With only two significant rivals, a network could afford to discount the preferences of minorities—particularly when its two competitors also ignored those predilections. But in the narrow-

Figure 20.1: Viewing Discrepancies by Racial Households, January–February 1986

Program	Black Rank	Others Rank
The Cosby Show	1	1
227	4	16
The Facts of Life	6	26
Hunter	9	46
Charlie & Co.	12	75
Murder, She Wrote	25	3
60 Minutes	32	4
Dallas	52	7
Who's the Boss	54	9
Newhart	59	12

Figure 20.2: Rating/Ranking Discrepancies by Racial Households, January–February 1988

Program	Black Rating/Rank	Others Rating/Rank	Final Rating/Rank
A Different World	46.6/1	22.4/4	25.0/2
227	35.1/5	14.8/31	16.9/22
Knots Landing	24.3/9	15.4/29	16.4/25
Growing Pains	21.0/17	22.9/3	22.7/5
My Two Dads	16.4/38	16.7/20	16.7/24

cast universe, where a multitude of stations fractionalize the mass audience and dissipate network appeal, such statistics assume enhanced importance. For advertisers targeting the African-American consumer market worth more than $200 billion by the early 1990s—a socioeconomic entity wealthier and more populated than most independent nations in the world—the solidity of the minority audience was reassuring. For a production studio or network seeking a base of "guaranteed viewers" on which to build a hit show, these figures illustrated the importance of bringing attractive black talent into a program.

This was particularly the case with free television in its competition with cable. Cable may have lured viewers from over-the-air TV, but the vast majority of homes being wired belonged to whites. By the end of 1989 only 39 percent of black households

subscribed to cable compared to 59 percent of non-black households.[11] Furthermore, cable has flourished in the white suburbs and in white communities within most major cities. More than a decade after the technology became a commercial boom, however, many large inner-city communities remain unwired. And cable costs money. Often the poorest residents in large American cities, people of color have less disposable income than whites to spend on video entertainment. Thus, even when cable is made available to African-American households, many find it unaffordable.

Should such realities have failed to substantiate the economic soundness of curbing racial bias in the industry, then the popularity of several black-centered series surely proved that African Americans and millions of non-black viewers would accept minority actors on TV, perhaps more readily than advertisers and programmers. The most influential person in talk television during the past decade is an African-American woman: Oprah Winfrey. In an entertainment format that competes with Phil Donahue, Regis Philbin and Kathie Lee Gifford, Geraldo Rivera, and Joan Rivers, Winfrey has combined her affable personality and engaging openness to become the nation's premier talk-show host.

Significantly, not only did she make *The Oprah Winfrey Show* the most popular syndicated program of its type in the United States, since making her Chicago program a national phenomenon in 1986 she has built a small entertainment empire. Winfrey established in Chicago her own production studio and media corporation, Harpo, which packages her talk show as well as her other video and film ventures—such as the short-lived series *Brewster Place* in 1990—as well as projects from other media companies. And Winfrey has been heralded, winning critical acclaim from her peers, winning Emmy awards for her work in television, and receiving a nomination for an Academy Award in her first performance in a feature film, *The Color Purple*.

What Oprah Winfrey accomplished in reality-based daytime TV, Bill Cosby achieved even more impressively in prime-time situation comedy. Since it premiered on NBC in the fall of 1984, *The Cosby Show* has been monumentally successful. First, the series triggered a renaissance in television humor. Industry analysts in the early 1980s had actually written of the demise of TV humor, and particularly the family-centered sitcom. During the 1983–84

season, for example, only one such show, *Kate & Allie,* finished among the top fourteen series. But given the herd instinct that stampedes programmers to imitate a hit show, the popularity of *The Cosby Show* quickly drove producers to revive the sitcom and clone the Cosby model—in white and in black versions.

The roots of success for *The Cosby Show* were several. First, the program was well-produced and well-delivered from concept to final product. Few programs in video history have achieved such widespread acceptance so swiftly. All Cosby did was bring viewers something the networks had never offered in the past: a regular series that focused on a respectable African-American family with loving parents who respected their children, and respectful children who loved their parents.

Despite this simple premise, *The Cosby Show* was revolutionary for U.S. television. At once it was as familiar as *Father Knows Best* and as inventive as the first series in TV history to highlight a black nuclear family in a positive light. No divorced or single parents here, no bickering or rude children. No demeaning racial stereotypes, either, for the story of the Huxtable family centered about a pediatrician father, a lawyer mother, and several upstanding upper–middle-class children. Further, via well-written scripts, sensitive direction, and attractive performances, the show delivered subtle messages that were universally understood: an appreciation of human dignity, the nurturing of respectful and loving relationships, support for social accomplishment, the rewards of education, and the central importance of constructive family ties.

Undoubtedly, *The Cosby Show* was good television, but just as surely, it was propitious. At a time when conservative family values were a prominent part of the political ideology espoused by President Ronald Reagan and his supporters, the Cosby formula hit a responsive chord. The series inspired a nation seeking role models in responsible family life—black or white, rich or poor. As figure 20.3 illustrates, the program was rapidly and thoroughly embraced by American viewers.

The Cosby Show was also easy for white viewers to accept. As a celebration of African-American achievement and assimilation, it never threatened its audience. Much as the two *Roots* miniseries painted a racism so horrendous that contemporary whites could discount their own prejudices, *The Cosby Show* of-

Figure 20.3: Ratings of *The Cosby Show*

Season Ending	Rank
1985	3
1986	1
1987	1
1988	1
1989	1
1990	2
1991	5

fered a black family so successful that whites could feel confident, despite the wailing of some minority leaders, that the American system was working well for minorities. As black social critic Shelby Steele has mockingly pointed out, "the success of this handsome, affluent black family points to the fairmindedness of whites who, out of their essential goodness, changed society so that black families like the Huxtables could succeed." Indeed, as Steele has written, "Cosby, like a priest, absolves his white viewers, forgives and forgets the sins of the past. . . . He tells his white viewers each week that they are okay, and that this black man is not going to challenge them."[12]

Whatever its social implications, *The Cosby Show* remains a black program, one that is highly popular with black viewers; and Bill Cosby's professional triumph has affected the complexion of broadcast television since the late 1980s. Since Cosby's success, most of the leading programs on network TV, and the majority of new shows each season, have been situation comedies. The trend peaked by the end of the decade when ten of the top fourteen shows for the 1988–89 season were sitcoms, and fifty of the ninety-three entertainment series scheduled on network video in 1990 were comedies—most of them sitcoms, and many set in nuclear families.

While *The Cosby Show* influenced the general tenor of national television, its impact upon NBC was phenomenal. In the early 1980s the network was in serious trouble because it had no hit shows. In fact, NBC had offered only a few popular series since the mid-1970s. Statistics from the top twenty-five network programs in the eight seasons between 1975 and 1983 reveal that only

271

twenty-three of those two hundred shows—a total of 11.5
percent—were NBC programs.[13] This dismal record led television
historian Laurence Bergreen to conclude in 1980 that "NBC gives
signs of becoming the first network to become obsolete."[14]

Sparked by *The Cosby Show*, however, the network experi-
enced renewed acceptance. The series brought in money, pres-
tige, and viewers. With Bill Cosby at the lead, Thursday nights
on NBC became the most formidable evening schedule in the
industry. As the following chart indicates, audiences gathered to
watch the Huxtable family and did not change their dials. Pro-
grams that had struggled for ratings for two years—*Family Ties*
and *Cheers*—achieved overwhelming acceptance once *The
Cosby Show* was scheduled ahead of them in the 1984–85 season.
In the case of *A Different World*, this NBC sitcom from the pro-
ducers of *The Cosby Show* never lacked a large viewership be-
cause since premiering in the 1987–88 season it followed the
Huxtables on Thursday evening. Figure 20.4 demonstrates the
importance of *The Cosby Show* to the success of those NBC se-
ries following it.

Figure 20.4: NBC Programs Following *The Cosby Show*

Season Ending	Show	Rank
1983	*Family Ties*	56
	Cheers	73
1984	*Family Ties*	43
	Cheers	34
1985	*Family Ties*	5
	Cheers	12
1986	*Family Ties*	2
	Cheers	5
1987	*Family Ties*	2
	Cheers	3
1988	*A Different World*	2
	Cheers	3
1989	*A Different World*	3
	Cheers	4
1990	*A Different World*	4
	Cheers	3
1991	*A Different World*	4
	Cheers	1

Not only did *The Cosby Show* propel other NBC Thursday-night series to the top of the ratings, it also validated the financial soundness of the African-American presence on television. Since the mid-1980s the networks have been seeking more black-centered comedy hits. With shows such as *The Robert Guillaume Show, Charlie & Co., 227, Amen!, Frank's Place, Family Matters, Fresh Prince of Bel Air*—even *True Colors* with its interracial family and *The Days and Nights of Molly Dodd* (in which, shortly before its cancellation from the Lifetime cable outlet in 1991, Molly became the first white, unmarried TV character to give birth to a baby fathered by a black man)—the results have ranged from success to failure. It is interesting, however, that the swing to blacks in comedies has not been total. In the main, white-centered sitcoms are still void of meaningful minority presence.

TV has reluctantly embraced black-centered domestic comedies, and its record with African Americans in dramatic series is marked by strong characterization but sparse utilization. In made-for-television films, where the casting pattern has remained restrictive, even less has changed. The color line inherited from earlier decades is still operative, thereby blocking black actors from starring in the abundance of run-of-the-mill stories about romance, medical problems, foreign intrigue, courtroom matters, criminal victimization, and the like. Blacks may be plentiful as local color types, even loyal buddies to white central characters, but when they appear as the principal stars of movies made for network or cable release, it is almost always in roles that must be played by minority actors. Familiar here are biographies of celebrated African Americans (*The Josephine Baker Story*), docudramas based on famous or infamous events (*The Atlanta Child Murders*), or dramatizations of great moments in civil rights history (*Separate But Equal*, the Emmy-winning docudrama about attorney Thurgood Marshall and the NAACP's successful court challenge to legalized segregation in the early 1950s). As one African-American critic wrote in 1991, "I wish there were a television schedule that reflected the world I live in, with black people doing all kinds of things every day of the year.[15]

Actor Joe Morton also faulted contemporary television for its failure to portray the everyday lives of African Americans. Appearing in February 1991 on *Story of a People: The Black Road to Hollywood*, a syndicated report on the black condition in the en-

tertainment industry, the co-star of the NBC lawyer series *Equal Justice* chided filmmakers for confining blacks to familiar roles. "We're still talking about equality. We're still talking about slavery. We're still talking about the Civil War. We're still talking about the '60s," Morton complained. "There are hundreds and hundreds of stories that need to be told about black people—and about their history, about who they are, and about what we've done, and about what we want to do, about what our families are like, what our everyday lives are like—that have nothing to do at all about striving toward equality."

While this narrowness has excluded African-American actors from many fulfilling roles, employment statistics suggest that priorities in U.S. commercial culture are improving for minority performers. According to data released by the Screen Actors Guild (SAG), between 1983 and 1989 there was more than a 100 percent increase in the casting of black performers in the movie and prime-time TV projects of the major production studios. While African Americans accounted for less than 5 percent of all speaking roles in 1983, they appeared in 10 percent of such parts in 1989. When added to figures for other minorities, SAG reported that 14 percent of all speaking parts went to non-whites. Nonetheless, as a Guild official pointed out, "People of color are still looking for improvement because the current ethnic population [of the United States] is about 27 percent. So we are still not seeing the full diversity of the American scene."[16]

Improvements in minority representation on TV have not been confined to comedy and drama series. Blacks also made significant strides in actuality programming. The appearance in 1990 of *Jesse Jackson*, a syndicated talk show hosted by the peripatetic national leader, the Reverend Jesse Jackson, offered not only a major national forum for political argumentation, but its persistent concern with issues confronting blacks gave the program a moral focus uncommon for American television.

In a totally different area, a number of black weather forecasters, led by Steve Baskerville, who left KYW in Philadelphia and joined the *CBS Morning News* in January 1984, rose quickly from local to network prominence. By 1990 three men—Spencer Christian on ABC's *Good Morning, America*, Mark McEwen on *CBS News This Morning*, and Al Roker on NBC's *Today* and *Sunday* programs—had become the nation's premier weathercasters.[17]

While the premature death of Max Robinson ended the career of the first black anchorman in network news, by the 1990s Bernard Shaw emerged as the principal anchor on the Cable News Network. And since his CNN newscasts are seen in almost one hundred foreign countries, Shaw has become the most widely-viewed broadcast journalist in the world. By reporting live from the scene of great human crises—be it Tiananmen Square, where in 1989 the government of the People's Republic of China brutally suppressed demonstrations for democracy, or Baghdad, where during the Persian Gulf war in 1991 the U.S. and its allies employed high-tech missiles and aircraft to bombard the Iraqi capital—Shaw has helped to redefine electronic journalism in terms of its immediacy and impact.

Still another dimension of contemporary home entertainment affected by black performance has been TV sports. Here blacks have achieved strategic importance. In boxing, track and field, and summer Olympics competition, as well as in the dominant college and professional sports, basketball, baseball, and football, African-American athletes have excelled in numbers well beyond their percentage of the national population. Black competitors have even entered professional wrestling, long a segregated TV attraction.

In recent years, moreover, several standout black players have been able to exploit their sports achievements in peripheral areas. Typically, Magic Johnson and Dominique Wilkins, celebrated for their achievements on the basketball court, translated that prestige into TV advertising where they became prominent commercial spokesmen for athletic footwear. Bo Jackson's unique success at two professional sports, football and baseball, made him not only a potent salesman for Nike footware, Cheerios cereal, Pepsi-Cola, and AT&T, but also the symbol of mastery in all sports. And Michael Jordan's singular athleticism has led this basketball star into commercial endorsements for products as diverse as Nike, Coca-Cola, Chevrolet, Wheaties cereal, the Illinois Lottery, Gatorade, and McDonald's restaurants.[18]

On the other side of sports competition, many blacks who had retired from professional athletics have returned as TV sports commentators. Among these personalities are James Brown, Bill Russell, Ahmad Rashad, O.J. Simpson, Quinn Buckner, Lynn Swann, and Dan Jiggets. Add to this the numerous

275

African-American sportscasters on local stations, plus those on national sports scoreboard and talk shows, and it becomes clear that television has begun to recognize the importance of African Americans in and out of athletic competition.

Still, the real power in television rests not with on-air talent, but with the executive leadership behind the scenes. Here is where directors, producers, and corporate vice presidents establish policy, initiate projects, employ talent, spend money, and create cultural products and trends. Here, too, is precisely where African Americans and their interests remain inadequately represented. While there are experienced black directors such as Michael Schultz, Bill Duke, Georg Stanford Brown, Kevin Hooks, and Thomas Carter, blacks directed only 4 percent of all television shows made in 1988, and less than 1 percent of all motion pictures.

The black presence among entertainment executives is even more dismal. In network TV corporate offices, African Americans remain a rarity. Of the forty entertainment vice presidents at ABC and NBC in the spring of 1989, only two were black; at CBS none was black. Similarly, at the eight major Hollywood studios there were no African-American officials with the power to put a movie into production. Interviewed on CNN at the time, Michael Schultz noted that in the course of his fifteen years as a motion picture director, "never once did I sit across the table from a black executive and trade ideas and develop a project and have that kind of relationship." And this powerlessness has dangerous implications, he suggested, because "People really believe that what they see on the screen is real. Since we don't control the ability to put those images out there, we can't change what's on the screen."[19]

A year later David Kissinger reported in *Variety* that matters were still dismal. There were no black entertainment presidents at the four networks, including Fox. And only six programming directors and two vice presidents out of the 120 such executives were black. At Fox, where she was the only African-American official, Karen Barnes was vice president for children's TV. The other executives were three women at NBC (Winifred White, Charisse McGee, and Phyllis Tucker Vinson, who was vice president for children's and family programming); two women at CBS (Kelly Goode and Adoley Odunton); and at ABC two women and

the only black male executive (Kim Fleary, Mary Ann Henderson, and Richard Hull). These were statistics that Stanley Robertson—the first black programming executive at NBC a quarter-century earlier—described now as "more than frustrating. They are truly embarrassing." He added, "The unspoken attitude is still that blacks are great for singing and dancing, but not for giving orders." But, Robertson cautioned, "You can't blame the networks without blaming society as a whole."[20]

Certainly, there were notable exceptions behind the cameras. In 1990, for example, Jonathan Rodgers—who then headed the CBS station in Chicago, WBBM—was promoted to the presidency of the CBS Television Stations division. In the process he became the highest-ranking African American in the history of a broadcasting corporation that had been employing executives since 1927.

That power placements for blacks remain rare in white television is due in great part to the chronic unwillingness of the broadcast industry to regularly hire and develop minority officers. As journalist Ted Koppel described the situation on *ABC News Nightline* on April 6, 1987, "Whites have been running the establishment of broadcasting . . . for too long and seem to be reluctant to give up power." At a time when the changing economic and technological realities of TV are compelling increased minority participation on the screen, there are still no material reasons to anticipate an increase in black occupancy rates in television executive offices. There may be dark new wine to behold on the screen, but it is being offered up in the same white old bottles.

Perhaps as a portent of improved opportunities for minorities behind the camera, *Variety* reported that by the spring of 1991 a record number of theatrical films involving black creators was in production. This included thirteen movies directed by African Americans scheduled for release in 1991, and twenty other motion pictures starring black actors slated to be released that year, "the most since the explosion of the early seventies, when hundreds of so-called blaxploitation features were made." Cautiously, Melvin Van Peebles suggested that matters finally might be improving. "We have the beginnings of a technical infrastructure today," he said, "but still there are no blacks in Hollywood in a position to green-light a picture and no black-owned theater circuits."[21]

21

The Cultural Debate

The increasing visibility of African Americans in television has produced a mixed blessing. On the one hand, it has created well-received entertainment and has proven the marketability of black productions. Increased use of black performers has also enhanced the careers of a growing number of black actors and actresses. Many new minority talents have emerged, among them Malcolm-Jamal Warner and Lisa Bonet on *The Cosby Show*, Jaleel White of *Family Matters*, "Downtown" Julie Brown of *Club MTV*, Fab 5 Freddy on *Yo! MTV Raps*, Sinbad and Jasmine Guy on *A Different World*, and Robin Givens of *Head of the Class*. Meanwhile, show business veterans such as octogenarian Jester Hairston, who plays Rolly Forbes on *Amen!*, and Helen Martin, who appears as Pearl Shay on *227*, have achieved great popularity after years of relative obscurity. For a nation in which more than 20 percent of the population is non-white, the rise in black presence on TV suggests that the industry may be catching up with social reality.

But increased visibility has produced a downside as controversy has arisen over the appropriateness of some of the characterizations offered to the mass audience. It is a dispute that strikes at the root of depicting African Americans in a society chronically abusive toward its citizens of color. It involves matters of social class, racial imagery, integration, and black cultural integrity.

Most video blacks are culturally and socially assimilated and at least middle-class. As it does with Poles, Irish, Italians, Jews,

and other white nationalities, the medium generally avoids the authentic qualities that make African Americans distinct. While Bill Cosby's Dr. Cliff Huxtable may be an extreme example of such acculturation, from soap operas to sitcoms blacks on TV usually exhibit the bourgeois values, habits, and attitudes that are so familiar in white characterization. This has especially been the situation in broadcast television where the principal target of programmers has been the middle-class white viewer. To attract this person, the networks historically offered positive African Americans who approximated the mores of bourgeois Caucasians, and negative blacks who personified the derisive stereotypes familiar to most white viewers.

Television has been inhospitable to blacks who were not middle class and/or pejoratively stereotyped. Less visible, for instance, have been representations of the authentic African-American lower class and urban underclass. Seldom has television been able or willing to portray disadvantaged or working-class blacks in their own cultural terms. As sociologist Herman Gray indicated, these people have traditionally been relegated to the crime and mayhem stories reported on TV newscasts. And since such reportage rarely explains lower-class failures in terms of root causes, the emerging picture is one of lawlessness brought about by poor citizens all by themselves.[1] In real life, however, a large number of black men and women labor in blue-collar jobs. Others are poorly educated and ill-prepared to function constructively in a world growing increasingly technical and specialized. And many are economically impoverished, trapped in inner-city slums that are spiritually degrading and dangerous. There are millions of African Americans who do not experience life as portrayed on *The Cosby Show* or even 227. But there are millions who continue to cling, however tenuously, to the belief that life someday will improve for them or for their children. Television has had little interest in any of these people.

While TV avoids sympathetic characters drawn from the black lower classes, African-American culture—especially that which is urban and economically deprived—remains an inventive resource for all commercial entertainment. Poor blacks inspired the music of ragtime, jazz, blues, swing, rhythm and blues, and rock and roll. Dance, dress, language, sports, comedy, drama, and other forms of human expression have been influenced by

279

the black declassé as well. Contemporary popular culture in the United States is greatly indebted to the African-American poor.

The need for programming ideas in the 1990s, however, has led the video industry to the black lower classes. And from ghetto slang and the hip-hop rhythm of rap music to the varieties of basketball slam dunks, disadvantaged urban blacks have responded, infusing American pop culture with renewed vitality and seductive style. However, the move has often been accomplished in television with questionable taste and excess, thereby sparking debate over what should or should not be characterized in the mass media.

It is a debate with a history. Just as the salty lyrics and bawdy dance gestures of rhythm and blues prompted many in the early 1950s to condemn the "leer-ics" and passion of this black adult music, so today does rap music generate hostile commentary. Just as reliance upon minstrel-show stereotypes provoked the condemnation of television and radio, and cinema before that, so today do many black comedians exasperate those who are sensitive to racial misinterpretation and abuse. More than a century after the Emancipation Proclamation, and decades since the U.S. Supreme Court ruled in favor of integrated public schooling, a poll of white Americans in 1990 confirmed that the majority population overwhelmingly understood blacks in unflattering terms. According to the National Opinion Research Center, 77 percent of whites still held negative stereotypes (laziness, preference for welfare, prone to crime, etc.) about African Americans.[2]

As television continues to produce racial controversy, a different aspect of the black-white cultural question is being argued. In the 1950s the moral problem posed to white TV was primarily quantitative: "When will there be more blacks on the screen?" In the 1970s social developments transformed the question to a qualitative one: "When will the medium abandon demeaning characterizations and present blacks more honorably?" While these early inquiries still have not been fully answered, the prepossessing challenge of the 1990s is directed primarily toward artistic and political integrity: "Must African Americans always be presented with a veneer of middle-class assimilation, or can television portray the fullness of black social diversity, its strong points and weak points, without fueling white bigotry or undermining black accomplishment?"

This latest problem is made all the more perplexing because it involves black creativity in the popular arts. As Henry Louis Gates, Jr. pointed out in early 1991, the debate about the nature of black art and its political implications "can be identified as the dominant concern of black artists and their critics for the last seventy years."[3] Even African-American creators have been troubled over how to display the black lower classes without feeding the prejudices of the dominant white population. While there is little doubt that the distorted caricatures of the minstrel show validated white bias and eroded minority self-esteem, can contemporary artists depict themes such as the unsophistication of rural blacks or the crude street culture of urban youth without encouraging the ignorant to characterize all African Americans as unsophisticated and crude?

Conversely, must all positive black characters be clones of Dr. Cliff Huxtable, or can television respectfully create and audiences maturely accept a wide range of black personalities? Can satire, that subtlest of comedy forms, be widely understood as contemptuous parody instead of self-defeating confirmation for white bigots? Can drama portray distressing black realities without inviting racial insult?

White Americans are not unfamiliar with the syndrome themselves. While the skin color of Caucasians is no impediment to humorous dramatic characterization, controversy always erupts when representation touches insensitively on differences in religion, ethnicity, or life-style. Even if some Italian or Latino Americans speak English with thick accents, their depiction as inept in English generates argument. Ethnic slurs and religious jokes, while a vigorous part of American vulgarity, are seldom used in commercial popular culture. Less than honorable portrayals of homosexuals are intolerable to most citizens. And given the destructive history of anti-Semitism in the Christian world, most Americans are enraged by negative images of Jews in the mass media.

The problem confronting African Americans, however, is more complex. Given the historic intolerance of the dominant culture in the United States, it seems myopic and even dangerous for blacks to tolerate portrayals of themselves that are not complimentary. For all their achievements and honors, black Americans are still struggling for social empowerment, still seek-

ing to integrate the entrenched and obstinate white power structure. Thus, depictions that might connote generic inequality—be it physical, intellectual, social, political, or otherwise—have dire implications that affect individuals as well as the entire race.

Adding to the dilemma, black characters are almost always recognizable as minority figures. Where the racial, religious, or ethnic origins of a white actor or his part are not necessarily announced, that same is not true for African Americans. In a nation where assimilation means sameness, the "differentness" of black Americans is immediately apparent. Whereas Caucasian stars can portray uncouth or stupid or cunning characters without being ethnically or religiously specific, a black actor in such roles inescapably brings race to the part. Condemned always to be black in a society where bigotry endures, the African-American entertainer is forever vulnerable to interpretations that may be self-abusive. He or she can never be certain that the predominantly white audience is laughing at the performance instead of at the performer; never certain, too, that the majority population understands negative black roles as dramatic pretense rather than racial authenticity.

As television accomodates increased minority participation, the classic dilemma of the black artist is being debated in the 1990s. Were it simply a matter of balanced representation—adverse stereotypes being acceptable because there is now a sufficient number of affirmative black portrayals on TV—the quandry might be more easily resolved. But it involves much more than a certain symmetry between detrimental and favorable portrayal. The problem goes to the essence of black existence in the United States. It concerns the status of minorities of color in a democratic civilization that historically has moved toward actual racial equality only through controversial laws and the force of arms. If television continues to present African Americans without reference to lower-class and underclass realities, it runs the risk in the age of narrowcasting of excluding a creative and economically significant segment of minority society. Yet, if the debilitating nature of poverty is distorted or glorified or overexposed for the sake of ratings, as TV is capable of doing, it risks compromising the modest achievements toward practical racial equality the nation has realized.

This is not to say that TV cannot display the complexity of

black America without resorting to controversial representation. This has been accomplished, although more successfully in non-fiction programming than in fiction-based entertainment. In particular, several documentaries are noteworthy for their treatment of minority realities. As it has done since the 1960s, public television has offered disturbing inquiries into the African-American experience. "The Bloods of 'Nam" which appeared in May 1986, was a *Frontline* documentary concerning black soldiers during and after the Vietnam War. Based on a book by Wallace Terry, the program sensitively related the destructive experiences of several black servicemen during and after the conflict. It also contrasted the nation's need for these young black men when it was waging war in Southeast Asia to its contemporary disinterest in their economic and psychological needs once they returned to civilian life.

In the two parts of *Eyes on the Prize*—the first six episodes aired in 1988 and covered the years 1954 to 1965, the last eight installments appeared in 1990 and treated the period 1965 to 1985—producer Henry Hampton used archival film footage and contemporary interviews to reconstruct the history of the civil rights movement. In the process he created the fullest and frankest visual record of American racial history, a production that won Emmy and Peabody awards and continues to be marketed to educational institutions, where it influences a new generation's understanding of the African-American struggle.

Less comprehensive, but nonetheless informative and inspirational, Don Bogle in early 1986 wrote and produced *Brown Sugar*, a four-part PBS documentary celebrating the cultural contributions of legendary black female entertainers. In this project, Josephine Baker, Dorothy Dandridge, Carmen McRae, Lena Horne, and many other African-American women became models of the enrichment of all civilization that is attainable when human potential is unfettered and talent is nurtured.

On occasion, too, network television has sought honestly to expose the debilitating social conditions facing large numbers of powerless black Americans. In his *CBS Reports* investigation of ghetto realities, "The Vanishing Family—Crisis in Black America," first broadcast on January 26, 1986, Bill Moyers looked candidly at the human toll exacted from African Americans having to survive in a world of poverty, ignorance, and crime. Here were

poor black women raising families in the bleak ghetto of Washington, D.C. And just as they were enveloped by the depressing, destructive realities that result from chronic deprivation, so, too, was the beauty of this capital city of a nation of immense wealth surrounded by dehumanizing, abject poverty.

Five years later Moyers offered yet another striking treatise on the exploitation of the race. This time the focus was on the way college sports used young minority athletes to fill their sports teams. In the PBS documentary "Sports for Sale," telecast March 18, 1991, Moyers showed how college athletes were "shot through with greed, fraud, and flagrant violations of the rules." Here were black stars talented in basketball, football, and other intercollegiate sports, but they were often academically unprepared to compete for grades on the college level. Lured from the ghettos of America with promises of academic betterment and a chance at careers in pro sports, they were used by colleges only to create good teams that could attract lucrative television contracts, thereby bringing millions of dollars to the alma mater. As for education, the vast majority would never graduate. And when their athletic eligibility was completed after four years or because of injury, they lost their scholarships and were otherwise dumped by their colleges.

It may not sound bold, but in 1989 when ABC permitted its black journalists to investigate, write, produce, and report on the African-American condition, it was the first time in twenty-eight years—since the same network produced and telecast "Walk in My Shoes"—that a similar project had been undertaken by national TV. And in this *ABC News Special,* "Black in White America," which was aired August 29, executive producer Ray Nunn found that whatever their social status or personal achievements, whatever joy and purpose they had found in their lives, black Americans still faced special difficulties in their struggle to succeed in a society where prejudice against blacks continued to affect the ground rules for social, economic, political, and intellectual improvement. As correspondent George Strait commented at the end of the broadcast:

> There's a notion that white folks have done enough for black folks, but black people still remain the poorest and most segregated people in this land. So, America, don't kid yourself.

When it comes to black people, there's still a lot of unfinished business—business that won't be completed until America begins to live up to the promise that it made to itself more than two-hundred years ago: that every individual is free to succeed or fail based on who they are and not what they are.

Even more distressing, Charles Thomas, who with Strait and Carole Simpson co-hosted the program, offered a perspective seldom communicated in U.S. broadcasting. Appearing on *ABC News Nightline* following "Black in White America," Thomas explained how the mortal fear he encountered among the underclass residents of Washington, D.C., was common to all blacks in the United States, regardless of their station in life. As he pointed out, this was not a dread of ghetto crime, but a subtle terror bred by years of physical mistreatment by white police authority.

It doesn't just happen to blacks who live in housing projects. It happens to me when I get in my car and I drive to the grocery store. I realize that if I'm stopped by a white police officer who happens to be a racist, who's having a bad day, I might not see the sunset that night. But in their case, they're dying every day. When they wake up in the morning, they might not see the sunset that day, and they realize that. But it's something that we live with every day, and we've lived with this for as long as we've been on this earth. You're taught this very young when you're black in America. This is part of the feeling. . . . It's real in black America.

While in actuality television reports honestly on the black lower classes only infrequently, fiction television practically never offers respectful portrayals of the black disadvantaged. Situation comedy seldom makes the effects of racism the center of its humor; detective dramas may spotlight African-American policemen and private eyes, but they are falsely emblematic of minority respect for the criminal justice system; and although made-for-TV movies may show black heroes triumphing over adversity, they send the message that the system works and that racial oppression can be overcome through the strength of individual personality.

Yet, there have been significant exceptions to this pattern of denial. The telefilm *Heat Wave*, a riveting docudrama on TNT in

1990, explained the Watts riot of 1964 by dramatizing its impact on a group of sympathetic black characters. Here were southern black teenagers, recently migrated to Los Angeles, who found their lives threatened by white punks from "across the tracks." Here were citizens chronically abused by the police, and qualified men unable to get meaningful work because of their race. And here were bad blacks, young men only too willing to resort to violence and looting to vent their frustrations.

In a different vein, Oprah Winfrey's made-for-TV production of *The Women of Brewster Place* conscientiously probed the personal relationships and dreams of inner-city women. During its short run on ABC in 1990, viewers were able to visit with working-class blacks who cared for their children, but often anguished over their fate; African-American business owners who labored long hours to survive; people who were not middle class, but who were otherwise respectable people with goals, ideals, and ethical standards that shaped their existence.

Although it did not deal with the black lower class in the United States, singularly striking in its invention and authenticity was the British miniseries *Shaka Zulu* which was syndicated in the U.S. in the late 1980s. Its theme was the establishment of the Zulu nation in southern Africa; its perspective was black African. Through its fierce theatricality and awesome depiction of social customs, political life, and military battles in Africa in the early nineteenth century, the miniseries provided stunning insights into black ancestral history.

As well as through special productions, entertainment series on occasion treated the black condition with respect and sensitivity. As a sequel to her telefilm, *The Women of Brewster Place*, Oprah Winfrey's dramatic series *Brewster Place* concerned the residents of a poor, black Chicago neighborhood. Although quickly canceled, it offered a sympathetic portrait of working-class African-American existence. Despite its middle-class appearance, *A Different World* has used its comedic innocence to spotlight issues critical to black America. Especially after direction of the show was assumed by Debbie Allen beginning with its second season, this sitcom set in a black college environment became a vehicle for exploring social problems as disparate as date rape and the high percentage of blacks in the U.S. military.

On the surface *Frank's Place* was a CBS dramatic sitcom

concerning a Boston professor, played by Tim Reid, who now owned and operated a neighborhood Creole restaurant in New Orleans. During its acclaimed network run in 1987–88, the series drew much of its inspiration from local black folklore and customs. Like oral historians, Reid and Hugh Wilson, the white producer of the program, accumulated background items for the show by visiting churches, funeral homes, and other gathering places in the area, and by tape-recording interviews with black citizens of New Orleans. According to Wilson, the insights gleaned from these encounters helped to create characterizations, set designs, and story lines for the series.[4]

With programs such as *Frank's Place* or *Brewster Place*, little negative criticism was heard—except as angry commentary about their low ratings and quick cancellation by the networks. But when TV approached African-American culture less understandingly, protest often became substantial. This was not the result of occasional racial indelicacies, or the exclusion of blacks from the medium. This controversy arose from the growing confidence of many white producers and black performers that America was ready for a broader portrait of the African American. After decades of dwindling national interest in civil rights issues, and an increasing permissiveness in U.S. popular culture, the time seemed right to reintroduce race humor. Similarly, it seemed possible to supplement the bourgeois image of African Americans with a lower-class cultural style that was crude, occasionally profane, markedly less respectable, but amazingly marketable.

This was not always the honest TV fare that disadvantaged minorities are capable of creating or inspiring. Perhaps the most authentic manifestations of inner-city culture has appeared in the amateur productions offered on access cable stations in many U.S. cities. Here gospel songfests and religious sermons, music and dance showcases, educational lectures, talk shows, and political forums constructively project African-American life as never seen on over-the-air television. While these productions attract minuscule ratings and are confined to specific cable systems that may not even cover an entire city, they remain informative and among the most unpretentious cultural expressions offered by the medium.

When commercial television turned to the inner city for in-

spiration, however, controversy arose as racial caricatures were resurrected and the boundaries of what is racially allowable on TV were broadened. While most viewers understood the sitcom *227* as a positive series blending humor with a flattering portrait of working-class life—with especially strong family values communicated by Marla Gibbs and Hal Williams, plus a production corps that included more African-American writers than any other network show—by accentuating the man-crazy, vampish Sondra Clark played by Jackee Harry (later, just Jackee), the series revived the controversial stereotype of oversexed black women last realized by Flip Wilson's Geraldine. Although *Amen!* is a comedy series about a minister, his wife, father-in-law, and friends at the First Community Church of Philadelphia, to some this successful program—especially with Sherman Hemsley's portrayal of Deacon Ernest Frye as a slightly-restrained version of George Jefferson—belittled black religion, turning church workers into buffoons and the church into a laughingstock.

Clearly, the rising star of late-night variety programming in the 1990s has been comedian Arsenio Hall. With the young comedian as host, The *Arsenio Hall Show* offers a nightly party, pulsating with urban rhythms and a relentless vitality. In the process Hall has weakened the appeal of his vaunted ratings competitors such as Pat Sajak, Johnny Carson, Jay Leno, Rick Dees, and Ted Koppel. While Hall has accomplished this, he has helped to widen the perimeters of black expression on broadcast television. With frequent references to African-American culture—from allusions to the colorful inventiveness of black surnames and playing "the dozens" with guests like Will Smith and comedian George Wallace, to frequent references to the ghetto as his own creative wellspring—Hall has brought a strong racial identity to late-night TV. But in the process, he has helped to legitimize inner-city experiences, offering the ghetto as a positive environment from which warm memories and inspiration flow. For those who believe the best thing about a ghetto is escaping it, this aspect of The *Arsenio Hall Show* seems self-defeating. Still, blacks constitute a large percentage of the audience for late-night programming, and they and millions of white viewers have embraced the dynamism of the program. Ironically, a stronger criticism of Hall's show has been the charge that the comedian does not employ enough African-American writers.

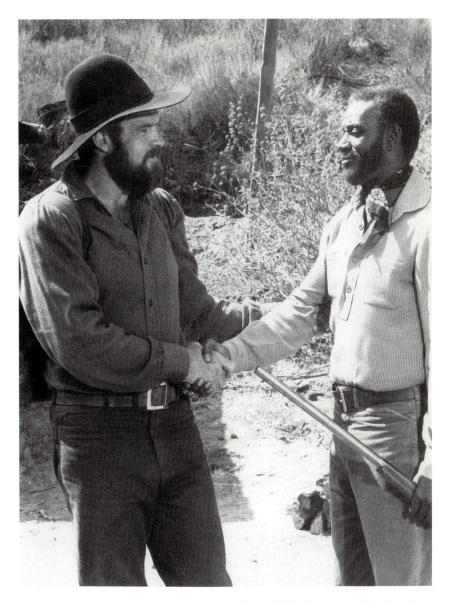

One of the last Western heroes on TV was Moses Gunn (right) who portrayed the friend and partner of Merlin Olsen on *Father Murphy* in the early 1980s. (*Courtesy of NBC*)

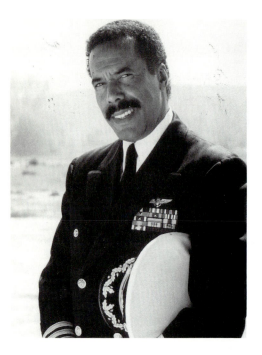

Robert Hooks appeared as a U.S. Navy air group commander in the short-lived series, *Supercarrier*. (*Courtesy of Robert Hooks*)

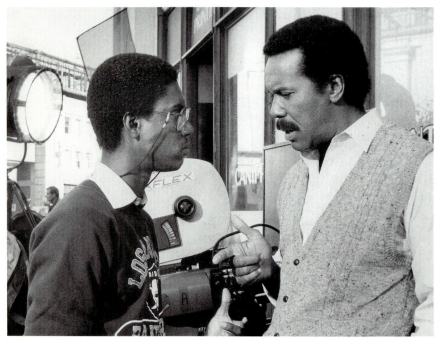

Two generations of television talent confer as Robert Hooks (right) is directed by his director-actor son, Kevin Hooks, during the filming of the science fiction series V. (*Courtesy of Robert Hooks*)

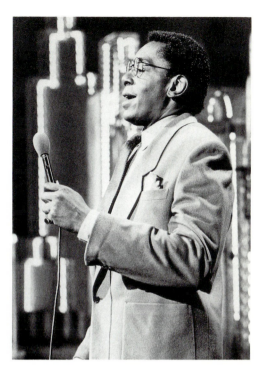

The longest-running African-American musical program in TV history is *Soul Train,* hosted by Don Cornelius since it began on local Chicago TV in 1970 and was nationally syndicated the following year. (*Courtesy of* Soul Train)

As head of the cable network, Black Entertainment Television, Robert Johnson has linked African-American programming and audience concerns to the expansion of choice afforded by cable TV. (*Courtesy of Black Entertainment Television*)

In the 1980s Bernard Shaw became the premier news anchor on the Cable News Network. With CNN newscasts received in almost one hundred different countries, Shaw clearly is the first global news anchor. (*Courtesy of CNN*)

From his Blackside Productions, producer Henry Hampton fashioned a compelling documentary portrait of the civil rights movement, *Eyes on the Prize.* In two separate series—the first six episodes in 1988 covering the years 1954 to 1965, the last eight installments in 1990 treating the period 1965 to 1985—Hampton reminded the nation of its successes and failures in the struggle against racism. (*Photo by Eric Roth/Courtesy of Blackside, Inc. Film and Television Productions*)

The first African-American weatherman in national television was Steve Baskerville when he came to the *CBS Morning News* in 1984. (*Courtesy of* WBBM-TV)

As talk-show host, actress, and producer, Oprah Winfrey has emerged as the most influential woman in U.S. television. Into the 1990s her syndicated daily program, *The Oprah Winfrey Show,* remains the most popular talk-show in TV, while her production company, Harpo Productions, continues to develop video specials and series. (*Courtesy of Harpo Productions*)

Proof of what may happen when African Americans are able to operate behind the cameras was the *ABC News Special*, "Black in White America," aired in 1989. In it, executive producer Ray Nunn offered a frank and troubling portrait of black realities at all levels of economic accomplishment. Nunn works now as director of new project development for Oprah Winfrey's media empire, Harpo Productions. (*Courtesy of Harpo Productions*)

Bryant Gumbel moved from sports reporting to principal anchor duties on NBC's *Today*, a role he has successfully occupied since 1982. (*Courtesy of NBC*)

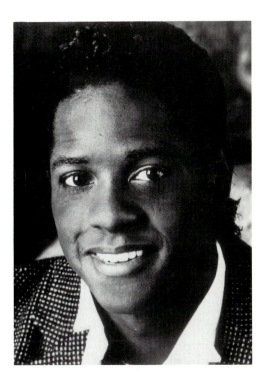

As lawyer Jonathan Rollins on *L.A. Law* since 1987, Blair Underwood has become a major player in this influential NBC series. (*Copyright Buena Vista Television*)

As the perky and obtuse southern belle, Whitley Gilbert, actress Jasmine Guy has become the central female character on the highly-successful situation comedy, *A Different World*. (*Copyright Buena Vista Television*)

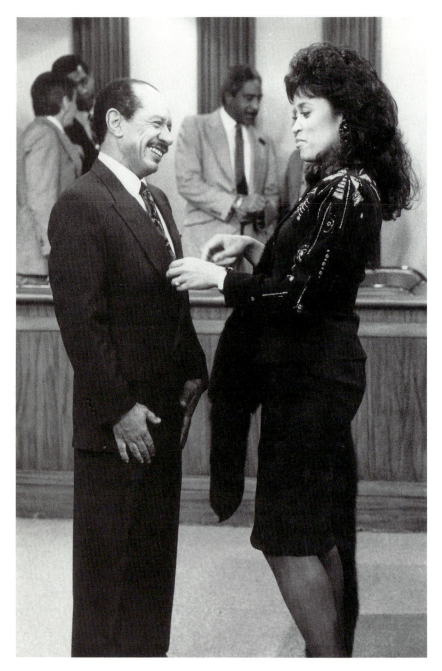

Portraying an attorney and scheming church deacon, Sherman Hemsley has helped to make *Amen!* a popular, long-running series. Here he appears with guest star Jackee in an episode in 1988. (*Courtesy of NBC*)

The most debated black comedy program, however, has been the satirical *In Living Color*, created by producer-writer-director-star Keenen Ivory Wayans and an ensemble of talented young black comedians such as Damon Wayans, Kim Wayans, Tommy Davidson, and David Alan Grier. This weekly review of satirical sketches has produced an array of controversial black characters. Homey the Clown is a mean-spirited clown dressed in his silly costume accentuated by a big red nose, painted face, and pointed hat. Bonita Butrell is the busybody gossip of the housing projects who seems to slander everyone she knows. "The Home Boys Shopping Network" is a recurring skit in which two young ghetto thieves humorously sell stolen merchandise from the back of a van. In another familiar skit, "Men on Film," where sexual innuendos are plentiful and obvious, an outrageous pair of gay film reviewers downgrade most motion pictures starring women, but they are ready to award "two snaps up" to movies such as *Dick Tracy* ("You know, I loved the title, but the movie just left me limp").

Nothing better epitomizes the satirical irreverence permeating *In Living Color* than a skit in which Frenchy, a brash jeri-curled street hustler, crashed a black "Save the Dolphins" fundraiser. As broadcast on January 27, 1991, the uninvited guest arrived at the tuxedoed party wearing a yellow-fringed, red leather suit and carrying a bucket of chicken wings and bottle of Cold Duck wine in a brown paper bag. At one point he compared credentials with a bourgeois black man who declared, "I received my B.A. from S.M.U., and my Ph.D. from M.I.T." Frenchy's response was mocking: "I'll have you know that I bought my B.L.T. from Mickey D's . . . and once got VD in D.C."

Before the sketch ended, Frenchy had humiliated his unwitting host, insulted the invited guests, passed around his cheap booze, and had most of the party-goers gyrating in a funky dance line. Whether intended as a reminder to middle-class blacks of their humble origins, or offered as a contrast of "authentic" street values with "pretentious" bourgeois attitudes, the skit ridiculed minority social achievement, while lauding ostentation and ignorance. It also belittled the environmental movement. And by exploiting class tensions existing between blacks, the sketch belied whatever notions of racial solidarity viewers may have held.

For Benilde Little, a senior editor at *Essence* magazine, such comedy represented a social step forward. As she explained it to a British TV audience, "I think *In Living Color* is funny. I think it's insightful, and I think it's necessary. I think the time has come for us to be able to laugh at ourselves, and not be too concerned what white people think of us."[5]

On the other hand, it was precisely such representation that prompted Franklyn Ajaye, a black comedian and writer with *In Living Color*, to quit the program at the end of 1990. Ajaye expressed his disillusionment with the glorification of the ghetto inherent in the series—and with the foul-mouthed, ignorant direction taken by modern comedy stars such as Richard Pryor and Eddie Murphy. Ajaye explained, "I have no desire to be hip to the latest black slang and the stereotypical hip thing. . . . When [profanity and street slang] becomes a whole thing that defines [blacks], we're limiting ourselves—the enemy is us." He continued, "This whole street, urban rap thing needs to be pulled back some. The ghetto is being glorified, and there's nothing good about a ghetto except getting the hell out of one. Being black and speaking properly are not mutually exclusive. My father was an African, and he spoke beautifully at home. Nelson Mandela speaks beautifully. Should Mandela put his hat on backward and say, 'Yo homey, this is Nelson. Yo Winnie yo, this is def'?"

Ajaye recognizes the self-defeating ramifications of a culture that questions the legitimacy of social achievement and celebrates uncouth behavior. To him, much of contemporary black culture, especially that created for youthful consumption, was destructive. He complained, "I look at so many young black kids and I don't see the dignity. I don't see us carrying ourselves with dignity." Ajaye continued:

> As recently as the seventies there was just as much anger as there is now. But we used the anger to motivate us to study and to try to expand our base of knowledge. . . . Sometimes I feel that Dr. King and Malcolm X died in vain. These were men who spoke and expressed themselves eloquently. They died hoping that we would be able to achieve things. And now I see our achievements dropping, not expanding. There is nihilism now, and I don't know where it comes from. . . . If

young kids are allowed to believe that ignorance is all right, then we are going to be in worse trouble than anyone has yet imagined.[6]

While comedy sketches on *In Living Color* frequently belittle the values of the black bourgeoisie, *Fresh Prince of Bel Air* is a situation comedy that has class conflict built directly into its foundation. When a brash young rap musician from the streets of Philadelphia crossed the country to move in with his wealthy aunt and uncle in Southern California, a future rich in class-conscious comedy was assured. While the effete uncle might verbally fight back, reminding the Fresh Prince (Will Smith) that he was there when Malcolm X spoke all those poignant words, there is no way a glamorized hip-hop dude can lose to this accomplished, but dull businessman.

Above all, *Fresh Prince of Bel Air* communicates a message dear to the hearts of many in white America: that it is the responsibility of the black middle class to clean up the ghetto—that bourgeois African Americans, not the taxpaying innocents of the greater white society, have the obligation to spend time and money and sweat preparing inner-city residents to succeed in the capitalist world. On the premiere broadcast in the fall of 1990, the embodiment of ill-mannered, undereducated street culture lectured his prosperous uncle. "I don't have the problem. You have the problem. I remind you of where you came from and what you used to be. Now I don't know, but somewhere between Princeton or the office you got soft, you forgot who you are and where you came from."

For all its racial tension, the series is more theatrical pretense than social vilification. This fresh Fresh Prince is no menacing rap artist. Before coming to the NBC series he was essentially a suburban rapper whose one hit record, "Parents Just Don't Understand," was a teenage boy's protest against a dominating mother who would not allow her son to select his own shirts, slacks, and gym shoes when buying back-to-school clothes at the shopping mall. Moreover, the writers of the series are white, and its creators are two white Harvard-educated producers-writers.

Nevertheless, Smith and executive producer Quincy Jones have defended their show. Smith, an intelligent young man who

once was admitted to study engineering at the Massachusetts Institute of Technology, told an interviewer that the show would enlighten white viewers who still believed "what black means is chicken, watermelon, and a big radio."[7] Jones, too, argued that the series possessed an educational potential. "It initiates the hip-hop sensibility into the mainstream in a clash," he told a questioner. "It's a very powerful dramatic vehicle for comedy to have this type of clashes of cultures—from a ghetto kid in a very affluent black family—inside the same family." And Jones promised, "Nobody's going to turn the rapper around, so you know you've got conflict right there. And this affluent society, they have their mores that are almost, in some cases from the surface, that appear to be white. But that's just a duality that most of the families like that go through."[8]

Unappreciative of the program's potential for popular enlightenment, Don Bogle blasted *Fresh Prince of Bel Air*, calling it "an old formula—a familiar contrast between high and low, loose and uptight—that's been updated to appeal to a new audience. It's a mix of 'The Beverly Hillbillies' and 'Diff'rent Strokes.' . . . The updating makes it a contrast between the bourgeois Negro and the street niggs." More than a refurbished formula, however, Bogle detected in the central character a return to familiar minstrel-show elements. The Fresh Prince, he noted, "is turned into a jivey, clownish figure out to dissemble the home of his aunt and uncle. The Fresh Prince cannot simply walk into a room, he has to bop." Bogle wrote:

> he bodaciously enters the room outlandishly dressed in old-style coon fashion; he wears a tuxedo jacket over a colorful striped T-shirt with the cummerbund around his chest, sneakers, and wearing his cap (which he doesn't take off when inside the house). Throughout, the hip-hop clothes, language, and culture—which could be a real fashion/cultural statement—are mainly used to make him look silly and cartoonish.

Missing, too, in the Fresh Prince's character is respect for the black family. The rapper is rude to his elders and ungrateful to his relatives who have allowed him into their home. As the product of his mother's parenting, he is no credit to her love or concern for his well-being. According to Don Bogle, "Hollywood

has never understood that there are many people from the inner city who can speak without slang (or who use it judiciously), who have manners and are perceptive enough to know when to talk loud and bad and when to sit back, listen, and take in the scene before making any moves."[9]

The assault upon the black middle class and its values seems relentless in modern TV humor. But not all TV comedy has had such a focus. Those series modeled after *The Cosby Show*—productions such as *Family Matters* and *A Different World*—have avoided such an aggressive approach. Yet, jokes made at the expense of successful black people have their appeal. In the 1990–91 season, for example, *In Living Color* was the third-highest-rated Fox network offering, and *Fresh Prince of Bel Air* was ranked among the top 40 programs.

The most strident iconoclasm, however, has occured on pay-cable channels such as Home Box Office and Showtime, where stand-up comedy acts by Eddie Murphy, Richard Pryor, Charlie Barnett, Whoopi Goldberg, and others have explored new areas of expression on television. In these presentations profanity, scatology, misogyny, and sexual frankness liberally punctuate the personalized, well-received comedy routines. There is rough talk here that verbally explores all areas of sexual activity, employs every four-letter word, and shocks the audience with epithets usually heard in juvenile locker rooms or in the streets.

Certainly, black stars have not been alone in popularizing this standard of comedy. Many white TV comedians have embraced vulgar humor. Profanity is abundant in the routines of many stand-up performers on cable, and stars such as Sam Kinnison and Andrew Dice Clay reached the top of their profession by delivering jokes that emphasized hate, explicit sex, woman-bashing, and racial denigration—all punctuated by a constant stream of invectives and expletives.

Most of this bawdy humor has been accepted enthusiastically by viewers. Although Clay's career crashed once opposition from critics and racial and women's groups made him a liability for programmers, Kinnison endures, and Murphy and Pryor have been especially successful in entertaining the nation. And they all have influenced other performers. By 1990 even *The Cosby Show* shed some of its stately demeanor. By adding Claire's teenage cousin Pam—who came to the Huxtable house-

293

hold from her home in the infamous Bedford-Stuyvesant section of Brooklyn—the program widened its focus to include situations confronted by African Americans in the inner city. Accordingly, one show in early 1991 involved Pam in matters of high school sex and the use of condoms.

While broadcast and cable humor has generated considerable debate, the most intense controversy over cultural standards has occurred in popular music where rap, as a product of urban underclass youth, has mounted a forceful assault on middle-class norms. Television has played a major role in this development, weaving rap productions into the music video programs that have saturated the medium, especially on cable outlets such as BET, MTV, and VH-1. The leading program on MTV by 1990 was *Yo! MTV Raps*, a hip-hop showcase replete with the full range of rap's verbal transgressions—from grammatical inexactitude and sexual boasting to crude sexist ideas—plus the stifling of melodic song by the repetitive rhythm and unsophisticated chant that are hallmarks of the musical phenomenon.

Rap emerged from the ghetto. Its frequent themes of immediate gratification and physical violence seem drawn from the stark realities of "the streets." In lyrics that are sexually explicit, hostile to authority, and often brutally disrespectful of women, rap has defied bourgeois standards. But it must not be discounted as a cheap thrill or an exploitive fad. Its practitioners are indignant and demand understanding. The more authentic rappers are part of a new generation of angry young men, communicating the rage and the confusion of minority communities wracked by poverty, drugs, crime, gangs, fear, indiscipline, and the hopeless feeling of being abandoned by the greater society. In recordings such as "Fuck the Police" and "Gangsta Gangsta," N.W.A. (Niggers with Attitudes) rapped about police brutality in the ghetto and the need for the brutalized to respond to this force. Themes in the music of Public Enemy—a group tinged with accusations of anti-Semitism, but still considered the most influential group with black teenagers—include beating women and achieving power through violence. The infamous 2 Live Crew has used frank sexual description, in particular a preference for anal intercourse, to proclaim its distinctiveness.

Most of these egregious pieces never appeared on TV as mu-

sic videos. Nonetheless, they are on commercial albums, and they are marketed through videos of other songs appearing on those disks. For white writer Pete Hamill, rap music is "puerile doggerel," symptomatic of the growing distance between the black underclass and the genuine cultural accomplishments of gifted black creators such as James Baldwin, Alice Walker, Dizzy Gillespie, Charlie Parker, and Wynton Marsalis.[10] But black critic Harry Allen has applauded the openness of rap. "When Ice-T releases a record called 'Let's Get Buck Naked and Fuck,' when 2 Live Crew on a cut called 'S & M' calls to women to bring their 'd--k-sucking friends,' when Ultramagnetic M.C.'s Kool Keith on 'Give the Drummer Some' talks about smacking up his bitch in the manner of a pimp, sisters understandably scream. . . . Hip-hop is sexist. It is also frank."[11]

It is also familiar. On *ABC News Nightline* on November 24, 1989, rapper Ice-T explained that his music was popular because its words and themes reflected the world of the greatest fans.

> When I call one of my home boys a nigger, I don't look at it as a dis [disrespect], or anything like that. You know, I mean the kids that I rap to in my music—I could speak for myself—they heard all these words by the time they're five years old, and it's nothing new to 'em, and stuff. When their parents look at 'em and say, "Oh, you're hearing something vile and offensive," they're lookin' at moms like, "Yeah, right, you know. I heard you say that yesterday." So, I don't think we're really givin' 'em anything that they haven't already heard. That's why they like the music, 'cause we're talkin' the language they talk.

This is not to say that all rap is so socially confrontational. A number of performers have taken it into the mainstream of pop music. Through the efforts of rappers such as Run-D.M.C., The Fat Boys, and M.C. Hammer, the rhythmic chant has been left intact—and in the case of M. C. Hammer, it has been supplemented with stunning dance routines—but the lyrics have been purged of profanity and sexual explicitness. Hammer has even become a TV pitchman, making elaborate rap commercials for products as diverse as Diet Pepsi and British Knights gym shoes. And with the premier of *Hammerman* in September 1991, he became the animated star of his own Saturday-morning cartoon show.

But rap entertainers have also emerged as provocative political spokesmen, turning their music into the most sustained critique of black-white relations since the 1960s. Increasingly, African-American rappers have employed their recordings and videos to proclaim the dissatisfaction of the inner city with the status quo, to assault white complacency, and to revitalize feelings of pride and self-worth among the urban poor. In "My Philosophy," Boogie Down Productions lashed out at distorted stereotypes of inner-city blacks, recognizing them as injurious to racial self-esteem. Several leading rap artists combined as Stop the Violence Movement to produce "Self Destruction," a powerful appeal to black youth to unite and end black-on-black violence. And Intelligent Hoodlum in "Arrest the President" blamed government and the president of the United States for failing to solve the staggering problems of the inner city.

In preaching esteem, many performers have brought historical figures into their videos, drawing from the African-American experience to illustrate continuity in the struggle against oppression. "Self Destruction" begins with the voice of Malcolm X speaking of America's serious problems. In "Black and Proud," Intelligent Hoodlum hailed the accomplishments of racial leaders from Marcus Garvey to Nelson Mandela; and in "Heed the Word of the Brother," X Clan employed images of Martin Luther King, Jr., Malcolm X, Harriet Tubman, and others to explain the linkage of African-American history with the continuing struggle against oppression. In this way rap has become not only a supplement to formal education, but an insistent response to the abandonment of disadvantaged blacks by much of the American political system.

Female rap artist Queen Latifah has argued that the mixing of pop music and historic references is constructive, since the resultant videos might prompt youngsters "to find out about who these people are and what they meant to black people in the United States." Similarly, music video director Charles Stone III endorsed the educational dimensions of such productions. "These faces of history . . . are not shown on mainstream television and aren't discussed in school. And through rap and through rap videos, we are able to see these faces. It's reschooling African-American children."[12]

While television generally has avoided the most defiant rap

music, themes of power through sexual gratification and the domination of women are familiar in the videos of groups such as 2 Live Crew ("Me So Horny"), Tone Loc ("Wild Thing"), and Digital Underground ("The Humpty Dance"). In October 1990, Phil Donahue devoted his talk show to consideration of the obscenity charges filed in Florida against 2 Live Crew and the owner of a record store who sold the group's controversial record album, *As Nasty As They Wanna Be*. On *Donahue* the group's live performance of the sexually explicit "Head Down, Ass Up" was filled with words bleeped out for the home audience.

Rap music and black performers are not alone in offending traditional social-sexual standards. Sultry, sexy, suggestive images pervade most rock-and-roll music videos. Although this is programming aimed primarily at teenagers and children—with sponsors that include bubble gum, candy, and soft drink companies—scantily clad women and undulating torsos abound on MTV and other music outlets. Misogynous themes have long propelled the career of The Rolling Stones from "Under My Thumb" and "Some Girls" to more recent releases. From writhing strippers in "Girls, Girls, Girls" by Motley Crue and bikini-clad nymphettes running throughout most of David Lee Roth's videos to the eroticism prevalent in most of Madonna's productions, sexual titillation permeates the pop music of American youth. And one of the most popular white rock groups, Guns N' Roses, has gone beyond sex and profanity, defying decades of advances in civil liberties to declare in song that "niggers" and "faggots" and "foreigners" are threats to society.

But when angry young black men perform this way, it is predictable that a hostile reaction will occur. In its milder form it is recognizable as appeals for recording artists to exercise reason and responsibility; in its most virulent manifestations it is manifest as police power employed to censor or otherwise suppress performance. It is no wonder that several rap groups have created videos that address issues of free speech and other constitutional liberties. Among these productions are "Banned in the U.S.A." by 2 Live Crew and "Fight the Power" by Public Enemy.

The appearance of iconoclastic expression in African-American comedy and music has rekindled the chronic debate concerning the responsibilities of minority art in a racist society. To some, such bold representation of blacks—even when writ-

ten, directed, and produced by African Americans—is too reminiscent of the classic racist images created by white Americans. As Dr. Alvin Poussaint, Professor of Psychiatry at Harvard University, said when denouncing the use of the word "nigger" in contemporary pop music, "It may be reflecting racism and bigotry in the society, but at the same time it's promoting it. . . . And it is hateful. . . . It's damaging to people. It's damaging to black children. It's teaching white children that the word is legitimate to use."[13] But in a commercial culture that proclaims its dedication to free speech, it is difficult to repress language and physical expression, even if the final product is insulting, distorted, or infuriating. Were it otherwise, depictions offensive to African Americans would never have appeared on television for so many years.

The essence of the artistic problem involves social timing: at what point is there enough black representation on television so that negative black characterization does not cast aspersions on the entire race? The traditional argument against negative images of African Americans has been that the narrowness of black video roles turned comedic misrepresentation into racial ridicule and satire into slur. Logically, fuller and more honest depictions should neutralize any misconceptions.

According to this line of argument, with so many African-American men and women appearing on TV by the late 1980s, distorted images once termed racist must now be considered as inoffensive artistic license. If exaggerated characters like Herman Munster or Archie Bunker did not denigrate Caucasian manhood, then the old hallmarks of anti-black derision—sexual preoccupation, dim-wittedness, profanity, broken grammar, unemployment, criminality—were counterbalanced in a medium where virile Philip Michael Thomas captured crooks and women's hearts, where Bernard Shaw had become the news anchorman for the world, and where Oprah Winfrey hosted the premier talk-show in the nation. If in 1988 George Bush could win the presidency of the United States by using a convicted black rapist-murderer, Willie Horton, to symbolize the menace of lenient law enforcement, surely minstrel-show characterization in a situation comedy could not be considered socially unacceptable. Conversely, if African Americans were so well assimilated into middle class society that many could run—often successfully—for

every elected office from city mayor to president of the United States, then tough black young men talking dirty on TV could not compromise the black struggle toward political empowerment.

But it is not that easy. There are drawbacks, the most overwhelming of which is the lingering problem of race. Where TV has handled the white ethnic differences by ignoring them, the medium has never found a way to handle African-American differentness with similar objectivity. On TV white people are just people. There may be young-old, rich-poor, intelligent-ignorant dichotomies in their characterization, but since the late 1950s there has been little effort to offer portrayals of French Americans, Greek Americans, Jewish Americans, Italian Americans, Polish Americans, Irish Americans, and the like.

The actor of African ancestry, however, is not just a person on TV, he or she is "the black person," recognized almost reflexively as standing out. Writers usually have this character do or say "something black" to demonstrate that he or she is as aware of differentness as are the white viewers at home. In a nation hostile for so long to its racial minorities, this unsolicited distinction instantly places the African-American performer, and by extension his or her race, in a position of vulnerability.

Thus, performance that divides the black community and confounds the white audience—even if created by black artists—may be detrimental to continued racial progress. If there has been improvement in the black condition over the past two decades, it is due in great part to the solidarity among African Americans who struggled in common for minority rights. While the increased utilization of black talent on television should be applauded, the nature of much of that representation may be counterproductive.

The battle for civil rights has not been won, the fight for economic and social opportunity is ongoing. If television played a critical propagandistic role for the movement during the 1960s, surely it continues to affect public understanding of racial injustice. But are black representations on TV today delivering the same constructive message as those of three decades ago? More importantly, if distorted racial portrayals were attacked for decades as perversions that eroded African-American self-esteem and prejudiced white attitudes toward blacks, is the minority imagery on contemporary television furthering or corrupting the struggle?

It is definite that broadcasting alone could never have re-solved the racial dilemma confronting U.S. television. The key to improvement must lie in the emerging narrowcasting present and future. Only by offering so much choice can the minority audience—any minority audience—receive the respect it de-serves. When video success is based upon attracting that black 12 percent of the population, and when sponsors want minority customers badly enough to respect them, only then will deroga-tory imagery diminish and credible representation flourish.

And there is hope. At the 1991 convention of the National Cable Television Association, industry leaders heard predictions of a virtual explosion in cable capability which by the year 2000 could produce as many as five hundred channels. Relating the optimism of John Malone, president of the major cable operator, Tele-Communications, Inc., *Broadcasting* magazine reported that technological developments will revolutionize cable by the turn of the century. "Systems could deliver 200-500 high quality signals. . . . Such a system could provide fifty to one hundred channels of PPV [pay-per-view] . . . giving viewers record and time shift options. Niche channels will proliferate. . . . There will be an enormous profusion of education channels . . . as well as twenty to thirty shopping channels, reflecting the shopping mall concept."[14]

In this proliferation of video offerings, the future for minori-ties in general, and for African Americans in particular, seems encouraging. When one hundred, two hundred, or five hundred stations compete for the American viewer, the black audience will become a powerful force. Surely in such a universe, white programmers will finally comprehend that minorities are to be prized. Surely, too, black entrepreneurs will understand that the time is propitious for investment in the burgeoning TV future: that this is the chance to enter the business, to gain power, to make money, and to act as gatekeepers correcting—as white tele-vision officials presently do for their own minority interests—erroneous impressions before they are propagated, while initiat-ing projects that tell the authentic story of black America.

Television with hundreds of channels is also an industry in great need of programming. Here is the chance for a new genera-tion of African-American creators to emerge. A quantum leap in opportunity should render racism less debilitating. Producers, di-

rectors, writers, actors, editors, all will be needed in abundance. There will be a need, too, for technicians: men and women who can handle all aspects of these complex video operations.

If the original promise of TV was impractical under the original organization of the industry, it is more realizable today than ever—and more so tomorrow than today. The revolution sweeping the networks toward extinction can catapult racial minorities to new levels of power. Hopefully, in a nation with hundreds of video outlets there will finally be consistent, plentiful, honest representation of African Americans that will be worthy of the egalitarian ideals that continue to guide, but not really define, American civilization.

Notes

Introduction

1. Gladys Hall, "Are Comedians Through on the Air?" *Radio Stars*, Feb. 1936, p. 73.
2. *New York Times*, May 25, 1930.
3. Orrin E. Dunlap, Jr., *The Outlook for Television* (New York: Harper and Row, 1932), p. 3.
4. Alvin E. White in *Our World* magazine. Cited in Estelle Edmerson, "A Descriptive Study of the American Negro in United States Professional Radio, 1922–1953" (Master's thesis, University of California at Los Angeles, 1954), p. 378.
5. U.S. House of Representatives, Subcommittee on Telecommunications, Consumer Protection, and Finance, of the Committee on Energy and Commerce, *Minority Participation in the Media*, September 19 and 23, 1983 [No. 98–93], p. 104.

Part One: The Promise Denied, 1948–1957

Chapter 1: The Promise

1. *Ebony*, June 1950, p. 22.
2. Ibid., p. 23. See also Ed Sullivan, "Can TV Crack America's Color Line?," *Ebony*, May 1951, pp. 58–65.
3. Steve Allen, "Talent Is Color Blind," *Ebony*, October 1955, p. 41.
4. Maurice R. Davie, *Negroes in American Society* (New York: McGraw-Hill, 1949), p. 507.
5. For a history of blacks in radio broadcasting, see J. Fred MacDonald, *Don't Touch That Dial! Radio Programming in American Life,*

1920–1960 (Chicago: Nelson-Hall, 1979), pp. 327–70. For a detailed description of the radio dramas of Richard Durham, see J. Fred MacDonald, "Radio's Black Heritage: *Destination Freedom*, 1948–1950," *Phylon*, March 1978, pp. 66–73; J. Fred MacDonald, *Richard Durham's Destination Freedom. Scripts from Radio's Black Legacy, 1948–50.* (New York: Praeger, 1989).

 6. *Variety*, April 23, 1952, pp. 1, 14.

 7. Ibid., Jan. 27, 1954, p. 1; Jan. 9, 1952, p. 32.

 8. See the argument of Thomas Cripps, "The Myth of the Southern Box Office: A Factor in Racial Stereotyping in American Movies, 1920–1940," in James C. Curtis and Lewis L. Gould, eds., *The Black Experience in America* (Austin: University of Texas Press, 1970), pp. 116–44.

 9. *Variety*, July 31, 1957, p. 1; Aug. 28, 1957, pp. 1, 63.

 10. Ibid., Jan. 9, 1952, pp. 1, 20.

 11. Robert D. Swezey, "Every Town a Show Town U.S.A.—Yeah?," in *Twenty-Two Television Talks Transcribed from BMI TV Clinics* (New York: Broadcast Music, Inc., 1953), p. 9.

 12. *Variety*, July 18, 1951, p. 16.

Chapter 2: Blacks in TV: Nonstereotypes versus Stereotypes

 1. *Ebony*, June 1950, p. 23.

 2. Sammy Davis, Jr., *Yes I Can. The Story of Sammy Davis, Jr.* (New York: Pocket Books, 1965), pp. 148–49.

 3. *Ebony*, Oct. 1958, p. 65.

 4. *Radio and Television Life*, April 17, 1949, p. 33.

 5. *Variety*, Oct. 5, 1949, pp. 1, 55.

 6. *Ebony*, Dec. 1957, pp. 102–6.

 7. *Variety*, May 31, 1950, p. 25.

 8. Estelle Edmerson, "A Descriptive Study of the American Negro in United States Professional Radio, 1922–1953" (Master's thesis, University of California at Los Angeles, 1954), p. 391.

 9. *California Eagle*, Aug. 23, 1951. Cited in Edmerson, "A Descriptive Study of the American Negro," pp. 393–94.

 10. James Edwards in the *New York Age*. Reprinted in *California Eagle*, August 23, 1951. Cited in Edmerson, "A Descriptive Study of the American Negro," p. 396.

 11. Edmerson, "A Descriptive Study of the American Negro," pp. 385–86.

 12. United States Commission on Civil Rights, *Window Dressing on the Set: Women and Minorities in Television* (Washington, D.C.: Government Printing Office, 1977), pp. 4–5.

13. *Variety*, Feb. 22, 1956, p. 1.

14. Ibid., June 3, 1964, p. 50.

15. Chester L. Washington, in the *Pittsburgh Courier*, June 26, 1951. Cited in Edmerson, "A Descriptive Study of the American Negro," p. 395.

16. *Variety*, Aug. 8, 1951, p. 36.

17. *Pittsburgh Courier*, Nov. 17, 1951. Cited in Edmerson, "A Descriptive Study of the American Negro," p. 387.

18. Bart Andrews and Ahrgus Julliard, *Holy Mackerel! The Amos 'n' Andy Story.* (New York: Dutton, 1986), p. xix.

19. Melvin Patrick Ely, *The Adventures of Amos 'n' Andy: A Social History of an American Phenomenon.* (New York: The Free Press, 1991), p. 92.

Chapter 3: Blacks in News Programming

1. The interview with King occurred only hours after Ghana became a sovereign state. A tape recording of the interview is part of the Etta Moten Barnett Collection housed at the Schomburg Center for Research in Black Culture, a division of the New York Public Library.

2. Edward R. Murrow and Fred W. Friendly, eds., *See It Now* (New York: Simon and Schuster, 1955), pp. 69–70.

Chapter 4: Bias in Video Drama

1. *New York Times*, Dec. 23, 1953, p. 32.

2. *Variety*, Oct. 21, 1953, p. 33.

3. Edmerson, "A Descriptive Study of the American Negro," p. 389.

4. *Jet*, May 21, 1953, p. 66.

5. *Ebony*, Aug. 1954, p. 54.

6. Thomas Cripps, "The Noble Black Savage: A Problem in the Politics of Television Art," *Journal of Popular Culture*, 8:4 (1975), pp. 688–89.

7. Reginald Rose, *Six Television Plays* (New York: Simon and Schuster, 1956), pp. 105–7; Erik Barnouw, *The Image Empire. A History of Broadcasting in the United States from 1953* (New York: Oxford University Press, 1970), p. 34.

8. Edmerson, "A Descriptive Study of the American Negro," p. 354.

9. Rod Serling, *Patterns: Four Television Plays with the Author's Personal Commentaries* (New York: Simon and Schuster, 1957), p. 21.

10. Paddy Chayefsky, on David Susskind's *Open End* program, Nov. 18, 1958. Cited in *Advertising Age*, Dec. 1, 1958, p. 76.

11. Serling, *Patterns*, p. 21.

12. *Televiser*, Sept.–Oct. 1947, p. 31.

13. Julian Houseman, "The Julian Houseman Story," in William I. Kaufman, ed., *Best Television Plays of the Year* (New York: Merlin Press, 1950), p. 247.

14. *Variety*, Jan. 26, 1955, p. 31; Aug. 12, 1960, pp. 1, 42.

15. Robert Alan Aurthur, "Remembering *Philco Playhouse*," *TV Guide*, March 17, 1973, p. 10.

16. *TV Guide* (Chicago ed.), Oct. 12, 1957, p. A-52. See also reviews in *Variety*, March 28, 1951, p. 30; and *TV Guide*, March 23, 1959, p. 15.

Chapter 5: The Perimeters of Black Expression: The Cases of Paul Robeson and Nat King Cole

1. Dorothy Butler Gilliam, *Paul Robeson All-American* (Washington, D.C.: New Republic Book Co., 1976), p. 54.

2. *New York Times*, March 14, 1950.

3. *New York Journal-American*, March 13, 1950.

4. Ibid.

5. *Baltimore Afro-American*, March 25, 1950.

6. *Variety*, April 5, 1950, p. 35; *New York Times*, April 3, 1950.

7. *New York Amsterdam News*, March 25, 1950.

8. *Baltimore Afro-American*, March 25, 1950.

9. Ibid., March 11, 1950.

10. *Ebony*, Oct. 1956, p. 48.

11. *TV Guide*, Sept. 7, 1957, p. 15.

12. Nat King Cole, "Why I Quit My Show," *Ebony*, Feb. 1958, p. 30.

13. *Variety*, Sept. 11, 1957, p. 22.

14. Cole, "Why I Quit My Show," p. 30.

15. *Variety*, Sept. 11, 1957, p. 22.

16. Ibid., p. 2.

17. Cole, "Why I Quit My Show," p. 31.

18. *Variety*, Sept. 11, 1957, p. 2.

19. Cole, "Why I Quit My Show," p. 32.

20. *Variety*, June 20, 1956, p. 17.

21. Ibid., Aug. 1, 1956, p. 24.

22. Ibid., Nov. 21, 1956, p. 2.

23. Jay S. Harris, ed., *TV Guide: The First 25 Years* (New York: Simon and Schuster, 1978), p. 45. This letter appeared only in the Northeastern regional issues of *TV Guide*, since letters to the editor were submitted and published on a regional basis.

Part Two: Blacks in TV in the Age of the Civil Rights Movement, 1957–1970

1. Charles S. Aaronson, ed., *International Television Almanac, 1962* (New York: Quigley Pubns., 1961), p. 9A.
2. Paul Adanti, "Programming for TV As a Sales Medium," in *Twenty-Two Talks Transcribed from BMI TV Clinics* (New York: Broadcast Music, Inc., 1953), p. 87.

Chapter 6: The Southern Factor

1. *Variety*, Oct. 22, 1958, p. 31.
2. Ibid., Oct. 8, 1958, p. 23.
3. Ibid., April 2, 1958, p. 1.
4. Ibid., Aug. 7, 1957, p. 1. For reaction in South Carolina, see ibid, May 15, 1957, p. 1.
5. Ibid., Sept. 27, 1961, p. 46.
6. Ibid., Aug. 2, 1961, p. 45; Sept. 11, 1963, p. 27.
7. Ibid., Feb. 25, 1959, p. 27.
8. S. I. Hayakawa, "Television and the American Negro," in David Manning White and Richard Averson, eds., *Sight, Sound, and Society: Motion Pictures and Television in America* (Boston: Beacon Press, 1968), p. 74.

Chapter 7: Blacks and Network TV: The Early 1960s

1. *Variety*, Oct. 31, 1962, p. 37.
2. Ibid., June 27, 1962, p. 31.
3. Ibid., July 24, 1963, p. 29.
4. Ibid., April 1, 1964, p. 1; April 15, 1964, p. 27.
5. Ibid., August 14, 1963, p. 1. For examples of earlier sponsor interference in the *Ed Sullivan Show*, see ibid., Nov. 7, 1962, p. 22.
6. Ibid., Aug. 15, 1962, p. 25.
7. Ibid., Dec. 23, 1964, pp. 19, 32.
8. Ibid., May 30, 1962, p. 1; June 6, 1962, p. 19.
9. Ibid., Oct. 31, 1962, p. 37.
10. Ibid., Sept. 11, 1963, p. 31.
11. Ibid., July 3, 1963, p. 27.
12. Ibid., July 31, 1963, p. 23.
13. Ibid., p. 66.
14. Ibid., June 19, 1963, p. 1.
15. Ibid., Sept. 14, 1966, p. 78.

Chapter 8: Actualities and Blacks in TV: The Early 1960s

1. Mary Ann Watson, *The Expanding Vista: American Television in the Kennedy Years.* (New York: Oxford University Press, 1990), p. 104.

2. Stephen B. Oates, *Let the Trumpet Sound: The Life of Martin Luther King, Jr.* (New York: New American Library, 1982), p. 160–63.

3. Malcolm X, *Autobiography of Malcolm X* (New York: Grove Press, 1964 and 1965), pp. 238–39.

4. A. William Bluem, *Documentary in American Television: Form—Function—Method* (New York: Hastings House, 1965), p. 134.

5. David G. Yellin, *Special: Fred Freed and the Television Documentary* (New York: Macmillan, 1972 and 1973), pp. 239–40.

6. Alexander Kendrick, *Prime Time: The Life of Edward R. Murrow* (Boston: Little, Brown, 1969), pp. 348–49.

7. Fred W. Friendly, *Due to Circumstances Beyond Our Control* (New York: Random House, 1967), p. 99.

8. *TV Guide,* May 18, 1963, p. 7.

9. William Small, *To Kill a Messenger: Television News and the Real World* (New York: Hastings House, 1970), p. 46. Reaffirming this interpretation, Professor Molefi Kete Asante (Arthur L. Smith) concluded that:

> Television found this confrontation with guns, whips, and electric cattle prods on one side and love and non-violence on the other as the classic drama of black and white, good and evil. By structuring the discourse around traditional dichotomies, television was able to present instantaneous conflict and, therefore, interest.

See Molefi Kete Asante, "Television and Black Consciousness," *Journal of Communication,* Autumn 1976, p. 138.

10. *Variety,* Sept. 4, 1963, p. 31.

11. Ibid.

Chapter 9: The Emergence of "Relevancy" in TV Production

1. *Variety,* Dec. 9, 1964, p. 28. It is interesting to compare the less encouraging statistics from late 1967 in which one group monitored 8,279 commercials over a three-week period and found only 2.3 percent with minority representation. See statement by Gordon Webber of the Benton and Bowles advertising agency in *Television Quarterly,* Summer 1968, p. 72.

2. D. Parke Gibson, *The $30 Billion Negro* (New York: Macmillan, 1969), pp. 24–25.

3. *TV Guide,* Dec. 4, 1963, p. 4.

Chapter 10: The Golden Age of Blacks in Television: The Late 1960s

1. *Variety*, July 8, 1964, p. 20.
2. Ibid., Sept. 8, 1965, p. 2.
3. Ibid., Sept. 11, 1968, p. 30.
4. Ibid., July 12, 1966, p. 48.
5. *TV Guide*, March 19, 1966, p. 1. For a detailed discussion of why the *Sammy Davis, Jr. Show* failed, see the two-part article by Alan Ebert, "How Sammy Davis, Jr. Met Disaster," *TV Guide*, July 9, 1966, pp. 4–9; July 16, 1966, pp. 22–26.
6. Richard Warren Lewis, "The Importance of Being Julia," *TV Guide*, Dec. 14, 1968, p. 28. See also, Carolyn See, "Diahann Carroll's Image," ibid., March 14, 1970, pp. 26–30.
7. Lewis, "The Importance of Being Julia," p. 27.
8. Richard Warren Lewis, "Cosby Takes Over," *TV Guide*, Oct. 4, 1969, p. 15.
9. James Oliver Killens, "A Black Writer Views TV," *TV Guide*, July 25, 1970, p. 7.
10. Dick Hobson, "The Odyssey of Otis Young," *TV Guide*, March 1, 1969, pp. 19–20.
11. Donald Bogle, *Toms, Coons, Mulattoes, Mammies, and Bucks: An Interpretive History of Blacks in American Films* (New York: Viking, 1973), p. 10.

Chapter 11: TV in the Age of Urban Rebellion

1. *Variety*, Feb. 14, 1964, p. 43.
2. Ibid., Oct. 30, 1966, p. 33. See also Small, *To Kill a Messenger*, pp. 58–77.
3. *Variety*, Aug. 16, 1967, p. 52.
4. Ibid., Oct. 5, 1966, p. 44. For another view of media responsibility, see William L. Rivers, Wilber Schramm, and Clifford G. Christians, *Responsibility in Mass Communication* (New York: Harper and Row, 1980), pp. 203 ff.
5. United States Government, National Advisory Commission on Civil Disorders, *Report of the National Advisory Commission on Civil Disorders* (New York: Dutton, 1968), p. 2.
6. Yellin, *Special*, pp. 239–40.
7. *Variety*, Dec. 13, 1967, p. 34.
8. Ibid., Aug. 7, 1968, p. 36; July 24, 1968, p. 1.
9. For an interesting discussion of the CBS series *Of Black America*, see Small, *To Kill a Messenger*, pp. 50–55.
10. *Variety*, Aug. 21, 1958, p. 37.

11. Ibid., July 17, 1968, p. 42.

12. Ibid., July 3, 1968, p. 40.

13. Ibid., July 17, 1968, p. 38.

14. Richard M. Levine, "The Plight of Black Reporters," *TV Guide*, July 18, 1981, pp. 3–6.

15. Killens, "A Black Writer Views TV," p. 7.

16. George T. Norford, "The Black Role in Radio and Television," in Mabel M. Smythe, ed., *The Black American Reference Book* (Englewood Cliffs, N.J.: Prentice-Hall, 1976), p. 886.

17. Richard Lemon, "Black Is the Color of TV's Newest Stars," *The Saturday Evening Post*, November 30, 1969, pp. 42, 84.

Part Three: The Age of the New Minstrelsy, 1970–1983

Chapter 12: TV and the Politics of the Early 1970s

1. For the complete text of Vice President Spiro Agnew's speech, see the *New York Times*, Nov. 21, 1969.

2. Spiro T. Agnew, "Another Challenge to the Television Industry," *TV Guide*, May 16, 1970, p. 10.

3. *Variety*, May 13, 1970, p. 31. See also William E. Porter, *Assault on the Media, The Nixon Years* (Ann Arbor, University of Michigan Press, 1976), pp. 42–48.

4. *Variety*, May 27, 1970, p. 42.

5. Ibid.

6. Ibid., Nov. 18, 1970, p. 46.

7. Ibid., Dec. 23, 1970, p. 31.

8. Ibid., May 27, 1970, p. 25.

9. Ibid., Aug. 5, 1970, p. 29.

10. Ibid., May 13, 1970, p. 31; Dec. 16, 1970, p. 30.

11. Ibid., Jan. 14, 1970, p. 46.

12. Ibid., May 13, 1970, p. 31.

13. Ron Powers, *The Newscasters: The News Business as Show Business* (New York: Nordon Pubns., 1977, rev. 1980), p. 67.

14. *Variety*, Dec. 24, 1969, p. 27.

15. Ibid., Nov. 11, 1970, p. 31.

16. Ibid., March 8, 1972, p. 31.

17. Ibid., Nov. 12, 1969, p. 47.

18. Patrick D. Maines and John C. Ottinger, "Network Documentaries: How Many, How Relevant?" *Columbia Journalism Review*, March/April 1973, pp. 36–38.

19. *Variety*, Nov. 18, 1970, p. 47.

20. Ibid., Sept. 1, 1971, p. 1

Chapter 13: Blacks in Television in the Early 1970s

1. *Variety*, Jan. 12, 1976, pp. 46–53.

2. Manuela Soares, *The Soap Opera Book* (New York: Harmony Books, 1978), p. 117.

3. Ross Drake, "Ellen Holly Is Not Black Enough," *TV Guide*, March 18, 1972, p. 38.

4. *Variety*, Jan. 8, 1975, p. 18.

5. Ibid., May 1, 1974, p. 36. For casts and plot summaries of this and other made-for-TV films, see Alvin H. Marill, *Movies Made for Television: The Telefeature and the Mini-Series, 1964–1979* (Westport, Conn.: Arlington House, 1980).

6. Ronald Kisner, "TV Breaks Old Taboos with New Morality," *Jet*, Dec. 1, 1977, p. 56.

7. *Variety*, Sept. 23, 1970, p. 50.

8. Les Brown, *Televi$ion: The Business Behind the Box* (New York: Harcourt Brace Jovanovich, 1971), p. 293.

Chapter 14: Norman Lear, Bud Yorkin, and the Flourishing of Racial Humor

1. Michael Arlen, "The Media Dramas of Norman Lear," *New Yorker*, March 10, 1975; as cited in Richard P. Adler, ed., *All in the Family: A Critical Appraisal* (New York: Praeger, 1979), pp. 193–94. For a cogent and useful summary of the launching of *All in the Family*, see Harry Castleman and Walter J. Podrazik, *Watching TV: Four Decades of American Television* (New York: McGraw-Hill, 1981), pp. 226–28.

2. Norman Lear writing in the *New York Times*, Oct. 10, 1971; as cited in Adler, *All in the Family*, p. 108.

3. Ibid., pp. 107–8.

4. *Variety*, April 26, 1972, p. 30.

5. John C. Brigham and Linda W. Giesbrecht, " 'All in the Family': Racial Attitudes," *Journal of Communication*, Autumn 1976; as cited in Adler, *All in the Family*, pp. 139–40.

6. *Variety*, March 14, 1979, p. 72.

7. Statistics are drawn from listings of total seasonal ratings of A.C. Nielsen, as cited in *Variety*, May 24, 1972, p. 35; May 30, 1973, p. 30; May 8, 1974, p. 262; May 14, 1975, p. 132; April 28, 1976, p. 44; April 27, 1977, p. 50; May 3, 1978, p. 54; May 23, 1979, p. 52; June 4, 1980, p. 48; June 10, 1981, p. 36; May 12, 1982, pp. 452, 457.

8. *Variety*, Sept. 26, 1979, p. 50.

9. Ibid., January 3, 1973, p. 106; "Dialogue on Film: Norman Lear," *American Film*, June 1977, p. 45.

10. Lance Morrow, "Blacks on TV: A Disturbing Image," *Time*, March 27, 1978, p. 101.

11. Ibid.

12. *Variety*, Oct. 10, 1973, p. 24.

13. On *Richard Pryor Show*, see *Variety*, Sept. 21, 1977, p. 60; Tim Brooks and Earle Marsh, *The Complete Directory to Prime Time Network TV Shows, 1946–Present* (New York: Ballantine, 1979), pp. 527–28.

Chapter 15: Blacks in Noncomedic Television

1. Gerald S. Lester, *Children and Television* (New York: Random House, 1974), p. 187.

2. Ibid., pp. 179, 200.

3. *Variety*, Oct. 18, 1972, p. 29.

4. Much less successful than *Fat Albert* was the ABC multi-ethnic children's show, *Kid Power*, which premiered one week after the Cosby program. See Gary H. Grossman, *Saturday Morning TV* (New York: Dell, 1981), pp. 267–68.

5. Edwin Kiester, Jr., "Todd Bridges of *Diff'rent Strokes*," *TV Guide*, Dec. 6, 1980, p. 36.

6. *Variety*, Oct. 17, 1973, p. 28.

7. *TV Guide*, Dec. 29, 1973, p. 25.

8. Eugenia Collier, "New Black TV Shows Still Evade the Truth," *TV Guide*, Jan. 12, 1974, p. 7.

9. Richard Meyers, *TV Detectives* (San Diego: A.S. Barnes, 1981), p. 187.

10. *Variety*, Oct. 17, 1973, p. 28.

11. Richard Warren Lewis, "Teresa Graves of *Get Christie Love!*" *TV Guide*, Nov. 30, 1974, pp. 20–23.

Chapter 16: The Black Television Program

1. *Variety*, Nov. 11, 1970, p. 1.

2. Ibid., June 21, 1972, p. 39.

3. William Bradford Huie, "The Fight to Force Alabama Educational TV Off the Air," *TV Guide*, Feb. 8, 1975, pp. 20–24; United States Commission on Civil Rights, *Window Dressing on the Set: Women and Minorities in Television* (Washington, D.C.: U.S. Government Printing Office, 1977) pp. 60–62.

4. *Variety*, June 10, 1970, p. 70.

5. Ibid., March 8, 1972, p. 30.

6. Ibid., Nov. 22, 1972, p. 51.

7. Ibid., Feb. 22, 1978, p. 44; Dec. 4, 1974, p. 40.

8. Ibid., Nov. 14, 1973, p. 27.

9. Ibid., March 15, 1978, p. 68.

10. U.S. Civil Rights Commission, *Window Dressing on the Set*, pp. 21–22.

11. *Variety*, Nov. 22, 1972, p. 51.

12. U.S. Civil Rights Commission, *Window Dressing on the Set*, pp. 71–72. See also, United States Civil Rights Commission, *Window Dressing on the Set: An Update* (Washington, D.C.: U.S. Government Printing Office, 1979).

13. Gil Noble, *Black Is the Color of My TV Tube* (Secaucus, N.J.: Lyle Stuart, 1981), pp. 62–64.

14. *Variety*, March 4, 1970, p. 35.

15. Ibid., July 29, 1970, p. 35. See also Dorothy Gilliam, "What do Black Journalists Want?" *Columbia Journalism Review*, May/June 1972, p. 49.

16. Ibid., April 25, 1979, p. 59.

17. Ibid., Sept. 18, 1974, pp. 35, 77.

Chapter 17: The Roots Phenomena

1. Phillip Wander, "On the Meaning of 'Roots'," *Journal of Communication*, April 1977, p. 69.

2. Stuart H. Surlin, " 'Roots' Research: A Survey of Findings," *Journal of Broadcasting*, Summer 1978, p. 315.

3. *Variety*, Oct. 6, 1976, p. 2.

4. Bill Davidson, "A Tough Act to Follow," *TV Guide*, Feb. 17, 1979, p. 4.

5. Stephen Zito, "Out of Africa," *American Film*, Oct. 1976, pp. 14–15.

Chapter 18: The Broadcast Synthesis: TV and African Americans by the Early 1980s

1. Robert Sklar, "Is Television Taking Blacks Seriously?," *American Film* Sept. 1978, pp. 25–29. This article is reprinted in a compilation of article reprints by Robert Sklar, entitled *Prime-Time America: Life On and Behind the Television Screen* (New York: Oxford University Press, 1980), pp. 100–110.

2. *TV Guide*, Aug. 1, 1981, p. 32.

3. D. Parke Gibson, *$70 Billion in the Black* (New York: Macmillan, 1978), pp. ix, 8–14.

4. Morrow, "Blacks on TV," p. 101.

5. Glenn Esterly, "Ronald Hunter of *Lazarus Syndrome*," *TV Guide*, Oct. 27, 1979, p. 34.

6. *Variety*, June 14, 1978, p. 40.

7. *Variety*, March 21, 1978, p. 68.

8. *Variety*, Oct. 15, 1980, p. 310.

9. Pilar Baptista-Fernandez and Bradley S. Greenberg, "The Context, Characteristics, and Communication Behaviors of Blacks on Television," in Bradley S. Greenberg, *Life on Television: Content Analyses of U.S. TV Drama* (Norwood, N.J.: Ablex, 1980), pp. 19–20.

10. Kate Moody, *Growing Up on Television* (New York: Time Books, 1980), pp. 118–19. See also Russell M. Weigel, James W. Loomis, and Matthew J. Soja, "Race Relations on Prime Time Television," *Journal of Personality and Social Psychology*, Nov. 1980, p. 888.

11. Cecil Brown, "Blues for Blacks in Hollywood," *Mother Jones*, January 1981, pp. 28, 59. See also his interview, "Why Blacks Have the Blues in Hollywood," Pacifica Radio, 1981.

12. For a written condemnation of alleged racism in television production, see Pamela Douglas, "The Bleached World of Black TV," *Human Behavior*, Dec. 1978, pp. 63–68. For an opposing view of the people who write TV shows, see Ben Stein, *The View from Sunset Boulevard* (New York: Basic Books, 1979).

13. *Variety*, Oct. 18, 1978, p. 255.

14. Associated Press story cited in the *Chicago Sun-Times*, May 18, 1982.

15. Jack Craig in the *San Francisco Chronicle*, April 21, 1982.

16. Charles L. Sanders, "Has TV Written Off Blacks?," *Ebony*, Sept. 1981, p. 114.

17. Robert MacKenzie, "Review: Gimme a Break," *TV Guide*, Jan 9, 1982, p. 23. For a rebuke of MacKenzie's review, see the letter to *TV Guide*, from Pluria W. Marshall, chairman of the National Black Media Coalition, in *TV Guide*, Jan. 30, 1982, p. A-4.

18. *Variety*, Jan. 13, 1982, p. 170.

Part Four: Blacks in the New Video Order, 1983–Present

1. For a detailed discussion of the disintegration of the network monopoly, see J. Fred MacDonald, *One Nation Under Television. The Rise and Decline of Network TV* (New York: Pantheon, 1990), pp. 221–87.

Chapter 19: African Americans and the New Video Realities

1. *The Economist*, March 30, 1991, p. 21.

2. *Variety*, Aug. 30, 1989, p. 73; *Broadcasting*, Aug. 28, 1989, p. 55; *Jet*, Sept. 18, 1989, p. 61.

3. MacDonald, *One Nation Under Television*, p. 276.

4. *TV Guide*, May 5, 1984, p. 43.

5. U.S. House of Representatives, Subcommittee on Telecommunications, Consumer Protection, and Finance, of the Committee on Energy and Commerce, *Minority Participation in the Media*, Sept. 19 and 23, 1983 [No. 98-93], p. 103.

6. Ibid., p. 123.

7. Kathryn C. Montgomery, *Target: Prime Time. Advocacy Groups and the Struggle over Entertainment Television* (New York: Oxford University Press, 1990), p. 152.

8. Don Bogle, *Blacks in American Films and Television. An Encyclopedia* (New York: Garland, 1988), p. 286.

9. Ishmael Reed, "Tuning Out Network Bias," *New York Times*, April 9, 1991.

Chapter 20: Toward a New Relationship in the Age of Cable

1. *Soap Opera Digest*, April 4, 1989, pp. 98–99. See also, Dalton Narine, "From Domestics to Interracial Lovers," *Ebony*, Nov. 1988, pp. 92, 94, 96, 98.

2. *Soap Opera Digest*, March 21, 1989, pp. 92–99.

3. Ibid., April 4, 1989, p. 100.

4. Kathryn Baker, "Black and White TV," *The American Way*, Sept. 1, 1989, p. 38.

5. C. Gerald Fraser, "Fans Mourn Soap Opera Cancellation," *New York Times*, March 5, 1991.

6. A.C. Nielsen Company, *Television Viewing Among Blacks, January–February 1986* (Northbrook, Ill.: A.C. Nielsen Co., 1986). Two years later gaps in black–non-black viewership patterns had widened slightly; see A.C. Nielsen Company, *Television Viewing Among Blacks, January–February 1988* (Northbrook, Ill.: A.C. Nielsen Co., 1988); *Variety*, Jan. 14, 1991, p. 29.

7. A.C. Nielsen Company, *Nielsen Newscast*, No. 3 (1986), p. 13.

8. Nielsen, *Television Viewing Among Blacks, 1988*, pp. 9, 20. For a summary of similar Nielsen findings about black viewership in 1989-90, see *Variety*, Jan. 14, 1991, p. 29.

9. Nielsen, *Television Viewing Among Blacks, 1986*, pp. 26–27.

10. Nielsen, *Television Viewing Among Blacks, 1988*, pp. 24–25.

11. As reported by the Bozell advertising agency, *New York Times*, April 30, 1990.

12. Shelby Steele, *The Content of Our Character: A New Vision of Race in America* (New York: St. Martin's Press, 1990), pp. 11-12.

13. Tim Brooks and Earle C. Marsh, *The Complete Directory to*

Prime Time Network TV Shows 1946–Present, 4th ed. (New York: Ballantine Books, 1988), pp. 971–74.

14. Laurence Bergreen, *Look Now, Pay Later. The Rise of Network Broadcasting* (New York: New American Library, 1980), p. 264.

15. Rosemary L. Bray, *New York Times*, March 4, 1991.

16. *Variety*, April 6, 1983, p. 1; Dec. 31, 1990, p. 5.

17. Robert Henson, *Television Weathercasting: A History* (Jefferson, N.C.: McFarland, 1989), pp. 88–90.

18. *Chicago Tribune*, April 4, 1991.

19. Cable News Network, "Showbiz Tonight," April 28, 1989.

20. *Variety*, May 30, 1990, pp. 1, 4.

21. Ibid., March 18, 1991, pp. 1, 108.

Chapter 21: The Cultural Debate

1. Herman Gray, "Television, Black Americans, and the American Dream," *Critical Studies in Mass Communication*, Dec. 1989, p. 384.

2. As cited in Gail Lumet Buckley, "When a Kiss on Screen Is Not Just a Kiss," *New York Times*, March 31, 1991; see also, *The Economist*, March 30, 1991, pp. 17–18.

3. *New York Times*, Feb. 10, 1991.

4. Richard Campbell and Jamie L. Reeves, "Television Authors: The Case of Hugh Wilson," in Robert J. Thompson and Gary Burns, *Making Television. Authorship and the Production Process* (New York: Praeger, 1990), pp. 9–10.

5. "Prime Time," *The Media Show*, Channel 4, Great Britain, Oct. 21, 1990.

6. Bob Greene, "If hope isn't hip, a generation suffers," *Chicago Tribune*, Jan. 7, 1991; Bob Greene, "Ways of the ghetto—saying no to 'yo'," Ibid. Jan. 15, 1991.

7. NBC-TV, *Later . . . with Bob Costas*, Sept. 18, 1990.

8. "Prime Time," *The Media Show*.

9. Don Bogle, "TV's New African American Images: Good or Bad?," *Dollars & Sense*, Dec./Jan. 1991, pp. 41–42.

10. Pete Hamill, "Breaking the Silence: A Letter to a Black Friend," *Esquire*, March 1988, p. 98.

11. *Essence*, April 1989, p. 117, as cited in Reebee Garafalo, "Crossing Over: 1939–1990," in Jannette Dates and William Barlow, eds., *Split Image: African-Americans in the Mass Media* (Washington, D.C.: Howard University Press, 1990), p. 115.

12. "Prime Time," *The Media Show*.

13. *ABC News Nightline*, Nov. 24, 1989.

14. *Broadcasting*, April 1, 1991, p. 27.

Bibliography

Publications

Advertising Age. 1955–1958.
American Film. 1976–1980.
Baltimore Afro-American. 1953.
Broadcasting. 1988–.
Chicago Sun-Times. 1982.
Ebony. 1948–
The Economist. 1991.
Jet. 1953–
New York Amsterdam News. 1953.
New York Journal-American. 1953.
New York Times. 1930; 1948–
Radio and Television Life. 1949.
San Francisco Chronicle. 1982.
Soap Opera Digest. 1989–
Televiser. 1945–1949.
Television Quarterly. 1968.
TV Guide. 1953–
Variety. 1948.

Public Documents

A. C. Nielsen Company, *Television Viewing Among Blacks, January–February 1986*, Northbrook, Ill: A. C. Nielsen, 1986.
———, *Television Viewing Among Blacks, January–February 1988*, Northbrook, Ill: A. C. Nielsen, 1988.

Bibliography

U.S. Commission on Civil Rights, *Window Dressing on the Set: Women and Minorities in Television*. Washington, D.C.: Government Printing Office, 1977.

U.S. Commission on Civil Rights, *Window Dressing on the Set: An Update*, Washington, D.C.: Government Printing Office, 1979.

U.S. House of Representatives, Subcommittee on Telecommunications, Consumer Protection, and Finance, of the Committee on Energy and Commerce, *Minority Participation in the Media*, Sept. 19 and 23, 1983 [No. 98–93].

U.S. National Advisory Commission on Civil Disorders, *Report of the National Advisory Commission on Civil Disorders*. New York: Dutton, 1968.

Unpublished Materials

Brown, Cecil, "Why Blacks Have the Blues in Hollywood." Pacifica Radio, 1981.

Edmerson, Estelle. "A Descriptive Study of the American Negro in United States Professional Radio, 1922–1953." Master's thesis, University of California at Los Angeles, 1954.

Published Television Scripts

Houseman, Julian. "The Julian Houseman Story." In *The Best Television Plays of the Year*, William I. Kaufman, ed. New York: Merlin Press, 1950.

Murrow, Edward R., and Fred W. Friendly, eds. *See It Now*. New York: Simon and Schuster, 1955.

Rose, Reginald. *Six Television Plays*. New York, Simon and Schuster, 1956.

Serling, Rod. *Patterns: Four Television Plays with the Author's Personal Commentaries*. New York: Simon and Schuster, 1957.

Secondary Materials—Books

Aaronson, Charles S., ed. *International Television Almanac*. New York: Quigley Pubns., 1961.

Andrews, Bart, and Ahrgus Julliard. *Holy Mackerel! The Amos 'n' Andy Story*. New York: Dutton, 1986.

Barnouw, Erik. *The Image Empire. A History of Broadcasting in the United States from 1953*. New York: Oxford University Press, 1970.

Bergreen, Laurence. *Look Now, Pay Later, The Rise of Network Broadcasting*. New York: New American Library, 1980.

Bluem, A. William. *Documentary in American Television: Form—Function—Method*. New York: Hastings House, 1965.

Bogle, Donald. *Blacks in American Films and Television. An Encyclopedia*. New York: Garland, 1988.

————, *Toms, Coons, Mulattoes, Mammies, and Bucks: An Interpretive History of Blacks in American Films*. New York: Viking, 1973.

Brooks, Tim, and Earle C. Marsh, eds. *The Complete Directory to Prime Time Network TV Shows, 1946–Present*, 1st and 4th eds. New York: Ballantine Books, 1979, 1988.

Brown, Les. *Televi$ion: The Business Behind the Box*. New York: Harcourt, Brace, Jovanovich, 1971.

Castleman, Harry, and Walter J. Podrazik. *Watching TV: Four Decades of American Television*. New York: McGraw-Hill, 1981.

Davie, Maurice R. *Negroes in American Society*. New York: McGraw-Hill, 1949.

Davis, Sammy Jr. *Yes, I Can. The Story of Sammy Davis, Jr*. New York: Pocket Books, 1965.

Dunlap, Orrin E., Jr. *The Outlook for Television*. New York: Harper and Row, 1932.

Ely, Melvin Patrick *The Adventures of Amos 'n' Andy. A Social History of an American Phenomenon*. New York, The Free Press, 1991.

Friendly, Fred W. *Due to Circumstances Beyond Our Control*. New York: Random House, 1967.

Gibson, D. Parke. *$70 Billion in the Black*. New York: Macmillan, 1978.

————. *The $30 Billion Negro*. New York: Macmillan, 1969.

Gilliam, Dorothy Butler. *Paul Robeson All-American*. Washington, D.C.: New Republic Book Co., 1976.

Grossman, Gary H. *Saturday Morning TV*. New York: Dell, 1981.

Harris, Jay S., ed. *TV Guide: The First 25 Years*. New York: Simon and Schuster, 1978.

Henson, Robert. *Television Weathercasting: A History*. Jefferson, N.C.: McFarland, 1989.

Kendrick, Alexander. *Prime Time: The Life of Edward R. Murrow*. Boston: Little, Brown, 1969.

Lesser, Gerald S. *Children and Television*. New York: Random House, 1974.

MacDonald, J. Fred. *Don't Touch That Dial! Radio Programming in American Life, 1920–1960*. Chicago: Nelson-Hall, 1979.

————. *One Nation Under Television. The Rise and Decline of Network TV*. New York: Pantheon, 1990.

————. *Richard Durham's Destination Freedom. Scripts from Radio's Black Legacy*. New York: Praeger, 1989.

Malcolm X. *The Autobiography of Malcolm X*. New York: Grove Press, 1964 and 1965.

Marill, Alvin H. *Movies Made for Television: The Telefeature and the Mini-Series, 1964–1979*. Westport, Conn.: Arlington House, 1980.

Meyers, Richard. *TV Detectives*. San Diego: A. S. Barnes, 1981.

Montgomery, Kathryn C. *Target: Prime Time. Advocacy Groups and the Struggle over Entertainment Television*. New York: Oxford University Press, 1990.

Moody, Kate. *Growing Up on Television*. New York: Time Books, 1980.

Noble, Gil. *Black Is the Color of My TV Tube*. Secaucus, N.J.: Lyle Stuart, 1981.

Oates, Stephen B. *Let the Trumpet Sound. The Life of Martin Luther King, Jr.* New York: New American Library, 1982.

Porter, William E. *Assault on the Media: The Nixon Years*. Ann Arbor: University of Michigan Press, 1976.

Powers, Ron. *The Newscasters: The News Business as Show Business*. New York: Nordon Pubns., 1977; rev. 1980.

Rivers, William L., Wilbur Schramm, and Clifford G. Christians. *Responsibility in Mass Communication*, 3d ed. New York: Harper and Row, 1980.

Sklar, Robert. *Prime-Time America: Life On and Behind the Television Screen*. New York: Oxford University Press, 1980.

Small, William. *To Kill a Messenger: Television News and the Real World*. New York: Hastings House, 1970.

Soares, Manuela. *The Soap Opera Book*. New York: Harmony Books, 1978.

Steele, Shelby. *The Content of Our Character: A New Vision of Race in America*. New York: St. Martin's Press, 1990.

Watson, Mary Ann. *The Expanding Vista. American Television in the Kennedy Years*. New York: Oxford University Press, 1990.

Yellin, David G. *Special: Fred Freed and the Television Documentary*. New York: Macmillan, 1972 and 1973.

Secondary Materials—Articles

Adanti, Paul. "Programming for TV as a Sales Medium." In *Twenty-Two Talks Transcribed from BMI TV Clinics*. New York: Broadcast Music, Inc., 1953.

Agnew, Spiro T. "Another Challenge to the Television Industry." *TV Guide*, May 16, 1970.

Allen, Steve. "Talent Is Color Blind." *Ebony*, Oct. 1955.

Arlen, Michael. "The Media Dramas of Norman Lear." *New Yorker*, March 10, 1975. Cited in Richard P. Adler, ed., *All in the Family: A Critical Appraisal*. New York: Praeger, 1979.

Asanti, Molefi Kete (Arthur L. Smith). "Television and Black Consciousness." *Journal of Communication*, Autumn 1976, p. 138.

Aurthur, Robert Alan. "Remembering *Philco Playhouse*." *TV Guide*, March 17, 1973.

Baker, Kathryn. "Black and White TV." *The American Way*, Sept. 1, 1989.

Baptista-Fernandez, Pilar, and Bradley S. Greenberg. "The Context, Characteristics, and Communication Behaviors of Blacks on Television." In Bradley S. Greenberg, *Life on Television: Content Analyses of U.S. TV Drama*. Norwood, N.J.: Ablex, 1980.

Bogle, Donald. "TV's New African American Images: Good or Bad?" *Dollars & Sense*, Dec./Jan., 1990.

Brigham, John C., and Linda W. Giesbrecht, " 'All in the Family': Racial Attitudes." *Journal of Communication*, Autumn 1976. Cited in Richard P. Adler, ed., *All in the Family: A Critical Appraisal*. New York: Praeger, 1979.

Brown, Cecil, "Blues for Blacks in Hollywood." *Mother Jones*, Jan. 1981.

Buckley, Gail Lumet, "When a Kiss on Screen Is Not Just a Kiss," *The New York Times*, March 31, 1991.

Campbell, Richard, and Jamie L. Reeves. "Television Authors: The Case of Hugh Wilson." In *Making Television. Authorship and the Production Process*, Robert J. Thompson and Gary Burns, eds. New York: Praeger, 1990.

Cole, Nat King. "Why I Quit My Show." *Ebony*, Feb. 1958.

Collier, Eugenia. "New Black Shows Still Evade the Truth." *TV Guide*, Jan. 12, 1974.

Cripps, Thomas. "The Myth of the Southern Box Office: A Factor in Racial Stereotyping in American Movies, 1920–1940." In *The Black Experience in America*, James C. Curtis and Lewis L. Gould, eds. Austin: University of Texas Press, 1970.

————. "The Noble Black Savage: A Problem in the Politics of Television Art." *Journal of Popular Culture*, 8:4, 1975.

Davidson, Bill. "A Tough Act to Follow." *TV Guide*, Feb. 17, 1979.

Douglas, Pamela. "The Bleached World of Black TV." *Human Behavior*, Dec. 1979.

Drake, Ross. "Ellen Holly Is Not Black Enough." *TV Guide*, March 18, 1972.

Ebert, Alan. "How Sammy Davis, Jr. Met Disaster." *TV Guide*, July 9 and 16, 1966.

Esterly, Glenn. "Ronald Hunter of *Lazarus Syndrome*." *TV Guide*, Oct. 27, 1979.

Fraser, C. Gerald. "Fans Mourn Soap Opera Cancellation." *The New York Times*, March 5, 1991.

Garafalo, Reebee. "Crossing Over: 1939–1990." In *Split Image: African-Americans in the Mass Media*, Jannette Dates and William Barlow, eds. Washington, D.C.: Howard University Press, 1990.

Gilliam, Dorothy. "What Do Black Journalists Want?" *Columbia Journalism Review*, May/June 1972.

Gray, Herman. "Television, Black Americans, and the American Dream." *Critical Studies in Mass Communication*, Dec. 1989, pp. 376–386.

Greene, Bob. "If hope isn't hip, a generation suffers," *Chicago Tribune*, Jan. 7, 1991.

_____, "Ways of the ghetto—saying no to 'yo'," *Chicago Tribune* Jan. 15, 1991.

Hall, Gladys. "Are Comedians Through on the Air?" *Radio Stars*, Feb. 1936.

Hamill, Pete. "Breaking the Silence: A Letter to a Black Friend," *Esquire*, March 1988, pp. 91–94, 96, 98, 100, 102.

Hayakawa, S. I. "Television and the American Negro." In *Sight, Sound, and Society: Motion Pictures and Television in America*, David Manning White and Richard Averson, eds. Boston: Beacon Press, 1968.

Hobson, Dick. "The Odyssey of Otis Young." *TV Guide*, March 1, 1969.

Huie, William Bradford. "The Fight to Force Alabama Educational TV Off the Air." *TV Guide*, Feb. 8, 1975.

Kiester, Edwin, Jr. "Todd Bridges of *Diff'rent Strokes*." *TV Guide*, Dec. 6, 1980.

Killens, John Oliver. "A Black Writer Views TV." *TV Guide*, July 25, 1970.

Kisner, Ronald. "TV Breaks Old Taboos with New Morality." *Jet*, Dec. 1, 1977.

Lemon, Richard. "Black Is the Color of TV's Newest Stars," *The Saturday Evening Post*, Nov. 30, 1969, pp. 42–44, 82–84.

Levine, Richard M. "The Plight of Black Reporters." *TV Guide*, July 18, 1981.

Lewis, Richard Warren. "Cosby Takes Over." *TV Guide*, Oct. 4, 1969.

_____. "The Importance of Being Julia." *TV Guide*, Dec. 14, 1968.

_____. "Teresa Graves of *Get Christie Love!*" *TV Guide*, Nov. 30, 1974.

MacDonald, J. Fred. "Radio's Black Heritage: *Destination Freedom*, 1948–1950." *Phylon*, March 1978.

Maines, Patrick D., and John C. Ottinger. "Network Documentaries: How Many, How Relevant?" *Columbia Journalism Review*, March/April 1973.

Morrow, Lance. "Blacks on TV: A Disturbing Image." *Time*, March 27, 1978.

Narine, Dalton. "Blacks on Soaps: From Domestics to Interracial Lovers," *Ebony*, Nov. 1988. pp. 92, 94, 96, 98.

Norford, George T. "The Black Role in Radio and Television." In *The Black American Reference Book*, Mabel M. Smythe, ed. Englewood Cliffs, N.J.: Prentice-Hall, 1976.

Reed, Ishmael. "Tuning Out Network Bias," *The New York Times*, April 9, 1991.

Sanders, Charles L. "Has TV Written Off Blacks?" *Ebony*, Sept. 1981.

See, Carolyn, "Diahann Carroll's Image." *TV Guide*, March 14, 1970.

Sklar, Robert. "Is Television Taking Blacks Seriously?" *American Film*, Sept. 1978.

Sullivan, Ed. "Can TV Crack America's Color Line?" *Ebony*, May 1951.

Surlin, Stuart H. " 'Roots' Research: A Survey of Findings." *Journal of Broadcasting*, Summer 1978.

Swezey, Robert D. "Every Town a Show Town U.S.A.—Yeah?" In *Twenty-Two Television Talks Transcribed from BMI TV Clinics*. New York: Broadcast Music, Inc. 1953.

Wander, Phillip. "On the Meaning of 'Roots'." *Journal of Communication*, April 1977.

Weigel, Russell H. H., James W. Loomis, and Matthew J. Soja, "Race Relations on Prime Time Television." *Journal of Personality and Social Psychology*, November, 1980.

Zito, Stephen. "Out of Africa." *American Film*, Oct. 1976.

Index of Television Programs

Index of Television Programs

Index of Television Programs

Index of Television Programs

Index of Television Programs

Index

Index

Index

Index

Index

Index

Index

Index